Insights in Applied Theatre

Insights in Applied Theatre

The Early Days and Onwards

EDITED BY

John O'Toole, Penny Bundy and Peter O'Connor

Bristol, UK / Chicago, USA

First published in the UK in 2022 by
Intellect, The Mill, Parnall Road, Fishponds, Bristol, BS16 3JG, UK

First published in the USA in 2022 by
Intellect, The University of Chicago Press, 1427 E. 60th Street,
Chicago, IL 60637, USA

Copyright © 2022 Intellect Ltd

Paperback © 2023 Intellect Ltd

All rights reserved. No part of this publication may be reproduced,
stored in a retrieval system, or transmitted, in any form or by
any means, electronic, mechanical, photocopying, recording, or
otherwise, without written permission.

A catalogue record for this book is available from
the British Library.

Cover designer: Aleksandra Szumlas
Copy editor: Susan Jarvis
Production manager: Jessica Lovett
Typesetting: Newgen

Hardback ISBN 978-1-78938-524-3
Paperback ISBN 978-1-78938-864-0
ePDF ISBN 978-1-78938-525-0
ePub ISBN 978-1-78938-526-7

Printed and bound by Lightning Source.

To find out about all our publications, please visit
www.intellectbooks.com

There you can subscribe to our e-newsletter,
browse or download our current catalogue,
and buy any titles that are in print.

This is a peer-reviewed publication.

This book is dedicated to those pioneers of applied theatre who are no longer with us, and in particular to four contributors to this book, John Carroll (d. 2011), Christine Sinclair (d. 2020), Philip Taylor (d. 2020) and Kennedy Chinyowa (d. 2021).

Contents

Acknowledgements	x
Introduction: Then and now	1
John O'Toole	

PART 1: INSPIRING STORIES

	Introduction to Part 1	9
	John O'Toole	
1.	Life Drama Papua New Guinea: Contextualising practice	16
	Andrea Baldwin	
2.	Audience participation, aesthetic distance and change: Reflections on *Fifty Square Feet*, a theatre in education programme on urban poverty	32
	Chan Yuk-Lan (Phoebe)	
3.	Converging worlds: Fostering co-facilitation and relationships for health promotion through drama at the grassroots	49
	Christine Sinclair and Andrea Grindrod	
4.	Shakespeare in Nicaragua	62
	Els van Poppel	

PART 2: WHAT IS APPLIED THEATRE?

	Introduction to Part 2	69
	Peter O'Connor	
5.	Applied theatre: Problems and possibilities	74
	Judith Ackroyd	
6.	Applied theatre and the power play: An international viewpoint	94
	Bjørn Rasmussen	

INSIGHTS IN APPLIED THEATRE

7.	Conversations with the devil	101
	Tim Prentki	
8.	Applied theatre: An exclusionary discourse?	114
	Judith Ackroyd	

PART 3: RISKY BUSINESS: GOOD INTENTIONS AND THE ROAD TO HELL

	Introduction to Part 3	127
	Penny Bundy	
9.	Ethical tensions in drama teachers' behaviour	130
	Shifra Schonmann	
10.	Community theatre in a South Samic community: The challenges of working with theatre in small communities	141
	Tordis Landvik	
11.	Spectacular violence and the Kachahari theatre of Sindhuli, Nepal	154
	Alberto Guevara	

PART 4: THE DESIRE FOR CHANGE: VOICE, POWER AND PARTNERSHIP

	Introduction to Part 4	171
	Penny Bundy	
12.	Tabula rasa: Starting afresh with classroom drama	176
	Kathleen Gallagher	
13.	Making a break for it: Discourse and theatre in prisons	187
	James Thompson	
14.	Evaluating the efficacy of community theatre intervention in/as performance: A South African case study	193
	Kennedy Chinyowa	
15.	'We like good disco!': The 'public sphere of children' and its implications for practice	206
	Nora Roozemond and Karola Wenzel	

CONTENTS

PART 5: THEATRE OF INNOVATIONS

	Introduction to Part 5	221
	Peter O'Connor	
16.	Theatrical reflections of health: Physically impacting health-based research	226
	Julia Gray	
17.	Playing the game, role distance and digital performance	236
	John Carroll and David Cameron	

PART 6: A NOD TO THE ANCESTORS

	Introduction to Part 6	253
	John O'Toole	
18.	Educational and critical dimensions in Turkish shadow theatre: The Karagöz Theatre of Anatolia	257
	Mehmet Takkaç and A. Kerin Dinç	
19.	Christmas traditions and performance rituals: A look at Christmas celebrations in a Nordic context	269
	Stig A. Eriksson	

Editors' biographies	279
Contributors' biographies – original and updated	281

Acknowledgements

The editors wish to acknowledge with thanks the assistance to *Applied Theatre Researcher* and to this book of Griffith University, the University of Auckland, Intellect Books Ltd, our ever-encouraging commissioning editor Jessica Lovett, our administrative assistant Alex Harvey and our indefatigable copy editor Susan Jarvis, who was with us at the beginning and is still getting it right for us two decades on.

Introduction:
Then and now

John O'Toole

This book is both old knowledge and new knowledge: a rediscovery and a reconfiguration; a restoration – salvage, even – and an archive; a recent revelation to its editors; and, above all, an entirely contemporary handbook of applied theatre for today's practitioners and scholars.

Put simply, the book is the editors' pick of the best and most important articles from the world's first journal of applied theatre, *Applied Theatre Researcher* (2000–11), together with our commentaries and re-evaluation. It is a critical anthology of the cream of early scholarship in applied theatre, chosen by three old hands who have ourselves been centrally involved in applied theatre since the term emerged (see below), and are still up to our necks in it.

The nascence of applied theatre

The earliest usage (more or less) of the term 'applied theatre' that we can identify was by Norwegian drama scholar and contributor to this volume Bjørn Rasmussen, who used the phrase 'applied theatre science' in the mid-1980s. Helen Nicholson (2011: 241), among the keenest and most conscientious chroniclers of the field, suggests that 'applied theatre' was not a term coined by a particular individual to describe a very precise set of practices, but that it emerged haphazardly and spread like a rhizome to fill a gap in the lexicon. We prefer to see it as a phrase whose time had come, which serendipitously emerged in a finite number of places, quite precisely to create the rhizome to fill that gap in the lexicon. That is not uncommon in this strongly collaborative field. There are quite a few specialist drama coinages

that have sprung up synchronously in several places just when a name for a concept was needed – 'process drama', 'actor-teacher', 'hot-seating' and 'teaching artist', to name a few. (This is rather like those children's rhymes and jokes that pop up spontaneously in half a dozen locations and are collected at the far ends of the earth within 24 hours).

Since one identifiable node in the rhizome that is particularly relevant to this anthology was Griffith University in Queensland, Australia, we can quite precisely identify the timing too, because two of us 'were there', playing our part in the genesis. A group of Griffith University drama lecturers were sitting in a Gold Coast waterfront café one day in 1991, speculating – as we all do – on the changing, broadening scene in drama and theatre. We were trying to find a new term (as we endlessly do too) that was broad enough to bring together the common and converging elements of drama education, community, fringe and experimental theatre, Theatre for Development ... and those other manifestations of drama for purposes beyond just entertainment that were taking place outside formal theatre contexts and buildings. There was an element of tension in this discussion, as we were considering overdue changes to our tertiary course offerings; moreover, one of our number had an abiding and deep distrust of all things educational, especially those labelled as such. It was he who suddenly came up with the suggestion 'How about "applied theatre"?' There was a rare moment of agreement among us as we embraced the term, not too critically.

Over the next two years, we started to put together plans for a degree course in applied theatre, and we founded the Griffith Centre for Applied Theatre Research. Just a few years later, in 2000, the centre's director, the late Philip Taylor, started the *Applied Theatre Researcher (ATR)*, the journal upon which this book is based. In the interim, we had stumbled across the visionary work of James Thompson's centre at Manchester University in the United Kingdom, synchronous with ours or possibly starting even earlier, the work of which shared most of our own emerging definitions and principles. (There was one significant difference, which will be discussed below.) We also began to hear the phrase, independently, from other colleagues in Canada and Africa. The rhizome was certainly taking root.

The story of the Applied Theatre Researcher

From the start, the journal attracted submissions from distinguished scholars and practitioners, and over its twelve years we published over 90 articles with a progressively broader and deeper geographical reach and breadth of context as the field developed its expertise and expanded worldwide. Philip Taylor edited the first three volumes, followed by John O'Toole for the next three, then John in

INTRODUCTION

co-editorship with Penny Bundy for the last six. Several of those issues were simultaneously branded as the *IDEA Journal*, resulting from a bargain with the International Drama/Theatre and Education Association (IDEA), which was looking for a journal outlet for its elite Congress papers. That further broadened the *ATR*'s global reach and credibility.

By 2011, the editors were finding the production in our spare time of an expanding and increasingly influential online journal without technical or administrative support too onerous, and with perfect timing, international publishers Intellect UK contacted us with a proposal for a professionally produced journal, to be available both online and in hard copy. So, 'ATR2 – The Next Gen' was born, better known as *Applied Theatre Research*, with the same editorship as the first issue in 2013. While that journal has gone from strength to strength with international academic recognition, the next part of the old *ATR*'s story is sad and wasteful. Its original sponsors, Griffith University, were no longer able to either promote it or support its continued online existence, despite frequent hits by *ATR* devotees; on two occasions, the second with finality, Griffith wiped it from its website in an IT upgrade. For several years, the journal was unobtainable, and by many forgotten. But not by its editors, who each managed to unearth a badly corrupted and incomplete edition of the twelve issues, and eventually combine and restore them to approximately their original whole. Intellect generously agreed to host this precious archive on its *Applied Theatre Research* website, where it now sits, once again picking up hits from applied theatre devotees with long memories. These back issues are available from https://www.intellectbooks.com/applied-the-atre-research-back-issues.

By the time of the Griffith-published *ATR*'s demise, applied theatre was spreading across the globe, and, almost as fast, gaining footholds in academia. Griffith's BA was quickly followed by undergraduate and postgraduate courses – mainly Anglophone – from Canada and the United Kingdom to the United States, South Africa, New Zealand and beyond. The field had already begun to get its own base of academic literature and chronicles of practice. Taylor (2003), Thompson (2003) and Nicholson (2005) all published useful introductory books, and soon edited readers and collections of applied theatre were emerging. More recently, two series of books on applied theatre have been published. *Applied Theatre Research* continues to thrive with its next generation of editors (Peter O'Connor and Kelly Freebody), and the British journal *Research in Drama Education* has added to itself the subtitle '*The International Journal of Applied Theatre*'.

This, of course, raises the question of what this volume can provide to today's growing literature, especially from the lens of the past.

And now what?

The first thing, of course, is that this book restores continuity by completing the important thread of the history of *Applied Theatre Research* from its origins to now. Yet that mainly archival purpose is much less important than our contemporary aims. The nineteen articles we feature have all been judiciously chosen by us to represent key themes and elements from the early days of applied theatre that are still – and indeed now more than ever – relevant. They are all, in the view of the three of us, high-quality articles, some of which were highly influential in their own time. All of them still have plenty to say to today's applied theatre, both in their own terms and sometimes in terms of how their publication influenced the development at the time of this still-expanding field, or refracted it in ways that give us new insights with hindsight. We have arranged them in sections according to some of the key themes – and problematic issues – that were discovered, thought out and sometimes stumbled across by the pioneer writers in the collection. Each section is preceded by a critical editorial commentary on those themes, besides thorough introductions to all the articles and in some cases re-evaluations. We have been necessarily immodest, we think, and have gone well beyond the normal practice of an editorial introduction that just introduces the author and main themes of the articles. To put these into current perspective, we have brought all of our own applied theatre experience to bear on these themes, as they raise general questions that are wide-ranging, contemporary and urgent: from the vital and contested issues of power, partnerships and the giving of voice through theatre to applied theatre's proactive response to COVID-19, to the need to identify, take account of and address the needs of all stakeholders in any applied theatre project.

The book is first and foremost a critical reader for today's applied theatre practitioners and scholars. We are using the term 'applied theatre' inclusively, as the journal did. Some of our writers use other terminology to describe what they were doing, like 'community theatre', 'Theatre for Development', 'theatre in education' and 'drama education'. However, the single definitional criterion we are using is that the writers all chose to submit their articles to a journal offering 'applied theatre' in its title. In the Introduction to Part 2, we provide further detail about what applied theatre actually is and what it comprises, in what is sometimes still a contested debate.

Our other more qualitative criteria for selection for the book included that the writers were all assured in their field and could articulate a clear definition for themselves of their field of activity, navigate it surely, and map or depict it for us with confidence. They have done their homework thoroughly on their particular contexts and have absorbed the literature and the traditions and conventions in

which they are working. However, they are not overawed by those traditions, and there is a freshness of approach in all the articles. They are all honest, mostly humble, and they all respect what they are writing about and who they have been working with. Furthermore, they are reflective and self-critical, not writing victory narratives, welcoming the problematics, seeking to address inconsistencies and failures, and thinking laterally as well as logically.

One further quality is shared in common: they are all experienced and accomplished – and reflective – practitioners in applied theatre, and they are therefore writing as insiders, most of them telling of projects which they led themselves, in which they took part or were privileged observers. This, of course, inevitably means that their commentary is not disinterested, and so it is unable to provide an unbiased view from outside. That's where we – the Editors - come in with the benefit of hindsight; not involved ourselves in any of the articles or the projects they describe, we nevertheless bring to our critical commentaries the combined experience of almost a century of applied theatre and many, many similar projects.

Partly by happenstance, partly deliberately, we have left out projects that were designed in universities or as training for actors' or teachers' courses. Those academic settings have in fact produced, and continue to produce, a sizeable proportion of the total corpus of applied theatre, and they have generated many successful and inspired projects chronicled in the pages of *ATR* and its successor. However, such projects are inevitably compromised – indeed, made more difficult – by other purposes, aims and factors beyond using applied theatre for its primary purpose in its context. This is true for their leaders, the students participating and, of course, for the participant community. These factors include the training itself; the variable skills, commitment and experience of the students; their level of understanding of the community; the ability of the institution to effectively resource the project; often (for the students) assessment; and (for the leaders) the need to produce community engagement and publishing outcomes for their institution.

The shape of the book

For Part 1, 'Inspiring Stories', we have selected four articles that represent just a fraction of the diversity of geography, community contexts, forms of applied theatre and organizational factors that characterizes applied theatre. As we have said, we take an inclusive view of the term 'applied theatre', and Part 2, 'Defining Applied Theatre', consists of four articles that explore the definition and nature of applied theatre, helping us to map the field and navigate our way through the semantics, the terminology and the early priorities. The opportunities for applied theatre to go wrong are

manifold, just as in the conventional theatre, from incompatible funding aims to ill-controlled emotional or ideological dimensions of the work, and bad reading of the needs and tolerances of the audiences; so Part 3, 'Risky Business', presents three bravely acknowledged examples of difficulties that arose in widely different contexts, and compromised part or all of a project designed with the best of intentions. The four articles in Part 4, 'The Desire for Change', articulate how applied theatre can offer opportunities for communities or the individuals within them to express thoughts or ideas that might otherwise not be comfortably shared, to change power relationships and to offer new partnerships. Part 5, 'Theatre of Innovation', explores two particular applications of theatre form and aesthetic: the incorporation of new media technologies, and ethnographic performance, two factors that have now become major preoccupations for our field, particularly in the years since the articles were written. The final Part 6, 'A Nod to the Ancestors', recognizes, with just two offbeat examples, that applied theatre has been around not for 30 years, but for thousands, and in countless cultures.

There are numerous gaps, of course. One that we acknowledge with regret is that within our limited corpus there were no articles that comprehensively represented any one of the many contexts and usages of applied theatre tied to specific, primarily instrumental educational purposes that do not have any underlying aim for significant social change, social rescue and the betterment of society. These include leadership training in business and commercial contexts, teaching languages through drama, assisting debate in corporate conferences, and theatre shows and simulations in museums and tourist parks. This was the main original difference in principle between Griffith's Centre (and the *ATR*) and Manchester's – and most of the discourse and literature since. Quite a proportion of professional applied theatre workers make most or all of their income from those non-altruistic contexts, but unfortunately (as here) they rarely appear in our literature or our debates, as if they are a black-sheep relation who is somewhat shameful even to mention. It is more heart-warming to focus on our efforts for the betterment of society. And this is what we do instead.

The articles are not organized chronologically, although the articles do happen to represent most of the years of publication. We hope that the unfolding narrative of applied theatre, within each section and between the sections, comes across as a still-dynamic dialogue among the writers – many of whom knew each other well then and now, as applied theatre is still a small field.

REFERENCES

Nicholson, H. (2005), *Applied Drama: The Gift of Theatre*, London: Macmillan.

Nicholson, H. (2011), 'Applied drama/theatre/performance', in S. Schonmann (ed.), *Key Concepts in Theatre/Drama Education*, Rotterdam: Sense, pp. 241–45.

Taylor, P. (2003), *Applied Theatre: Creating Transformative Encounters in the Community*, New York: Greenwood Press.

Thompson, J. (2003), *Applied Theatre: Bewilderment and Beyond*, Oxford: Peter Lang.

PART 1

INSPIRING STORIES

Introduction to Part 1

John O'Toole

We call these inspiring stories because we see them as quite typical models of practice of their kind and their time: they are imaginative and thoughtful, and it seems they mainly achieved their purposes and generated some valuable insights. They are stories told realistically and not through the rose-coloured glasses that sometimes colour the memories of drama and theatre educators. They are partly chosen for their multiple diversities and contrasts, most obviously of *geography*, but also of *scale*, of *intention*, of participant *community*, of *resources* and *funding*, and *of dramatic and aesthetic form*. In addition, the first two provide their own highly articulate definitions for how they name and describe the applied theatre work they do, in terms of the shifting and contested discussions in our field relating to nomenclature and meanings. In this they help the reader new to the field to know what the book is actually about, and neatly lay the groundwork for the articles in Part 2, which thoroughly map the whole context – the practice and the theory.

Three of them also explicitly raise, explore and debate several of the biggest questions and most vexed issues with which applied theatre has been wrestling since its inception, and which still confront in one way or another all the work in the field. These questions are often interlinked, forming a problematic complexity that is a challenge to any applied theatre project designer. They implicitly also form a sub-text at least to most of the other articles in the book.

Multiple interests and purposes

In conventional theatre, the relationships and interests (in both senses of the word) are fairly clear and usually known in advance by all participants, to form a straightforward and agreed transaction: a group of performers choose or are paid to provide a performance with the main purpose of entertainment, to a willing audience that expects just that. There is a clear and mutually agreed power relationship here. Of course, this can all easily get murky or even screwed up when the interests and expectations are not in fact clear or mutual. Because theatre is a group artform, everyone has to be on the same page – at least metaphorically. Those in the performing company must understand each other's capacities and place in the ensemble, and they must know what the audience wants and expects. Even if they set out to challenge that with an additional purpose such as artistic experiment, educational aim, controversial message or polemic, they must know the limits of tolerance of their audience. If they transgress, the audience has one potent power: to walk out, or disrupt the transaction in some way, by throwing critical comments to break the atmosphere, or insults, or tomatoes and projectiles – or even, in some cultures, to invade the stage and take over the performance. Mostly this does not happen, however, because the contract is agreed and upheld.

In applied theatre, this almost never happens, because there are by definition multiple purposes and usually multiple stakeholders, with disparate sets of interests that must be reconciled. The theatre is being made for instrumental purposes that at the primary level have nothing to do with entertainment, and usually for funders and sponsors who may know nothing about theatre. The theatre-makers (I'm using this word because there is not always a recognizable performance as part of the project) have to know their whole context extremely thoroughly, and navigate into the agreement the interests, knowledge and/or ignorance, and the emotional, intellectual and political tolerances, of those multiple stakeholders.

Power relationships

At the bottom level is usually the target group for the whole experience: the community that somebody has decided needs educating in sanitation, environmental education or HIV-AIDS prevention; the children receiving the theatre-in-education experience; the nurses, police or medical trainees for whom the applied theatre is devised. These are not necessarily either informed or willing audiences. They may indeed be literally captive audiences, unable – because of the power of the

organization, the curriculum or the sponsors – to walk out if they don't like what they are getting. In such cases, applied theatre workers have learned to their cost and chagrin that their purpose in applying theatre to that community group is rarely achieved, and may be severely damaged.

To our credit, and as these four articles demonstrate, this question of power imbalances is one of which the applied theatre community is usually conscious, and that it has often found ways to overcome. It might be as simple as inviting the target community into the planning and design from the start (that's almost a requirement these days), involving them in the performance itself, and/or giving them some control over the project. Sometimes, highly ingenious solutions have been found – for instance by Victor Nyangore (2000). He was tasked by a health charity to explain to his own community through theatre that they needed to change their traditional personal sanitation methods. A further difficulty was the resistance of key community members to the message, and their reluctance to be involved ... except for the responsible older women, the community mothers, who thereupon became the acting company, and delivered their message in a way that was certain to gain at least a respectful hearing.

The dangers of outsiders coming to do good

Nyangore did have one advantage – he was working with his own village, and his own mother was one of those open-minded women. By its very nature, and the needs and demands of the funders, applied theatre usually involves theatre-makers bringing their skills to work for a community of which they are not a part (that's a normal professional relationship). As in the above example, there can be a disparity between the beliefs of the initiators of the project – in Nyangore's case, the health agency that was funding it – and the beliefs and wishes of the 'target' community. In some projects, the agency and the theatre group may potentially be seen by the community as 'the enemy' – for instance, a theatre group hoping to use theatre for local community behaviour change on an issue such as 'save the trees', rather than destroying them for necessary firewood or for profit. These theatre-makers are right in the firing line, with the responsibility – before they have a hope of any theatrical or educational success – of at least making the community responsive to the experience ... and interested. To do this, they have to thoroughly understand the perspectives of their audience, which means doing their homework, listening, lengthy prior discussion and often two-way negotiation, where the theatre-makers understand and reflect the community's position too. The theatre-making starts there and

no earlier – as our first story in this section, from Papua New Guinea, shows in exemplary fashion. Fly-in-fly-out (FIFO) applied theatre is usually just a waste of time and money, as countless examples vividly testify, such as Jamil Ahmed's (2002) now legendary bleak comparison of projects in Bangladesh, often used today as a basic lesson in how-not-to practise applied theatre 101 for students. However, twenty years on, many funders at all levels still prefer the apparent metric and economic advantages of a theatre show that can be performed three times a day to a grand total of thousands of spectators, to a program that may work for a week, a month or years with one single community or class. Luckily, the Indian theatre collective Natya Chetana had been doing this in its program to help a village understand the need to save their trees, and had established that rapport for which theatre and performance can itself be a great catalyst, of course ... Then one day the local timber industry sent its bullies into the village with the avowed intention of running these subversive interlopers out of town, and even killing one or more, just as an example. The hapless theatre group members immediately found themselves surrounded by a protective group of outraged villagers, who all refused point-blank to release their new friends to the standover team (Patnaik 2004).

Stakeholder expectations

The multiple stakeholders all have their agendas for what they want, what they know, what they don't or don't want to know and what they can offer. Applied theatre-makers have to somehow match all of these, and then incorporate them into whatever use they make of their theatre skills. For instance, most theatre-in-education shows or programs immediately need to: (1) satisfy their primary captive student audience; (2) ensure that the show educates, illuminates or at least doesn't upset their secondary audience of teachers (and the third audience in the teachers' heads – the parents); and (3) fulfil some educational or curriculum aim given by their funders ... before (4) they can consider building their own educational or ideological purposes into the mix. This often demands extreme flexibility, as Chapter 2 vividly shows. If, as often happens, the applied theatre is a collaboration between the theatre-makers and another profession, such as health or medical workers, or police, or university leaders, they may share a common aim, but each of these agencies will bring to the table their agendas, their expertise and their world-views. One factor that any of the stakeholders is quite likely to bring along is a total or partial ignorance about what theatre can do – and, just as important, what it can't do. Chapter 3 analyses this sensitively.

Sustainability

By its nature theatre is an ephemeral art form – normally a fleeting and transitory experience – and those surprises and provisional insights that it creates are part of its aesthetic. That is in direct contradiction to the usual aim of applied theatre, which is to create lasting effects and behaviour or attitude change, often in contexts where long-term reinforcement of that change is needed – say in prisons, or in working with children of war zones. This problem has to be faced on two levels. In the case of our first three stories, there is no avoiding it, and one-off programs or visits are long discredited as part of those FIFO experiences, except in exceptional circumstances; the theatre-makers therefore have to negotiate something longer and more substantial than the normal 'one-off' project. That one-off characteristic is itself a problem for the theatre-makers, whose job is to bring their expertise to a particular situation or commission, and thus work in an endless series of 'one-offs'. All four of our storytellers in this section show that the question of sustainability, both for themselves, and for their projects, has received considerable thought.

Andrea Baldwin's story (Chapter 1) is set right at the beginning of what she hoped would be a long and sustained project in Papua New Guinea, where as part of an Australian university team she was commissioned to help especially remote Papua New Guinean communities to deal with the scourges of HIV-AIDS and other sexually transmitted diseases, and the attitudes that promulgate them, by encouraging behaviour change. There's a minefield for a bunch of outsiders. So she started by grounding her account in careful study of the literature, especially on some of the issues mentioned above, before bravely using the word 'empowerment' as one of the stated aims of the project. The team's task was eased somewhat by the fact that they were commissioned by major PNG health agencies, with considerable local resources and a generous timescale for the project to mature. It was a large-scale project in every way, with major funding from the university and the Australian Research Council (which of course both had their agendas and demands to be reconciled), and two very diverse and geographically problematic locations for the action research. The project was based on a long-term 'train the trainers' plan, with the intention being for the Australians to eventually withdraw and leave it all to the locals. A decade on, discussion with the author reveals that this has in fact happened, and a form of the project still exists in Papua New Guinea, entirely independent of the 'Life Drama' team.

Phoebe Chan's theatre-in-education project (Chapter 2) was set right at the other end of the scale, a small independent theatre in education company with strong views about what Hong Kong children should know that did not normally form part of either their experience or their curriculum. Her team's aim was to bring about change, at least in the children's attitudes and understanding, with

the intention of helping them to empathize with Hong Hong's poorest citizens, and to reflect on the causes of urban poverty.

Like Baldwin, she meticulously backgrounded her story from the literature to explain her approach, as well as her choices of aesthetic and theatrical form. Also like Baldwin, she made the choice to use mainly processual theatrical techniques, including significant deep participation from the audience, to permit active audience engagement in decision-making, which would affect the final dramatic outcome. A remarkable quality of her account is how flexible the team was in monitoring the actual effects of the program, spotting a major flaw through ongoing critique and then making major changes in the aesthetic shape of the whole experience. This also allowed for a measure of sustainability. As a form, theatre in education is by definition FIFO, although this program did allow a significant amount of time (three hours) for their 'one-off' experience, and the program's devisers did not expect results more tangible than a slight shift in understanding – certainly not behaviour change. What their sensitive fine-tuning did ensure was that the program had an extended life – at the time of writing this article, for another two years at least.

Christine Sinclair and Andrea Baldwin's story (Chapter 3) is another modest, small-scale and entirely local project, where the team and all the stakeholders were local too: insiders responding to a particular purpose, to help local community health workers better understand the needs of their clients. It was initiated not by theatre-makers, but by a group of health workers who were inspired by a demonstration of the power of drama by an outside expert, and initially driven by this group. First, a local school and then (conveniently) a locally based drama expert (the co-author) were co-opted, with a very close relationship ensuing. The story is jointly told by the health leader (Grindrod) and the drama leader (Sinclair), and it explores the importance of effective and equal partnerships in applied theatre. This story is impressive for the way the authors (those leaders themselves) analysed the power relationships in the project, and in particular a crucial unseen power shift that was undermining and inverting the priorities of the project, partly because of the very potency of drama itself. The question of the project's sustainability was discussed, but this issue was problematized by their recognition that some of the most important outcomes were both unexpected and indirect, and also unquantifiable. How long the project lasted is not told, but it may be significant that in recent correspondence about this over a decade later, the health professional leader acknowledged that she had not done any drama work for many years, and had not had any contact with her co-author, but that she was now, from a higher-level position, reconsidering drama's possibilities.

Els van Poppel's story (Chapter 4) is another intensely local story (or rather four linked local performance stories). It provides about as complete a contrast

as could be imagined with the three Chapters that precede it. Geographically, first: from the Asia-Pacific right round to Latin America – Nicaragua, with a flavour of the Netherlands – and a choice of theatrical content that is quite English (Shakespeare). However, it is Shakespeare as applied by Nicaraguans for Nicaraguans – an insiders' job. Aesthetically, unlike the processual emphasis selected by the first three, this is pure, upfront audience theatre, although the selected locations were far from conventional theatres and they demanded considerable, albeit passive, participation from their audiences. And, unlike all the three earlier stories, this account is entirely unreflective, uncritical and untheorized – it is pure description. But we called this section 'Inspiring Stories' and this is just that: an inspiring story, full of joy and enthusiasm. No research has gone into the impact or the problematics to test whether the author's confident assertions were justified and agreed by all the participants. However, some of the proof of that pudding is in the sustainability of the community organization that produced the Shakespeare. Movitep, combining actor training, children's work and performance, was founded by the author in 2000. This organization was itself the child of an annual community theatre festival that had already been in existence for a decade. Movitep is still active today, although with a diversified activity calendar comprising many other embodied activities besides drama and storytelling.

REFERENCES

Ahmed, S. J. (2002), 'Wishing for a world without theatre for development: Demystifying the case of Bangladesh', *Research in Drama Education*, 2:1, pp. 207–19.

Nyangore, V. (2000), 'Listen to your mothers: Theatre and health in village settings', in J. O'Toole and M. Lepp (eds), *Drama for Life: Stories of Adult Learning and Empowerment*, Brisbane: Playlab Press, pp. 77–85.

Patnaik, S. (2004), 'Theatre and propaganda: How far do they go together?', presentation to IDEA'04, 5th World Congress of Drama/Theatre Education, Ottawa, July.

1

Life Drama Papua New Guinea: Contextualizing practice

Andrea Baldwin

As applied theatre practitioners, we are often engaged fully in designing and implementing projects to meet identified needs, and struggle to find the time to articulate and share the theoretical and contextual underpinnings of our practice. However, making that effort is a worthwhile exercise, both to help maintain a shared vision for the project among its various stakeholders and to share with others working in similar fields.

Life Drama is a workshop-based, participatory form of applied theatre and performance being developed in Papua New Guinea. At this time, the aim of Life Drama is to address the gap between 'awareness' and behaviour change in relation to sexual health, particularly HIV. It is envisioned that the programme could be adapted in future by applied theatre practitioners seeking to address a range of issues that may confront communities.

The purpose of this chapter is to use Life Drama as a case study to illustrate some of the contextual and theoretical factors that have informed the development of this health education initiative to date. First, we will endeavour to situate Life Drama within the field of applied theatre and performance. Next, we will locate Life Drama as a form of practice under the umbrella of Theatre for Development. Finally, we will show how Life Drama has been informed by previous practice and research into HIV education. The article explains how the developers of Life Drama have attempted to address the theoretical, ethical and practical dilemmas identified in the literature of these fields.

Situating Life Drama within applied theatre

We have chosen to define Life Drama as a form of 'applied theatre and performance'. By using the term 'applied', we make the unapologetic (though by no means

unproblematic) claim for Life Drama that it aims to create change. Life Drama is a research project designed to develop and test a drama-based intervention to help slow the interacting epidemics of sexually transmitted infections and HIV.

Drama-based or theatre-based? Like Helen Nicholson (2005), with the title and subtitle of her book *Applied Drama: The Gift of Theatre*, we are having a bite each way. Nicholson (2005) points out that the terms 'applied drama' and 'applied theatre' are often used interchangeably, although some have argued that 'theatre' says something about space and implies the presence of an audience. Philip Taylor (2003) has distinguished between 'applied drama', which he associates with the British tradition of drama in education, and 'applied theatre', which he claims is 'usually centred on structured scenarios presented by teams of teaching artist-facilitators'. Nicholson (2005) sees in this distinction an echo of an older distinction between drama in education (DIE), regarded as 'a teaching methodology across the curriculum', and theatre in education (TIE), typically a performance by actors for students with some element of interaction or audience participation. Nicholson (2005: 4) concludes that across the board, in a field that itself has no unanimously agreed name (and whose journals include *Research in Drama Education*, *Applied Theatre Researcher* and *Music and Arts in Action*), 'there is a reluctance to make a neat separation between process and performance-based work'.

This seems to us only right and proper, since the idea of 'performance' incorporates both the perspective of the actor (the one doing the performing), who is concerned with the processes of performing, and the perspective of the audience member (the one being performed to), who is concerned with the processes of apprehending the performance. However, in the context of the developing world, it is useful to make a distinction between forms of applied theatre that seek to create change *in an audience*, through the medium of a performance by actors, and those that have no separate audience, but seek to create change *in the performers* through the act of performance. We will describe the latter as process-based forms and the former as performance-based forms, while recognizing that this over-simplification trades off rich territories of theoretical nuance for linguistic convenience. In this, we are following Mwansa and Bergman (2003: 13), who differentiate between 'performance-based' and 'workshop-based' forms of Theatre for Development, and state that in the field of HIV education in Africa, 'the most common approach of Theatre for Development is performance-based'.

Situating Life Drama within Theatre for Development

Mwansa and Bergman (2003) have analysed forms being used to address HIV in Africa in terms of three elements: play (or spectacle), message and participation.

According to their analysis, forms that work *for* the people tend to emphasize the play; forms that work *with* the people give equal emphasis to all three elements; and forms enacted *by* the people emphasize participation. They view forum theatre as a form *for* the people since the animateurs are in charge, and 'the depth of discussions is often narrow and the work is "hit and run"' (2003: 11). Theatre *with* the people means that 'animateurs invite a select group of people to participate in the process. Artists work jointly together with the select group, from the beginning to the end. Together, they present the play to the community and facilitate discussions' (2003: 12). Theatre *by* the people is theatre in which, 'The role of animateurs is limited to that of trainers. Local groups identify and analyse problems, make and perform plays and conduct discussions under guidance of animateurs' (2003: 12).

Mwansa and Bergman (2003: 12) argue that the higher the level of participation, the more likely it is that the intervention will result in behaviour change:

> The central target for HIV/AIDS prevention is *behaviour change*. Performance-based approach of TFD without involvement of the target group can hardly bring about meaningful behaviour change. People need to grapple directly with the issues, be the thinkers and problem solvers and testers of new solutions and behaviours themselves. A focus on DRAMA – a process of creating new scenes to try out solutions or show the reality behind problems – needs to replace a focus on THEATRE, where a finished product is being performed for other people. The learning needs to be an active process, which deepens people's own awareness.

The tradeoff, assuming limited resources, is between reaching more people via less participatory models (as Mwansa and Bergman say is the case with forum theatre), and reaching fewer people with more participatory models, such as the drama-discussion method (attributed to Ross Kidd – see Mwansa and Bergman 2003: 16).

In terms of the above analysis, Life Drama can best be understood as a form that works *with* the people and aims to be a form eventually used *by* the people. The Life Drama pilot focuses on HIV, a problem identified by donor agencies and the PNG government but not always by communities. The team observed a difference between the two pilot sites. In Tari, Southern Highlands Province, Life Drama was proactively invited to enter the community by community leaders who perceived that HIV posed a growing problem in the area. Karkar Island in Madang Province, on the other hand, was perceived as an appropriate research site precisely because the community did not recognize the threat of HIV on the island. In future, it is envisioned that Life Drama techniques can be used by any

community to address a range of problems its members may be facing, whether to do with health, gender relations, peace, governance or environment.

Life Drama trainers

The Life Drama model aims to mobilize and train trainers, or key individuals who have the capacity to disseminate the training further. Trainers are trained by lead trainers, who at this time are all Australian but in future will be Papua New Guinean. Six potential Papua New Guinean lead trainers, three male and three female, are at different stages of professional development, with the aim of becoming Life Drama lead trainers and carrying on the initiative beyond its three-year research and development phase.

The pilot study has identified a number of qualities and capacities in people who nominate to be trained as Life Drama trainers, which make them most likely to operate effectively once trained. The most effective trainers are usually individuals with a background in teaching and training, or performance (ideally both). If they do not have a performance background, they must at least have an interest in and passion for drama, and a belief in the educational power of participatory drama. They are usually (though not always) people who hold a leadership role in their own community (e.g. chiefs, church leaders, women's leaders, teachers, police officers, youth leaders, health-care workers). In this role, they must be respected and seen as people of integrity by those they lead. They should have regular access to a group with which they can work (a school class, Sunday school class, youth group, church congregation, civil society, women's group, outpatients, etc.). Ideally, they are employed or working voluntarily in positions where they have a mandate to provide HIV education, and some infrastructure or support to do this (e.g. a training space, travel allowance). Since trainers are trained but not paid or provided with further support by Life Drama, they need to be self-motivated people who are passionate about the welfare of their community and convinced of the threat posed by HIV and its attendant issues. Finally, they need to have the personal energy, drive, confidence, self-motivation, self-organizing skills, social skills and charisma to work effectively as trainers.

While both pilot sites to date have involved the training of community leaders, the next phase of the project will test the effectiveness of a dissemination model focused on teacher educators and student teachers at the University of Goroka.

Life Drama training

Life Drama is a workshop-based approach, which combines techniques drawn primarily from drama in education and improvisational drama with non-drama activities such as condom demonstrations and group discussions.

The trainers work with the lead trainers over a period of approximately one week, undertaking the basic Life Drama training. At the end of the course, they receive a certificate of completion. They are provided with the *Life Drama Handbook*, which contains photographic representations of all the activities included in the training, along with short verbal descriptions and space to write notes or draw additional pictorial representations. Since many trainers are illiterate and/ or do not read English, they are encouraged to find other ways to support their memory of the training activities (e.g. having colleagues translate the English words for them, jotting notes in Pidgin). The trainers are encouraged to repackage the Life Drama activities to suit their own groups and training times. Several trainers from the Tari site have already adapted Life Drama techniques from a focus on HIV to other issues of relevance for their own groups (e.g. teaching about gender relations in a high school classroom).

At this time, the basic Life Drama training provided to trainers consists of two nine-hour units, divided into three-hour modules. The first unit engages the training group in processes of working dramatically, including using role work and image theatre. The modules are Fundamentals of Life Drama; Introducing Role Play and Open Story; and Progressing the Open Story. The second unit engages more directly with the HIV content material and the 'world of objective fact'. The modules are Bodies and Diseases; Negotiating Safer Sex; and Overcoming Stigma. Gender relations is a theme that permeates most modules, and it is explored explicitly in the context of Negotiating Safer Sex.

The training experience is structured around an Open Story (Figure 1.1), concerning a woman, her husband, their daughter, the husband's girlfriend and the communities to which the characters belong. The story is carefully contextualized as happening within the community of the training participants. When the woman discovers that her husband is seeing another woman, and the husband's boss raises concerns about his sexual health, the possibility of HIV infection enters the scenario.

The participants provide the information that allows the choices made by individual characters in the story to be situated within the local realities of family, community and society. For example, through a combination of planning and emergence, the local Research Advisory Group and workshop participants provide the details of where the husband works, how he met his girlfriend, why she is sleeping with a number of men, what the wife's daily life is like, how she learns of her husband's infidelity, what health services are available to provide HIV

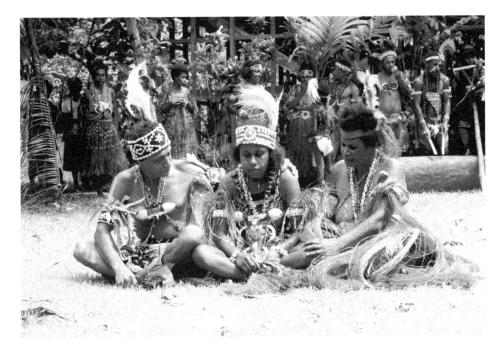

FIGURE 1.1. The 'Open Story' unfolds. Copyright author.

counselling and testing, what options are available for treatment and support, how the community might respond to someone who is HIV positive and what the implications are for the daughter's future.

Importantly, Life Drama seeks to enrich the performance forms 'imported' or created by the Australian facilitators, by harnessing the power of cultural performativity within the workshop group. It has been pointed out that performativity is a valued aspect of daily life in Papua New Guinean culture, from the rituals and individual 'sung prayers' associated with cultivation and food gathering to more communal and formal performances such as initiation rites, mourning rites and public celebrations (e.g. Murphy 2010). By inviting the participants to tap into their cultural means of expression through body adornment, dance, oration, singing and music, it is intended that the Life Drama experience becomes more culturally relevant, meaningful and memorable, which in turn enhances learning.

Situating Life Drama within HIV prevention

In Papua New Guinea, as in other regions, an intensive and expensive 'awareness' campaign over the past few years has resulted in some 98 per cent of people

being aware of something called HIV, but there is little to no evidence of behaviour change as a result. The literature suggests that one reason for this dispiriting finding is over-reliance on one-way dissemination of messages, through billboards, posters, stickers, caps, shirts and advertisements on radio and television. Since the message is externally imposed, the reader, viewer or listener has no ownership of it. The recipient cannot engage with or debate the message, tailor it or change it. In addition, being aimed at a wide audience, the message may fail to provoke the desired response because the recipient receives no specific support, guidance or encouragement to apply it personally.

Life Drama is situated near the opposite end of the spectrum from the one-way, mass-mediated health message. It is highly participatory – group members engage with the content of the workshop with 'head, heart and body' (thoughts, emotions and physical enactment). They thus have the opportunity to challenge, question and probe the information provided, to educate one another, and to actively devise various ways of expressing and furthering their understanding.

King (1999) provides a comprehensive overview of the theories that inform most HIV education approaches in the developing world, divided into three categories: theories that focus on individuals; social theories and models; and structural and environmental models. Rather than being driven by any one theory, Life Drama incorporates aspects of many within a coherent framework.

Focus on individuals

Health belief model

The health belief model states that a person must hold the following beliefs in order to change health-related behaviour:

- perceived susceptibility to a particular health problem ('Am I at risk for HIV?')
- perceived seriousness of the condition ('How serious is HIV; how hard would my life be if I got it?')
- belief in effectiveness of the new behaviour ('Condoms are effective against HIV transmission.')
- cues to action ('I have witnessed the death or illness of a close friend or relative due to AIDS.')
- perceived benefits of preventive action ('If I start using condoms, I can avoid HIV infection.')
- barriers to taking action ('I don't like using condoms.') (King 1999).

Life Drama engages participants in discussion about the risks of HIV in their local area, and ensures that they are provided with accurate, meaningful information. For example, pre-training interviewing revealed that most of the Karkar Island participants believed there was little to no risk of contracting HIV on their island, with perhaps two people affected in the whole population. In fact, surveillance statistics obtained from Gaubin Hospital suggest that over 1000 people on Karkar Island have HIV, but since testing rates are low only a few are aware of their status. The seriousness of HIV infection is explored in the workshop emotionally and cognitively through the Open Story and related activities. Through role-play and discussion, the group explores the effectiveness of behaviours known to prevent transmission and looks at how realistic these are (e.g. how realistic is abstinence for couples who want children, or condom use for women who lack the power to negotiate sex).

It has been reported in Africa that people only begin to change their sexual behaviour when they have had personal experience of the illness or death of a family member (VSO Tokaut AIDS, personal communication). Life Drama aims to provide the same impetus through vicarious experience, instead of waiting for a real tragedy to occur. Workshop participants are encouraged to identify and empathize with the characters in the Open Story, sometimes by playing the characters and sometimes by watching and interacting with other participants playing these roles. In this way, illness, death, loss and other consequences of HIV infection become 'real' experiences, while still providing the safety and distance required for reflection, processing and learning (Haseman and O'Toole 1987). On the other side of the coin, Life Drama allows participants to explore the benefits of preventive action, and to experience a sense of emotional relief that preventive action is possible. Finally, barriers to preventive action are also explored dramatically. An example is the use of a 'sing sing form', in which the husband faces the dilemma of whether or not to go for voluntary counselling and testing.

Social cognitive theory

According to Albert Bandura's (1994) social cognitive theory, behaviour is determined by the interaction between two types of cognition: expectancies (beliefs about the positive and negative consequences of performing the behaviour) and self-efficacy (the belief that one is able to perform the behaviour). By providing participants with the opportunity to rehearse real-world behaviours through role-play (for example, going for HIV testing, negotiating condom use, refusing sex), Life Drama aims to increase the self-efficacy of these behaviours. By exploring the consequences of these decisions through role-play and group discussion, participants are able to demystify some behaviours (such as using condoms) and to refine vague or unrealistic expectancies.

Bandura is also known for the development of social learning theory; his work has demonstrated that expectancies and self-efficacy can be formed through vicarious experience (e.g. observing others) rather than necessitating personal experience (Bandura 2001). While many would argue that personal experience is the more powerful teacher, and that the act of enacting is what gives process-based interventions the advantage over performance-based ones, we postulate that meaningful social learning also takes place through vicarious experiencing in the small-group context of the Life Drama workshop.

Theory of Reasoned Action

The theory of reasoned action, now known as the theory of planned behaviour, is similar to social cognitive theory in that it regards behaviour as volitional and driven by rational cognition. A person's intention to perform a behaviour is seen as a function of three components: attitude towards the behaviour; subjective norms (beliefs about the social acceptability of the behaviour); and perceived behavioural control (Ajzen 1991). Ajzen (2002) has suggested more recently that perceived behavioural control also consists of two related components: Bandura's (1994) concept of self-efficacy (whether the actor can perform the behaviour) and the notion of controllability (whether the performance is within the actor's control).

In a Life Drama workshop, there are likely to be a range of attitudes towards protective behaviours such as condom use. Various workshop activities provide the opportunity for these attitudes to be aired, discussed and debated in relation to the action of the Open Story. For example, the question of whether condoms should be available to unmarried people like the husband's girlfriend was energetically explored in the Tari pilot programme through a workshop activity called 'Debate', adapted from a technique used by Wan Smol Bag Theatre (an NGO-based theatre group in nearby Vanuatu).

Social theories and models

Diffusion of innovation theory

Diffusion of innovation theory (Rogers 1983) describes the process by which an idea is disseminated throughout a community. Interventions using this theory generally investigate the best method to disperse messages within a community, and the best people to act as role models to change community norms. Life Drama aims to enlist community leaders who are, or have the capacity to be, champions for health-promoting behaviours, and build up their skills and confidence to act as trainers.

Since Life Drama techniques rely heavily on group dynamics and interactions, the whole group is encouraged to explore the major issues and find ways to help their community respond. Taboos on talking about reproductive organs and processes have been identified as preventing the dissemination of accurate health information and creating an atmosphere of mystery in which myths and misinformation fill the vacuum (King and Lupiwa 2009). Similarly, serious issues that are commonplace in some areas, such as teacher–student seduction or gang rape by police, contribute to the spread of HIV and cannot be addressed while they are hidden in social 'silence' (King and Lupiwa 2009). Life Drama provokes participants to speak out about the realities of what happens in their community, and to reach agreement about what does or does not need to change.

Social influence or social inoculation theory

This educational model emphasizes the role of peers in influencing the behaviours of young people (Howard and McCabe 1990). The metaphor of 'inoculation' is based on the idea that learning to handle peer pressure in a performed context, in the safety and controlled environment of a drama workshop, will give young people the skills and self-efficacy to handle it in the real world. When the Life Drama trainer conducts training with a school class or youth group, a bonus effect may be a reduction in peer pressure (e.g. to have sex) due to the open, supported exploration of the issue by the group.

Theory of gender and power

The theory of gender and power is a social structural theory addressing the wider issues surrounding women, such as distribution of power and authority, and gender-specific norms (Connell 1987). Structurally determined gender differences are explored explicitly in Life Drama through the Open Story and related activities. For example, 'Sexual Network' is a structured activity that explores how the HIV virus may have moved through the community to infect the husband's girlfriend. Each pilot group has identified forced sex, sex expected and demanded within marriage, and sex in exchange for goods or money as realities in many, if not most, Papua New Guinean women's lives. 'Hotseat Roleplay' provides an opportunity for the group to challenge, and hear from, the husband's girlfriend. Individual participants have demonstrated marked changes in discriminatory and judgemental attitudes towards the girlfriend as a result of 'experiencing' her familial, social and economic situation and options through this activity.

Structural and environmental models

Theory for individual and social change or empowerment model

Werner et al. (1997) state that 'empowerment is the process by which disadvantaged people work together to take control of the factors that determine their health and their lives' (cited in King, 1999: 10). Although empowerment can only come from the group itself, 'enabling empowerment is possible by facilitating its determinants' (1999: 10). King states that interventions using an empowerment approach address issues at the community and organizational level and include participants in the planning and implementation of activities. Life Drama seeks to add value to the existing efforts of a number of organizations in Papua New Guinea, including the National AIDS Council, which is our major partner. In addition, we work with organizations and individuals in each pilot site through a local Research Advisory Group, which plays a major role in planning and implementing the Life Drama training and evaluation. By training community leaders, and seeking ways to support their organizations, Life Drama aims to 'facilitate the determinants' of empowerment and grass-roots activism.

Critical reflection

Life Drama is in its very early stages – as a pilot project, it is barely eighteen months old. While the project has made a promising start, there are many issues yet to be grappled with as the partnership moves forward and strives to establish a base for sustainability.

Education is just the beginning ...

There is plenty of evidence in the literature and in international practice that education alone cannot be expected to result in behaviour change that the environment does not support. King (1999), reviewing best practice in HIV education, states that programmes must address the determinants of sexual behaviour by targeting the society rather than the individual. Wan Smolbag in Vanuatu, while still working with young people to produce plays, radio plays and a popular television soap opera, has found that the effectiveness of its Theatre for Development projects is greatly enhanced by the other services it now provides. These include a range of life and vocational skills training courses, a computer laboratory, a sexual health clinic and outreach service, regular meals for homeless young people, a drop-in centre, sports and leisure activities, and one-to-one informal counselling and mentoring (Wan Smolbag 2010).

While Life Drama can encourage participants to be tested for HIV, the intention may be defeated by the realities of travel costs to the nearest testing facility, inadequate privacy at the clinic and the low level of resourcing for medical care at the hospital. As a small team of researchers developing a new applied theatre approach to HIV education, we can play only a small role in helping to address these broader systemic issues. At present, our approach is to continue building partnerships with both centralized organizations such as the National AIDS Council Secretariat and local stakeholders such as Gaubin and Tari Hospitals, in order to help progress the formulation and implementation of HIV policy in whatever ways we can. We also aim to help empower training participants to advocate for and participate in service improvements at the local level.

Individual behaviour change versus community transformation

In many ways, the aims of Life Drama remain modest: to achieve small but significant and sustained changes in people's knowledge and attitudes regarding HIV, in the hope that these will lead to changes in intention and behaviour. The programme seeks to achieve these changes through group processes, in the hope that a shift in the attitudes of a group will resonate in the community. However, the trainers are aware of a tension between a 'Western' focus on individual characters and their internal processes, and a 'Melanesian' emphasis on the importance of relationships, family and community. We acknowledge the criticism that we have not yet adequately defined the mechanism by which Life Drama can be expected to support community transformation.

Reason and emotion

It is a general criticism of cognitive science that models tend to treat human decision-making as a 'rational' process, a species of mental algebra, while the impact of emotions on decision-making and behavioural choice remains poorly understood. Since many would argue that the power of applied theatre lies in its capacity for emotional engagement, further theoretical work is needed to bridge the gap between cognitive models of health promotion and applied theatre models of practice. The Life Drama team hopes to contribute to this work as the project moves forward.

How participatory is participatory?

Life Drama purports to be a participatory action research project. However, the project has been instigated by Australian researchers, is mostly funded by an Australian research body and is largely conducted by Australian trainers who 'fly in

and fly out'. There is an argument that such a model is not truly participatory, since the project has not been instigated by Papua New Guineans to effect a change for which they perceive a need.

It is important to note that 'participation' is a concept that drives the project on several levels. At the highest, most strategic level, a number of Papua New Guinean organizations have committed cash and in-kind support to the project, and key staff participate via a number of mechanisms including an annual Stakeholder Meeting in Port Moresby, formal reporting channels, email discussions and ad hoc meetings with researchers. It would not be possible for the project to be conducted if these organizations did not consider it important and did not contribute their resources and expertise.

At the level of the research team, two Papua New Guinean academics participate actively in the design, delivery and evaluation of each pilot. A Research Advisory Group has been established at each pilot site, and the members of these groups provide perspectives on the group's needs and participate in creative decision-making about activities to be conducted in training. Where possible, local staff are recruited as interviewers to conduct pre-training, post-training and follow-up interviews in the trainees' own language, and also contribute to the design and implementation of the research.

At the level of the trainees, who are considered the major beneficiaries of the project, they are enlisted as co-researchers. They are provided with tools and guidance to report and reflect on their own practice and its impact as they implement what they have learned with groups in their communities. Data collected by the participants, and provided through qualitative interviews, shape the further development of the Life Drama programme.

While Life Drama is currently in its pilot phase, it is hoped that the initiative can be established on a sustainable footing in Papua New Guinea over the next few years, with local researchers and trainers taking more and more control of its direction and implementation.

Time and structure

King and Lupiwa (2009) note that the most successful HIV interventions are those in which educators revisit the same groups repeatedly. In Melanesia, relationships are of vital importance to individual identity and social functioning, and ongoing relationships with high-status outsiders are very highly valued (Wesch 2008). It is not surprising that the VSO Tokaut AIDS programme, in which theatre trainers revisit the same communities four times over several years to progressively deepen their knowledge and understanding of HIV and AIDS, is considered one of the most successful models in PNG (Levy 2008).

LIFE DRAMA PAPUA NEW GUINEA

In Tari, we have observed a strong commitment on the part of the trainers, all of whom returned for the second week of training after a month of conducting workshops and research. When we returned for an evaluation visit several months later, approximately half the group could be contacted: reasons for attrition included being in hospital with malaria, being on the run from tribal enemies and being away conducting training in a remote area. It seems inevitable, given the rapid pace of change in Papua New Guinea and the pressures of making a living and supporting a family, that groups will be progressively difficult to reconvene as time goes on. We have attempted to address this difficulty by compressing the Life Drama training into one week rather than two for the Karkar Island pilot. However, feedback from participants indicated that, while they felt they had learned a great deal from the programme, they did not yet feel confident enough to act as trainers. We are currently investigating the options for providing a follow-up training module that focuses explicitly on providing supervised practice and building the confidence of the trainers. In the meantime, several of the participants did feel confident that they could adapt the content of the training for a different mode of delivery: the 'performance-based' mode with which they were already experienced. Future evaluation will focus on how the trainers have impacted their community, and what combinations of 'performance-based' and 'process-based' techniques they have adapted from their training.

Conclusion

Health education is a multidisciplinary endeavour, and arguably the work of improving the efficacy of practice is enhanced by considering the wide range and scope of theory generated from various research perspectives. We hope that this case study in how theory has been used to inform the development of a specific practice initiative contributes to ongoing discussion and practice improvement in the area of HIV education in developing regions.

Acknowledgements

This chapter was originally published as Article 1 in Volume 11 (2010). The Life Drama project is funded by the Australian Research Council, in partnership with Queensland University of Technology and the National AIDS Council Secretariat, Papua New Guinea. The author wishes to thank the ARC; the National AIDS Council (especially Mr Wilfred Kaleva, Ms Caroline Wayne and Mr Tony Lupiwa); the Life Drama research team (Professor Brad Haseman, Professor Don

Stewart, Associate Professor Anne Hickling Hudson, Associate Professor Elizabeth Parker, Ms Hayley Linthwaite, Ms Jane Awi and Mr Martin Tonny); support staff of QUT, Griffith University, the University of Papua New Guinea, and the University of Goroka; Mr Motsy Davidson and Mr Daniel Waswas at the University of Papua New Guinea; the Research Advisory Panel based in Port Moresby; the Madang/Karkar Island Research Advisory Group (Dr Greg Murphy, Ms Jeddah Suare and Mr Beno Ibik) and Tari Research Advisory Group (Ms Veronica Payawi, Ms Marilyn Peri, Ms Noreen Tom, Mr Jacob Ten and Ms Mary Michael Tamia); and all Life Drama participants in Tari and Karkar Island. The author would also like to thank Peter Walker and Jo Dorras of Wan Smolbag for permission to reference their work.

REFERENCES

Ajzen, I. (1991), 'The theory of planned behaviour', *Organisational Behaviour and Human Decision Processes*, 50:2, pp. 179–211.

Ajzen, I. (2002), 'Perceived behavioral control, self-efficacy, locus of control, and the theory of planned behavior', *Journal of Applied Social Psychology*, 32:4, pp. 665–83.

Bandura, A. (1994), 'Social cognitive theory and exercise of control over HIV infection', in R. J. DiClemente and J. L. Peterson (eds), *Preventing AIDS: Theories and Methods of Behavioral Interventions*, New York: Plenum Press, pp. 25–59.

Bandura, A. (2001), 'Social cognitive theory of mass communication', *Media Psychology*, 3:3, pp. 265–99.

Connell, R. (1987), *Gender and Power*, Stanford, CA: Stanford University Press.

Haseman, B. and O'Toole, J. (1987), *Dramawise: An Introduction to the Elements of Drama*, Melbourne: Heinemann.

Howard, M. and McCabe, J. (1990), 'Helping teenagers postpone sexual involvement', *Family Planning Perspectives*, 22:1, pp. 21–26.

King, E. and Lupiwa, T. (2009), *A Systematic Literature Review of HIV and AIDS Research in Papua New Guinea 2007–2008*, Port Moresby: National AIDS Council Secretariat.

King, R. (1999), 'Sexual behavioural change for HIV: Where have theories taken us?' in UNAIDS (ed.), *Best Practice Selection: Key Material*, Geneva: UNAIDS, http://www.who.int/hiv/strategic/surveillance/en/unaids_99_27.pdf. Accessed 2 February 2010.

Levy, C. (2008), *VSO Tokaut AIDS Evaluation Report: Research and Evaluation on the Impact of the Awareness Community Theatre Program in Raikos and Jimi Districts*, Port Moresby: VSO Tokaut AIDS.

Murphy, G. (2010), *Fears of Loss, Tears of Joy: Raun Raun Theatre and National Culture in Papua New Guinea*, Port Moresby: University of Papua New Guinea.

Mwansa, D. and Bergman, P. (2003), *Drama in HIV/AIDS Prevention: Some Strengths and Weaknesses. A Study in Botswana, Tanzania, South Africa, Kenya, Ethiopia and Uganda*, http://www.comminit.com/en/node/270296/304. Accessed 2 February 2010.

Nicholson, H. (2005), *Applied Drama: The Gift of Theatre*, New York: Palgrave Macmillan.

Rogers, E.M. (1983), *Diffusion of Innovations*, New York: The Free Press.

Taylor, P. (2003), 'Musings on applied theatre: Towards a new theatron', *Drama Magazine*, 10:2, pp. 37–42.

Wan Smolbag Theatre (2010), Home page, http://www.wansmolbag.org. Accessed 2 February 2010.

Werner, D., Sanders, D., Weston, J., Babb, S. and Rodriguez, B. (1997), *Questioning the Solution: The Politics of Primary Health Care and Child Survival with an In-depth Critique of Oral Rehydration Therapy*, Palo Alto, CA: Healthwrights.

Wesch, M. (2008), 'Creating '*Kantri*' in Central New Guinea: Relational ontology and the categorical logic of statecraft', *M/C Journal*, 11:5, http://journal.media culture.org.au/index.php/mcjournal/article/viewArticle/67. Accessed 2 February 2010.

2

Audience participation, aesthetic distance and change:
Reflections on *Fifty Square Feet*, a theatre in education programme on urban poverty

Chan Yuk-lan (Phoebe)

This article draws on my experience of planning, developing and implementing *Fifty Square Feet*, a theatre in education programme on global citizenship education, as the premise for discussing the notion of audience participation and aesthetic distance (Jackson 2007) in using theatre as social intervention to bring about change.

For the purpose of this article, I use the term 'theatre in education' (TIE) to refer to a form of theatre that is devised, age specific and participatory, and contains not only a production but also pre- and post-performance activities, as described by John O'Toole in his seminal work *Theatre in Education* (1976: vii):

> Firstly, the material is usually specifically devised, tailor-made to the needs of the children and the strengths of the team. Secondly, the children are often asked to participate; endowed with roles, they learn skills, make decisions, and solve problems, so the programmes' structures have to be flexible ... to respond to the children's contributions within the context of the drama and still to uphold the roles ... Thirdly, teams are usually aware of the importance of the teaching context, and try to prepare suggestions for follow-up work ...

Other terms related to TIE include 'educational theatre', used by Jackson (1993) – who later preferred 'interventionist theatre' (Jackson 2005, 2007), with which he referred to a wider scope of works that may not necessarily happen within schools

and formal educational settings. Other authors use 'applied theatre' (Prendergast and Saxton 2009; Prentki and Preston 2009; Taylor 2003; Thompson 2003) or 'applied drama' (Nicholson 2005) to refer to works of similar nature, with a slightly different focus on the applied nature of theatre (as opposed to theatre that purely serves to entertain). In this chapter, I have opted for 'educational theatre' as a general term to refer to works that happen mainly in school and other educational contexts, and TIE as its sub-set, embodying the devised, age-specific and participatory features mentioned above.

In discussing educational theatre, including TIE, Schechner (cited in Jackson 2007: 139, my italics) suggests that a more fluid, contemporary notion of theatre needs to be considered – one that sees theatre as 'an interplay among space, time, performers, action and *audience*'. Audience participation, rather than being seen narrowly as a process that denies or compromises the aesthetics of theatre, is an integral element in a theatre event. Jackson (2007) also asserts that audiences actively engaged in participatory theatre can engage in ways that retain a degree of aesthetic distance, enabling them to simultaneously believe and not believe, and to be engaged and distanced.

It is in this liminal space of engagement and detachment that the potential for change and transformation becomes paramount. Bertolt Brecht (1964), in maintaining that theatre should aim to promote social change, calls for the effect of *Verfremdung* (defamiliarization) in theatre, distancing the audience to bring about heightened consciousness and reflection in social and political orientations. Boal (1979: i) sees theatre as necessarily political and emancipative, where 'change is imperative'. His forum theatre techniques further Brecht's notion of alienation by breaking the conventional separation between 'actors' and 'spectators', turning the theatre into an empowering ground for people to rehearse for changes in real life.

Dorothy Heathcote also asserts that drama provides a framework for participants to negotiate their change when the 'self-spectator' of a learner is awakened:

> It is through the awakening of what Heathcote terms the 'self-spectator', which is the participants being aware of what they are doing while they are doing it, that she aims to bring about knowledge and change.
>
> (Muir 1996: 25)

Gavin Bolton (1998: 266) describes 'self-spectatorship' as a 'double valence of being an audience to one's own creation and being an audience to oneself'. He explains that such a concept takes the percipients (a term to denote the combined function of participant/spectator) beyond individual watching to collective and shared feelings. Cecily O'Neill (1989) regards this form of spectatorship as a more

productive kind of audience presence, as the dual function of 'actors' and 'audience' facilitates reflective action, collective meaning-making and thus a change of understanding of human issues.

These notions of change are highly relevant to education in modern society, where learning tends to be reduced to passive processes of receiving prescribed knowledge for examinations. Participatory TIE aims to hand knowledge back to the people, encouraging active participation so that people make changes in their learning, in their lives and eventually in their society.

In collaborating with Oxfam Hong Kong in conceiving and conducting the work *Fifty Square Feet*, our TIE team found that the above notions of change strongly echoed the core value of global citizenship education advocated by Oxfam: 'Through an interactive approach, global citizenship education encourages young people to actively participate in the society, and to discover their potential to make a difference' (Oxfam Hong Kong 2010).

Fifty Square Feet

The TIE programme *Fifty Square Feet* was devised and conducted by a team of three drama educators: Liu Pui-fong, Tang Yiu-hing and myself. It addressed the situation of poverty and social exclusion faced by people living below the poverty line in Hong Kong, especially the working poor. The work was targeted at secondary school students aged from twelve to eighteen years, with the aim of arousing empathic understanding of the poor and critical reflection on issues around urban poverty. It also problematized the mainstream notion of development adopted by many in Hong Kong as well as other developed countries – one that had been 'too narrowly seen in terms of economic and social progress' (wa Thiong'o 2009: 149).

In Hong Kong, the divide between rich and poor is widening despite the SAR's economic improvement as a whole. The Gini coefficient – a widely used measure of income disparity – increased from 0.476 in 1991 to a record high level of 0.533 in 2006. According to the United Nations' *State of the World's Cities 2008/ 2009: Harmonious Cities* (United Nations Human Settlements Programme 2008), Hong Kong has become one of the most inequitable societies in Asia. Oxfam and the Alliance Concerning CSSA state that among the three million people in the Hong Kong labour force, 14.6 per cent are low-income workers earning less than HK$5050 a month. Around 181,000 people in the labour force are unemployed while 90,200 are under-employed (Hong Kong SAR Census and Statistics Department 2009).[1]

As devisers and actor-teachers of the TIE work, the foremost questions our team considered were:

1. What kinds of changes do we want to offer the young audience who are brought up in such a socio-economic context?
2. What kinds of changes can be achieved in a three-hour, one-off TIE experience?

Hong Kong students are not unfamiliar with the subject of poverty, as it is a prevalent topic in their curriculum, included variously in the subjects of Integrated Humanities, Liberal Studies, Life Education, and Moral and Civic Education. However, existing civic or social education practices favour acquisition of knowledge over feelings, and critical thinking is understood as merely conceptual rather than an affective, experiential process. Neither of these really leads to students' connectedness to what they learn, so such approaches are unhelpful in bringing about attitudinal or behavioural changes.

Our main goal was therefore to restore young people's connectedness to the subject matter. We believed a useful way of doing this was to invite the young people to actively participate in the theatrical event and get in touch with the immediacy of feelings and actions of the drama. By involving audience participation, we aimed to use theatre as social intervention to bring about a number of changes.

Change in knowledge and understanding of poverty

Participating in TIE brings about a different form of understanding – an empathic one that not only entails cognitive knowledge of facts or figures but also calls for feelings and experiences. By letting the students embody the characters in the drama through audience participation, we aimed at 'cracking students' previous understanding into new awareness and insights (Johnson and O'Neill 1984: 122).

Change in social awareness

By engaging the students actively in the TIE work, we aimed to bring them into interactive dialogues that problematize and critically examine norms and values that easily go unquestioned yet have an enormous impact on marginalizing the poor. We saw our work as sowing the seeds of many 'small p' political initiatives that may help develop more critical and informed citizens. As Jackson (2007: 172) puts it:

We cannot change social processes overnight, but by understanding that our attitudes, prejudices and behaviour are to a considerable degree 'constructed' by the cultural values and systems around us, that they are not natural, universal or timeless, we may at least see the point of questioning our assumptions and re-thinking our own attitudes and actions as a result.

Change in the process of learning

Boal (1995: 44) asserts that 'change in theatre will extrapolate into the spect-actors' real life'. Cockett (1998: 42), however, argues against such a proposal and asserts that students' changes in the real context outside drama is beyond our knowledge, but 'from the evidence of the quality of the drama ... What's real for them is rooted in the quality of the drama they create.' If we agree that what is real in drama only lies within the actuality of the learning process, then one real observable change that participatory theatre can bring is an empowerment of the learners in the process of learning. Students who participate in TIE works no longer sit back to observe and listen, but rather make a step forward to change the circumstances in the learning setting. The construct of audience participation devolves power to the hands of the learners, giving them the right to change not only the elements of the story but power relations in the theatre-cum-classroom setting.

Devising, implementing and evaluating the work

Fifty Square Feet is based on a newspaper interview featuring a teenager from a poor family. On first reading it, our team was intrigued by a photo of an eleven-year-old girl sitting on a bunk bed in a tiny cubicle apartment – one that houses a family of four, with no individual toilet or kitchen of their own – filled with second-hand belongings (Figure 1.1).

The pre-text quickly conjured up images and sparked the imaginations of the devising team. We gave the teenage girl the name Ah Yee, and devised a story about her and her parents, both low-income workers, living in a 50 square feet cubicle apartment filled with stuff from second-hand markets or scrap-picking.

The development of the TIE work involved the three of us, as devisers and actor-teachers, working closely with Oxfam's staff in:

- formulating the educational goals of the work
- researching the topic (including interviews with some poor teenagers to get first-hand information and 'flesh and blood' contact with real people in poverty)

- turning hard facts, information and opinions on poverty into human stories – which is what drama should be about
- piloting the work-in-progress at schools to understand teenagers' views and possible responses to the work and poverty issues
- running a trial session of the final work at Oxfam's Interactive Education Centre, the actual performance venue, with a group of adults affiliated with Oxfam and the acting team, to test out audience response and the audience participation activities.

FIGURE 2.1. Image of the girl in the cubicle apartment (Apple Daily, 27 December 2004).

From 2006 to 2010, more than 80 performances of *Fifty Square Feet* have been conducted and the work will continue to run in the 2010–11 school year. During the course of the work, our team continually reflected on and evaluated the work based on our personal experiences – in interacting with the students, observing their responses and examining post-workshop questionnaires from students and teachers, as well as engaging in dialogues with other critical friends who came to observe our work. We engaged on a journey of reflective practice in which understandings, as O'Mara (1999) asserts, were developed through actual experiences, and were constantly changing and developing as we continued with our practice. Our ongoing reflections and re-examinations of the

work regarding its form, content and purpose, and the mistakes we made along the way, led to a number of revisions of the work, particularly in the audience participation form that is the focus of this article. The following account documents our developing understanding of the subject and how the understanding emerged as we engaged in practice and maintained dialogues with theoretical notions of audience participation.

First version of the work

Working with an audience size of 30–40 (the usual size of one class in secondary schools), we were able to consider a high audience participation level that would preserve the intimacy of the experience. We went for what O'Toole (1976: 88) terms 'integral participation', where the audience takes roles within the drama and contributes to the drama in ways that alter the dramatic action. We also decided to opt for a mode that was wholly participatory, where the audience would be in one role within the drama throughout the play. The decision was partly to do with a belief that our audience needed a role frame to motivate them for a seemingly boring topic, but also largely based upon a personal desire – we wanted to make a difference, as we were dissatisfied with the lack of understanding of educational theatre exemplified in the works of many local theatre companies, which were still adopting superficial modes of audience involvement in their works. (Yes, the 'Look out, behind you!' type of shallow participation that O'Toole criticized in some TIE works in the 1970s unfortunately still exists in Hong Kong.) Such a stance was eventually found to be unhelpful, as it led us to make the choice of form for the sake of making it, without carefully considering its appropriateness.

After devising the three major scenes in Ah Yee's story (details of which will be introduced later in this chapter), we were still unable to find a point of view that would give the audience a useful role as 'integral participants'. About a week or so before the trial run, we finally came up with an idea of framing the audience in role as trainee guardian angels for Ah Yee's family. Undergoing a test to be certified as real guardian angels, they were presented with problems faced by the family and asked to suggest solutions. The frame of 'guardian angel' was adopted to provide the will to help and the power to make changes, while the frame of 'trainee' was adopted to slow down the action, avoiding the invocation of angels to use their magic power to provide a quick fix for the problems.

We implemented the work with this role frame in the trial session and soon found it redundant, too limiting and even at odds with our educational goals.

First, with only three hours for the program, it proved to be too time-consuming to enrol the participants and help them work out the complicated logic of their role. Worse still, even after considerable time had been spent on this, they didn't seem particularly engaged. They pointed out to us afterwards that the idea of playing a guardian angel was far too remote and hard to believe. Some also said that the story of Ah Yee was very engaging, but the role of guardian angel got in the way, so they quickly decided to ignore it.

To make things worse, we also found that the role of guardian angel, had it really worked, went against the meaning we wanted to put across. An angel is essentially of higher status than Ah Yee's family, and such a role risks giving the participants a point of view that could appear patronizing. Moreover, the hidden message that comes with the role is also problematic: to solve the problem of the poor, one has to rely on the angels – the supernatural – to rescue them! This severely contradicted what we wanted the participants to understand: that many problems of poverty are socially constructed, and everybody in society has a role to play in dealing with those problems.

We learned a good lesson from this experience. We made a big mistake by only adding the role frame on to the play at the very last stage. An integral, holistic role will only work when it is considered with the dramatic actions as a whole. Also, meticulous consideration must be given to the implications of the role in relation to the educational purpose of the work.

Second version of the work

We dropped the idea of using holistic audience participation after the trial session, and opted for tailor-making a different mode of participation for each of the three scenes. This second version of the work was what we implemented with our real target audience, secondary students, and it was carried out for one school year. The following paragraphs explain the kinds of participation entailed and our reflections on the choices.

Scene 1

The programme starts with two short pre-performance activities:

1. Each student writes a personal wish on a small piece of paper and clips it onto a piece of installation (which will appear in the set at the end of the play).
2. The audience considers the size of 50 square feet, marks it out on the floor and discusses where it can be and who may live there.

Scene 1 starts, giving an overview of the family's background and living conditions. It highlights the vulnerability of the father's work life – he was a freelance construction site worker whose income was highly susceptible to the economic downturns in the late 1990s. He worked hard to make ends meet but unfortunately died in an accident at his workplace. His family did not receive any compensation since he was not formally registered for the job that day.

The first scene ends here and resolves into a small-group discussion. Participants are invited to share their views about something in the story about which they feel most strongly. A discussion following those points is conducted to help the students understand the social forces that led to the misfortune of this family. This part wraps up with a newspaper caption-writing activity for the participants to consolidate their views on the play up to this point. The captions are then read aloud to the whole class by the actor-teachers.

In this first part of the programme, audience participation was kept at an 'extrinsic' level (O'Toole 1976). The students did not take any roles, and they were only asked to respond to the play outside the drama. The level of exposure was minimal, with the audience members mostly remaining in their seats. Meanwhile, we began to plant the seeds for the more active participation modes that would occur later – getting the students used to interacting with us by requiring everyone to take part in the discussion. To make the task easier, we started with something that anyone could readily talk about – something in the play they felt most strongly about.

The rationale for designing the activities this way was that a certain degree of 'protection' was deemed necessary before the students felt ready to engage more actively in drama. In discussing the notion of 'self-spectatorship', Heathcote (1994, cited in Shillingford 1994: 20) asserts that although a pedagogical goal of drama is to 'alert the self-spectator so the child begins to monitor the quality of its work and gradually become autonomous learners', the development of such an ability needs to be carried out in a progressive manner. She strongly holds that before students get involved with the issues in a drama, they should be '[sheltered] from the embarrassment of being stared at' (Wagner 1999: 20). Referring to this as a kind of 'negative self-spectatorship', she argues that the self-consciousness could bring about shallow and clichéd behaviours. She suggests that teachers should monitor the degree of self-spectatorship by paying attention to the progress of the students and the drama in order to protect (reduce the negative effects of self-spectatorship) or challenge (promote the positive effects of self-spectatorship) the students at different times (Shillingford 1994: Ch. 3).

While Heathcote discusses self-spectatorship in terms of the participants' behaviours in role in process drama, we regard her idea as valid for this TIE work when students have not yet stepped into role but are preparing to do so.

Scene 2

Ah Yee wanted to participate in a birthday party her classmates were planning to throw for a teacher, but she could not afford the money. In a plea to her mother for an advance payment of her travel money (she planned to save up for the party by walking to school), she found it hard to make her mother understand that she needed to take part in social activities at school to get acquainted with her friends.

The scene flashes back to the day when Ah Yee's friends invited her to the party. Ah Yee failed to convince her friends to scale down the party, as their concepts of spending money and what made a decent party were very different. While she was still worrying about the money, her friends decided to go shopping together. Ah Yee made up a lie to excuse herself, but the lie was exposed. Her best friend got angry with her.

The scene is followed by Forum Theatre in which the students are asked to think of ways of helping Ah Yee deal with the situation.

After the forum theatre, the students do a piece of in-role writing as Ah Yee.

This part of the work adopted Boal's forum theatre techniques by inviting the audience to go on stage to suggest and enact solutions to a problem, thus turning passive 'spectators' into active 'spect-actors'. Unlike classic forum theatre, where the primary aim is to empower the oppressed to test out alternative ways of dealing with social injustice, our forum theatre aimed at something different. In Theatre of the Oppressed, those in the audience are members of the oppressed groups and are trying to deal with their own problems through theatre. However, the students who participated in our work were not necessarily people in poverty. Thus, we opted for a focus that would help them gain a deeper understanding of the situation by physically and emotionally engaging with the feelings and actions of Ah Yee and her classmates. As I pointed out earlier, there is a gap between what students cognitively understand about poverty and what they feel/experience about the issues involved. The forum theatre allowed us to bring the audience into the immediacy of feelings and actions, the 'here and now' of the situation, in order to gain knowledge and insights.

Boal (1995: 28) explains how changes in knowledge occur when a complex process of self-observation takes place in theatre:

The extraordinary gnoseological (knowledge-enhancing) power of theatre is due to these three essential properties: (1) plasticity, which allows and induces the unfettered exercise of memory and imagination, the free play of past and future; (2) the division or doubling of self which occurs in the subject who comes on stage, the fruit of the dichotomic and 'dichotomizing' character of the 'platform', which

allows – and enables – self- observation; (3) finally, that telemicroscopic property which magnifies everything and makes everything present, allowing us to see things which, without it, in smaller or more distant form, would escape our gaze.

Putting the above ideas in the context of our work, we understood the process of student participation in this forum theatre as one in which the following occurs:

1. Each spect-actor takes advantage of the 'plasticity' of the theatre to create meaning by juxtaposing what they know about poverty in the past with Ah Yee's story. With their physical and affective faculties fully engaged in a creative process that liberates memory and imagination, the knowledge created would not be just an abstract idea but a concrete and real experience.
2. The 'telemicroscopic' nature of the theatre allows them to take a closer look at Ah Yee's situation, enabling them both individually and as a whole audience to examine it and understand something that they might not have noticed, or might not be able to examine so closely in real life.
3. The 'dichotomic' nature of the theatre would allow them not only to see what is happening to themselves but also see themselves seeing it – as they would act upon a problem, they would see themselves acting. They would also able to see the world as seen by Ah Yee and see themselves as seen by other classmates in the audience. This 'dichotomic' nature of theatre is important in bringing about opportunities for reflections.

An understanding of these ideas – particularly the last one – was highly useful for us as facilitators of the forum theatre. For example, after spect-actors had acted as Ah Yee or her classmates, we would invite them to stay behind and share how they saw the matter as the character, comparing it with how they saw it when they were part of the audience. We also invited the audience to share their observations on the different actions and consequences of the actions. By encouraging these dialogues between the role and the self, as well as between actors and the audience, we were often able to bring about deeper reflections on the situation, the characters' way of thinking and their dilemmas.

Scene 3

After Ah Yee's father died, her mother became the breadwinner. She did different labouring work and low-paid jobs and ended up being a cleaner in a public housing estate. Faced with all kinds of unfair employment terms, she burst out in anger one time and shouted to the foreman, 'I'll quit!' She soon regretted it as she realized she could not afford to lose the job, and she decided to beg the foreman to let her stay.

In a poetic epilogue to the play, the audience sees Ah Yee, Mom and the deceased Dad making humble wishes but finding them extremely hard to fulfil, despite their hard work. The common saying 'work hard and you will get a better life' never seemed to work for them.

Post-performance activities:

1. The audience hot-seats the mother to understand the problems faced by the working poor. They also hot-seat the foreman to understand why the cleaning companies are making conditions so harsh for their workers.
2. The students form small groups to look at the wishes their classmates made at the beginning of the programme, and compare them to those of Ah Yee's family.
3. The programme ends with an out-of-role discussion on the participants' feelings of the experience, and their reflections on poverty issues.

The audience participation mode in the hot-seating was more 'peripheral' (O'Toole 1976: 88) in its nature, where 'the quality of the experience was ... primarily theatrical' when the students conversed with the characters but their response 'took no part in the development of the drama' (1976: 104).

In the implementation of the work, we found that the students' response in hot-seating was greatly affected by the way we presented Scene 3. The naturalistic style of performance successfully called for deep sympathy for the mother – to such an extent that they put the blame solely on the foreman, an individual, rather than the social system, despite that fact that we had embedded many social elements in the script (e.g. problems with outsourcing, lack of minimum wage guarantee policies). What originally aimed to be a conversation to understand the employment structure and its impact on the poor turned into a moralistic lecture aimed at the foreman.

Jackson (2007: 44) asserts that in considering audience participation in educational theatre, the 'aesthetic distance' needs to be scrutinized carefully. When a drama is 'over-distanced', catharsis may be less likely to occur. When it is 'under-distanced', the reawakening of the audience may be correspondingly harder to achieve. Although he warns that a 'satisfactory balance' – should it ever exist – may be difficult to achieve, his ideas helped us to further refine the work.

The insights we gained from this experience were related to what Szondi (cited in Lehmann 2006: 3) terms a 'crisis of drama', where he sees that the 'epic' social themes called for by modern theatre can no longer be contained by the traditional Aristotelian dramatic form with its interpersonal emphasis, which is characterized by

the dominance of dialogue and interpersonal communication; the exclusion of anything external to the dramatic world (including the dramatist and the spectators, who are condemned to silent observation); the unfolding of time as a linear sequence in the present; and the adherence to the three unities of time, place and action.

We learned that in order to fulfil our pedagogical goals, we needed to look for a different artistic presentation of Scene 3 to realign the degree of empathy and detachment of the audience.

Third version of the play: Revised Scene 3

This new version of the TIE work emerged after one year of implementing Version 2, when we were able to re-devise the work during the semester break. We made minor adjustments to Scenes 1 and 2, but a major change to Scene 3. The content was still focused on the mother's employment conditions, but rather than adopting an Aristotelian theatre model, we once again broke the fourth wall by inviting the audience to interact with us in three job interview scenes. The scene we formed was tested and modified throughout the second year of implementation to come up with the version described here.

> The students form groups to prepare for three characters, all working poor, who would compete with the mother in the job interviews. One representative from each group takes up the acting task, while the rest become that person's 'brains trust' as he or she goes through the interview. Such an arrangement was made to ensure that the audience members also had a certain kind of involvement in the scene rather than purely watching.
>
> In interacting with the interviewers (played by the actor-teachers), the spect-actors encounter different constraints from those faced by the poor. The programme ends with a small-group discussion about these constraints, and how some values and norms in the society have helped to shape those constraints.

We found that this version was better suited to our goals. As revealed in the student discussions after the scene, the audience was much more ready to point out the social problems involved in the labour market. By diversifying the jobs from one to three, it became possible for us to bring the students to the understanding that oppression does not occur only due to the wickedness of one 'Big Bad Boss'. It also allowed us to include more diverse types of constraints faced by poor people (related to gender, age and family circumstances).

Although our initial reason for changing Scene 3 was to achieve greater 'distance' for the audience, this was not the outcome; rather, we found that the aesthetic distance experienced by the students was no longer a clear-cut 'distanced/engaged' or 'Aristotelian/epic' differentiation. On the one hand, the students were more distanced from the fiction with the fourth wall demolished, but at the same time the first-person participation as the interviewees and their 'brains trust' gave them a stake in the drama and emotional investment. The highly sentimental scene in the last version of the work was gone, but the interview scenes that replaced it were still mostly naturalistic and 'Aristotelian', apart from the breaking of the fourth wall. We found that, as we were playing the balancing act of aesthetic distance, we were coming to be more aware of the complexity of this notion. As Jackson (2007: 157) puts it:

> Aesthetic distance cannot be reduced to a formula which can be applied in a number of permutations to achieve specific effects with specific audiences. It is a problematic notion and requires enormous imagination, understanding of the audience and grasp of artistic forms on the part of the theatre makers, especially in the context of participatory theatre, if it is to be handled well.

Looking ahead: Reflective practitioners keep learning

The third version of the work has been implemented for two years now, with minor revisions made during that time. Oxfam and our team are very aware of the need for continual reflection on the work with reference to the changing society and the audience.

In the 'Five Year Strategic Review' conducted at Oxfam Hong Kong's Interactive Education Centre (IEC) in 2010,[2] it was pointed out that there was a pressing need to revise the IEC programmes, *Fifty Square Feet* included, to address the rapid changes of young people's needs over the past two years. These changes involve more sophisticated knowledge about and attitudes towards poverty as a result of the introduction of Liberal Studies as a new compulsory school subject, and as a result of the increased youth participation in large-scale anti-government campaigns, and the social atmosphere generated by this. Furthermore, a widening socio-economic disparity among the students attending IEC programmes is also observed, and so ascertaining how the IEC programmes could address such diverse needs within one event is a challenge that lies ahead.

It is not my intention in this chapter to discuss how these needs will be addressed, as this is something for our team to work out and learn through vigorous reflections, experimentation and actual experiences. We are very fortunate to have this opportunity to undertake a project that allows us to undergo a very long process of reviewing, revising and refining without the pressure of having to prove our success to funding bodies in order to survive. It allows us to adopt evaluation processes that are flexible, grounded in experiences and built on critical reflection and dialogical praxis – evaluation mechanisms that applied theatre practitioners regard as pertinent to improving practice (Etherton and Prentki 2006; Jennings and Baldwin 2010; Taylor 2003). In sharing our reflective narratives in this article, we also hope others may find in them useful ideas as they engage in similar participatory TIE works.

Acknowledgement

This chapter was originally published as Article 4 in Volume 11 (2010).

NOTES

1. CSSA stands for 'Comprehensive Social Security Assistance', which is a scheme provided by the Hong Kong Government for those who cannot support themselves financially.
2. This is an internal review involving all staff members of Oxfam's education team – senior management as well as freelance facilitators who work at the Interactive Education Centre, including the author and the other two actor-teachers of *Fifty Square Feet*.

REFERENCES

Boal, A. (1979), *Theatre of the Oppressed*, London: Pluto Press.

Boal, A. (1995), *The Rainbow of Desire: The Boal Method of Theatre and Therapy*, trans. A. Jackson, London: Routledge.

Bolton, G. (1998), *Acting in Classroom Drama: A Critical Analysis*, Stoke-on-Trent: Trentham Books.

Brecht, B. (1964), *Brecht on Theatre: The Development of an Aesthetic*, trans. J. Willett, London: Methuen.

Cockett, S. (1998), 'What is "real" in drama?', *NADIE Journal*, 22:2, pp. 33–43.

Etherton, M. and Prentki, T. (2006), 'Drama for change? Prove it! Impact assessment in applied theatre', *Research in Drama Education*, 11:2, pp. 139–55.

Hong Kong SAR Census and Statistics Department (2009), Press releases on statistics: Unemployment and underemployment statistics for September–November 2009.

Jackson, A. (2005), 'The dialogic and the aesthetic: Some reflections on theatre as a learning medium', *The Journal of Aesthetic Education*, 39:4, pp. 104–18.

Jackson, A. (2007), *Theatre, Education and the Making of Meanings: Art or Instrument?*, Manchester: Manchester University Press.

Jackson, A. (ed.) (1993), *Learning Through Theatre: New Perspectives on Theatre in Education* (2nd ed.), London: Routledge.

Jennings, M. and Baldwin, A. (2010). ' "Filling out the forms was a nightmare": Project evaluation and the reflective practitioner in community theatre in contemporary Northern Ireland', *Music and Arts in Action* , 2:2, pp. 72–89.

Johnson, L. and O'Neill, C. (1984), *Dorothy Heathcote: Collected Writings on Education and Drama*, Evanston, IL: Northwestern University Press.

Lehmann, H.-T. (2006), *Postdramatic Theatre*, trans. K. Jurs-Munby, London: Routledge.

Muir, A. (1996), *New Beginnings: Knowledge and Form in the Drama of Bertolt Brecht and Dorothy Heathcote* , Stoke-on-Trent: Trentham Books.

Nicholson, H. (2005), *Applied Drama: The Gift of Theatre*, New York: Palgrave Macmillan.

O'Mara, J. (1999), 'Unravelling the mystery: A study of reflection-in-action in process drama teaching', Ph.D. thesis, Brisbane: Griffith University.

O'Neill, C. (1989), 'Ways of seeing: Audience function in drama and theatre', *2D*, 8:2, pp. 16–29.

O'Toole, J. (1976), *Theatre in Education: New Objectives for Theatre, New Techniques in Education*, London: Hodder & Stoughton.

Prendergast, M. and Saxton, J. (eds) (2009), *Applied Theatre: International Case Studies and Challenges for Practice*, Bristol: Intellect.

Prentki, T. and Preston, S. (eds) (2009), *The Applied Theatre Reader*, London: Routledge.

Shillingford, L. (1994), 'An explanation of the self-spectator construct: Its function in D.I.E. as practised by Dorothy Heathcote', MA dissertation, Birmingham: University of Central England.

Taylor, P. (2003), *Applied Theatre: Creating Transformative Encounters in the Community*, Portsmouth, NH: Heinemann.

Thompson, J. (2003), *Applied Theatre: Bewilderment and Beyond*, New York: Peter Lang.

United Nations Human Settlements Programme (2008), *State of the World's Cities 2008/2009 – Harmonious Cities*, Geneva: United Nations.

wa Thiong'o, N. (2009), 'Theatre for the development of imagination', in J. Shu and P. Chan (eds), *Planting Trees of Drama with Global Vision in Local Knowledge: IDEA 2007 Dialogues*, Hong Kong: IDEA, pp. 149–52.

Wagner, B. J. (1999), *Dorothy Heathcote: Drama as a Learning Medium*, rev. ed., Portland, ME: Calendar Islands.

冼麗婷，(2004年12月27日)，《有錢的同學不一定出色》，蘋果日報, (Interview in Apple Daily, 27 December 2004).

樂施會、關注綜援檢討聯盟，(2008)，《綜援NIZATION：13個綜援人士的口述故事》，香港：樂施會, (Oxfam Hong Kong & Alliance Concerning CSSA. (2008), Oral Accounts of 13 Recipients of Comprehensive Social Security Assistance).

3

Converging worlds: Fostering co-facilitation and relationships for health promotion through drama at the grassroots

Christine Sinclair and Andrea Grindrod

Active engagement in intellectual and artistic activities is one way of re-evaluating our perceived reality and our collective habits of thinking and acting. This engagement can expose communities and decision-makers to previously unimaginable ideas that challenge our values, leading to personal growth, lifelong learning and change (Mills and Brown, 2004: 9).

'So tell us about this health & drama project, Andrea,' my colleagues ask me at a regional health promotion meeting. 'Well,' I begin, painfully aware that all eyes are currently on me and I need to somehow sound like I know what I'm talking about, and even more concerning, somehow translate an inkling of understanding to them. 'It's a drama and health project, kind of teaching health through drama, it's … it's kind of like role-play, but it's not role-play.' The silence in the room continues, waiting for some words that might register. 'Well, there's this guy Boal … he founded the work of the Theatre of the Oppressed … and he worked with Third World countries on social issues and he coined this term "metaxis" …

A colleague interrupts, 'pardon, is it …?'

… 'errh … no,' I reply … 'it's not something you do at the end of the financial year … It's kind of like when you're in role-play, you're not yourself … well you're yourself of course …

… but you're both yourself and someone else at the same time' … the silence is deafening.

(Andrea, Health Promotion Project Worker)

This chapter reflects on the development of a grassroots programme for health promotion in which drama is the core pedagogy. It attempts to construct a 'convergent lens' through which to examine and represent the emerging understandings of both the health professional and the applied theatre practitioner from research conducted into this practice. A central focus of this discussion is the impact that building and engaging in a drama/health partnership has on two key participants, on how this process changed them and on the way they defined the drama/health paradigm within which they worked. This focus is reflected in the different voices employed through the text. The health professional's experience provides a counterpoint to the discussion of the programme and the chapter concludes with a move from the third- to the first-person plural, as health and drama practitioner views converge.

Bringing health and drama together in the 'Hills'

> Health is a state of complete physical, mental and social wellbeing, not merely an absence of disease.
> Health is, therefore, seen as a resource for everyday life, not the objective of living.
> Health is a positive concept emphasizing social and personal resources, as well as physical capacities.
>
> (World Health Organization 1986)

This story begins with a small community health organization that discovered drama pedagogy and decided to look for a sustainable way to embed drama practice into its approach to health promotion. This organization, Ranges Community Health Service, situated in an outer suburban region of Melbourne, Australia (informally known to its residents as 'the Hills'), first encountered health and drama working together at a health conference, in a workshop run by eminent drama practitioner Helen Cahill. Helen's workshop focused on working with young people as 'experts' in adolescence and medical students learning about key management factors in adolescent health. A series of carefully designed drama activities provided the structure for the workshop and, significantly, the young people had been given some prior training in these activities. The medical students were well versed in the theory of dealing with young people, but they had not necessarily encountered 'real' young people since they had been adolescents themselves. The Health Development Manager from Ranges was especially struck by the immediacy and impact of the drama techniques, the power of the young voices and the way all the participants – including those watching – started to think differently about the health issues at the core of the workshop. She proposed that this was what her organization should pursue in health promotion.

Recent research (Boal 1995; Burton and O'Toole 2005; Cahill 2005; O'Toole 1992) has suggested that the embodied learning processes associated with drama pedagogy lend themselves to a greater engagement with content by the target group, and that by putting the drama tools in the hands of the target group (e.g. young people) they can take a role in the education of the others (e.g. peer groups, health professionals, student teachers).

Description of the Sherbrooke pilot

In 2005, inspired by what they had seen at the health conference, the staff employed in the Ranges Health Promotion Programme took the first steps towards setting up a community-based partnership involving young people and health professionals, placing drama at the heart of the practice. They invited a local school to assist them in piloting a programme that they called Community Health and Drama (CHAD). With the help of the drama teacher and the student welfare coordinator, a special Year 10 programme was created. Once a week, these students would work on the development of drama skills, workshop facilitation activities and some simple forum theatre techniques with their drama teacher and welfare coordinator, two community health nurses and an experienced drama facilitator. The aim was to prepare these students to take a leading role in workshops that brought them together with a range of health professionals from the region. Ranges and the school committed to the pilot throughout 2005, and eventually the students developed a series of small forum theatre pieces and took leadership roles in a number of workshops with health professionals.

For the health professionals who participated in the workshops, the experience of engaging with the young people was powerful and enlightening. In preparing for the workshops, the students addressed strategies for seeking appropriate health support and other help-seeking behaviours, and in doing so their own attitudes to help-seeking and their awareness of resources available to them in their community improved markedly. Although the pilot proved to be difficult, and was perhaps too ambitious for the Ranges staff at that time, it did affirm for them that continuing to pursue a health drama paradigm within their approach to health promotion was worthwhile:

> I was usually filled with trepidation on Sunday evening. The CHAD class was scheduled on Monday morning. Whilst I mostly enjoyed the class once we got started, the lead up was not enjoyable. I always felt like I was supposed to know what I was doing as project co-coordinator, and I rarely did. For the most part I had a feeling of dis-ease and I was concerned about letting the students down. When something

didn't look right in the classroom I couldn't put us back on track, when the new drama teacher was lost I couldn't find the way, when there were silences in the class I couldn't fill the void. I felt destabilized. I could not work comfortably using drama and I failed to see the relevance or role of my health expertise.

<div style="text-align: right">(Andrea)</div>

Two critical discoveries were made in the forging of this first drama: health and community partnership. First, ongoing and meaningful partnerships between the health and education sectors are complex and challenging. Inevitably, the agendas of the partners will be different, as will the institutional understandings and infrastructure that constrain certain activities and value others. Goodwill and a commitment to a shared outcome are important, but not quite sufficient to ensure sustainability. Timetabling and finding a common language to talk about the work at hand are also pivotal rather than peripheral issues.

Second, when a drama pedagogy is placed at the centre of the partnership, the complexity is heightened. Regardless of Ranges' commitment to developing a community health and drama programme, it realized that it could not proceed without appropriate drama expertise — in the form of a drama practitioner (within or beyond the school setting). It also identified the need to build its own internal capacity to work within a drama-infused health promotion programme.

Working in the dark

I found it difficult working on the CHAD project during this time. It was like working in the dark. We had a strong commitment to approaching health issues using drama, but that was not enough in itself. We not only needed expertise and advice from the drama field for this project to continue; we also needed expert practical assistance. An issue for project sustainability and feasibility.

<div style="text-align: right">(Andrea)</div>

An important working relationship emerged out of the 2005 school pilot. Community drama and applied theatre practitioner Chris Sinclair became involved with the establishment of the partnership with the school – she was a 'Hills' resident and a parent of children at the school. In this capacity, she provided drama input on a voluntary basis to the programme for the first few months of the pilot. Andrea Grindrod was the Ranges staff member leading the project known as CHAD and was one of the community health nurses who attended classes and workshops at the school throughout the year.

Subsequently, Ranges allocated funding to engage Chris as a consultant in its ongoing drama-based work, and Andrea and Chris began to work closely together. The professional relationship signalled the beginning of a dialogue between health and drama, and the first stage of constructing a drama/health paradigm appropriate to this specific context.

Forward steps

For the next two years, the challenges that emerged from the school-based pilot translated into more questions and challenges for Ranges, as it continued to include community health and drama in its health plan. Several questions dominated the thinking and planning of the health promotion staff at Ranges:

1. What do we as health professionals need to know and be able to do in order to develop and run a community health and drama programme?
2. How do we talk about this approach to health promotion with our colleagues?
3. What kind of partnership/relationship do we need to set up with a drama practitioner?
4. How do we engage the education sector in an ongoing and genuine partnership with health?

The health promotion staff planned a small action research pilot project to address these questions. The participants would be health professionals and teachers, attending drama-based workshops designed to introduce both groups to the concept and practice of using drama to teach and promote health in schools. These participants would also be co-researchers in the action research.

This small pilot study proved to be a turning point for the Community Health and Drama programme at Ranges Community Health Service. Not only did it provide some insight into the questions formulated by the drama and health practitioners in order to drive the research, but it cast new light on more fundamental questions, such as the nature of the partnership between drama and health in this context.

For the health and drama practitioners working on this ongoing exploration of drama in health settings, funded and operated at grassroots level, a number of critical findings emerged from this small action research study.

The first was the appropriateness of the methodology. Action research methods provided a framework for shared and focused reflection – the participants engaged in the workshops as co-researchers and enriched the emergent findings with their insights as health or education experts. The cycles of action and reflection also enabled Chris and Andrea, as research leaders, to respond immediately and

through action to discoveries made in their field. Given that time and resources were short, this reflexivity enabled the researchers to devise and shape the nucleus of a 'training model' for health and educational professionals. Based on their experiences in this project, the researchers hope to further investigate the potential for action research as a methodology to complement more conventional forms of project evaluation traditionally employed in the health sector.

The second critical finding related to the nature of co-facilitation. As this chapter suggests, bringing two sets of expertise together carries some hazards. When drama is placed at the heart of shared practice, it is easy for the drama practitioner to assume leadership, gliding over the concerns of the health professionals and subsuming their pedagogical agendas within the learning and aesthetic agendas of the drama practitioner. Through the reflective processes of action research, this issue was addressed in this project. The health and drama practitioners leading the work identified gaps in the workshop processes they had set up. They found instances when health was not acknowledged as central to the endeavour, instead operating as a pretext and conduit for the drama rather than the other way around. They also discovered that their initial workshops were powerfully engaging for the participants; however, as an approach to introducing participants to the specific skills they might be able to adopt in future practice and preparing the way for future co-facilitation, they were limited.

Chris and Andrea took some simple but significant steps to address the question of co-facilitation. They began to plan sessions together. Previously, Chris had shaped the drama workshop and Andrea had slotted the 'health' in where appropriate. In co-planning, the key question became, 'What is the critical health issue to be addressed?' and the subsequent question became 'How can drama strategies serve this inquiry?' Co-planning was time consuming, but through the dialogue of planning, the health professional's voice began to emerge.

The notion of *inquiry* as the central premise of the work led the researchers to understand that co-facilitation was not about the drama practitioner leading health-related segments of workshops, and a health professional leading drama exercises, but about each of the workshop leaders understanding the nature of the *inquiry* and the nature of the *form* at the heart of the workshop; which teaching and learning strategies opened up the inquiry at key points; and how to draw explicitly on their own areas of expertise. Co-facilitation was thus about supporting the knowledge and expertise of the other facilitator and collaborating on the pursuit of the key point of inquiry at the heart of the workshop or programme. In this context, the focus would always relate to health.

The third critical finding from the action research emerged directly from the discoveries regarding co-facilitation. In working together to plan workshops, the researchers began to develop a model to assist health and education professionals to design and implement a health and drama programme in their own work context.

The model is deliberately both structured and open. It is also provisional, awaiting further opportunities to apply it and explore it in a range of health promotion settings. The 'model', not surprisingly, mirrors effective team-teaching practice and sound pedagogy from any educational context, and is constructed on a set of simply articulated principles:

- that a clearly defined health issue or construct is determined before planning begins;
- that the inquiry into this issue can be considered through a drama inquiry space, a health inquiry space and a reflective space (framed by a health inquiry or drama focus);
- that movement from one kind of space may occur sequentially (as above) or as needed, within one session, or the shift of inquiry modes may occur from one session to the next, and;
- that the inquiry operates in a cooperatively constructed and regularly reinforced safe space.

Planning for co-facilitators begins with a question: 'What change in understanding for your participants would you hope to achieve through a drama/health workshop programme or individual workshop?' Key characteristics of the spaces are outlined below.

Drama space

- Fictionalized framework, distancing the participants from their connection to the issue being considered.
- Operates imaginatively and playfully.
- Engages the whole body.
- Learning through empathy – through looking at something while standing in somebody else's shoes.

Health inquiry space

- Provides a focus to the health/learning agenda.
- Draws links between the fictional and the real world.
- Uses questioning and discussion strategies.
- Provides opportunities to deliver factual health information and dispel health-related myths.
- Often attends to social, emotional and mental health issues.

Reflective space

- May draw on drama or health strategies.
- Privileges the voices of the participants.
- Ensures the safety of the participants through checking in and checking out.
- Provides clarification and reiteration of information learnt.

Andrea played a pivotal part in establishing and leading the action research study, yet was quick to acknowledge in the early workshops that she did not feel confident to take a lead in the health and drama inquiry. It was not until the last session that she took the opportunity to 'road test' the model that had been devised. Her reflections highlight a further aspect of the health/drama praxis: the health professional's fundamental principle – do no harm:

> I enjoyed the session I facilitated immensely. I was thrilled with the increased level of confidence I had. It was to be a pivotal personal moment where I shifted from engaged observer to practising facilitator. A shift two years in the waiting.

> On reflection, I realized that the key to this personal shift lay not in the confidence of knowing what to do, but rather in knowing what not to do. The action research had raised important issues of safety, especially for the health professionals. I became acutely aware of what should not be done when facilitating in a drama/health paradigm, more than what should be done, and it seemed that this was the critical missing element that I needed to move forward. I was not so frightened of facilitating poorly as I was of not having the skills and expertise to direct the work to maintain appropriate levels of safety.

> For this to occur, I needed to know intimately and thoroughly the drama paradigm. Knowing what not to do translated to knowing how to respond skilfully and confidently no matter what situation arose, a benchmark that I could work with. The drama/health paradigm by definition requires working in areas of personal risk and with spontaneity (protected by 'distancing'), and with this comes responsibility and duty of care to participants.

> This increased level of competence allowed me to experiment with the work, knowing that first and foremost I was a safe practitioner, giving me permission to practise the skills of facilitation more confidently.

> (Andrea)

Sustaining CHAD

While CHAD continues at the community level, funded by Ranges Community Health Service, its efficacy and sustainability have been challenged by the principal funding source, the Department of Human Services:

> The use of creative processes needs broader recognition in the policies of government health agencies. To a large extent, they remain on the margins of health activities and, when they are introduced, it is more often as a one-off project rather than as part of any sustained policy and programme commitment.
>
> (Mills and Brown 2004)

The commitment to the long-term inclusion of CHAD activities within the health promotion plan comes from the individuals involved and from the support of these individuals by senior management at Ranges. It is embedded in the overall health plan; however, it is still very much driven by Andrea as project leader. The question of sustainability is a very real one – there is no one else at Ranges who could take the project on. After three years, CHAD remains an exotic branch of the Health Promotion area, requiring the use of an unfamiliar language, different ways of approaching training, facilitation and partnerships – in fact, a different way of thinking about health. In health-speak, there has been no 'capacity-building around CHAD in the organization'.

Road-testing the drama/health inquiry space paradigm

While it is true that the CHAD programme has remained on the margins, something significant has occurred in the past six months in the 'Hills' and the outer eastern region. Other health organizations are looking for ways to include drama-based approaches in their health promotion or capacity-building (training) programmes. New organizational partnerships are beginning between schools and health organizations (one of the goals of the action research project). Andrea has been working for several months with a teacher who participated in the research study – the teacher, trained in drama and English, was allocated Year 9 health. The drama/health inquiry model that was introduced in the final weeks of the pilot became the starting point for their work together. The dialogue between drama teacher and health professional is facilitated through this framework. Andrea and the teacher have evolved the simple notion of a health inquiry space and a drama space into an approach to teaching sex education with Year 9 students aged 13–14 years. Within the drama/health framework they have devised, there is a safe and distanced space (through drama) for students. There is also an opportunity for

teacher and health professional to explore the social factors that influence behaviour, in the context of 'safe sex' messages and the essential information about sex and reproduction that their curriculum obliges them to provide.

Andrea's confidence in facilitation, based on knowing what not to do, prompted her to develop the relationship between the drama and health inquiry in a way that has engaged the Year 9 students (principally through the drama activities) and enhanced their knowledge base about contraception and sex (principally through a more formal delivery of health information). The reflective process in this context is housed within the drama inquiry space. As Andrea and the teacher planned and reviewed each session of the sex education programme together, they continued to adapt and refine the simple model presented in the pilot study. As they reflected on the health education purpose of the programme, they became increasingly aware that drama was not always the most appropriate form for their teaching. Their experience had some similarities to Ball and Smith's in the applied theatre project *Man's World*, where they 'used a number of participatory activities including discussion, brainstorming, small group work, skills-based radio and video production training and drama. However, drama did not always prove to be the most appropriate method for exploring a particular personal, social or health issue' (Ball and Smith 1999: 112–13). In contrast, Andrea and her co-facilitator discovered that while using a 'drama inquiry space' was invaluable for addressing emotional or social aspects of a health issue, it was not particularly useful for examining the health issue itself.

Conclusion: Two practitioners reflect on embodied learning, aesthetic encounters and metaxis

In the time we've spent reflecting on CHAD, we have returned often to the question of learning through drama and the nature of drama-based pedagogy. We've grappled with the word 'pedagogy' – just one more word from the vocabulary of the academy that does not translate easily into the world of health promotion. To be clear, though, it is the word that does not translate, not the practice. Health promotion staff and drama educators share a focus on teaching and learning in their respective worksites. When the worksites merge, as in community health and drama, the question of how teaching and learning is undertaken is both challenging and fundamental. In our experiences with health professionals and teachers, we have been reminded of the power and immediacy of *embodied learning*. We've speculated that it was witnessing this in Helen Cahill's workshop that first drew the Ranges staff to want to use drama in their health promotion work.

From our first workshops with the health professionals, we noted that the engagement of the participants shifted when we moved from the ubiquitous

PowerPoint presentation of 'important information about drama and health' to physical, drama-based activities requiring an imaginative and personal investment, through the body. From here, we created transitions into activities that were more deliberately crafted and designed to engender an aesthetic experience. In these transitional moments, we discovered ways to house the challenging and difficult stories from the health sector in distanced, but personally powerful forms. This was by no means easy. We stumbled early and often, sometimes moving beyond what felt safe for the group, then having to retreat and review. Bringing drama teachers and health professionals together magnified the challenges that we two project leaders had encountered frequently as collaborators, including the need to negotiate and clarify meanings and experience from the other person's professional perspective; to move beyond discipline specific language; and to find ways to frame a genuinely open inquiry through open questions and then to find forms to accommodate the responses. The symbolic languages of drama proved invaluable, as did a periodic reminder of just what 'health' is, as the lynchpin to this drama/health paradigm. As Helen Nicholson (1999: 21) suggests when she describes the function of the aesthetic within the drama space, 'Because the aesthetic encompasses a range of artistic and dramatic narratives, it offers both a safe place from which to explore values, emotions and experiences, and invites a more dangerous, and unsettling, challenge to familiar beliefs.'

In this fusion of embodied engagement with the aesthetic space, provided by the dramatic form, new ways of knowing and understanding appear possible. A description by Boal (1995: 21) of the consequences of this kind of fusion is useful here: 'It liberates memory and imagination. Through the properties of the aesthetic space, art and pedagogy meet.' The aesthetic space, says Boal (1995: 21), 'promotes learning by experience'.

When health is invited in, a new space of inquiry is created: the drama changes the content; the content defines or informs the drama. The relationship is dynamic, dependent on context, purpose and personnel.

Partnerships and relationships

In an applied drama/theatre context, partnership is 'core business'. In fact, the 'intentionality' that is seen as a key characteristic of applied theatre practice implies the action of drama or theatre reaching beyond itself to another field or another sector. As Judith Ackroyd (2000) suggests, applied theatre practitioners 'share a belief in the power of the theatre form to address something beyond the form itself' in such fields as theatre in education, community development or health promotion. A partnership between the applied theatre practitioner and the site or sector to which it is being 'applied' is implicit in the term itself. However, partnerships in

the health sector usually mean institutional partnerships rather than partnerships between people. Where health and applied theatre converge, however, is in the implementation of partnerships at grassroots level, as institutional arrangements are only as strong as the commitment and continued employment of the people who negotiate and manage them.

We came together as representatives of two different sectors and, while building the partnership that became CHAD, we built a professional and personal relationship. It is a relationship built on countless meetings, planning sessions, phone conversations, collaborative presentations and a shared commitment to community-based practice. Through this lengthy collaboration, and now writing about it, we have arrived at a convergent lens that makes it possible for us to conceive of a drama/health paradigm appropriate for our shared context:

> I call it 'drama imperialism'. As the person experienced in the form and in the pedagogy, I assumed it was the drama professional who would lead the programme and that the health professional would support. However, this was a project conceived by a grassroots community health service and it was being driven by the needs of the health professionals who wanted to find ways to engage more meaningfully with community members about health. It was not enough to bring my drama expertise into their world, however carefully and sensitively. The health professionals needed to set the agenda.
>
> (Chris, CHAD drama practitioner)

> It is not merely the application of health to drama, nor the application of drama to health, which implies doing something to the other, it is a process of deep learning, of being willing to give something up in order to hold and accommodate something new, and to allow two separate worlds to transform and converge as a new understanding that is neither only drama nor only health any more.
>
> (Andrea, health promotion project worker)

Acknowledgement

This chapter was originally published as Article 5 in Volume 8 (2007).

REFERENCES

Ackroyd, J. (2000), 'Applied theatre: Problems and possibilities', *Applied Theatre Researcher*, 1, Article 1, https://www.intellectbooks.com/asset/755/atr-1.1-ackroyd.pdf. Accessed 17 November 2020.

Ball, S. and Smith, I. (1999), 'Drama, media and peer education', *NJ*, 23:1, n.p.

Boal, A. (1995), *Rainbow of Desire* (A. Jackson trans.), London: Routledge.

Burton, B. and O'Toole, J (2005), 'Enhanced forum theatre: Where Boal's Theatre of the Oppressed meets process drama in the classroom', *NJ*, 29:2, pp. 49–57.

Cahill, H. (2005), 'Profound learning: Drama partnerships between adolescents, tertiary students of medicine and education', *NJ*, 29:2, pp. 59–71.

Mills, D. and Brown, P. (2004), *The Arts and Wellbeing*, Sydney: Australia Council of the Arts.

Nicholson, H. (1999), 'Aesthetic values, drama education and the politics of difference', *NJ*, 23:2, n.p.

O'Toole, J. (1992), *The Process of Drama: Negotiating Art and Meaning*, London: Routledge.

World Health Organization (1986), *Ottawa Charter for Health Promotion*, Ottawa: Health and Welfare Canada and Canadian Public Health Association, http://www.who.int/hpr/archive/docs/ottawa.html. Accessed 12 May 2007.

4

Shakespeare in Nicaragua

Els van Poppel

The Movimiento de Teatro Popular Sin Fronteras (MOVITEP-SF) is a non-profit arts organization in Nicaragua that was born in 2000 as an initiative of three theatre directors, a visual artist and an organizer of cultural events. Before that time, we were all employees of a national arts organization but, seeking independence, we separated ourselves and started our own 'business', taking with us five theatre groups from different places in the country. At present, MOVITEP comprises nine groups, whose plays are directed by the three directors and some young directors we have trained. The scenery is created by the group, together with the visual artist. Most of the groups involved comprise young people, some consist of children and there are also participating adults. Some of these are professionals who make their living through theatre. Others are students or people who have another 'day' job. Depending on the project and the time available for realizing it, sometimes all groups are involved and sometimes just some of them.

The themes of the plays that we direct and present are mostly based on a subject concerning a social issue: family violence; the problems associated with HIV-AIDS; environment issues; sexual exploitation of children and youngsters; and so on.

Another branch of MOVITEP's work involves a two-year training programme for theatre-makers. As well as this, our visual artist offers a two-year training course on technical theatre to young people, with the objectives of working independently and being involved in the production work of the MOVITEP presentations. The pilot training programme will end in 2008 with fifteen graduates; however, we hope that this training will continue, although it is difficult to get a job in Nicaragua and even more difficult to get one in theatre! Nevertheless, some non-governmental organizations and other institutions such as embassies have recently become more open to the use of theatre in their programmes. This,

together with the very culturally aware character of the Nicaraguan people, will perhaps lead to more theatre work in the country.

One of the most vital characteristics of MOVITEP-SF, besides the concentration on social themes, is its multidisciplinary character. While at the beginning we emphasized the special character of our work mainly through the performance style, now we are developing an interdisciplinary theatre in which the location, the objects made by some of the actors and the creation of special and unusual lighting all play an important role because of their effect on the whole performance event. Over the years, we have come to realize through experience that the kind of audience that gathers to watch a play in the street likes to be surprised by shifting images, while long word-based texts are not generally suitable.

Our kind of multidisciplinary theatre has been developed through a number of processes and phases. The first project that we did as MOVITEP-SF (2000) was an interchange with Monsterverbond, an object-theatre group from Holland. This project resulted in an intercultural theatre event on the theme of 'machismo', based on Nicaraguan legends. The making of objects in a range of different forms relating to the context of the play took priority in this cooperation. One of the conditions was that the material had to be found in the country itself. Moreover, the close collaboration with our visual arts colleague led to an explosive and creative expansion in the use of visual effects by the members of the organization. This was further developed through the Shakespeare work that followed.

Shakespeare project

As Martin Esslin (1974: xi) states in his introduction to Jan Kott's *Shakespeare our Contemporary*:

> Great works of art have an autonomous existence, independent of the intention and personality of their creators and independent also of the circumstances of the time of their creation, that is the mark of their greatness.

It is exactly for this reason that, in 2005, MOVITEP-SF launched the interesting idea that we would not only study Shakespeare, but much more importantly, bring his work to life in performance. His universal themes – power, the abuse of power, the women behind the power and murder for power, as well as love in all its aspects – are all very pertinent to contemporary Nicaraguan society.

Besides the subject matter itself, in the Shakespeare project we had to incorporate some other unconventional disciplines, which until now had not been used in the work of the MOVITEP-SF groups. These disciplines were essential and

autonomous parts of the 'scene-setting' or mise-en-scène, and they influenced in an unconventional way how we used the theatre space. We needed to create lighting that would be effective in accomplishing theatrical effects to enrich the performance. We also had to investigate and identify an adequate location that would intensify and reinforce the impact of the subject and the performance.

In 2005, Nicoline Nagtzaam and Erik Gramberg, two specialists in 'Shakespeare based on lighting and location', who were lecturers in the Theatre Department of the HK-Amsterdam, were invited by MOVITEP-SF to develop a project with us based on their specialty. Their starting point was *Richard III* and the following quotation might have been quite an appropriate response to the boldness of this enterprise: What, do you tremble? Are you all afraid? Alas, I blame you not, for you are mortal ... (Richard III, 1, 2)

This was followed by five weeks of analysis and exploitation of the chosen space and experimentation with the most intricate and appropriate lighting for the different scenes and situations, including working in the ridge of the roof and outside around the building.

The following is one example of how the space contributed to the play's theme and impact: while inside the theatre there is a scene going on between Richard III and Isabel (Queen Elizabeth in English), literally and figuratively outside there is a personage, the hated Queen Margarita (Margaret), Richard's mother, now repudiated and in exile. She is an outsider who slides and manoeuvres now outside the corridors of power, represented in our version of Richard III by her manoeuvring and sliding around the building, along the wall, half of which is composed of an iron structure with holes through which she whispers words of damnation to the actors inside, who react with fear and horror. The effect of this kind of use of the space intensifies the mysterious and hostile impact of the performance.

In the middle of the performance space inside, a square wooden batten is hung with a lot of small lamps, which light up only the character who has the power at that moment. At the start of the scene appears Isabel (Elizabeth), the wife of Richard's sick brother the King. It is Richard who wants to take the power (and the throne), and the only way he can reach that is through manipulation, intrigues, attacks and murders – the real struggle for power, which he achieves through a series of coups. In relation to the content, the possession of power is represented by his seizure of the lit performance space under the wooden square. So he has to expel Isabel from this space, taking a cruel joy in the expulsion. After that, when he has won the space, automatically the only space left for Isabel is outside, where she confronts the same destiny as Margarita – a powerful evocation of the theme.

In this Shakespeare project, attention was paid to the poetic language, the dramaturgy and the *creación colectiva*, or collective creation process. The play took shape first in small groups, then with the whole group (nine actors and the two specialists) through a process where everyone could experiment, give their ideas and comments, and all contributions were discussed. The final presentation product was both experimental and successful.

In 2006, four groups of MOVITEP-SF each produced a Shakespearean play, based on their apprenticeship in the *Richard III* project, emphasizing the location to create more impact with the public.

El Capullo is a theatre-group in Lagartillo, a village of 1000 very culturally minded inhabitants that further develops with every new play, because from the beginning the whole village is involved with the group in the process of creating a play – a real example of community theatre. El Capullo presented *A Midsummer Night's Dream* in the woods at the end of the village (see Figure 4.1), which naturally provided a romantic atmosphere. The effect was actually enhanced by a technical problem. The electricity was lost that night, so they had to solve the problem with candlelight. This gave a special effect to the three love stories, developing on their different social levels. Physically, this was represented on three different levels for which a huge space was needed, in which the characters and their stories – each one in its own space – appeared at a distance from the audience, almost like puppets or dolls, jumping, playing, flirting and running around to create the atmosphere of lightness and joy.

FIGURE 4.1. Madejas, Membrillo and Comodon (Bottom, Quince and Snug) rehearse their right royal entertainment. Copyright author.

The audience was impressed by the fact that a well-chosen location could be of such an importance in the presentation of a play.

In Pueblo Nuevo, a village of 3000 inhabitants in the north of the country, the theatre group is called Teatro Nuevo. This group has its origin in the annual Easter presentation of traditional Passion Plays, so they are very well known by

the people. On the night they presented *Hamlet* (see Figure 4.2), performed in the marketplace, the whole village came running to the event with their plastic chairs to sit on. The market bordered the cemetery where the ghost of Hamlet's father appeared. The palace of Claudius and his Gertrudis (Gertrude) was situated on the roof of the marketplace. The fundamental impression that this location tried to transmit to the audience was one of a wide, majestic environment, in which the characters lose themselves and also lose contact with the other characters, and with reality. After the presentation, the people went back to their homes carrying their chairs while earnestly discussing the problems posed by the play. For the audience, this space was actually too huge: it was entirely impossible to follow the play uninterrupted – for instance, the scenes in the cemetery were too far away. Besides, there were children, dogs and cats, and drunken people who wandered in and out of the scenes, which were a distraction. Nevertheless, Shakespeare would have been very amused seeing that about 600 people really were enjoying his play, following Hamlet and Ophelia's every step, and offering them plentiful comments and advice.

FIGURE 4.2. Hamlet, flanked by Horatio and Bernardo, confronts the ghost. Copyright author.

In Matagalpa, the theatre-group Quetzalcoatl presented a very interesting Macbeth in a four-floor building constructed round a central atrium (see Figure 4.3), so that the audience, who were sitting inside the building on the atrium floor, could follow the play from all sides. The inventive lighting effects made a particularly deep impact on the public. The choice for the setting of this four-floor building was based on the idea that Macbeth runs away from his actions and runs away from his bad and desperate conscience. He runs through the whole building: we see him, followed by his henchmen, first above, then below, now on one side then on the other side: mind and body unable to rest. Meanwhile, Lady Macbeth stays on the same floor (the first floor) throughout, where she organizes her meetings

FIGURE 4.3. Macbeth and Lady Macbeth have murder in mind. Copyright author.

with her husband. She doesn't move to another floor. The witches inhabit only the ground floor. They are very earthly and concrete.

In Managua, another and different *Midsummer Night's Dream* was presented under, in and through old, enormous and romantic trees (see Figure 4.4), from which appear Theseus and his Hippolyta on horseback, with Puck beating around and in the bushes. Again, the space was specially chosen for this play. We made an extensive investigation to see what the possibilities for us might be if we used the location as it was, how to use the trees, moving from one tree to another, going through the trees, having some of the trees painted as animal figures, using branches for a rocking chair or a canopy. This was an important feature and, again, part of the success of the production. The imaginative use of the trees fitted well into the complicated love affairs, their complexity and density reinforced without imposed psychological effects. The play's happy end was symbolized by confetti that showered down from the trees, falling like leaves on Puck and the lovers.

FIGURE 4.4. Theseus and Hippolyta, not forgetting the horse. Copyright author.

The most important benefit of this exciting experience is that the actors are now more conscious of what they can achieve, and therefore they dare to experiment. Even for non-professional actors, the use of a special location gives their acting added impetus. In any good atmosphere, the actor always grows. It is our opinion that, for community theatre especially, it can be a very interesting and useful method to identify a good natural setting, with artistic, well-designed lighting, for the rehearsals and presentation of a play with the aim of enhancing the performance and consequently the whole production.

Another very important positive feature of such use of space and lighting is that we always choose a location that is accessible to its audience, far away from the official theatre where a high entrance price is invariably asked. Besides, such theatres only exist in the capital city, Managua (three of them, to be exact). The remainder of the Nicaraguan people do not see much theatre – except when MOVITEP-SF passes by to present a play. And then the whole town turns out to watch Shakespeare.

Acknowledgement

This chapter was originally published as Article 6 in Volume 7 (2006).

REFERENCE

Esslin, M. (1974), 'Introduction', in J. Kott (ed.), *Shakespeare Our Contemporary*, New York: W.W. Norton.

PART 2

WHAT IS APPLIED THEATRE?

Introduction to Part 2

Peter O'Connor

In 2001 I attended the launch of the Applied Theatre Research Centre at Griffith University and wrote about my experience in the very first *Applied Theatre Researcher* journal. It is one of the very few articles that was lost from the online archive,[1] but my memory was jogged by rereading three of the articles reprinted in this section of the book.

I was staying with John O'Toole as he was supervising my Ph.D. at the time and Judith Ackroyd was also there at his home in Brisbane's South Bank. Judith presented a keynote at the launch that was to become the basis for the seminal article that appropriately launches this section of the book (Chapter 5). The article began the decades-long debate on definitions of applied theatre. She spoke and then wrote in this article of the key defining elements of applied theatre as *intentions* and *participation*, and suggested that applied theatre was always participatory and had intentions beyond the actual theatre-making. It was theatre that was applied to some thing or place with an explicit agenda to change or alter perception, attitude or behaviour. In that sense, she argued, it was always pedagogical.

The most striking element of the article is her recognition that theatre is morally neutral; applied theatre can do both good and harm. Vital to ensuring that applied theatre 'does good' is ensuring that there is always an element of active participatory reflection, and that the art-making needs to be as important as any instrumental end. My strongest memory of the two-day event is of sitting on

John and Robby's deck in the short Brisbane twilight after a few glasses of perfect Australian red wine. John, Jude and I talked about where the stress was in the phrase 'applied theatre research'. Was it *applied* theatre research or *applied theatre* research? We were excited about the possibilities of the new centre, the promise of a new journal and the opportunities inherent in a new language to describe the work we had all been doing for many years.

Until the launch of the centre, I had never heard the term 'applied theatre'. I began to wonder whether I was in fact doing applied theatre. Did it mean that if I was doing applied theatre, I was a theatre maker and not a drama teacher? Strangely, twenty years later many of the questions of definition still haunt our field.

I loved the term 'applied theatre'. I was excited that the work I was doing in psychiatric hospitals, in anti-racism work, with the long-term unemployed and with newly appointed judges had a name. 'Theatre' sounded grander, larger than 'drama', and 'applied' ... well, that also freed me, it seemed, from the constraints of the mainstream theatre that in those days largely left me feeling cold. In my mind, it was always about theatre applied to issues of justice, of human rights, of an alignment to the progressive politics in which I was embedded. Theatre beyond itself, applied to an explicit agenda of social transformation, was my kind of theatre.

I had been working freelance on applied theatre projects for years. Work was growing and I needed to formalise that within a company structure. I returned to New Zealand and announced at home, 'So, I've got the name for the company. Applied Theatre Ltd.' The response was underwhelming.

'Applied theatre – what on earth is that?'

'Applied theatre is this new thing that has kicked off in Australia. It will eventually get here. It's basically what I've been doing in and around communities for years – it's all about intention and participation and there are ethical issues and my Ph.D. in psychiatric hospitals, that's apparently applied theatre not process drama, like I've been calling it. It's what we've been looking for: it closes off the debate about product and process, it elevates our work and talks about participatory aesthetic forms of embodied learning as being part of the theatre tradition.'

(I'm making up this part of the conversation. I was, after all, only in my first year of my Ph.D. and that sort of phrase wasn't yet part and parcel of my vocabulary, nor necessarily of the theoretical pioneers of our field.)

I remember another conversation I had with John O'Toole as I worked on my Ph.D. We were talking about drama education and theory, and John said, 'Don't forget when we started [referring to the beginnings of modern drama education], we were first and foremost practitioners, all of us: Peter Slade, Brian Way, Dorothy

Heathcote, Gavin Bolton, Cecily O'Neill and Jonothan Neelands. And we used our practice to build our theory and then used that to strengthen our practice.'

At that launch, I vividly remember Jude Ackroyd's workshop where we looked at staging the *Romeo and Juliet* 'waking from sleep' scene. I remember her artistry, her sweeping powers as a theatre-maker and teacher, and her relentless questioning of practice in the reflection session she led after the practical work. Jude was also doing her Ph.D. research (at the time with the late Sir Ken Robinson) and she was looking at the level and form of acting involved in teacher-in-role. So that she could analyse it later, I videoed a process drama of John O'Toole teaching alternative versions of the classic Australian anthem 'Waltzing Matilda'. It was applied theatre research. Jude was moving beyond how we had largely written about our own theatre-making to move into deeper, more nuanced, theory-informed accounts of others' practice. As I stood behind the camera, I realised that John wasn't just acting when he was working in role: he was teaching and acting at the same time; he was engaged in deeply sophisticated theatre work. It demonstrated to me that applied theatre is more than an instrumental use of theatre devices for learning. It is ground-breaking theatre and its practitioners are artists.

The notion that the instrumental nature of applied theatre might diminish the aesthetic power of theatre is also explored by Bjørn Rasmussen (Chapter 6), who was another participant at that Brisbane launch in 2001. Rasmussen reveals his discomfort with the term 'applied', and he suggests that the status of applied theatre within university contexts needs to be secured, to avoid a discourse of hierarchy between applied and mainstream theatre. He argues too for our need to broaden our ideas and approaches to practice rather than narrowing them. His argument that the binary between pure and applied theatre is false and counterproductive resonates strongly when the boundaries between commercial theatre and applied become more blurred.

Many theatre companies increasingly engage in more socially committed and participatory forms of theatre, perhaps most spectacularly realized in the enormously popular forms of immersive theatre that now span days of improvised politically charged events attended by tens of thousands of people. Even some more traditionally sedate institutions such as the Scottish and Welsh National Theatres now operate without a built theatre and engage in socially motivated embodied participatory programming. In these movements we can see that the concerns articulated by Rasmussen and Ackroyd have been met with a change and shift in practice where the dissolving borders between pure and applied theatre are crossed regularly. Our practice as theatre-makers is diversifying and the aesthetic of our work is as important as our models of participation and our intentionality.

Tim Prentki continues this part in Chapter 7 by reminding us that the radical edge of applied theatre as revolutionary theatre-making, as a disruptor to the

capitalist system, is very much part and parcel of the applied theatre tradition. He discusses the relationship between applied theatre and the pedagogic principles that sit behind Freirean critical theory, and Marxist theatre-making and the politics of Brecht. For Prentki, applied theatre does and should embrace an ideologically driven politic. It is a theatre of and for the marginalized and dispossessed, whose stories are rarely told honestly. He argues that alongside participation and intentionality, democracy and sustainability are core principles of applied theatre practice that are realized within specific contexts.

He argues, using theatre in education examples, that the power for change in applied theatre resides in providing spaces for dialogue within and across communities, reinforcing our understanding that theatre is never a linear process that arrives at predetermined outcomes. Prentki argues that applied theatre must be centrally concerned with, and passionately make, powerful theatre that shakes and disrupts, that helps us reimagine different, better, more just worlds.

In 2007, Judith Ackroyd revisited her article from the first edition, reflecting on how the nascent field had already changed. We close this section on defining applied theatre with that article (Chapter 8). Ackroyd recognizes that the origins of much applied theatre work can be found in explicit social agenda movements but, unlike the umbrella term in play in 2001, she is already warning that an exclusionary discourse is building around both the term and the practice. Ackroyd argues for a broader and more inclusive use of the term – a less politically motivated theatre that might, for example, embrace theatre in business. Perhaps most poignantly, she is considering drama in education: as applied theatre is being taught more frequently in faculties of education, she fears the integrity and substance of drama education might become lost in the glamour and sheen of a new field. She notes how another journal devoted to drama in education became so preoccupied with applied theatre that it had to commission a special edition on drama in schools because research had evaporated in this space. The same journal changed its name some years later. Ackroyd worries that by valuing applied work because it apparently does or should do good – or at least attempt to influence a purpose external to the theatre itself – drama/theatre has become underestimated for its own intrinsic value. This divide is also discussed in the Introduction to this book.

In editing the *Applied Theatre Journal* over the last five years, I recognise that this passion for social change and justice sits behind nearly all of the articles I have reviewed. It is sometimes hidden in academic language that acts as a restraint on the political impetus of the work, yet the practice that speaks so powerfully about the curses of our times – climate chaos, racism, colonisation, the death of democracy and gender violence – suggests that applied theatre has not fundamentally

shifted from its progressive and radical traditions. A part of me hopes it never will, and that it will always retain a spirit of radical disruption and resistance.

NOTE

1. This article (Article 4, Volume 1) was subsequently recovered, and can be found in the ATR Back Issues on the Intellect Books website, https://www.intellectbooks.com/applied-theatre-research-back-issues.

5

Applied theatre:
Problems and possibilities

Judith Ackroyd

Old aims, new title and diverse practices

The term 'applied theatre' is relatively new. It brings together a broad range of dramatic activity carried out by a host of diverse bodies and groups. Many of those who would fall under the umbrella title of applied theatre may not be familiar with or even aware of those with whom they huddle. The drama therapist sees her work as distinctly different from those in the group who employ drama to enhance the skills of a company sales team. The prison theatre practitioner will not necessarily relate to those using drama to support the elderly. The practitioners in each group will see themselves working with specific skills appropriate to their work and not necessarily as the same as those in other fields. How, then, can we gather diverse practices into one bundle? Some may be dragged there screaming! A Christian street theatre group may not wish to reside alongside a company canvassing for the reduction of the legal age for sex between consenting adults of the same sex.

In the face of this plurality, I suggest it is an intentionality that all the various groups have in common. They share a belief in the power of the theatre form to address something beyond the form itself. So one group uses theatre in order to promote positive social processes within a particular community, while others employ it in order to promote an understanding of human resource issues among corporate employees. The range is huge, including theatre for education, for community development and for health promotion, as well as dramatherapy and psychodrama.

An intentionality is presupposed in all these examples. The intentions, of course, vary. They could be to inform, to cleanse, to unify, to instruct, to raise awareness. The use of theatrical form to achieve such intentions is not new. The Yoruba have used drama to reaffirm a sense of community through celebratory dramatic ritual

from traditional times. It is widely held that the plays of ancient Greece intended to cleanse, through *katharsis*. Mystery plays have been used to provide instruction in Christianity. These functions of theatre are not new; it is the term that is new.

Since theatre forms have been used for these purposes for so long, why do we now need to attach a new label to them? Why is it necessary to bring broad-ranging theatre practices into the academy for dissection and analysis? I welcome the creation of a Centre for Applied Theatre Research and this new journal because I am convinced that we do need to bring these forms together for inspection for three main reasons.

The first is that the use of drama has grown so quickly that it warrants our attention. It is no longer small groups of enthusiasts, or politically active individual writers, who seek to utilize the powers of drama. Role-play and simulation exercises are used in the training of managers in a way that would have been unthinkable 30 years ago and theatre extends into new territories as I write. Something growing so quickly in many different directions deserves our attention. The second reason is for the new perspective it can offer each of us engaging in applied theatre. Bringing these diverse groups together, seeking out what makes them distinctive as well as their commonalities, will enrich our practice.

Third, there is a crying need for evaluation of applied theatre. Research is required to look at the efficacy of applied theatre in its various forms. We need to know what distinctive contribution drama can make to changing attitudes and behaviour, and to be alert to any unintended consequences of using it. At the same time, we need to appreciate that applied theatre is not only applied, but also theatre. So there is also a need for critical analysis of the theatre forms themselves.

Family resemblances and distinguishing features

I have referred to intentionality as a common feature, but this is clearly not enough to define the term. Although it seems commonsensical to distinguish theatre and applied theatre, I wish to move away from a notion of two distinct forms, 'theatre' and 'applied theatre', and propose a continuum. As a preliminary, let us envisage a continuum, at one end of which lies applied theatre in its most nakedly functional form (Figure 5.1). Here, the artform is a means to a quite distinct end which is not concerned with theatre form or practice. At the other end it gets more complex. It needs to include commercial, experimental and children's theatre.

This continuum is immediately reminiscent of a familiar drama education debate: drama as a 'dramatic art' (Hornbrook 1998) and drama as a 'learning medium' (Wagner 1979). I should like to qualify the continuum I propose by stipulating my belief that nothing at either end of that continuum or between can

Theatre ←----------------→ Applied theatre

FIGURE 5.1. Applied theatre matrix 1.

exist without an understanding of theatre form. Applied theatre is applied theatre because it uses the artform of theatre. In order to experiment with that form, there needs to be a prior understanding of it. So at both ends the artform is a prerequisite. In applied theatre, the producers must consider what dramatic construction will best fulfil their purposes. The appropriate use of the theatre form is essential in order for the intentions to be achieved. In this context, it is noteworthy that at Roehampton Institute where a postgraduate certificate is offered in dramatherapy, all students first learn practical theatre. This is described as 'a prerequisite for facilitating a theatre model of drama therapy' (Roehampton Institute 1999). An understanding of theatre is essential, in short, for any position on the continuum.

The continuum above is reminiscent of Schechner's (1994) famous efficacy–entertainment continuum. Efficacy and entertainment are not so much opposed to each other; rather, they form the poles of a continuum: 'No performance is pure efficacy or pure entertainment' (120). Schechner (20) describes an efficacious performance as one whose purpose is to 'effect transformations'. We will consider this further in the next section. At this point, though, we must consider whether a performance contrived to effect transformation – or, in my words, to address something beyond the theatre form itself – is sufficient for a definition of applied theatre.

Schechner identifies a period of high efficacy in British theatre history in the mid-eighteenth century. Presumably, he is thinking of the so called 'sentimental plays'. *Love's Last Shift* (though written earlier in 1696) by Colley Cibber is often cited as an example of this genre of plays, which intended to provide moral instruction. While Schechner places it high in efficacy, and clearly it had another purpose, would we wish to define the play as applied theatre?

Let us take another more complex example. In 1773, Oliver Goldsmith wrote *She Stoops to Conquer* to make a point about theatre itself. Goldsmith uses his prologue to make his purpose abundantly clear to the audience. He fears for the death of comedy.

> Pray, would you know the reason why I'm crying? The Comic Muse, long sick, is now a-dying! And if she goes, my tears will never stop;

and through his play he proposes a remedy:

One hope remains: hearing the maid was ill, A doctor comes this night to show his skill. To cheer her heart, and give your muscles motion, He in five draughts prepared, presents a potion: A kind of magic charm - for be assured, If you swalloe it, the maid is cured.

(Goldsmith 1967: 85)

Goldsmith is concerned to resurrect his notion of comedy. His intention is to write a comic play and his concern is therefore with comic theatre form. Since it is concerned with theatre form, we may be inclined to place the play at the 'theatre' end of the continuum. Yet it is also clear that Goldsmith wanted to bring about a transformation! The members of the audience were to take the medicine, to resurrect the comic muse and to turn their backs on *a mawkish drab of spurious breed, Who deals in sentimentals* (Goldsmith 1967: 85). So perhaps we should move it to the right towards 'applied theatre' but still leaving it to the left of centre. *Love's Last Shift* could rest a little further right towards applied theatre than *Peacemaker* (Holman 1982), a contemporary scripted play for school children. That tells of a wall dividing the Reds from the Blues. At the beginning of the play they know nothing about each other and obey commands to keep away from the wall. By the end, they have discovered that neither is demonic, they can be good friends and they pull down the wall. The play is a delight in performance for its theatricality, its wit and its dramatic tension. The message is very clear to adults and to many of the young children watching. Like *Hedda Gabler* and *She Stoops to Conquer*, it is scripted. Like them, it seeks both to entertain and at the same time convey a message with a desire for change – or at least re-evaluation. Yet *Peacemaker* is more likely to be included on a course in applied theatre than the other two. Why?

Plotkin's (1997) essay on applied theatre distinguishes the field in a way that resembles Schechner's continuum, by identifying some clear purpose overshadowing the entertainment function. However, I wonder if this doesn't entail demarcating the field in too inclusive a way. The outraged members of the audience who left the first production of Ibsen's (1988) *A Doll's House* decrying the playwright would have identified the play as the purpose overshadowing the entertainment function. Their response was to a perceived purpose, not to theatrical entertainment. However, we would not expect to encounter this play within the field of applied theatre. Thus, the desire to transform or overshadow the entertainment function with clear purpose is not by itself enough of a distinguishing feature of applied theatre to demarcate the field.

Peacemaker was identified above as similar in many ways to the Ibsen and Goldsmith plays, yet it appears in a volume of 'theatre in education' texts, which places it in the field of applied theatre. So ... why is it different? In my experience of performance, it is distinctly different. I have only ever seen the play accompanied

by a workshop involving the participation of the audience. Perhaps the role of the audience is significant in characterizing applied theatre.

Boal's (1993) Theatre of the Oppressed actively engages the audience, as do dramatherapy, drama in education, psychodrama and drama for workplace training. In these cases, the audience move from being watchers to active participants. For Schechner, active participation constitutes a precondition for transformation to take place. *Peacemaker* does not require the integral role of the audience during performance that O'Toole (1992) seeks for true theatre in education, but the programme includes full participation in a follow-up workshop. There is not time here to consider the process of learning through dramatic engagement, but it is widely held that unless the children have explored ideas themselves, experimented and made what they watched their own experience, the learning opportunities will not be maximized.

However, I do not wish to suggest that theatre without any active audience participation cannot deliver a message or bring about 'a shift in appraisal' (Bolton 1979). My own experiences prevent this. I imagine that a performance of Kushner's *Angels in America* at the National Theatre, London could not have been more significant to me had I been 'workshopped' for days. The performance knocked me for six, albeit as a still, silent observer. My experience of *Capricornia* performed by Queensland University of Technology students at the Queensland Performing Arts Centre in Brisbane during the IDEA '95 conference provides another example of a play that carried an 'other' intention, though I was in no way physically involved with the creative process.

These examples would probably not, however, be classified as applied theatre. This suggests that audience participation may be a further distinguishing feature of applied theatre. There is now a rationale for a second continuum relating to audience participation. At one end is audience as observer, at the other audience as participant. We are now in a better position to delineate our field. I have identified two features that I believe to be central to our understanding of applied theatre: an intention to generate change (of awareness, attitude, behaviour, etc.) and the participation of the audience. I have suggested that neither single-handedly distinguishes theatre and applied theatre and that the distinction between them is a matter of degree. To clarify matters, let us draw two new continua at right angles to each other (Figure 5.2). The first relates to the degree to which theatre forms are attempting to effect transformation; the second relates to the degree of audience participation. All theatre forms arguably entail some element of transformation, however minimal, just as they will entail some form of participation from the audience. At the same time, it is hard to envisage a piece which could bring about a complete transformation, or complete participation. We should therefore not expect any theatre forms to be placed at the extreme ends of either continuum.

APPLIED THEATRE: PROBLEMS AND POSSIBILITIES

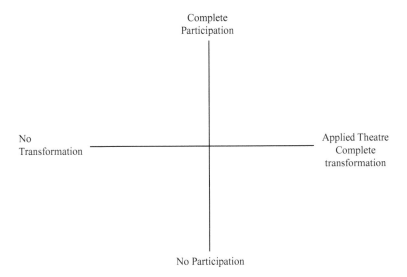

FIGURE 5.2. Applied theatre matrix 2.

Most forms and texts that we would consider to be in the domain of applied theatre are located in the top right-hand quadrant. *A Doll's House* and *Love's Last Shift* also occupy a position towards the right due to their intention to transform, but they remain below the horizontal due to the nature of their audience's role and are therefore in the bottom right-hand quadrant. *The Peacemaker* by contrast falls somewhere between the two.

This grid hopefully reveals what Wittgenstein (2001) describes as 'family resemblances' between such seemingly different theatre forms as drama therapy and theatre in education, and perhaps it goes some way towards aiding our identification of the distinguishing features that constitute the field of applied theatre.

For better or for worse

Whatever I read of applied theatre is delightfully positive about its possibilities and achievements. Joel Plotkin (1997), for example, is drawn to the forms of theatre that may be labelled 'applied theatre':

> for several reasons: first, a Brechtian attitude that theatre is a tool to make a better world by helping people look at their communities; second, dissatisfaction with commercial, academic, and even most avant-garde production; third, a personal need for spiritual, moral, and ethical purpose in focusing my limited vision and energy.

Course descriptions are enthusiastic. Manchester University offers a master's course in applied theatre that is normally taken to mean 'theatre applied to the needs arising from a particular social institution or marginalized community'. It seems so sound and optimistic. However, in this section I wish to consider the implications of the intentionality of applied theatre, and to raise the possibility that it may not always be employed for noble, humanitarian means.

We need to ask ourselves what purposes applied theatre activities are fulfilling and what values they are exemplifying. Looking at the course description above, for example, we can immediately identify a value system. Who defines the 'needs' of a particular institution for this course? And why *marginalized* communities? These questions are not asked or answered because certain assumptions come with the package.

Philip Taylor (1996: 14–16) demonstrates that it is quite impossible for teachers and researchers to be value free. This doesn't mean, however, that no attempt should be made to avoid bias. We have to live with the fact that each of us carries attitudes and values that will influence our work. Looking at many of the applied theatre forms frequently identified, there is an implicit political bias, as shown in the course description above. In some cases, theatre companies are explicit. Many groups nail their colours to the mast by their names. We are left in no doubt, for example, about the perspective of the company Gay Sweatshop. Theatre companies committed to education about drugs awareness are not going to be promoting drug abuse. So we accept that these applied theatre forms have a particular intention and we accept that their performances will have been constructed according to particular ideologies. We are also likely to assume that they have some efficacy.

It is perhaps this efficacy that explains the controversy often generated by theatre. People outside the field are also aware that theatre can be influential. Those opposing the depiction of a homosexual Jesus on Broadway must be protesting because they feel that theatre has a power that may entice a possible new perspective of the Christ figure. Stalin banned *Hamlet* during the Second World War. The Japanese censors demanded that all textual references to royalty be removed from Koreya Senda's 1938 production of *Hamlet*, a request that must have removed much of the dialogue (Richie 1999). Brecht's theatre was, of course, banned in Nazi Germany, while public theatres were closed during the puritanical Cromwellian years in England. Theatre has been perceived as a dangerous tool to many in positions of power. Plays have been cut and prohibited (*A Doll's House* was not performed in its entirety in England or America until ten years after it was written), and theatres have even been closed. So, the powerful potential for theatre to influence, to raise awareness, to inform and to transform is and has been widely assumed.

My question is that if theatre has been applied to the job of opening minds to new perspectives, to increasing self-esteem, to bringing together disparate communities, why should it not be used to produce restricted perspectives implying criticism of others, to reduce self-esteem and confidence with ideas, to divide and fragment established communities?

With the growth in applied theatre, it may not be emerging extremist playwrights or public, open performances about which we need to be wary, but something quite different. Our artform may be used for arguably unworthy causes – for shifts in market positions, for example, rather than 'shifts in appraisal'. Many in our field may have shared drama practice with those in business. Fair enough, but how far should we go? Should the arts be used to improve staff self-presentation skills? Should drama be used to promote sales? What about tobacco companies? Is it legitimate for drama to be used to any ends that our sponsors may support? In some ways the issue of values is writ large when it comes to applied theatre. A local authority in the United Kingdom, aware of drama's potential, used its drama support team for improvement in many ways. The drama team was enlisted to help with school governor training. A day came when they refused to help. That was when the drama team was asked to use theatre to encourage governors to feel good about themselves, rather than guilty, when they sacked teachers ... If it is known to be effective, why would those with the finances to invest not use applied theatre to dubious as well as positive ends? We must be prepared for theatre to be used for ends with which we wouldn't necessarily agree.

A close look at Schechner's (1994) efficacy–entertainment continuum is illuminating. His assertion is that performances aiming for maximum efficacy will probably have a range of other features in common too. The audience participates, there is collective creativity, but – more significantly – criticism is discouraged (120). While he is referring here to ritual, the extreme case in efficacy, most of us would be highly suspicious of applied theatre processes that do not allow for criticism.

The aims of drama in education have been more modest in articulation, although perhaps not in spirit. We have all believed we can create a drama that will encourage, or actually 'force', pupils to look again at the implications of bullying so that it is less likely to happen again among that class group. We believe that steadily – though admittedly slowly – we can chip away at the playground culture and create a better experience for the children. (I'm not the only one, am I?) We want a more secure school environment; we want a different attitude; we want an emerging sense of community; we want a transformed playground. In class drama, we ensure reflection. We encourage a distanced consideration of what we have been involved in. Morgan and Saxton (1987: 136) describe distancing as the strategy that allows the students to find meaning in situations which, by their

immediacy, might inhibit exploration. This signifies a stepping outside the all-embracing, all-encompassing form to counteract the felt experience with reflective practice. If these practices are neglected, something dangerous emerges. But what really bothers me is this: I have no difficulty imagining how I could construct a drama that could encourage a group to run into mortal combat with vigor and conviction. What is more frightening is that I can imagine designing a series of workshops that use the emotion in the drama to instil an antipathy to a group in a real community – well, can't you?

And we would draw on the features to which Schechner (1994) refers for maximum efficacy in ritual – full participation, collective creativity – and we would deliberately neglect that reflective mode which encourages a distanced objectivity.

It is not enough to look at whether or not the theatre piece achieves its ends. We also need to ask whether or not those ends *should* be achieved. Whose needs are served by a drama applied to calming inmates or young people in care? The inmates and young people? The authorities? Both? Is it efficacious, as in Schechner's (1994) definition, because there is no space for dissent? To decide whether or not the ends being sought are appropriate is clearly highly contentious. In our struggle to reach a conclusion, I suggest a question may help us: Are the ends in question publicly debated and defended? We might conclude, 'Yes for the bullying drama and the HIV education theatre project. No for theatre to promote smoking.'

Other cases are more difficult to pin down. Take, for example, the training for governors to sack staff. It could be raised for public debate. Perhaps it could be defended since the governors may need the training to manage the situation better for the benefit of the teacher losing her job, as much as for the governor herself. There are still areas of grey, but this benchmark may take us a step further in assessing intentions delivered through applied theatre.

In conclusion, I suggest that there is a danger of applied theatre being seen as a technique and forgetting not only that theatre is an artform, but also whose needs are being met. We forget at our peril the question of what applied theatre is for. We need to ensure that our practice comprises more than simulation exercises and role-play, that it is truly reflective and that we debate the purposes of what we are doing. Applied theatre is a mighty form and, like fire, can work either for us or against us.

Part 2: The Sins of the Fathers

I wish to describe a particular applied theatre project prepared with sociologist Andrew Pilkington. We called the drama *The Sins of the Fathers*. It represents a

piece that has an intention, as will be seen, and that also engages its audience as active participants who performed, as I did. It offers various viewpoints and different positions of distance for reflection. We will move through the stages of the drama and the thinking behind it.

The Sins of the Fathers

We live in an age of disbelief, where the grand narratives of the past no longer have credibility. The nation-states of the West continue to dominate the world order and particular ethnic groups remain privileged within nation states. The old triumphalism, however, has gone. Ruling groups no longer believe that they have a mission to civilize the world, and a self-confident belief in superiority grounded in nature is now rarely articulated. Voices from the margins can no longer be silenced. The result is that alternative histories and perspectives increasingly clamour for our attention. In this context, ruling groups find it difficult to shore up established national and ethnic identities and establish their legitimacy in the eyes of others. For we are all too aware that these identities are constructed, that the histories underlying them are selective and that, from the point of view of others, our privilege depends upon the barbarism of the past. Cultural relativism flourishes in this multicultural world, but it does not prevent us acknowledging that our history is characterized by evil actions. For liberal democracies subscribe to certain values, and in terms of these values allowing people to starve, maltreating prisoners of war, destroying minority cultures and conducting medical experiments on people without their consent are all wrong.

An acknowledgement that our history is characterized by barbaric actions can generate different responses. We may feel that actions we now consider barbaric need to be judged by the standards of their age; we may feel that we are not responsible for the actions of our ancestors. Or we may feel shame and perhaps guilt at what has been done by our forebears – especially when the descendants of the groups who were so badly treated in the past continue to be disadvantaged and continue to remind us of their 'ancient grudge'. Or we may seek to synthesize all these responses, as some official histories in our museums attempt to do, albeit in a somewhat contradictory manner.

Recently, an intriguing new phenomenon has been evident – the apology. Struck by the plethora of recent apologies by governments for the actions of previous generations, we wanted to construct a drama to explore the motives, meanings and consequences of such apologies. Is the apology given out of genuine remorse or driven by political manoeuvring? Why might an apology be withheld? What does an apology signify? Is it a genuine attempt to come to terms with the past and move on? Or is it a symbolic gesture, a substitute for real action

to remedy the consequences of past actions and a justification of a system that merely pretends to have changed? Will an apology alleviate a deeply felt hurt or will it have unintended consequences, perhaps being decoded as a cynical, political move?

Stage 1

It is good for us to meet together in this way. It is good that we remember the lives of the Bagels who have gone before us. It is right that we tell our story to our children so that they understand the evils that were committed against our forebears.

We gather here for the 244th year to retell the events that occurred when they arrived, when the Yetta came here. That's when Bagel lives changed; they took over Bagel land, they stopped Bagels from gathering for religious festivals, they took all that was dear to the Bagels, taking away our children, disturbing all that we knew and loved.

We have all heard of these terrible days and gather each year so that we do not forget, and so that we never allow it to happen again. All Bagel families have their own stories, which have been passed down the generations. Grandparents and parents have retold these stories so that new generations will know exactly what took place. It is now the turn of each new adult here to tell their stories as they have been passed down.

I will begin by telling a story that has been passed down through my family.

[Takes a step forward]

I'll never forget the day they came to our community. We knew as soon as we heard the marching feet, as soon as we saw the raised arms. We knew they had come for our children. We knew, too, that it was death to resist. My child was prised from my arms. 'Hannah, Hannah!'

The joy when the end of the term came, and the children were returned to us.

Reaching arms out and miming an embrace 'Hannah, Hannah!' I cried holding her close.

'Hannah?' she said. 'Hannah,' I said. 'Yettira,' she said. 'No, no Hannah, my Hannah!' 'Hannah,' she said.

The holiday came and went. The term dragged by, but soon my child was returned to me.

Arms stretched to hold the imagined child.

'Hannah, my dearest Hannah. You are home.' 'Hannah?' she said. 'Hannah,' I laughed. 'Yettira, Mama.' 'Hannah.' 'Yettira.' 'Hannah (points nervously now). Mama (points).'

'Hannah?' 'Yes, my child, Hannah' 'Hannah,' she said.

For Hannah's third holiday we had again prepared celebrations Yearning arms reaching out.

'Hannah, my Hannah.' 'Yettira.' 'Hannah.' 'Yettira.' 'No. You are Hannah, Hannah (with increasing desperation), Hannah!' 'No. You are mistaken. I am Yettira.'

[Takes step back to original position]

Our children were torn from us. Parents found they no longer knew those whose lives they had celebrated and cherished. We will never forget the pain of our forebears.

So began our drama with student teachers.

The students in small groups now devise a story and prepare a presentation of that story. The Bagel meeting reconvenes and the stories are told in turn by a narrator from each group, with other members providing images or action to support the narration. The teacher-in-role reaffirms the points made by each group:

They took everything from our children.
We all saw the pain of parting in their eyes. There was no mercy.
The woman died alone in pain and misery.

They are thanked for their stories and the gathering is formally closed.

Stage 2

The space is reorganized and all sit around a board room table ready to take on their new roles as members of the Yetta Council Chamber. The teacher, as Chair, addresses them:

I have called this meeting because there is an issue that I feel all members of the Yetta Council Chamber need to discuss.

We still have a pressing problem to cope with. There is still criticism abroad about our treatment of the Bagels. In view of the impending election, it is really urgent that we ward off as soon as possible any potential damage to our international reputation. You'll remember that we commissioned an independent enquiry to report on the situation re the Bagels. The report detailed the following points:

1. Land that belonged to the Bagels has for the most part been returned.
2. Their rights of worship have been restored. They are allowed to meet and worship according to their beliefs.

3. Legislation has been brought into place to provide for equal opportunities. What more can we do?

A number of points were raised:

We need to be seen to be doing something. There's danger in silence.
Who is informing people abroad about the Bagels? It's about things a long time ago.
We must respect our ancestors' wishes.
But what's the point of respecting our ancestors if we can't protect ourselves?

The teacher-in-role suggests a formal apology for the past:

It may make us seem woolly and they may take advantage of it.
We need to think of something that gets the best publicity without doing anything.
We need to keep the upper hand.
They may see through it. Bagels aren't clever like us.
Perhaps they are being stirred up by those abroad. They may get violent if nothing is done.
Are you prepared to fight? Conflict is not good for the young.
Do we really want to have equal rights?

The teacher-in-role reminds the Chamber that many political leaders have given formal apologies in recent years and suggests that they consider the pros and cons of a Yetta apology for past treatment of Bagels. They list the pros:

It's right because we and the Bagels need to let go of the past. It would clean the slate and encourage a new start.
Life would be a lot easier for children if there was no animosity between groups.
We would appear good and improve our public image.
It may help us to stave off a bad election result and gain us Bagel votes. It could actually avoid internal war.

and the cons:

We weren't responsible
It would be for something so long ago. An apology might alienate elder Yetta. It could make us look weak.
The Bagels might not accept an apology and feel that we owe them more. They would feel that we were mocking them.
Whatever we do won't satisfy them.

Although we are living in an era in which governments are less reluctant than in the past to apologize, we must not assume that apologies – even for the actions of previous generations – are given without cost. Demands for an apology are made when members of a group feel that a serious injustice has been committed against them. Such requests are by no means always met, however – for example, Indian pleas for an apology for the massacre of innocent people at Amritsar; Irish entreaties for the awful atrocity of Bloody Sunday to be acknowledged; and Australian Aboriginal demands for recompense for the 'stolen children' have not been accepted. And this is partly because it has been felt that 'an apology might alienate our elders' and 'could make us look weak' and indeed unmanly. It might be assumed that apologies for ancient grudges might be more easily given. To have credibility, however, apologies given by governments need widespread support among their populations and this may not be forthcoming if the apology is 'for something a long time ago' or, as is the case in some cultures, is seen as dishonouring one's own ancestors. The drama enables us to understand why an apology may not be given and, when given, the diverse motives that may underlie it. In this particular drama, an apology is, of course, forthcoming from the Yetta!

The teacher in role suggests that they carefully consider the wording of their apology. After some discussion, during which the word 'apologize' itself is jettisoned because it 'sounds very empty', they agree on the following:

> We publicly acknowledge and regret the atrocities committed against you, the Bagels, by our ancestors.

Stage 3

The space is reorganized. The sentence is written on a board and again the students change roles. The teacher in role addresses them:

> You have been commissioned to advise the leader on the most effective way to deliver the apology. The whole world is watching, and the apology must be delivered in such a way that it will achieve the desired effect. It is crucial that we get this right. You have been chosen because you are considered to be the top of the tree in public relations. We chose you because we cannot afford to make a mistake. You will work in teams. Each team must create a proposal and demonstrate how the apology might best be delivered.

One team recommends a solitary seated figure. The leader speaks directly to the camera, with legs uncrossed and hands gently laid on lap. This is interpreted as

creating a sincere, approachable, personal connection between the leader and the Bagels.

Another team presents five figures in a line walking slowly forward. The middle figure delivers the apology while the others link hands with their heads bowed. This is seen as the Yetta moving forward to meet the Bagels, with bowed heads, signifying regret, and joined hands, signifying togetherness.

A third team places the leader on a chair. She steps down and, flanked by four other figures with heads bowed, soberly speaks the apology. This is thought not to present a soft enough image. For, while the stepping down may be read by the Bagels as an attempt by the leader to reach out to them as equals, the flanking figures may be seen as aggressive, the iron fist behind the velvet glove.

Stage 4

The students are asked to return to their role as Bagels, with the teacher in role chairing a meeting in which they discuss their response to the apology delivered by the Yetta. Very different responses are forthcoming:

> I'd feel like a traitor accepting this apology. We need a new start.
> I am shocked that they have apologized. They're probably after something.
> What are they apologizing for? It's time we put this behind us.
> We should move on, but never forget.
> We're in the same situation as a year ago.
> Why are they doing this now? Is it real? Or do they want our votes? Haven't we already moved on?
> Some still can't accept us.
> The apology was an empty gesture. It doesn't change anything.
> We've got to think of the younger generation.
> We're in the position where we can make things change.

We were surprised that the Bagels – though clearly aware of the manufactured nature of the apology – were so ready to accept the Yetta gesture. We had anticipated that the students, who had just been engaged in the marketing of the apology, would, as Bagels, have reacted far more angrily to the apology or at least have expressed disappointment, as Jews have done in response to the Vatican's recent 'act of repentance' for the actions of some Roman Catholics during the Second World War.

Indeed, we had prepared a further stage in the drama that was designed to offer an alternative response to the apology. As it happened, we did not need to wheel in our mixed couple comprising a radical Yetta and a grateful-for-the-apology Bagel!

Later discussion with the students revealed that their overriding concern was to put wrongs right. They wanted the Bagels and the Yetta to live without discord. Not accepting the apology would move them further from their goal.

Stage 5

Moving from the fictional world, student groups are each given a card on which is printed a recent apology given by a government in the real world. They are asked to devise a dramatic image to represent the apology. The image could involve movement, but not words. The images are presented while the teacher reads the apology out loud:

1. 'We, the British Government, express "regret" for the Irish famines in the years 1845–49, when we failed to provide support leaving thousands to starve to death.'

The decision to make an apology is represented as one made in a cavalier manner over a cup of tea, for the person apologizing is casually sitting down, drinking tea, while beside her are three figures bent over in agony. The figures are clearly representative of those who starved to death and the person apologizing of a government, whose apology does not stem from deep remorse but from political manoeuvring.

2. 'We, the Japanese government, express "deep remorse and heartfelt apology" for the treatment of British prisoners during the Second World War.'

The apology is depicted in a formal manner. The characters line up and bow their heads slowly, one after the other. It is difficult to decide whether the apology really does express deep remorse – for the apology is culturally coded and is difficult to decipher by members of another culture.

3. 'As a country, we are burdened by past actions that resulted in weakening the identity of aboriginal peoples, suppressing their languages and cultures, and outlawing spiritual practices. The Government of Canada today formally expresses to all Aboriginal people in Canada our profound regret for past actions of the federal government which have contributed to these difficult pages in the history of our relationship together.'

Two figures are first seen pushing another figure down with stylized movements. A figure from the side appears, smiling with arms outstretched in a supportive

manner. The figure initially pushed down slowly begins to rise, but on nearly reaching an upright position, finds that an arm – stiffly stretched above her head – restricts any further move towards the upright position. The dramatic image expresses a sense of 'You can rise, but only so far' with stunning clarity.

4. 'We, the American government, "apologize" for the Tuskegee [syphilis] experiment, which involved suffering and death for black people, who were lulled into believing that they were being treated when in fact government doctors were observing the rate and symptoms of their deterioration.'

The apology is represented as an example of spin doctoring. The President arrives, accompanied by the press corps. Conscious of his media image and the photo opportunity provided by the delivery of the apology, he dons an expression of deeply felt remorse to the awaiting photographers and journalists before moving off, smiling and saluting the crowds.

Reflections

Intrigued by the scepticism evident in these images, we decided to give the same apologies to another group of students who had not taken part in the drama. These students were simply asked to create an image that would represent the apology on their card. The images are striking for their lack of cynicism. One group depicted a central figure delivering an apology behind a block, with others either side on their knees, while another group pictured the person delivering the apology, accompanied by others with their heads bowed. The first explained their kneeling as 'an expression of shame', while the second explained their bowed heads as 'looking down with guilt'. The difference between the images of apology created by those who had and those who had not experienced the drama suggests that the dramatic fiction sensitized them to the problematic nature of political apologies and generated a more critical approach.

As drama practitioners, we are aware that students bring their experiences, mediated by different cultural identities, to the fictions. It was quite extraordinary to discover after the drama that two students had interpreted the unfolding drama as specifically about their distinctly different experiences: in one case, about black–white relations, in the other case about the persecution of the Jews. The first spoke of the shame she had felt for being white when she had lived in Swaziland four years earlier. All aspects of the drama, for this student, contributed to her interpretation. The second spoke of her surprise when the 'real' apologies were handed out at the end, because she had perceived the drama as concerned with

forgiveness for the wiping out of her husband's (Jewish) family during the Second World War. The name 'Bagel' supported her meaning-making. When the name 'Yetta' emerged, which is also familiar to her as a Jewish name, she built this into her interpretation. This name, she surmised, was used to ensure that the Yetta were not viewed simply as the 'enemy'. We are left wondering how many other dramas were being played out.

The drama explores the motives, meanings and consequences of political apologies. It homes in on the fictional world of the Bagels and Yetta to do this and in the process expands our understanding of a new phenomenon. What it does not address, however, is the question of why such apologies have become so prevalent in the 1990s. In moving from our fictional world and turning to this question, more conventional teaching methods, such as a seminar, are appropriate. It is worth encouraging students to engage in speculation, however. For the sociological imagination involves speculating, even if at the end of the day our imaginings need to be critically interrogated in terms of their internal coherence and correspondence with the facts. Engaging here in our own speculation, five features of the late twentieth century predispose governments to consider apologizing for the actions of their predecessors.

The advent of a new century – indeed, a new millennium – has encouraged further reflection on the past. For many commentators, this has been a sobering experience. One depicts the twentieth century as 'the most unstable, dangerous and degrading phase of human history' characterized by 'genocidal wars, fire-bombed cities, nuclear explosions, concentration camps, orgies of private blood-letting. Should we not feel ashamed of what we have done to each other during this long century of violence?' (Keane 1996: 185).

The nineteenth-century faith in progress has disintegrated in the wake of our long century of violence. The Enlightenment project has consequently been re-evaluated and modernity itself seen as the root of our plight. In this context, few governments are able to view their past as unblemished. Atrocities characterize all histories and most liberal democratic regimes are no longer able to pretend otherwise. It is a short step from such an acknowledgement to the emotional response of shame and, given particular circumstances, the possibility of apology.

Globalization is one of the defining features of the late twentieth century, for our lives are increasingly, and remarkably quickly, influenced by distant events. The result is that 'we have to learn to cope with an overwhelming sense of compression of our spatial and temporal worlds' (Harvey, 1990: 240). It is no longer possible in the 'global village' to ignore different cultures and, as the voices from the margins refuse to remain silent, to maintain that modernity is an unmixed blessing.

Established identities are unsettled (Ackroyd and Pilkington 1997) and, although there are attempts to shore these up by pretending that they have remained sturdy and virtuous since time immemorial, their constructed – and therefore malleable – nature becomes more evident. The coexistence of competing accounts of the past challenges attempts to construct a progressive history and increases the likelihood that we shall acknowledge old atrocities, feel some shame about them and be more inclined to apologize for them. Once some regimes do this, the likelihood of others following suit becomes, given globalization, more probable.

To acknowledge past atrocities is one thing; to apologize for them is quite another. What predisposes governments to move from one to the other is a recognition that some groups in the 'global village' have ancient grievances and that these grievances challenge the legitimacy of liberal democracy. The authority of liberal democratic regimes depends on their espousal of certain values and their recognition of citizenship rights. When it is manifest that governments have not adhered to these values and ignored people's rights, a crisis of hegemony ensues. One way of seeking to restore legitimacy is to apologize for past atrocities. We were wrong to sterilize the mentally disabled, but we have learned the errors of our ways and of course no longer flout people's rights in this way.

Clearly, governments have a vested interest in claiming that barbarism is a thing of the past and that the system has since been reformed. In the case of Sweden's compulsory sterilization policy, this is indeed the case. Whether the same can be said of all regimes which have apologized for medical experiments on people is another matter. Certainly, the discovery that some companies are testing drugs on AIDS sufferers in Africa suggests otherwise.

When we have sinned, we have traditionally sought atonement. Such a discourse, however, is now less prevalent in an increasingly secular world. A new discourse, which in many ways is functionally equivalent, has taken its place – a therapeutic discourse in which we are enjoined to take responsibility for our actions through exorcising old demons and starting afresh. This phenomenon is evident in the decisions of governments to apologize for past misdeeds. Renewal demands that we take responsibility for our actions and put the past behind us.

The search for a new way may be motivated by a genuine concern to put right past mistakes. Alternatively, it may be a marketing strategy, a form of repackaging where nothing substantial has changed. We live in a world where media images bombard us on all sides. According to Baudrillard (1994), these images are so pervasive that we increasingly find it difficult to distinguish representation and reality. We don't have to go as far as this to recognize that images may masquerade as realities. Just as 'Watergate' was in Baudrillard's view reported as a scandal to conceal the fact that political corruption is rife, political apologies may

be represented as a substantial achievement when in reality they are merely symbolic gestures and substitutes for real action.

Acknowledgement

This chapter was originally published as Article 1 in Volume 1 (2000).

REFERENCES

Ackroyd, J. and Pilkington, A. (1997), 'New dramas for new identities', *Multicultural Teaching*, 16:1, pp. 26–30.

Baudrillard, J. (1994), *Simulacra and Simulation*, trans. S. Faria Glaser, Ann Arbor, MI: University of Michigan Press.

Boal, A. (1993), *Theatre of the Oppressed*, London: Theatre Communications Group.

Bolton, G. (1979), *Towards a Theory of Drama in Education*, London: Longman.

Goldsmith, O. (1967), *She Stoops to Conquer*, London: Macmillan.

Harvey, D. (1990), *The Condition of Postmodernity: An Enquiry into the Origins of Cultural Change*, Cambridge, MA: Harvard University Press.

Holman, D. (1982), *Peacemaker*, no publisher.

Hornbrook, D. (1998), *Education and Dramatic Art*, 2nd ed., London: Routledge.

Ibsen, H. (1988), *Ibsen Plays: Two*, trans. M. Meyer, London: Methuen.

Keane, J. (1996), *Reflections on Violence*, London: Verso.

Morgan, N. and Saxton, J. (1987), *Teaching Drama*, Cheltenham: Stanley Thornes.

O'Toole, J. (1992), *The Process of Drama: Negotiating Art and Meaning*, London: Routledge.

Plotkin, J. (1997), *Applied Theatre: A Journey* – Applied Interactive Theatre Guide, Applied Theatre Homepage.

Richie, D. (1999) 'How Hamlet and Lear got along with the sumo and the samurai', *The Times Higher Education Supplement*, 13 August.

Roehampton Institute (1999), *Prospects Postgraduate Directory*.

Schechner, R. (1994), *Performance Theory*, London: Routledge.

Taylor, P. (ed) (1996), *Researching Drama and Arts Education*, London: Falmer Press.

Wagner, B.-J. (1979), *Drama as a Learning Medium*, London: Routledge.

Wittgenstein, L. (2001 [1953]), *Philosophical Investigations*, Oxford: Blackwell.

6

Applied theatre and the power play: An international viewpoint

Bjørn Rasmussen

Let me congratulate Griffith University and its excellent theatre staff for launching a Centre for Applied Theatre Education and Research. Although my experience is placed in the Northern Hemisphere, the centre's visions and tasks seem familiar to me. After trying to achieve a similar idea of the field in Scandinavia, it gives great inspiration to find those ideas materialized on the other side of the globe. The varied and worldwide practices of cultural and educational drama and theatre deserve to centre themselves and settle as an area of worthwhile academic investigation and training. The new centre in Brisbane is a significant international effort, and will be recognized by many educators, artists and researchers around the world.

Shaping identity from context

A new academic centre does not invent new practices, but it does tell the world that we have reached the time for a united approach towards an increasing range of cultural dramatic practices with certain family resemblances (Ackroyd 2000). From my experience with influential and protective European institutions such as art, education and science, I will argue that those institutions and their community members still tend to favour their own distinctiveness. Any phenomena in play, drama or theatre that is seen as seemingly blurred, betwixt and between or crossover are regarded with suspicion. The best continental efforts seem to be to pursue a dialogue between their fixed counterparts in education, art and science. However, the interest in dialogue, in investigating resemblance, community and differences, the wish to centre the dramatic/theatrical phenomena as such, all these require an identity or a classification on a higher logical level.

The field we have identified seems to consist of a large number of different dramatic-aesthetic practices, some absolutely vital with a significant cultural status, others with lesser, even suppressed, status. Apart from the common aesthetic of theatricality, as found in all autonomous and significant theatre art, the common denominator for applied theatre seems to be a heavy concern with specific cultural contexts. These applied forms tend to exist at the fringe of or totally outside the institution of acknowledged art. If we can speak of a not-applied theatre (bearing in mind that we have yet to invent a new binary set) the not-applied theatre must be the autonomous high-status art form. Only this may explain the considerable non-essential, marginal experience felt by workers in the field of applied theatre in western societies – an experience that they also turn around and explain as a position of freedom and power.[1]

Any theatre artist with aesthetic intentions and a wish to communicate with their audience might be annoyed or threatened by this new binary construction. Indeed, the aesthetic autonomy, the intentions, the interaction, even the spontaneity are present in any good drama or theatre, applied or not. The important differences, I believe, are related to what extent the practice relates to the autonomy of the societal art Institution, and to what extent the cultural contexts change the aesthetic approaches. At one end of the continuum, you have dramatic applications that are context-related to such an extent that they have lost their aesthetic power and autonomy. At the other end, you find the high-status theatre art where autonomy is misunderstood to mean social detachment, contextual insensibility, elitism, protection of the canon and the profession – a play of power.

The desire to facilitate drama and theatre as a powerful medium, effecting changes for the attendees, is a family resemblance recognized and shared by those exercising the practice of applied theatre. Moreover, a typical desire for positive changes recalls a vital, still modern and educational project. No one wishes to question the power of theatre, but we need to question whether the practice of theatre is by nature only 'good'. If we believe in human and cultural changes as a sound dynamic principle, we should also think that the play medium is beyond good or bad. The outcomes are either good or bad according to values external to the aesthetic process. Even a profound and affective learning experience can be experienced as 'bad' or troublesome to children not familiar with learning paradigms other than cognitive absorption and consumption of factual information.

However, these 'changes' could not occur without a deliberate consideration of and application to the specific context. This consideration differs from the artist's intention, which inevitably is just one part of every aesthetic process. All the many and interactive intentions and conditions have to be taken into consideration. Unlike some orthodox theatre, which is focused on itself, applied practices all have in common that they must attend to specific cultural contexts and

contextual criteria. This 'empathic' attention guides the way they apply different and context-specific competencies and processes. Ideally, the contexts shape the practice into powerful aesthetic procedures. Of course we know, for instance from the history of role-playing methods in education, that a contextual adaptation process will eventually lead to a loss of aesthetic craft and power. A dedicated focus on the dramatic practice, and not just its context (for instance 'in education'), is an important way also to keep the aesthetic as the core dimension.

If we could see applied drama and theatre as applications of theatre *in* cultural contexts, rather than just inferior applications 'from' pure theatre, we should see not one or three 'methods', but hundreds of distinctive approaches emerging from a number of sets of complex contexts. These include the leader's and the participants' life and professional experience, including their age, the time, the cultural and political settings, connected events, the nature of the text or the programme, the curriculum and so forth. When we see traditions arise such as 'process drama' or 'TIE', it is because the practice has successfully been tried out and applied to stable and well-known contexts such as the western classroom and the established link between theatre groups and schools. As I believe some methods are developed from *theatre art*, a number of methodical approaches in the field of applied theatre are also developed from *play culture*. Furthermore, still arguing against debilitating notion of 'applied from theatre', I believe that dramaturgy is a dynamic concept in the applied field, always structured and restructured following different and new contexts. This is quite unlike the well-known retroactive effort of devising and analysing all theatre practices according to one or four models of acknowledged theatre dramaturgy.

I have already mentioned the dimension of spontaneity as a vital part of living theatre. In the field of applied theatre, I think spontaneity in the form of improvisation has progressed into demanding to be included in applied theatre's list of kinship qualities. I cannot think of any applied and context-interactive drama or theatre approaches not relying on spontaneous processes to an important extent.

Evidently, if your work is intentionally context-related and interactive, a totally fixed, pre-planned production would wreck your intentions and never reveal other perspectives than those pre-planned before the event. Spontaneity works contradictorily to any theatre form that is shaped either just by its context or by artistic canons. The elusiveness of the practice of applied theatre is one reason, I believe, why academia finds it hard to identify and acknowledge the field as such. Furthermore, a research centre investigating a dynamic culture such as applied theatre should be aware when the research itself, laying down its own determined labels, structures and concepts, actually works against the spontaneous and processual nature of the field itself, thereby impeding the spontaneous cultural practice.

The power play

This comprises identity, property, institutions, hierarchies, class, power and protection. These are interconnected concepts strongly present in the drama and theatre that is part of western culture.

As a drama teacher and scholar, struggling for new educational and academic paradigms, balancing innovation and tradition, trying to frame a concept of cultural dramatics, I have found myself partaking in an exhausting power play. The effort to gain academic and professional interest and status for the applied field has been both necessary and draining, since the cultural prejudices, preconceptions and institutional thinking are still strong in my region of the world. The lack of any cultural notion of an applied aesthetic field causes almost daily unfortunate tensions and exercises. For instance, when school authorities arrange further education courses for teachers in the new arts curriculum (after 1994), they are likely to hire renowned actors and dramatists, regrettably often with a slack educational attitude, no competence in dealing with teenagers and with their principal interest and efforts concentrated on passing on what are inapplicable canons and on protecting the image of a detached high-status artist. This attitude seems to be an attractive ideal for young students already bored to death within their educational context. Or, when some drama teachers would like to apply or 'borrow' new drama conventions from contemporary performance art, they are also likely to face artists who express almost aggressive opposition to any concept of education (Krøgholt 1999). Of course, artists also apply work from play leaders, drama teachers and drama therapists, but this is less frequently observed.

I remember I used the notion of 'applied theatre science' in the mid-1980s, when I was trying to explain and justify the perhaps unaccountable entry of drama education into an established academic tradition of European theatre science. At that time, we had a new department at the university called 'Anvendt Språkvitenskap' (Applied Language Science) and I thought the parallel was appropriate. However, I never found the expression 'applied' drama or theatre quite sound, because I always found it somewhat derogatory, implying that the applied stuff is second best, not quite as genuine as the 'pure' essence that it is being applied from. I thought the concept of 'applied' amplified a low status position in the power play already practised by art and science.

In June 1999, the first Nordic conference, surprisingly called 'Applied Drama', was held in Helsinki. 'Applied drama' is an odd concept, inasmuch as 'drama' in our region already is established as the applied term, whereas theatre is never applied theatre – just theatre, of course. The conference was arranged by the Nordic Association for Theatre, an organization serving the interests of amateur and professional actors and directors. This network is not yet associated with the

IDEA (International Drama/Theatre and Education Association) movement, nor with the field of drama education in our region. However, the conference must be seen as a new interest being invested in the life and market outside the theatre houses, and a sincere wish to develop better competence in working in vocational and community settings. Of course, a changing theatre market and resulting funding conditions are part of the crucial sub-text of this new interest. Still, we are finding a substantial interest among theatres in approaching people where they live and work, an interest inherited from a strong group theatre movement in the Nordic countries.

I cannot avoid reading conferences like that – as well as this launch of a new Centre for Applied Theatre Research – as strategies to gain attention, recognition, status and power. If my reading is accurate, I am still not quite happy with the notion of 'applied' drama or theatre. While the effort to centre these practices is important and plausible, the label still seems, at least in my language, to have the smell of the underdog. So, if we are supporters of applied theatre research, what do we need to be aware of?

First of all, if we have the freedom to operate in the margins, I believe we are able to play with those cultural hierarchies and turn them upside down. It is possible to read Western European cultural history as a power play in general, power as installed in an belief system inherited from the Greek class culture, infecting all dimensions of society: politics, education and arts. A short article such as this is not the place to explore how deconstructionists such as Derrida and Girard argue how Plato and Aristotle use mimesis and dramaturgy as tools for social power and hierarchies. My approach here will be to recall a few hierarchical assumptions we may all have experienced, and see what happens if we toss them around. In order to provide dramatic tension, forgive me for exaggerating these assumptions:

1. In the cultural hierarchy we experience, we know that drama education, as applied theatre, is applied from theatre art. It means we worship the actors and directors and are grateful that outsiders can borrow or apply their canons and craft. It is useful to have some tricks in the bag in education, therapy or other non-artistic work. You never know, drama teaching can be also useful to the artist, something the artist may fall back on in their retirement.
2. Theatre as proper art is more authentic, more true, than applied educational drama. Therefore, funding authorities tend to spend their money on projects recognizable as 'art', rather than 'blurred' and lower applications of artistic activity. The case of TIE is outstanding as an example in Norway.
3. However, art is also to be contained within other hierarchies. Art is a lower application of nature, which means that empirical nature, as we know from

Aristotle and western societies is above art in terms of truth and significance. We recall here Plato's notion of bad mimesis, leaving actors with low cultural status for centuries. Today, as academics, we still experience the difference in power and funding between the humanities and the natural sciences. In my university of 'science and technology', the arts are permitted according to a specific understanding of the relationship between art and technology, which classifies art merely as enjoyable artefacts, a form of cultural capital serving a bourgeois philosophy, like flower-trimmings on the technological dinner table. The presence of theatre is here more important than research in theatre.

4. Furthermore, nature itself is not at the top of the hierarchy – someone has to be responsible for nature, keeping the world in order. Therefore, God and religion are the ultimate rulers, interpreting those ideas that are beyond the unreliability of nature. If anything goes wrong, here is where we always find the real truth.

Now, if we reverse the positions, religion (4) could be placed lowest in this hierarchy, as just one example of those important human mental creations that are developed from the specific nature of human beings for the benefit of making sense of life. If we follow Nietzsche's philosophy, this would not be a shocking perspective. And furthermore, humans as natural beings (3) stand above religion. God does not create human beings; humans create a belief saying nature was created by God. To follow this reverse hierarchy, above nature stands mimesis and art (2). Art is more essential, more truthful than nature, because the way we understand nature is applied from what artworks tell us. Nature is nothing that has not been comprehended by our senses, imaginations and emotions, as in the arts. We find this perspective for certain in the tradition of idealistic aesthetics. Art is more essential as a refined aesthetic culture, a truer reflection of human nature than nature alone can provide. We may also recall Plato's notion of 'good' mimesis, as the 'harmony' of dance and music.

We still have not classified the field of the applied theatre (1), which would be at the top position in this inverted model. Can we imagine the applied theatre field with that kind of cultural recognition? Well, again following the deconstructive path, the arts are applied from a spontaneous aesthetic culture. Beyond refined culture stands a basic, spontaneous play culture that was once understood as a highly significant, high-status and spiritual Dionysian practice of mimesis. Perhaps this is now emerging in such forms as 'participatory theatre', 'forum play' or 'drama in education', after being devalued and made safe for centuries in a western cultural belief system.

Of course, we may not need any more to act according to rigid hierarchies of thought and belief. We may act and think laterally, as I remember Jonothan

Neelands pointed out in his fine article 'Theatre Without Walls'. I am sure a Centre for Applied Theatre Research is a good place to think and act laterally – or, in power terms, horizontally – and thereby close the power play in the play culture. However, it is not easy to act horizontally in the field as long as vertical power plays are going on. We should not under-estimate how we all, in our acting and thinking, are infected by power plays and hierarchies, and we just need to be aware of how we deal with this cultural dimension as we welcome the founding of centres of applied theatre research.

Acknowledgement

This chapter was originally published as Article 2 in Volume 1 (2000).

NOTE

1. A point made by Janek Szatkowski in his keynote address at the IDEA Congress, Lisbon 1992.

REFERENCES

Ackroyd, J. (2000), 'Applied theatre: problems and possibilities', *Applied Theatre Researcher*, 1, Article 1.

Krøgholt, I. (1999), 'Dramapædagogik og performanceteater', Ph.D. thesis, Århus: Institut for Dramaturgi, Århus Universitet.

7

Conversations with the devil

Tim Prentki

This chapter investigates the possibilities offered by Theatre for Development (TfD) for opening dialogues both within communities – formal and informal – and between communities and the wider worlds in which they are situated. The core principles of TfD are participation, democracy and sustainability. TfD ideally operates as a form of dialogical communication – a means of advocacy for those whose voices are typically unheard or dismissed, and a forum for collective, social analysis. We live in an age of global communication where information is available to us at previously undreamt-of speeds, in previously undreamt-of quantities, thanks to the technological advances of digital and satellite networks. However, despite the still largely embryonic possibilities of the internet, the nature of almost all of this communication is monological, not dialogical.

Consequently, we experience communication as passive, almost powerless consumers of information overload, unable to verify the truth according to our experience of the images and voices set before us. A very small group of people – mostly older white males residing in North America – determine what the world looks and sounds like for the rest of us. They tell us what democracy looks like; they put the epithet 'starving' in front of the noun 'African' and the adjective 'free' in front of the noun 'trade' to denote a system of rigged subsidies, which ensures their continuing wealth at the expense of the majority's poverty. They use all available communication resources to assure us that economic growth – *their* economic growth – is essential for the welfare of all in the face of the mounting contradiction between their belief in what they have labelled 'progress' and the capacity of the planet to survive this assault upon its non-renewable resources. One of the consequences of this information overload is a growing gap between the 'official' or 'authorized' world as presented through mass communications, and the world as experienced in the individual lives of ordinary people. This experience gap is

fertile ground for the alienation, dispossession and apathy that have manifested most recently in the suburbs of French cities. Passive citizenship may give political and business elites a comfortable ride for much of the journey, but eventually passivity becomes boredom, which becomes resentment, which in turn becomes violence that leads to direct action. The same media organizations that pay no attention to underlying social inequalities and contradictions within the dominant structures swarm like angry bees around the violent manifestations provoked by those causes. The 'other' becomes visible by deviating from the norms of 'decent' behaviour, like the bored or neglected child who knows from experience that acts of defiance are the surest way to claim the attention of teacher or parent.

The antidotes to this bleak social prescription are dialogue and ownership – key concepts in any process of active learning. But beware terminology, for the dominant is always quick to colonize the languages of resistance and separate the signifier from the signified via the relentless hegemonic seductions of its media. That which is called 'dialogue' more often than not is a conversation between the powerful and the powerless – be it a dialogue between the G8 nations and the majority world or a dialogue between teacher and child. Similarly, ownership can often amount to nothing more than getting someone else to accept your idea as their own. Businesses regularly employ consultants to come up with ways of getting the workforce to own the agendas of management. However, in TfD there can be no process without the community – individually and collectively – entering into a dialogue whose subject matter is determined by themselves. The starting point is the stories told about the experiences of living at a certain time, in a certain place with all members enjoying the right to tell their own stories. The specifics of context resist the universalizing tendencies of authority. Once stories have been told and listened to, the focus moves to the collective, theatrical process of devising and dramatizing into one agreed story which is felt to represent through a democratically expressed majority view, or speak for, the various individual stories previously articulated. In this way, the twin aims of dialogue and ownership are, at least partially, realized.

Origins of a Theatre for Development methodology

> The philosophers have only interpreted the world in various ways; the point is, to change it.
>
> <div align="right">(Marx 1977: 56)</div>

Bertolt Brecht stated that he took this statement by Karl Marx and applied it to the theatre. Thus, Brecht's notion of applied theatre is unequivocal: it is the application of his understanding of Marx to the processes of making theatre. Unsurprisingly,

Brecht – in both theory and practice – is the forerunner of what is practised today as TfD. For the production of several of his Lehrstücke, Brecht required the abolition of the distinction between performers and audience. Everyone present was to be engaged in the simultaneous process of learning and teaching, captured in the concept of 'Lehr'. These plays, referred to by Brecht (1971: 126) as his 'Major Pedagogy', are explorations of the contradictions to be encountered by the communist society that was anticipated for Germany prior to the 1933 elections. For example, *The Measures Taken* – where all those attending the performance take up a position in the Control Chorus – examines the dialectical relationship between the individual and the collective claims of the revolution. Without the passionate concern of the individual to combat injustice, there can be no revolutionary movement, yet if there is only an uncoordinated individual response, the revolution will fail and the cause of social justice must be set back (Brecht 1977: 34). Here Brecht is using a participatory process directed towards a confrontation with the contradictions that have to be faced if society is to progress towards greater equity. In essence, this is a TfD process, with the important exception that Brecht is operating as playwright and director rather than as the facilitator of a devised process. Even these distinctions are not absolute since, as playwright, he was sometimes obliged to rewrite in the face of the experience of his participants – as in the case of *He Who Says Yes* developing into *He Who Says No*. As the Chorus to *The Measures Taken* concludes, 'Taught only by reality, can reality be changed' (Brecht 1977: 34).

Grounded in the lived experience of its participants, TfD is a process that starts from reality – from the world as it is. The possibility of developing from that reality is the stuff of its processes: a dialectical relationship between reality and fiction; the theatrical 'as if'. In the same way, any transformative, educational experience has to begin with the reality that the learner brings to the encounter with new knowledge and altered understanding. When Brecht's own reality was irrevocably changed by the Nazi assumption of power in 1933, the nature and purpose of his plays changed in response. From this time onwards, he explored the contradictions both within the capitalist system – for example, *The Good Person of Szechwan* – and within Stalinism – for example, *The Caucasian Chalk Circle*, where one of the principal characters, Azdak, performs, within the tradition of European stage fools, the role of the Joker provoking the characters with whom he interacts to aspire towards a Golden Age, 'almost an age of justice'.

Because Brecht is associated so closely with Marxism, there has been a tendency to reduce his importance in contemporary, postmodernist theatre. He is frequently viewed as a modernist dinosaur, wrestling with grand narratives bypassed by the current preoccupations of globalization. Such a superficial view misses the essential point that Brecht's art is directed towards unpicking the contradictions in these narratives from the perspective of ordinary people's experience; for Brecht, the

personal is profoundly political. All meaningful political change emanates from the contradictions and discontents located within the psyche of individuals who are hungry for justice and the changes required to produce it. Nevertheless, Brecht's association with mainstream, formal theatre created by his years with the Berliner Ensemble meant that the possibilities of locating his dramaturgy within a grass-roots TfD context were severely reduced. Consequently, it required the emergence of practitioners operating in majority world contexts to reactivate Brecht's major pedagogy for contemporary applications.

Rather as Marx provides the ideological starting point for Brecht's theatrical practice, so Paulo Freire was the inspiration for the theatrical theory and practice of Augusto Boal, who acknowledges the debt in the title of the book that marks the formal beginnings of the TfD movement, *Theatre of the Oppressed* (Boal 1978), drawing directly upon Freire's own publication, *Pedagogy of the Oppressed* (1972). Boal's subsequent publications chart his journey through the various theatrical explorations that constitute his application of the principles of Freire's learner-centred pedagogy to a theatre process directed towards individual and collective social change. In particular, it is his model of forum theatre that has come to embody Freire's concept of 'naming the world' – the constant struggle between the powerful who seek to name the world for the rest of us in the interests of an unjust *status quo* and the resistance of the powerless who fight to claim the right to assert the validity of their own lived experience. So, the fiction offered by the once all-powerful actors, their 'named world', is now subject to the interventions of the 'spect-actors' who open the door onto the stage to let in an icy blast of their own reality. As for Brecht, so for the invading spect-actor: the stage fiction is only useful insofar as it offers developmental possibilities for changing the world, be that a micro- or a macro-level change.

The Cree nation

An example of using the personal story as a performed cultural intervention comes from a student project on the MA in Theatre and Media for Development at the University of Winchester in the United Kingdom.

Two students responded to an invitation from Darryl Wildcat, an activist on his home reservation, to undertake their fieldwork project with the Cree nation at Hobbema, on the wind-swept prairie south of Edmonton in Canada. The place took its name from a Dutch landscape painter of whose work it is reputed to be reminiscent. Thus is it mapped on to the cultural memory of the dominant, leaving the Indigenous inhabitants to survive in a world they have not named. Tourists heading south on highway 2A from Wetaskiwin to Ponoka pass through Hobbema

in about 30 seconds, scarcely aware that they are crossing the ancestral lands of four bands of Cree, lands floating on a sea of oil. Though the boom was past its peak by 1999, the legacy of cash in hand from the sale of leases to oil companies combined with the crisis of cultural identity was written in the high incidences of foetal alcohol syndrome, drug abuse, diabetes and teenage suicide. The recipe of consumption mixed with alienation, here as elsewhere, was producing deadly results. The colonized mind projected itself into poor self-esteem, which in turn transmitted itself into abuse of the body.

Among the specific initiatives with which the students engaged during this placement was a project with some of the young people attending the Alternate School, and spending time with some of the older people who were inmates of the hospital on the reservation. The small group of young people who regularly participated in the school were among those whose self-image had been severely distorted by the ravages of drug or domestic abuse brought on by the desolation of living with cash in their pockets, and without an image of who they were or whence they had come. For these young people, the notion of school conjures up cultural memories of the front line in the battle to empty their souls and douse their spirits with the cold learning of the white man's world.

The Alternate School was alternative in at least two important ways: it was as anti-authoritarian as was compatible with baselines of health and safety; and it sought to draw upon the students' knowledge and understanding of their own world, rather than displace these with an orthodox curriculum. The student facilitators worked on unlocking their innate creativity, which they then directed towards an identification with the school in the form of advertisements that they devised to encourage others to enrol for the coming Fall semester. The process was at times painfully slow, as the pupils tried to find and identify their authentic voices among the echoes, fragments and debris left to them by the invasive culture. But in most cases they were found, and with their discovery came confidence, self-assertion and the beginnings of an identity in harmony with the tattered remnants of their cultural memories. The highlight of the process was the visit to the community radio station where their advertisements were recorded for later transmission. From being voiceless beyond the margins of their already marginal society, these young people – at least for a few moments – became, quite literally, the voice of the community.

The MA students also spent considerable time with two women in their late fifties who were suffering from terminal illnesses and who had been more or less left to their own devices for their remaining period of their lives. As trust developed, conversations turned to stories of their traditional childhoods, brought up according to the rhythms of the hunter-gatherer way of life, following the paths of the Great Spirit. It soon became apparent that the stories and details these women

were sharing with the students were largely unknown to the generation of their own children due to the forced intervention of the residential schools that caused a fatal break in the transmission of culture between generations. The plight of the two women seemed increasingly like a metaphor for the position of Native American culture. Although the hospital was strategically located at the heart of the reservation, its patients were forgotten people whose store of knowledge, stories and myths was destined to die with them, leaving that particular reservation, the Cree nation and humanity in general all the poorer for having lost some of the means of creative, self-determined survival. Slowly, gradually, over the weeks, these women were persuaded to share the wealth of their understanding with the wider community through a performance. The combination of their infirmities and shyness ruled out conventional theatre, but a storytelling form using shadow puppets and narrative was devised with the support of the students, and this was augmented by musical accompaniment from a relative.

The performance took place inside the hospital one evening. The audience was composed of peers, the children's generation and the grandchildren's generation. The nature of the responses to the stories, which evoked a largely forgotten way of life, was markedly different from generation to generation. The narrators' own peers greeted the performance with a mixture of admiration for the bravery of the women, mixed with delight at sharing the recollections of times when their identity and sense of self had been so much more secure. Simple incidents such as fetching fresh water from the stream and falling off a pony became imbued not only with the joyful glow of nostalgia but also with the increasing confidence and sense of solidarity emanating from shared cultural memory. By contrast, their children – the so-called 'lost' generation of residential school victims – had difficulty relating to the event and appeared awkward and ill at ease with the ghostly echoes of a past that was not their own. The third generation, however, expressed great excitement and interest in the whole event, and many in the audience used that evening as the stimulus from which to open dialogues with their grandparents. These dialogues became, in effect, not only channels of communication but also channels of resistance through which the young people could assert their right to an identity not dependent upon the dominant culture. Perhaps for the first time, the notion of their place in the world – a world in which they had a right to exist – began to take shape as a creative and imagined reality.

The facilitators were able to work in that location because they approached this community in a spirit of dialogue, curiosity and humility – the qualities identified by Paulo Freire as essential prerequisites to learning. Here was an outside intervention not aimed at selling Nike trainers or Molson beer, but at releasing creativity for the benefit of the indigenous community. A counter-model of cultural intervention was used to assist in resisting the ravages of the dominant, neoliberal

model. A dialogue was made between the community which offered its context-specific knowledge and experience – in this case, of traditions and cultural forms on the verge of extinction – and the facilitators who gave their skills in communicating through performance languages (Prentki 2005).

Anhra Pradesh

Another example of the way in which the TfD process can move marginal or neglected voices into the heart of the community was provided by a Save the Children workshop conducted in 2000 in the town of Mahaboob Nagar in the south Indian state of Andhra Pradesh. The director of one of Save's local partners was in the group of facilitators and he had made arrangements prior to the workshop for us to work with a group of about 30 children drawn from two villages. A significant number of these were children whose mothers were Jogins. These are women who, as adolescent girls, are sent by their parents to be brides of the Mother of All. Consequently, they are not allowed to marry. In Andhra Pradesh and neighbouring states, this is an ancient practice by which parents who produce only girls can ensure that at least one is left at home to support them as they grow older. In other cases, children who are unmarriageable through disability or whose parents cannot provide sufficient dowry are also given to the temple. The practice has recently been outlawed throughout India and has certainly declined – though it is not extinct. Jogins have children as a result of liaisons with higher caste men who take them for a time as a supplement to their wives. They are not considered prostitutes, however, since they only ever have one partner at a time: a sort of marriage extension without rights. As our local facilitator ruefully pointed out, their untouchability (they are Dalits) does not extend to sexual relations. These children without fathers are thus at the very bottom of the social pecking order, the marginalized within the Dalit caste.

Initially, most of the stories were simple narratives, which often turned on an incident between the individual and the environment, particularly the danger of snakes. Gradually, however, topics involving human relations began to emerge together with an awareness of their place in society. The girls, in particular, were sensitive to the vulnerability of their position and, towards the end of the story-telling, began to address explicitly their situation as the offspring of Jogins. In at least two cases, this produced notable anguish and tears in the telling so that in our own daily evaluation session that evening we determined that the whole topic of Jogins was too sensitive to provide stories for the devising process. We were very torn between a feeling that we may have been side-stepping the major cultural issue for these children and a contrary feeling that we had no right to force an issue

beyond the emotional capacity of the children. I was particularly conscious that, as a result of our orientation, we had entered this community with a predisposition to explore the Jogin issue. Our decision to leave it to the children to determine their own agenda was proved spectacularly correct in ways we did not anticipate.

The following day, the children preceded us to the working area and were hard at work rehearsing a procession with music and singing when we arrived. It was quickly established that this was the temple ceremony of the Jogin initiation and, far from suppressing the topic, the children were overwhelmingly enthusiastic about showing us what such a ceremony comprised. As we watched intently, it was clear that several of the children were totally involved in the emotions of the moment and carried beyond themselves as they recreated an event which they had all witnessed for 'real'.

It was not entirely clear when the ritual had been completed, but we tried to guess, from the ebbing away of the energy, the most appropriate moment to call the group together and continue with the process. We had a short discussion, mostly confined to circumstantial details such as how many Jogins were in their community and when a dedication had last taken place. There was little point in pursuing any evaluation of the content of the ritual, since it spoke for itself in their performance. The emotions it generated among the children were also quite obvious, although hard to describe – a kind of anguished elation is about as close as I can manage. To me, it seemed to demonstrate how special, how beyond the reach of daily reality, were their mothers at this moment if at no other in their lives.

When the children discussed their stories from the previous day, each group selected the one they would recreate through the devising process. In some cases, this involved the amalgamation of elements from more than one. Once into this phase, the facilitators were more interventionist in matters of technique and communication, but still had to be circumspect with regard to the narrative. One story concerned the plight of a family whose Jogin mother falls sick. The responsibility for addressing the crisis falls upon the children, for there are no adults willing to involve themselves. Another was about the efforts of a family to save money so that the son could go to school – efforts that are thwarted on the first day of school when the teacher refuses to register the boy, who cannot give his father's name since legally he has no father. The third story concerned illegal discrimination against Jogins at a tea-stall, and their attempts to seek redress through corrupt local police. The accuracy and irony with which the police officers were depicted indicated all too clearly how familiar the children were with their behaviour. These three episodes formed the backbone of the performance, but their significance was greatly enhanced by the action of contradiction. It was decided – and, looking back, I cannot say for sure how the decision was reached, although of course I would like to suggest that it came from the children – that the performance should

begin with the dedication ritual the children had shown us. In any event, they were keen to do it again in front of their own village. So the special moment that sets Jogins apart from the rest of their community was set against scenes depicting the reality of their abuse and marginalization – a major contradiction with which to confront the audience, highlighted by the performance venue: the temple precinct.

As the light began to fail and men and women were returning from the fields, the children began to move through the village, beating their drums and announcing the performance. Gradually the audience assembled: important people on chairs; others sitting on the ground; others standing; beyond them some stood in the trailer and on the tractor parked alongside while others climbed a tree or stood on roofs. By the time the performance was fully underway, there were about 400 people in the audience and the acting area was severely shrunken. The audience was fully engaged by a combination of the subject-matter and the presence of hitherto largely disregarded children taking centre-stage. The confidence of the children swelled to match the occasion and for them this was a clear case of theatre *as* development.

The audience witnessed nothing it did not already know, but the effect of the performance, structured around blatant contradiction, was to begin a process that moved them from knowledge to understanding and, hopefully, on to action. Adults had begun to think about their behaviour; children had discovered through the fictions of representation a boldness, a daring through which to articulate their sense of injustice. One of the initial aims of the work was to create sustainable change by enabling the children to become facilitators in their own right, working with the children of their own villages. The local NGO has experienced the process and been active in it. It was frustrating not to stay longer, since social transformation is a long-haul process; however, sooner or later the communities and those who work with them on a daily basis have to move from development to self-development and, while outsiders can monitor, they also have to trust (Prentki 2003: 45–49).

Theatre for Development or theatre in education: Establishing a dialectical relationship

There is no intrinsic value or authority in a label, and it is not the intention of this chapter to propose a hierarchy of practices. Rather, this section is concerned with opening up possibilities that can emerge from recontextualizing some TfD practices within the bounds of the formal classroom. In so doing, theatre in education (TIE) does not suddenly metamorphose into TfD, but rather extends the possibilities of some of its existing practices – especially in the area of participation. Where the participants – usually children – have no choice about whether or not

they engage in the process, it is straining definitions to label such a practice TfD. However, the roles of children in setting the agendas for the work – in deciding, in short, what it is to be about – can be enhanced significantly by application of Freirean principles. I am not advocating any one model of practice here – for instance, a TIE team might engage with children as facilitators of their own stories from the start or offer the team's own theatrically devised story as a stimulus or gift to the class in order to initiate the children's creativity – but rather suggesting that whatever approach is adopted, it needs to connect with the lived experience of the children. The first phases of the encounter between theatre workers and children might properly be considered research into the *real* stories that children want to tell, as opposed to their reading of what the TIE company might regard as a *good* story. As with many practices in TfD, there is often a major contradiction between the radical and the domesticating tendencies of the process. In the contexts in which TIE companies usually have to work, the invitation to come into a school is frequently related to the relevance of their subject to the curriculum, which means that in order to secure work, the company is accepting that authority for naming the world resides with those who create the curriculum. In the United Kingdom today, as in many other countries, the curriculum designers are not even the increasingly deskilled teachers who have some sense of children's preoccupations from their daily contact with them, but rather government experts with little or no contact with children, who are responding to the perceived needs of politicians, business and other lobby groups.

In an attempt to elide rather than confront the contradiction, the TIE team becomes skilled in the arts of pseudo-participation, employing a range of seemingly child-centred ploys so that it appears to the children that they are participating upon their own terms rather than those of authority. They may get to tell the story, but whose story will it be? At best, they can be the tenants, not the owners, of the story building, filling out the details with their creativity and imagination while being guided to remain within the given structure or outline. Such a position accurately mirrors the condition of representative democracy that is the contemporary European and North American model. We are allowed to participate in the democratic process so long as we adhere to the outline shape of the agreed story. Provided we accept the starting premise that there is no alternative to the neoliberal model of economic and social development, any ideas or imaginative solutions we might offer to make it work more effectively ('For whom?' we might risk asking) or to reform its grosser manifestations are gratefully received as evidence of our free participation. As adults and children alike, we are positioned as passive consumers within a master narrative created elsewhere.

Even where a genuinely participatory, radical practice is achieved within a TIE process – usually the consequence of a dialogical relationship between a deviant

teacher and an innovative theatre company – the danger is that the experience becomes entirely disconnected from all other aspects of schooling. The children understand the process as time off from the normal, or real, business of education – which is, of course, the achievement of examination results as a precursor to obtaining the qualifications that are the gateway to employment. Once again, the contradiction between a notion of education to do with responding to the rights and needs of children and what Freire termed the 'banking' system of education has been elided, not confronted. Despite the best intentions of the company, and possibly the teacher as well, the whole process is embraced by the warm hug of the establishment as evidence of the humanity of the system. Notwithstanding the unremittingly hegemonic assault of the mass media upon the consciousness of all citizens, it is in the field of education that the values and precepts of the dominant are most cunningly enshrined. This is why such efforts are taken to ensure that teachers teach only what they are told to teach and, increasingly, told *how* to teach it, lest in the gap between form and content some random weed of the subversive imagination might spring up.

Educating children for a life in a world that is not theirs is, however, doomed in the long run. The components of the system are human: recalcitrant, disaffected and, until blunted by consumerist blandishments, yearning for a fairer world. As the present system fails more and more of its people, and increasingly the planet itself, so a different way of managing our affairs will have to be found. In the search for these other ways, education, in the proper sense of the concept, will have a key role to play in unlocking the creativity and imagination of young people so they can determine the agendas for change.

Think local, act global

TfD, either alone or in tandem with a learner-centred version of TIE, is no panacea for the alienation of young people across the globe, but it is one means of starting to address the widening gap between the 'official' world of authority and its incessant representations in every branch of the media, and the 'real' world of the daily experiences of so-called 'ordinary' people. Education, like culture, is about how we make meanings of our lives in relation to the worlds we inhabit and a theatre process that builds on reality to explore the possibilities of alternative ways of being and becoming is uniquely well situated to combine creativity with critique for young people seeking to take an active stake in the future. Children are not trainee adults in waiting but young people with their own rights, ideas and imaginations. They have their own views on what the world should be and what it can be. Education is the space where the encounter

takes place between their aspirations and the histories that shape the world. All too often, this encounter becomes a case of manipulating those aspirations to fit the existing structures of reality, rather than engaging learners and teachers (we are all both) in the debates that forge a dialectic between reality and aspiration. Only by reference to the actual lives that children experience can the monologue of neoliberalism's master narratives of free choice and unfettered consumption be challenged and ultimately replaced by more human-centred values.

The core element of Brecht's (1972) theatrical method, contradiction, is as relevant now as when he adapted the Marxist concept for his theatre. Throughout his career, he developed and refined a practice that enabled the theatre to confront its audiences with the major contradictions within the systems by which they lived. As the emphasis shifted from the epic to the dialectical theatre in the later years of his practice, both as playwright and director, so the locus for change in the societies that he depicted moved from the external to the internal, both in terms of the individual and of the social group. For example, in *The Good Person of Szechwan* it is not only Shen Te's need for her businesslike cousin Shui Ta that exposes the contradictions within her 'goodness', but also Shui Ta's need to reclaim Shen Te that highlights the limitations of his business practice when it is stripped of any philanthropic accessories (Brecht 1966). Such is the overwhelming hegemonic pressure of what Louis Althusser (cited in Cain et al. 2001: 1477) called the Ideological State Apparatus, that humans twist and turn in every direction in increasingly futile attempts to accommodate themselves to the contradictions before finally facing up to them as a last resort. Thus, contradiction is the motor of social change. Those who exert control at both micro levels (such as the patriarch in a traditional family) and at the macro level (such as the CEO of a transnational corporation) call upon all the resources of human ingenuity to persuade the rest that the present state of affairs is both normal and unchangeable. This is why Brecht (1972) placed the notion of *Verfremdung* at the heart of his dramaturgy. The defamiliarizing of all that is taken for granted, of common sense, is the precondition for social change. It is the recognition that most of what is taken to be natural is actually human-made, and can therefore be unmade and remade by people, that constitutes the 'development' in Theatre for Development. Where Brecht has *Verfremdung*, Freire (1976) introduces the notion of 'codification' to describe the process whereby reality is represented in such a way that it is perceived as capable of being changed by the actions of people.

Today, the major contradiction facing human societies across the globe is that between the neoliberal economic model, predicated upon the notion of continuous economic growth and requiring, in Noam Chomsky's (1999) famous phrase, 'profit over people' and the model implied by the Universal Declaration of Human Rights and the United Nations Convention on the Rights of the Child that places people

before profit. Currently we are still in a phase like that depicted in *The Good Woman of Szechwan*, where the contradiction is being elided rather than confronted. However, the environmental factor by which our present way of life will guarantee our extinction as a species is likely to bring this phase to an abrupt end in the interests of survival. The rights to freedom of expression and to freedom of choice in choosing the means of expression enshrined in Articles 12, 13 and 15 of the CRC mean that young people are entitled to the practices of TfD and TIE. Our governments (provided you are not a US citizen) have signed up to these processes and should be held accountable by young people and their teachers and parents where these rights are being withheld. A school curriculum that denies children the opportunity to practise active citizenship is illegal since European Union human rights legislation, the conduit for securing the enactment of the CRC for countries within the European Union, overrules any national laws regarding the setting of that curriculum. Perhaps the exposure of this contradiction can offer a subject for the first phase of implementing a pan-European TfD/TIE project: 'Social Transformation Through Young People as Active Citizens'. At the very least, such an approach might constitute a starting point for opening up a conversation with the devil.

Acknowledgement

This chapter was originally published as Article 1 in Volume 7 (2006).

REFERENCES

Boal, A. (1978), *Theatre of the Oppressed*, London: Pluto Press.

Brecht, B. (1966), *Parables for the Theatre*, trans. Eric Bentley, Harmondsworth: Penguin.

Brecht, B. (1971), 'Die Grosse und die Kleine Pädogogik', *Alternative*, 78/79, pp. 121–24.

Brecht, B. (1972), *Brecht on Theatre*, ed. John Willett, London: Methuen.

Brecht, B. (1977), *The Measures Taken and Other Lehrstücke*, London: Eyre Methuen.

Cain, W., Finke, L., Johnson, B., McGowan, J. and Williams, J. (eds) (2001), *The Norton Anthology of Theory and Criticism*, New York: W.W. Norton.

Chomsky, N. (1999), *Profit Over People*, New York: Seven Stories Press.

Freire, P. (1972), *Pedagogy of the Oppressed*, Harmondsworth: Penguin.

Freire, P. (1976), *Education: The Practice of Freedom*, London: Writers & Readers.

Marx, K. (1977), *Selected Writings*, ed. David McLellan, Oxford: Oxford University Press.

Prentki, T. (2003), 'Save the children? – change the world', *Research in Drama Education*, 8:1, pp. 39–53.

Prentki, T. (2005), 'Surviving the monoculture', in R. Chaturvedi and B. Singleton (eds), *Ethnicity & Identity*, Jaipur: Rawat Publications, n.p.

8

Applied theatre:
An exclusionary discourse?

Judith Ackroyd

Context

Earlier this year, while writing a paper on drama in training for diabetes counsellors for the 2007 International Drama in Education Association Congress in Hong Kong, I became aware that I was deliberately avoiding the term 'applied theatre' and referred instead to drama in education practices outside the classroom. In writing this chapter, I have been trying to understand what that reluctance was about.

Asked to give a keynote at the 'Applied Theatre: Engagement and Transformation' conference at Sydney University in October 2007, I was invited to revisit the article I wrote seven years ago (Ackroyd 2000, and see Chapter 5 in this volume). The original was the launch address at the opening of the Centre for Applied Theatre Research at Griffith University, Brisbane. It appeared in the first edition of the centre's journal, the *Applied Theatre Researcher*. It has been quite a strange experience in terms of looking back and realizing what a lot has been written since then. My first words in that article are: 'The term applied theatre is relatively new.' In just seven years, however, the term has become common parlance — even beyond the academy.

The second part of the article comprised the description and analysis of a drama. The other reason it has felt strange revisiting the article is because I had coincidentally just been using that very drama. It was constructed from a drama devised by Northamptonshire teachers 22 years ago. I revisited that drama at the end of the 1990s, working with sociologist Andrew Pilkington to create a piece that explored political apologies. We presented a demonstration paper on the work at the Cecily O'Neill-directed University College Cork conference, 'Texts: Transformations' in 1998. That is a long time ago. However, this summer we had been

asked to deliver workshops on this project at two sociology conferences. Hence, while revisiting the article, I have also been revisiting the drama through practice. After all that time, it was a very strange coincidence indeed.

Purpose

In this article, I wish to suggest that applied theatre has created its own discourse to articulate itself and now masquerades as something neutral and democratic. Yet it emerges as a restricted, even exclusive, theatre form. Given this new discourse, I am left wondering whether the drama I included in my original article would even be conceived as applied theatre now. It is interesting to reflect now on how my musings seven years ago describe something dramatically more modest in its claims than the psychological and community healings that frame the dominant current literature.

That article considered the difficulty of determining the parameters of the field of applied theatre since so many drama activities and theatre models might be categorized as applied theatre. Using examples of well-known play texts and performances, I offered a continuum rather than a categorical distinction between theatre and applied theatre. Identifying intentionality as common in the activities, I drew a grid comprising two axes measuring transformation and participation. Activities understood as applied theatre fell into the quadrant high in both of these. Finally, though welcoming the term, I noted the overwhelmingly positive descriptions of the work on the web and in conference papers, and I called for vigilance, since a powerful medium can be used for dubious as well as humanitarian ends. I should add that since then there has been the helpful addition of 'location' in defining the practice, identifying applied theatre as 'beyond theatre' (Thompson 2003) and 'beyond conventional theatres' (O'Toole 2007), not taking place in traditional theatre settings. The terms 'specific audiences' and 'specific location' have hence contributed to the depiction of the work.

In this chapter I consider three things:

1. why the term was introduced;
2. whether we need it, and;
3. what is happening to it.

Why was the term introduced?

Let me consider 'applied theatre'.
Applied.

Applied maths.

Pure maths.

Pure: no impurities maths; no watered-down maths; no compounds maths … just pure. So what are the implications of applied maths? Impure maths; containing impurities maths; watered down; compounds; not pure. Advertisers use 'pure' as the epitome of what we should want in food, fabrics and even air.

Applied research. *Pure* research. In the United Kingdom, with the scramble for research funding in the higher education sector, there seems to be an implicit expectation that old universities do pure research and new universities do applied research. Clearly, there is a hierarchy in the two types of university, and hence the privileging of pure is clear. All this supports Rasmussen's (2000) concern with the word 'applied' in his article in that first edition of the *Applied Theatre Researcher.* He explains, 'I have always found it [the term] somewhat downgrading, implying that the applied stuff is second best, not quite as genuine as the essence …' Interestingly, there has been an attempt to reclaim the term in a more positive light by identifying a usefulness apparent in applied maths and equating this with applied theatre.

Nicholson (2005: 6) argues that applied maths 'is concerned with using theoretical models to solve practical problems'. She adds that, 'Most practitioners working in applied drama are motivated by individual or social change and there is, therefore, a similar interest in the effects and usefulness of the work.' But this relies upon a shared understanding that all applied work is for a public good. I daresay mathematics was applied for the construction of Barnes Wallis's bouncing bomb, and indeed for the design of gas chambers. But because it is 'applied', and some theatre practitioners have 'sound' intentions, that doesn't mean 'applied' itself becomes a virtue or should be elevated in the hierarchy.

Given the seemingly reductive associations of the term, why has it been adopted? Many reiterate that the term 'applied theatre' is new, but that it has been taken up by many drama educators (Neelands 2007; Nicholson 2005). Drama education conferences, such as those delivered by the International Drama in Education Association (IDEA) and the International Drama in Education Research Institute, now include work beyond the classroom, though they did not when such events were first conceived. It is also the case with the journal *Research in Drama Education.* A journal with this title is full of articles using the term 'applied theatre'. Perhaps there is an assumed status distinction between drama in education and applied theatre. The latter, with its sweep of different contexts, does appear somewhat grander. It also contains that magic word 'theatre', which is what drama educators fought for. Given that long struggle to successfully argue the case for educational drama practice to be conceived of as theatre, it seems somewhat ironic that drama in education should so quickly be stripped of that status by the addition

of the word 'applied'. But I imagine the change was not motivated by a consideration of drama education, as I will explore below.

What else beyond status hierarchies could have initiated the change? Were we slightly bored by the limits of the field in which we worked and just wanted to diversify a wee bit? Is the attraction that applied theatre offers us a greater range of activity to engage with? Was it that the dramatic opportunities were so incredible that, knowing the impact they could have beyond the classroom, we had to spread the word and practice?

Perhaps it is more to do with the context of the time. There is now an established generation of academic practitioners from drama in education who work in the higher education sector, a context that barely existed when I was a young teacher. Doctorates in the drama in education field were barely known then. This new generation is creating careers. Some of us have shifted from education departments to theatre/performance arts departments, where 'applied theatre' might have more relevance than drama in education.

Let us look further at this higher education context in relation to the growth of the term 'applied theatre'. Applied offers a more utilitarian concept, as we have seen in maths and research. Hence this new term brings some alignment with the recent moves in higher education. There is less of a focus on learning for its own sake and more attention given to higher education's role in developing national competitiveness in a global age. Higher education requires preparation for life and skills that will contribute to the job market and engender economic growth. This more mechanistic agenda welcomes an applied theatre model.

Perhaps the change reflected a heightened sensitivity to the current trends in higher education and adapting to what is required – and, of course, implicitly what is therefore likely to be funded. Neelands (2007) argues that the UK New Labour agenda [under Tony Blair] for social regeneration, social inclusion, and participation and rehabilitation has created a labour market for applied theatre artists. Hence the broader category of applied theatre gives opportunities that drama in education practitioners may not be offered. As all universities demand academics to tap into new funding streams, academics will find that they have access to more options working beyond the classroom. I note that most of the projects cited by Taylor (2003) are funded projects – often by government offices (2003: xix). I have not seen much regular funding for drama in education projects.

Of course, the problem of funding involves the need to quantify outcomes. An edition of *Research in Drama Education* (RIDE) in 2006 is dedicated to the matter. Here too, we fall into almost mechanistic – or at least reductive – practices, since funders want to know how many people are benefiting and need to have evidence for that benefit. They are more interested in the number of participants who went on to apply for jobs or upskilling programmes rather than how many

felt touched by the drama encounter. There is a rhetoric of transformation in the new discourse of applied theatre, but applications for funding with proposed outcomes may be perceived as reductive. By stepping into applied, we are more vulnerable to demands for outcomes. The funding comes with the promise of change.

There is another driver welcoming the applied, outcome-focused, more utilitarian agendas: student recruitment. New courses bring with them new students and new income. Louise Keyworth (2002) is building on the growth of courses in applied theatre, carrying out a funded project to develop teaching resources for use in specialist applied theatre courses in the university. Many members of government, and indeed parents, will prefer the idea of young people rejecting a seemingly somewhat indulgent drama course if they can instead take up an applied theatre course that leads to specific training for employment and that has a point beyond the study itself. Perhaps applied theatre is helping recruitment figures too.

It seems that moving beyond the school context is a very good move for many different reasons.

Do we need the term?

I am focusing strongly on a drama in education and applied theatre connection, as though there may not have been other foundations for the work. Of course, people working in theatre in education or community theatre may not have started with school-based careers. However, such people do not often refer to their work as 'applied theatre'. They call it 'theatre in education' or 'community theatre'. My focus on the progression from drama in education is reasonable, since many who write on applied theatre – such as Nicholson, O'Toole, Taylor and many more – are from educational backgrounds.

While there is recognition of 'many precursors and prototypes' (O'Toole 2007), there is an increasing tendency to locate the origins of applied theatre in particular radical or avant-garde movements. It has been identified by Nicholson (2005: 6) as having 'roots in the libertarian practices of twentieth-century drama education, community theatre and alternative or political theatres'. Neelands (2007) writes of the antecedents of applied theatre being 'in the legacies of the 19th and 20th century Euro-American avant-garde movements in particular'.

Ukaegbu's (2004) work suggests that this may be a limited view, however, and that – rather than being relatively new – applied theatre forms are as ancient as theatre itself. He traces what might now be called applied theatre back to the earliest African performance rituals (2004: 45–54), seeing much of what is applied theatre practices as 'later spin-offs' (2004: 52). He explains that:

irrespective of cultural differences, traditional performances everywhere are 'applied', for history informs us that while ancient Greeks 'applied' Dionysian performances to strengthen community bonds, the early European Church used them to transform adherents' overall religious and cultural experiences.

(2004: 53)

Ukaegbu argues that what is being described as applied theatre has been going for a very long time – but it wasn't, of course, called 'applied theatre'. It was called 'theatre' or 'performance'. He explains (2004: 53) that, 'Traditional African performances straddle sacred-secular boundaries but by commanding some form of investment in efficacious outcome, most performances can serve ritual and aesthetic functions simultaneously.' He seems to be slightly bemused by the new discourse of applied theatre and its discussions of function and artistry, and is perhaps suspicious of the neat new term: 'What is needed is not a new concept or definition but the re-introduction of production strategies and collective concerns that created the traditional performances that audiences attended as participants instead of as detached spectators' (2004: 53).

The traditional African practices about which Ukaegbu writes are simply termed 'theatre' or 'performance'. Although a social purpose is well understood, the practice is still seen as theatre because, as explained, the aesthetic and purpose are not extricated in these theatre forms. Why, then, should it be called 'applied'? It has intentionality and participant engagement, it takes place outside a specific theatre setting, but it has always been just 'performance'.

For centuries, art has been seen as cathartic, instrumental, instructive. At the Tate Modern in London last week, I was interested to read the notes on a group of artists who had called themselves 'Die Brücke', meaning 'The Bridge' (Bolitho 2007). They read, 'Founded in Dresden in 1905, it included Ernst Ludwig Kirchner and Karl Schmidt-Rottluff. The title of the group reflected their belief that "art had the power to transform society".' These people didn't consider themselves applied artists. Some practices are being brought into the embrace of applied theatre in the new discourse, which have been developed for some time with their own specific defining categories. Drama therapy is included in understandings of applied theatre. Robert Landy's work in Taylor's text (2003) provides one example of applied theatre, but when I heard him present this work at a keynote address last month (Landy 2007) he did not refer to it as 'applied theatre' or to himself as an 'applied theatre practitioner'. (His title is Professor of Educational Theatre and Applied Psychology.) He spoke of his work as drama therapy, and of himself as a drama therapist. I don't recall the creators of the Laramie project calling their work 'applied theatre', but this is also identified as an example. I shall pursue the

implications of this further in the next section, but at this point it seems to support the need for considering whether the term is actually worth having.

I accept that in the 2000 article I welcomed the term and provided three reasons why it was helpful. I have changed my mind. I think that part of the reason I have changed my mind is the way the discourse has developed, which takes me to my third point.

What is happening to the term?

Here I wish to suggest that the term 'applied theatre' is being used only for specific practices. Certain examples of practice support the discourse and construct this 'new' field in a particular mould. The discourse excludes other practices, even though they fulfil the defining features presented. So, rather than applied theatre being an umbrella term for a range of practices (which have specific intention, participation and operate beyond conventional theatre spaces), the term is emerging as a label for particular *types* of practice.

Consider two book titles: *Applied Theatre: Creating Transformative Encounters in the Community* (Taylor 2003) and *Applied Drama: The Gift of Theatre* (Nicholson 2005). Neither title gives room for considering that there may be anything but *good* to arise from the practices entitled 'applied theatre'. And it is a particular mode of good. Nicholson (2005: 16) describes it as a 'discursive practice … motivated by the desire to make a difference to the lives of others', and as something undertaken by those who wish to 'touch the lives of others' (2005: 166). Taylor explains it as theatre that can 'be harnessed … to build stronger communities' (2005: xxi), and 'where new possibilities for mankind can be imagined' (2005: xxi). Manchester University's website explains that its 'applied theatre projects have made positive contributions to the everyday life of individuals and communities in a variety of contexts'.

I do not suggest that any of the activities described are not worthwhile and beneficial; rather, I suggest that a discourse is being created that enshrines applied theatre as, ironically, *pure*. There's no mention of gospel street theatre or work with the police (very valuably undertaken by Griffith University staff), nor of drama for business thoroughly developed in Tasmania, because these would mitigate against the politics of the discourse being constructed. These are not ideologically suitable. I have argued elsewhere that the term 'function' often camouflages a value judgement. I have suggested that it assumes a consensus that does not exist (Ackroyd 2004: 32–35): 'To say that education … [has] functions assumes a particular consensual value system that asserts what the function should be. So a description of what does take place is seen as a description of what it is thought *should* take place. Veiled behind an assumed assumption is a value-laden assertion' (2004: 33).

Similarly, I now wonder about the term 'applied theatre' (in the usage of Taylor, Nicholson and others), which assumes a consensus of practice and indeed a perimeter of practice. While there is occasionally a gesture towards different practices, the discourse emerging is one that embraces and focuses upon those that are designed to strengthen communities, transform specific groups and give participants the chance to find their individual and collective voices. After I provided the keynote address at the conference, John O'Toole gave me a copy of an unpublished keynote he had delivered shortly before in Taiwan. The similarities in our concerns are striking. He too argues that 'the use of the term "applied theatre" is often restricted to settings where theatre is being used for explicit social benefit'. However, he suggests that this as not an issue in Australia, where 'we are a bit less moralistic', but rather it is in the United Kingdom and the United States that the narrow use of the term exists (O'Toole 2007).

Cranfield, one of Britain's most prestigious business schools, has been employing actors and directors to devise training sessions for over 20 years. Theatre applied to the needs of business has provided support for bosses who need to feel better about making people redundant, as I said in the last article. While we may construe this as ugly, this should not deprive it from academic attention and analysis, like other examples that conform to the definition. It should not be excluded from what is understood by the term 'applied theatre'. Can we really provide a coherent account of applied theatre practices and not include aspects such as drama for business training? Can some forms of dramatic activity that exist primarily outside conventional mainstream theatre institutions be excluded from a notion of applied theatre? Geoff Davis, writer of a very popular text on primary drama, moved into business when his role as drama advisory teacher in the north of England was axed. He used all the practices of his very successful drama teaching and advising career. His work was demonstrated at National Drama's 'Thinking Drama' conference in 2004. This is not inferior theatre practice, just a different application – a different audience, different intention and different non-theatrical space. He tailored his work to individual companies' needs. It is very *specific* – a buzzword in the new discourse (Nicholson 2005; Taylor 2003). Davis probably wouldn't describe it as work that 'springs from a desire to change or transform human behaviour' (but he did health and safety projects that were designed to do just that). Clearly, it doesn't help communities deal with issues, and give voice to the views of the silent and the marginalized (Taylor 2003: back cover), but should it be excluded from a notion of applied theatre?

It is also argued that Theatre for Development isn't actually applied theatre either (Nicholson 2005), and that a project is applied 'where many members have no real experience in theatre form' (Taylor 2003: xxx), bringing yet another restriction or inclusion. Those participants with theatre experience need not apply. These

seemingly authoritative inclusions and exclusions trouble me. I am reminded of Danny Abse's (1973) poem about taking names and addresses from last year's diary to the new one:

> Who's in, who's out
> A list to think about
> when absences seem to shout
> Scandal! Outrage!

There seems to be a lacuna between rhetoric and practice. Nicholson (2005: 10) describes applied drama as 'arguably the most democratic of theatre practices', yet in reality it is emerging as a term used to depict only the favoured kinds of theatre practices. She suggests that the shift in terminology to 'applied drama/theatre is significant ... because it does not announce its political allegiances, community commitments or educational intent as clearly as many forms of politically committed theatre-making which were developed in the last century'. But this is precisely what it seems to be doing. On the previous page, two key strands of influence are identified as the Marxist, Freirean and progressive educational practices. These clearly indicate very specific allegiances, community commitments and educational intent. A seemingly inclusive, democratic term, 'applied theatre', is actually emerging as a discourse that is very clear about its allegiances and therefore clear about what it wishes to keep beyond its perimeters. (Of course, there are good reasons when seeking funding not to 'announce ... political allegiances'.) So here again there is a sense of the discourse presenting a case that doesn't fully reveal itself.

Drama in education and the new applied theatre discourse

But there is another omission in the narratives of applied theatre that bothers me: drama in education. Does it belong here now? Many school dramas are participatory and take place in the classroom and not a theatre, and they have specific intentions. However, these intentions are tied up with specific curricula or the school's context. The aims may be to encourage writing in role for literacy development, or teach about the life cycle or to investigate historical phenomena. These aims are not like those attributed to the examples of applied theatre projects found in key texts (Nicholson 2005; Taylor 2003; Thompson 2003). But I had assumed that they were part of the new term 'applied theatre'. Theatre form is applied to the context of curricular teaching.

Since I trained to be a drama teacher in 1982, I have aspired to Bolton's (1979) aim: to bring about 'a shift in appraisal'. It seemed so important and so difficult

to achieve after a wet break on Friday afternoon. But compared to community transformation and touching people's lives, it now appears pretty frail an aim. However, Michael Billington (2007), writing in *The Guardian*, says, 'But theatre rarely topples governments or incites direct action.' What, he claims, 'theatre can do is shift attitudes …' Now the political apologies drama *Sins of the Fathers*, which was (as has been stated) fully interrogated in my 2000 article, seeks to explore the motives and underlying implications of the increasingly popular political apology. It was created with a thought to the curriculum of advanced level sociology students, but it has been workshopped with other groups of adults and young people. There is undoubtedly an aim to shift appraisals or attitudes about political expediency. It challenges an acceptance of apologies and invites consideration of political expediency. But would it conform to the new concept now? Since Taylor had been the editor who published the first article (which included the drama), and had indeed established the research centre for applied theatre, I emailed him to ask whether he would now see such drama as applied theatre and whether he sees O'Neill's seal wife drama as applied theatre. Like the political apology drama, it uses teacher in role and participatory improvisation. Pondering an answer, he raises some questions (Taylor 2007): 'Is the intention to apply theatre in a transformative manner? Is a theatrical scenario at the core, and has community had input into its evolution – this would be contentious based on how one is defining core and evolution?' Taylor is very aware of the issues surrounding definitions and points out that: 'There would be some who argue that applied theatre has to be commissioned.' (The definition gets even more exclusive.)

So, we have different details in the precise definitions. *Sins of the Fathers* was not commissioned, nor did it have a community input into its evolution though the participants' made input in the drama process. It has drama at the core, I would argue, since I am not comfortable with a distinction between theatre and drama label for such teacher role-led work. But it doesn't seem like the Seal Wife or political apologies dramas fit comfortably into the current notions of applied theatre. I wouldn't have claimed that it offered 'a theatre in which possibilities for human-kind can be imagined' (Taylor 2003: xxx), but I may well have seen it as a strategy to 'open up dialogue' (2003: xxix). It might not claim to 'touch the lives of others' (Nicholson 2005: 166), but it engages participants emotionally and cognitively, and it invites them to consider different perspectives or standing in the shoes of others. It is participatory. It is not delivered in a traditional theatre setting. It has specific intentions and a desire to shift appraisals. But somehow it doesn't sit comfortably beside projects now being described in applied theatre texts.

Drama in education doesn't seem to get a significant stake. Taylor's (2003) examples in his chapter 'Implementing Applied Theatre' include teenage vandalism,

racism in a small town, and teenage pregnancy in a rural township. Nothing in the classroom. He includes an example of children improving literacy through applied theatre, but his applied theatre appears to have facilitators and actors rather than teachers working both in and out of role. Nicholson's examples of 'Drama and theatre in education' (from the index) are both theatre in education projects (2005).

Does this matter? I guess I feel a bit cheated to have embraced the term because I saw it bringing a range of practices together with drama education only to find it has eased my dramatic preference out. The International Drama in Education Association and the International Drama in Education Research Institute accepted papers on applied theatre projects, I had assumed, because they were alongside drama in education practices. However, I have heard that *RIDE* is going to have a special edition on … research in drama in education. What are we to conclude other than drama in education is no longer the regular focus of *RIDE* and, since applied theatre is, we must also conclude that drama education is not included in applied theatre. The places for focused academic debate on drama education are being usurped.

I want to use the term 'applied theatre' as a term, not a form or practice. I want to use it to be inclusive of a range of practices. I want it to enable analysis of those many practices, pretty or ugly. In the 2000 article, I warned that not all applied practice would be supported ethically by the majority of practitioners. The answer to this problem has been to create a discourse that excludes work that might not be deemed unethical. But who decides?

Victor Ukaegbu's (2004: 46) words are ringing in my ears: 'definitions create new discourses but they also generate … hierarchical relations'.

Acknowledgement

This chapter was originally published as Article 1 in Volume 8 (2007).

REFERENCES

Abse, D. (1973), *Let the Poet Choose*, Edinburgh: Harrap.

Ackroyd, J. (2000), 'Applied theatre: Problems and possibilities', *Applied Theatre Researcher*, 1, http://www.griffith.edu.au//centre/cpci/atr/journal/article1_number1.htm. Accessed 20 November 2020.

Ackroyd, J. (2004), *Role Reconsidered*, Stoke-on-Trent: Trentham Books.

Billington, M. (2007), 'Lifting the curtain', *The Guardian*, 24 October.

Bolitho, S. (2007), 'Text for *The Djanogly in material gestures*', Expressionists exhibition at Tate Modern, London.

Bolton, G. (1979), *Towards a Theory of Drama in Education*, New York: Longman.

Keyworth, L. (2002), 'Applied theatre: Three examples of practice', https://roehampton.rl.talis.com/items/C7D05B65-7CDD-867A-A445-68F6B3D88624.html. Accessed 20 November 2020.

Landy, R. (2007), 'Drama as a means of preventing trauma within communities', Keynote Address at Inspiring Transformations: Arts and Health conference, University of Northampton, September.

Manchester University (2007), 'Arts: About', http://www.arts.manchester.ac.uk/catr/about/index.htm. Accessed 20 September 2007.

Neelands, J. (2007), 'Taming the political: The struggle over recognition in the politics of applied theatre', *Research in Drama Education*, 12:3, pp. 305–17.

Nicholson, H. (2005), *Applied Theatre: The Gift of Drama*, New York: Palgrave Macmillan.

O'Toole, J. (2007), 'Applied theatre: New forms for new audiences', Keynote Address at Drama and Theatre Education Conference, University of Taiwan, May.

Rasmussen, B. (2000), 'Applied theatre and the power of play – an international viewpoint', *Applied Theatre Researcher*, 1, http://www.griffith.edu.au//centre/cpci/atr/journal/article1_number1.htm. Accessed 20 September 2020.

Taylor, P. (2003), *Applied Theatre: Creating Transformative Encounters in the Community*, Portsmouth, NH: Heinemann.

Taylor, P. (2007), email, 10 October.

Thompson, J. (2003), *Applied Theatre: Bewilderment and Beyond*, Oxford: Peter Lang.

Ukaegbu, V. (2004), 'The problem with definitions', in J. Ackroyd and J. Neelands (eds), *Drama Research*, 3, pp. 45–54.

PART 3

RISKY BUSINESS:
GOOD INTENTIONS AND
THE ROAD TO HELL

Introduction to Part 3

Penny Bundy

Risky business? Sure is. Well perhaps I should say, it sure can be. And at times should be. Drama is not a safe, polite form of communication. It is a way of exploring, experiencing and creating worlds that challenge and ask questions about what it means to be human in the different spaces and places in this world in which we all live. Sometimes those spaces are not particularly safe ones in which to ask questions. Even if we think it is safe, we can work with the best intentions, the best theoretical understandings of what creates a safe space within the aesthetic medium and with powerful aesthetic skills and understandings ourselves ... and still make grave mistakes. So much is in play, as is evident from the articles we have selected for this part of the book. Do we always have the ability, time, vision to enable us to see the risks in the work? Can we always create a safe place for those who take part? How do we remove the blinkers we must all wear at times in order to enable us to see more and thus to know, and be able to do more – both aesthetically and safely?

So what was in play? In Chapter 9, Shifra Schonmann takes us to an elementary school classroom (some time before this article was originally published in

2004) in Israel, a country and a time of significant violence and political unrest. The drama work was premised on beliefs about the importance of arts education offering aesthetic modes of knowing rather than being intended for instrumental purposes. Its planning was underpinned by understanding of aesthetic distance and its impact on engagement. The children were involved in a dress rehearsal for a performance on which they had been working for some weeks. One would expect this to be a fairly safe and predictable situation, as Schonmann herself states. However, the drama work reached a point where it failed to work with symbolic representation. Instead, for at least one of the children images of actuality took over from play. The events in the fictional world either triggered a reaction to events in the real world, or perhaps (considering the children had probably rehearsed this scene multiple times previously) offered an opportunity for anger at distressing personal events that had occurred in the real world to be played out in this classroom. Drama stopped. Violence started. Could the teacher have predicted this? At what point in the planning or management of this drama experience might things have been done differently? Would that assault have happened anyway? This article raises significant questions about safety and risk and opens for discussion the difference between doing the right thing and doing things right.

Violence and silence are also significant in Chapter 11 by Alberto Guevara. Guevara draws on performance theories to question and explain his experiences during time spent with a Dalit theatre group based in Sindhuli, Nepal during the summer of 2005. Here censorship, violence and the threat of violence frame the existence of the theatre workers in their actual community on a daily basis. Non-government radio stations are banned. All media is censored. Students and political leaders are detained. He writes of allegations of torture and of people disappearing. Fear is invoked and employed to control. When I read the original article, I was struck by the idea that it seemed like the nation's people were living in a fictional world where truths may not be spoken for fear of what the repercussions may be. Yet theatre-makers were encouraged to use their form as a social tool as long as the issues were seen as either being in line with government policy or non-political. Theatre was permitted to critique caste discrimination because such critique aligned with government policy. Theatre as a tool of the government of the day perhaps?

Chapter 10, neatly wedged between the two just mentioned, highlights different aspects of risk. Tordis Landvik takes us to a South Samic community theatre project that occurred in the period 2003–04. The project involved local people creating a work to tell the story of what happened to their own community during the 1950s and 1960s. The people had experienced great external pressure to accept societal change (read imposed development) on the grounds that it would be good for them. Thirty years later, they created a community theatre performance that

told stories detailing the negotiations and impact that the development (including the creation of a dam) had on them as a community.

Landvik adopts a theoretical concept emerging from the work of Habermas to frame her thinking about what occurred in that community. She discusses the world of systems and the world of life, indicating that what occurred with the developers meant the world of systems penetrated the world of life. However, for me there is another story in this article. It is a story of sustainability and of how the very nature of the community theatre practice offered an opportunity for the world of life to penetrate the world of systems.

Life is unpredictable. Creating theatre is unpredictable. In each of these articles in this section, we see how the actual world impacts the processes of the creative world and vice versa. Some of these influences are external to the dramatic works created and relate to day-to-day feasibilities. In each, at times, there is also a muddying of the boundary between what is fictional and what is actual. In some projects, it may be desirable to encourage actual voices and conversations to emerge (as we see in the Landvik project). However, in other work – for example, in the classroom event discussed by Schonmann, and certainly in the work about which Guevara writes – truth may be dangerous.

9

Ethical tensions in drama teachers' behaviour

Shifra Schonmann

The conceptual framework for this chapter is that *understanding mental images* is a vital component of the dynamic of process drama. Despite the emphasis on *instrumental* functions of drama and theatre in education, particularly in the United Kingdom, it is the author's conviction (following others, such as Bresler and Thompson 2002; Eisner 2002; Greene 2000; Uhrmacher and Matthews 2004) that the core value of any arts teacher's work lies in their ability to create learning experiences that elicit *aesthetic modes of knowing*. These are based on the ability to experience aesthetic distance, which is itself based to a certain extent on the ability to generate rather than destroy mental images. The study is therefore positioned within a theoretical framework of understanding the ways in which mental images are created and the ways in which they function. Our theatrical modes of knowing are constructed on the basis of having ethical tactics of how to do the *things right* and not relying only on a strategy of some common knowledge of how to do the *right things*. This notion builds on process drama, relating to Neelands' (1991) 'conventions' that enable teachers to structure the drama work and O'Toole's (1999) concept that 'drama is a charming art'.

Constructing mental images

A 'mental image', as used throughout this chapter, is a solid concept. It is a representation of an image, which emerges from a defined perception of an entity. A mental image is a holistic, highly integrated kind of knowledge and, as Perkins (1992: 80) argues, 'It is any unified, overarching mental representation that helps us work with a topic or subject.' Mental images help us to understand topics in history, science or any other subject. Mental images, Perkins (1992) claims, are

concerned with very basic entities such as the layout of one's home or the shape of a story. But they can also refer to very abstract and sophisticated matters. Drawing on Perkins's ideas, I argue that the concept 'mental image' is an impression formed by our experiences in life. It is based on strong and solid perception, whereas a stereotype, for example, could take information and place it in schemas that separate one event from another.

In order to get a more profound idea of what mental images are, and how they differ from what is just an image, let us try to imagine what might happen in a theatre performance if Medea did not kill her children one day or Don Quixote did not attack the windmills, just because they did not feel like it. The event would have been changed, but for most of the audience the *mental image* that they have of Medea or of Don Quixote would *not* have been damaged. On the contrary, it would have become stronger because the audience would have searched for the well-known image – or at least they would demand from the artist a good reason for the change: could it be a change in the type of the play? A parody perhaps? Could it be something else?

A closer look at the behaviour of Don Quixote shows that it is well rooted in the consciousness of the audience. The term 'quixotic' describes the concept of foolish and impractical behaviour, especially in the pursuit of ideals. Therefore, any attempt to change the mental image of Don Quixote is doomed to fail because quixotic has been adopted throughout the world, over time, to describe mainly those characteristics that are embedded in Cervantes' book. 'Don Quixote', taken literally, applies to no one, as Goodman argues, but taken figuratively, it applies to many of us. Moreover, there is the understanding that, 'Whether a person is a Don Quixote (i.e. quixotic) or a Don Juan is as genuine a question as whether a person is paranoid or schizophrenic' (Goodman 1978: 103).

Mental images serve as building blocks in any culture, and they should therefore be at the core of our educational theatre work. In our drama and theatre classes, we have to help construct mental images so that our students will realize that if Othello does not strangle Desdemona, it is a departure from the Shakespearian common understanding. In theatre, the thought is present and must communicate with the audience. In theatre we are in the sphere of *doing things*. Hence, as I have already defined in another context (Schonmann 2000, 2001), the theatrical *mode of knowing* is the embodiment of thought into actions. It is an hermeneutic activity, not a technical one. Hermeneutics is about creating meaning, not simply reporting it, and as Schleiermacher (1978) put it long ago, interpretation and understanding are creative acts, not just technical functions. It challenges us to inquire into what we mean when we use terms like 'mode of knowing', 'pedagogy' or 'theatre'.

In viewing a mental image as a vital component for building *theatrical modes of knowing*, we actually view it not as a state of possessing some information about something, but as the empowerment to carry out certain rational elaborations with that knowing – it gives us something to reason with. It lets our mind make all sorts of rational elaborations such as: application, justification, comparison, contrast, contextualization or generalization. This line of thought, I believe, goes well with Greene's (2001: 117) notion that, 'Works of art have a potential for evoking an intimation of a better order of things. I mean, of course, a consciousness of possibility.' That is to say, there must be a conscious readiness in order to evoke the potential of an intimation of a better order of things through art. A mental image is an imaginative entity that helps to embody that kind of awareness.

The dynamics of process drama

This understanding of how mental images are constructed and how they serve as building blocks of culture in general, and as building blocks in creating roles and characters specifically, we can now align with process drama. Cecily O'Neill (1994: 37–39) claims that process drama is closely aligned with contemporary theatre practice in its approach to role:

> Characters in process drama tend, by the nature of the activity, to be defined in the first stage of work by their roles as members of a particular group involved in a specific enterprise or circumstance according to the demands of the dramatic situation, for example as townspeople, journalists, celebrities, or advisers. This group orientation provides their initial perspective on the unfolding dramatic event and is likely to have a distancing effect.

However, O'Neill (1994: 37–39) argues that *individual identities* 'are necessarily more fluid and less predictable'. This fluidity permits the dynamics of process drama to evolve appropriately, as long as each of the participants can monitor their own engagement in the dramatic situation. In process drama, the character is built through improvisation, based on the possibilities that the dramatic encounter offers, as well as some aspects of the character that develop within the mind – like yeast in bread, as Muriel Bradbrook (1965) vividly suggests (in O'Neill 1994: 91). Using the metaphor of *yeast* is actually saying that in process drama there is a dynamic process of growth that stems from mental images that serve as seeds planted in one's mind. In the process of discovery and invention while building a role, these seeds maintain their power of growth – sometimes unpredictable growth, as I shall demonstrate below. Models for the process of structuring

dramatic activity use conventions that 'can be seen as part of a dynamic process which enables students to make, explore and communicate meaning through theatre form' (Neelands 1991: 3).

All art uses conventions. Conventions can be a way of overcoming some of the given limitations of an art form, and they can dictate the nature of the theatrical performance (Mayne and Shuttleworth 1986: 15). The question that interests me, and follows from this, concerns the extent to which working within known conventions can disguise the tensions and intentions of the participants in process drama, and the extent to which participants untie themselves from the conventions and use the 'charm of the dramatic event' for their own purposes (O'Toole 1995: 82).

Methodological note

To explore this question, I chose to examine an example from my personal practical experience. It took place while my teacher training class from Haifa University was visiting a drama lesson in an elementary school. The class was part of a seminar aimed at constructing the students' identity as drama-theatre teachers.

My concern in this study is not with the teacher's moral responsibility of deciding *what* to teach and *how* to teach it, but with unpredictable emerging situations that occur in the class or in theatrical performance, even though the teacher has very carefully cultivated the what and the how. For the purpose of this study, classrooms were entered with certain questions in mind: What could be considered as a teacher's ethical behaviour in drama classes? How do we know that it is an ethical behaviour? What makes a claim an ethical claim? Since ethics is concerned with what kinds of actions are right or wrong, it was my intention to explore ethical tactics of how to do the *things right* when unpredictable situations begin to develop.

However, these ethical questions did not remain dominant throughout the sessions, because the situations experienced on site seemed to invade the intimacy of the pupils, and thus raised more fundamental ethical questions concerning the strengths and weaknesses of the use of process drama. One archetypal experience was chosen here for description and analysis according to two defined postulates that are based on extensive writings, including Atkinson (2003), Eisner (2002), Greene (2000), McCaslin (1999) and Winston (1998):

- In the art of theatre, ethical considerations arise most clearly because of the proximity between life and theatre.
- The moral is inseparable from the artistic form.

The context of the experience was an incident that took place before the recent unrest in Israel. However, in the tense political situation throughout the last decade, education, politics and ethical issues have become inseparable.

A case to consider: The quarrel scene

I observed Lea's class at one elementary school. She told me they were going to do their last rehearsal for a play on which they had been working for the past six weeks. I thought to myself that things would go smoothly since it was the dress rehearsal, and it would probably be enjoyable. Everything ran smoothly until it came to the 'quarrel scene' – a scene in which two ten-year-olds, Mohammad (an Israeli Arab boy) and David (an Israeli Jewish boy), are playing football. The play, which was written by the children, contained a narrative of children having a fight over the ball, but after few minutes of quarrelling the situation had to be settled. At that point in the rehearsal, which was very carefully planned ahead, David continued beating Mohammad with all his strength as he might do in a real-life situation. He beat him and beat him, and, for a moment, I was aston-ished. The beatings were so real, the tears were real. Was the crying for help real? What's going on there? Had I lost my ability to grasp aesthetic distance? Had they lost it? Should I stop them? What about their teacher? Why was she doing nothing? Was this a play that they were in? While all these thoughts were whirling through my mind, Lea entered the circle and tried to stop David, but could not. It was beyond her control. Another teacher and I hurried to help, pulling David and Mohammad apart from each other by using physical force. Was it doing the *things right*? At that moment, we felt that nothing else could work, and the danger was real. We were confused and could not understand what had happened and why. After a short while, David, who was known as a non-violent pupil and a nice boy (that was actually the reason for choosing him to play this part in the 'quarrel scene' in the first place), told us with heavy breathing and endless tears that his brother was now lying in Afula Hospital, badly wounded. Yesterday at noon, he said, his brother 'was wounded by a Pal-estinian terrorist shooting' while walking along the street in Afula (a small town in the north of Israel).

David had calculated his revenge. He had waited until the rehearsal started, until the 'quarrel scene' was taking place, and then – overwhelmed by the mental image that he had of the Arab terrorist – he projected his anger, frustration and blame upon Mohammed and beat him really badly. David was not able to dis-tinguish between the Arab terrorist from Jenin in the occupied territories and an Israeli Arab who is just as much an Israeli citizen as himself. He failed to do so

because the mental image he had of the terrorist was stronger than any image he could have had of the Israeli Arab.

Here lies the ethical tension for the drama teacher. What should the teacher do? How will the teacher explain the incident to the class? What will the teacher do with David? With Mohammad? Would it be right for the teacher to take any stand? Would it be right for the teacher *not* to take a stand? How should the teacher explain the situation to the parents? What about the teacher's own feelings concerning the tense political situation? How could the teacher do *things right*? In order to know what to do and how, we should know what the consequences of our actions will probably be. But who has a clear idea of the consequences of our deeds (Strike and Soltis 1985)? In fact, it is not only ambiguity concerning the *consequences* that creates tension for teachers, but also ambiguity of *intentions*. As Neelands (1991) argues, if intentions are too definite and clear, students are denied the power and experience of being artists.

Neelands (1991: 55) asserts that the power of the gestalt in learning opportunities 'requires extrapolation from detailed analysis of known character traits; provides opportunities for insight into the development of individual motivation, attitudes and values against the wider canvas of a variety of social interactions and perspectives'. And that is exactly what happened in the 'quarrel scene'. But, contrary to the 'usual' controlled developments that end with a happy ending, this time the extrapolation act provided the opportunity for the violent act to be executed. The complex context of the real-life situation, and the mental image that emerged from it, served as live ammunition for David. He responded to the core situation of the drama in his own life and brought it into the process drama in class. So where could the 'charm of drama', in O'Toole's (2001) words, be found? O'Toole (2001: 212) argues very convincingly that, 'Where you stand in the dramatic context depends on where you come from in the real.' In the case that he describes, O'Toole concludes that, 'The students' behaviour exhibited that they felt liberated within the drama.' In our 'quarrel scene', the same process of liberation took place, but this time it meant the student had taken the liberty to use violence.

One might think that the teacher here is being regarded as an individual, isolated in the classroom, who must make a range of important decisions with no guidance from the school community. This would be a wrong impression. Issues of discipline, violence and ways of treating children who are quarrelling have a common, agreed policy. However, the situation described above is not the typical example of violent acts because it was a case of the 'as if' context preventing the adults considering the situation from taking it seriously. It took time to 'wake up' and see that it was not a play anymore. The context of drama rehearsal makes the difference. I should add that this is a case that involved an appeal not only to reason, but also to an intuitive sense of the *right thing to do*. These intuitions can

be used as a kind of data against which ethical theories are tested – in Strike and Soltis's (1985: 31) question: 'What is the source of our ethical intuitions?'

This analysis so far has highlighted difficult ethical questions in drama education. The Code of Ethics of the education profession adopted by the 1975 National Education Association (NEA) contains the following statement:

In fulfilment of the obligation to the student, the educator:

- shall make reasonable effort to protect the student from conditions harmful to learning or to health safety;
- shall not intentionally expose the student to embarrassment or disparagement.
(Strike and Soltis 1985: 23)

These guidelines raise the issue of providing students with a safe learning environment. The 'quarrel scene', in the light of the NEA Code of Ethics precepts, raises ethical problems in drama teaching that centre on the idea of providing a safe learning environment.

There are no rules for teachers' behaviour, and the ethical tensions are not specific to the drama teacher. We therefore have to be very alert to the potential of the high risks, especially in drama classes, because of the depth of the involvement that the activity requires from the participants and because of the nature of the dramatic action. Cecily O'Neill (1988: 2), based on Beckerman (1970), argues that

> the drama teacher's task is not just to be able to manipulate activity, but to understand the nature, texture, and power of the action we set up for our pupils. What action can we find for our students which will cause something to happen?

Here is my point: for too long we have been looking for ways to encourage the 'happening' in our classes. The great paradoxical idea of 'We escape from reality (in our drama activity) in order to participate more fully in it' (O'Neill 1988: 7) is sometimes too dangerous, not only in the political context but in the psychological and social contexts as well.

One way to reduce the risk-taking is to focus on the phase *before* the 'something happening' by working with mental images as a tool for examining the potential tension between the given situation and the complete action. Sometimes drama teachers fail to understand the importance of clarifying mental images, and this failure could be one of the causes of ethical problems in drama and theatre educational work. Truth on stage is not about imitating real life, but about representing it in a symbolic way. A clear line must be drawn between mere imitation of life and representing life. Working with mental images is one of the ways to struggle with the sources of violence and racism and prejudice by drawing lines between life and

art. As Solier (2001) claims, the demons of violence are embedded in the psyche of our troubled society; it is therefore mistaken to believe that the encounter between Arabs and Jews, as we saw in the context of creating a dramatic scene – that is, the 'quarrel scene' – will improve personal relations and political understanding.

After interviewing Lea, the drama teacher, about the preparations for the show, after interviewing the kids in the class and having their understanding of what had happened, after speaking with Mohammad and David and their psychologist (they both needed therapeutic treatment, which lasted quite a few months), I came to the understanding that the mantra we are all using – that 'playing drama is a safe thing to do, that being in a theatre class is being in an area akin to life yet without any real danger' – is false. For a long time, we have been asleep while on guard; we (theatre and drama teachers and researchers) have raised few doubts. We have not investigated adequately that mantra that unfortunately tends to be very problematic exactly because of the proximity between life and theatre. The very idea that proximity to life is a safe zone to play in turns to be a dangerous and conflicting one. A performance of a fictitious situation in which an imaginary danger existed turned into a real and frightening danger.

Examination of a crucial encounter in drama-theatre education between ethics and aesthetics as an essential part of the curriculum is actually challenging the premise that 'staged battles are without live ammunition' (Levy 2001). I claim that there is no such thing in our classes as 'battles without live ammunition'. Since ethics are always involved in our professional deliberation, the result of our decisions could hold serious dangers. When exploring the tension between ethics and aesthetics in the context of a school environment, we are dealing with live ammunition. By playing in the gap between ethics and aesthetics, there are open opportunities to construct modes of knowing in which knowledge is not objective, and is not passively received. Rather, it is constructed and shaped by the students' new insights and the variety of modes of connecting previous knowledge with the new (Glassersfeld 1990). Many different drama strategies can be used in the classroom, but *all* must convey the essence of dramatic action, which is inherently a constructivist approach to learning. To teach in the way we preach is not only to give a personal example to our students, but also to have a profound belief in the power of theatrical ways of understanding the world to change basic attitudes and behaviours.

The students were involved in a process of knowing by doing, searching with their teacher for the right balance in meaning-making. Bolton (1992: 2) argues that, 'Meaning-making is to work on the assumption that engagement with the art form is to do with seeing something differently.' Here lies the danger: the students are *not* engaging with the artform, but with its instrumental opportunities. David entered the fiction and used it as a real-life arena. He broke the aesthetic

distance; he shattered the convention of the 'as if' situation – he was himself. The convention of the theatre holds that suspension of disbelief is a mental exercise that becomes easier with practice and experience (Boyce 1987). In the drama process, conventions are 'indicators of the way in which *time, space and presence* can interact and be imaginatively shaped to create different kinds of meanings in theatre' (Neelands 1991: 4) An essential part of creating different kinds of meaning is exercising mental images, a process in which the line between reality and fiction is a fundamental characteristic.

The David/Mohammad case is a clear example of students misusing the opportunity they were given. The blurring of boundaries happened so easily because the children were referring to the play as a tool for revenge. At this point precisely, when theatre loses its aesthetic-artistic value, when it has only an instrumental function, the theatre becomes dangerous. It is losing its aesthetic merit – and that is what causes the danger. We learn from Eisner (1998: 38) that 'to confer aesthetic order upon our world is to make that world hang together, to fit, to feel right, to put things in balance, to create harmony. Such harmonies are sought in all aspects of life.' Such harmonies can be achieved by doing *things right* in process drama – that is, by allowing students to comprehend the similarities and differences among archetypal characters and to control the emotional and social impact of dramatic performances in their own life.

The polar encounter between a tense life-situation and a fictional situation building up is too dangerous. Even an experienced teacher can sometimes fail to keep a very tense and tricky situation under control, and thus faces ethical tensions.

The drama teacher should be aware of the power of mental images to destroy or to build, their ability to cure or wound. While working on a risky scene – especially when national or ethnic conflicts or extreme psychological elements are involved – a measure of caution is required to allow us to discover the mental images the students hold and how to prevent anyone from breaking the 'charm of drama'. The moral is inseparable from the artistic form. In relating to the 'quarrel scene' experience, it should be considered very seriously whether such a realistic form of presentation is a wise choice for children of that age in such tricky contexts. It is possibly beyond the ability of children to control situations that are so similar to those around us in our lives. Would it not be better for all concerned to work only with those situations in which we are sure that the aesthetic distance can be maintained?

Process drama does not begin and end with the audience, nor with the playwright, director or actors, as O'Toole (1992) argues. Instead, he explains, the dramatic event should be viewed as a whole, and investigated through the experiences of all participants, and their roles in the creation of the work. It is in this context that the strong connections between mental images and ethical problems that

might arise in the drama classes were clearly revealed in Lea's class. Sometimes we tend to forget that drama education is based both on the field of art and on the field of education. When an artistic need clashes with an educational purpose, the educational aspect should be considered first. However, the drama activity should be regarded as an artistic activity, and not only as an instrumental one. When it is an artform, then there is an aesthetic distance between the fiction and real life. There is a safety net to prevent the teachers as well as the children from becoming victims of unnecessary tensions. When the aesthetic distance disappears, as was clearly demonstrated in the 'quarrel scene', art also vanishes. Only then does an ethical tension of this sort arise and might evolve into a real danger that even an expert teacher would find difficult to deal with. Perhaps we can now understand more fully the thesis of David Best (1992: 202) in his book *The Rationality of Feeling*:

> My thesis is not primarily concerned with whether responses are or are not spontaneous, but with showing that the kinds of feeling which are central to involvement with the arts are necessarily rational and cognitive in kind. To put it briefly, they are inseparable from understanding.

It is worth considering that one way to nurture such an understanding is through a sensitive appreciation of mental images and a consideration of their use in the arts; thus, they can help to prevent unnecessary ethical tensions in drama process within education.

Acknowledgement

This chapter was originally published as Article 7 in Volume 5 (2004).

REFERENCES

Atkinson, D. (2002), *Art in Education: Identity and Practice*, Dordrecht: Kluwer Academic.

Beckerman, B. (1970), *Dynamics of Drama*, New York: Alfred Knopf.

Best, D. (1992), *The Rationality of Feeling*, London: Falmer Press.

Bolton, G. (1992), 'A balancing act: An approach to drama education', address to the first IDEA Conference, Porto, Portugal, July.

Boyce, N. S. (1987), *Welcome to the Theatre*, Chicago: Nelson-Hall.

Bradbrook, M. C. (1965), *English Dramatic Form*, London: Chatto & Windus.

Bresler L. and Thompson, C. M. (2002), *The Arts in Children's Lives*, Dordrecht: Kluwer Academic.

Eisner, E. (1998), 'Aesthetic modes of knowing', in E.W. Eisner (ed.), *The Kind of Schools We Need: Personal Essays*, Portsmouth, NH: Heinemann.

Eisner, E. (2002), *The Arts and the Creation of Mind*, New Haven, CT: Yale University Press.

Glassersfeld, V. (1990), 'Environment and communication', in L. Steffe and T. Wood (eds), *Transforming Early Childhood Mathematics Education: An International Perspective*, Mahwah, NJ: Lawrence Erlbaum.

Goodman, N. (1978), *Ways of Worldmaking*, Indianapolis, IN: Hackett.

Greene, M. (2000), *Releasing the Imagination*, San Francisco: Jossey-Bass.

Greene, M. (2001), 'Thinking of things as if they could be otherwise: The arts and intimations of a better social order', in M. Greene, *Variation on a Blue Guitar*, New York: Teachers College Press, pp. 116–21.

Levy, J. (2001), *Practical Education for the Unimaginable*, Charlottesville, VA: New Plays.

Mayne, A. and Shuttleworth, J. (1986), *Considering Drama*, London: Hodder & Stoughton.

McCaslin, N. (ed.) (1999), *Children and Drama*, Studio City, CA: Players Press.

Neelands, J. (1991), *Structuring Drama Work: A Handbook of Available Forms in Theatre and Drama*, Cambridge: Cambridge University Press.

O'Neill, C. (1988), 'The nature of dramatic action', *NADIE Journal*, 12:2, pp. 2–7.

O'Neill, C. (1994), 'Here comes everybody: Aspects of role in process drama', *NADIE Journal*, 18:2, pp. 39–52.

O'Toole, J. (1992), *The Process of Drama: Negotiating Art and Meaning*, London: Routledge.

O'Toole, J. (1995), 'The rude charms of drama', in P. Taylor (ed.), *Selected Readings in Drama and Theatre Education – IDEA '95 papers*, Brisbane: NADIE.

O'Toole, J. (2001), 'Drama is a charming art', in N. McCaslin (ed.), *Children and Drama*, Studio City, CA: Players Press.

Perkins, D. (1992), *Smart Schools*, New York: The Free Press.

Schleiermacher, F.D.E. (1978 [1819]), 'Outline of the 1819 Lectures', *New Literacy History*, 10:1, pp. 1–6.

Schonmann, S. (2000), 'Playing peace: School performance as an aesthetic mode of knowing', *Contemporary Theatre Review*, 10:2, pp. 45–60.

Schonmann, S. (2001), 'Theatrical modes of knowing in the pedagogy of teacher education', paper presented at the AERA conference, Seattle.

Solier, D. (2001), 'Building a culture of peace and anti-racism in our schools', *Peacebuilding*, 3:2, pp. 10–15.

Strike, K. A. and Soltis, J. F. (1985), *The Ethics of Teaching*, New York: Teachers College Press.

Uhrmacher, P. B. and Matthews, J. (2005), *Interactive Palette: Working the Ideas of Elliot Eisner*, Upper Saddle River, NJ: Pearson Merrill Prentice Hall.

Winston, J. (1998), *Drama, Narrative and Moral Education*, Bristol, PA: Falmer Press.

10

Community theatre in a South Samic community: The challenges of working with theatre in small communities

Tordis Landvik

The term, though not the practice, of 'community theatre' or 'community-based theatre' is quite new to Norway. Three years ago, one of my colleagues, Associate Professor Tor-Helge Allern, picked up on the concept in the book *Community Theatre, Global Perspectives* by Eugene van Erven (2001: 1), who traces the etymological roots of the term 'community theatre' back to 1920, when Cornell University Professor Alexander Drummond used it in upstate New York to refer to his stimulation programme for 'grassroots theatre'. In this book, van Erven discusses examples from six parts of the world, showing how the label 'community theatre' means something quite different in North America than it does in Europe, Africa and Asia. In North America, the term 'community theatre' means the same thing as 'amateur theatre' in Europe. Throughout most of Europe, amateur theatre is a middle-class theatre activity, while community theatre mostly belongs to the working class.

Different community (based) theatre projects have their own distinct, individual stories, but they also have qualities in common:

- The emphasis is on local and/or personal stories rather than pre-written scripts. These local/personal stories are processed through improvisation and then collectively shaped into theatre under the guidance of either outside professional theatre people or local amateur artists residing among groups of people who, for lack of a better term, could perhaps best be called 'peripheral' (van Erven 2001: 2).

- Community theatre also expresses the privileges of any artistic pleasure and sociocultural empowerment of its community participants. Its material and aesthetic forms always emerge directly from the community whose interests it tries to express (van Erven 2001: 3).
- Every community theatre production is unique, told in its owners' words and expressions, and with its own atmosphere.

Community-based theatre has a long tradition in Scandinavia, dating back to the late 1960s. One of the first performances took place in Tärpes in Finland, under the guidance of director Ralf Långbacka. In Scandinavia, it has been labelled 'local theatre performances'/Lokalspill/grassroot theatre or 'dig where you are'. These performances have often been based on local history and issues, with varying content and focus. They have been created by both idealistic theatre groups and by better organized commercial theatre enterprises using a mix of professional and non-professional actors and crew. These Nordic community performances often involve people from a wide range of professions, educational backgrounds and avenues of employment. It is common to have participants from all age categories. It is never a question of which social/economic class the participants belong to; the only criterion is an interest in creating something meaningful together with others.

Theatre tradition

In Norway and Sweden, the theatre structure is divided into professional and amateur theatre. In amateur theatre, none of the crew is paid, except the director and conductor in some productions. Musicians are occasionally hired and paid. Many types of theatre created by amateurs have been referred to as amateur theatre. In my experience over the past 25 years, I've discovered that there is little or no difference between those who do amateur theatre and those who do community-based theatre in Scandinavia.

Professional theatre is owned by the state, the county and local authorities. The boards of the professional theatres have representatives from the owners, but these representatives do not have influence on the repertoire or artistic issues. Some independent professional groups may get financial support from the state for some projects.

We can therefore assert that community-based theatre has existed in the Nordic countries since the 1970s, without being referred to using that particular term. In many places, people have simply created new performances about local issues, as in the *Vattufall* project discussed below.

Dearnan Sitje

The Samic people live in Norway, Sweden, Finland and Russia. In general, all people in the north have a traditional habit of moving between these countries – in particular Lapps, who work with reindeer. The move has not been from north to south, the way the borders run. One result of this is that we have, for instance, three dissimilar Samic languages, and the people are divided into the Northern Samic, the Lule Samic and the South Samic, which means that they cannot communicate with each other as Norwegians and Swedes can do. Of the three Samic groups, it is the southern group that has been most strongly oppressed, both by the larger Samic groups and interests and by the Norwegian or Swedish local and central authorities. In Sweden, the South Samic language has been under immense pressure for decades; as a result, it can now be regarded as a dying language and culture.

The South Samic group Dearnan Sitje is based in Björkevatn, in Tärna in Sweden and is a part of the Sámi Teáhter/Samic Theatre in Kiruna. The group is also a partner of Åarjelhsaemien Teatere/South Samic Theatre in Sweden and Norway. Åarjelhsaemien is collaboration between Norway and Sweden, working primarily with theatre for children and young people, and offering courses and workshops for the education of leaders and others. Through this, they are hoping to recruit and train new theatre workers in all aspects of the theatre. The Samic Theatre in Kiruna administrates all collaborative efforts and directs the Samic professional theatre productions in Sweden. The Samic Theatre in Kiruna has also partially collaborated on productions such as *Vattufall*.

The manager and director of the *Vattufall* project, Eva Helleberg, is employed by the Samic Theatre in Kiruna, which in turn is managed by Lillemor Mauritzdotter Nylén.

The main theatre tradition among the Lapps in the northern part of Norway and Sweden is storytelling and their *joik* music. As Ola Graff (2001: 42) explains, '*Joik* expresses a fundamental referred relation and a referring object.' It is mainly a kind of folk music based on oral traditions and the melody is very seldom written down. It is categorized into three different versions: ritual *joik*, storytelling *joik* and personalized *joik*. It is mainly a form of unaccompanied vocalized singing, but drums have been the accompaniment if instruments have been used. You may *joik* nature, spiritual phenomena, a story or poems, a person, a feeling or an action (Graff 2000: 263). Today, *joik* is used in various genres of pop and rock music.

I will now make a brief excursion into a theoretical framework derived from Habermas's work, because I find it useful for understanding community-based theatre in an indigenous context. Habermas has developed a model of 'the world of life' and 'the world of systems' (Madsen 1997: 80) (see Table 10.1).

The society

World of life

- Values
- Norms/rules
- Standards

In this world, values and norms influence people's actions towards and interactions with each other in social communities. We are all unconscious about our own relations to these norms and values – they are not questioned.

Relations between people are based on mutual understanding.

An action of communication is a coordinated action between people where individuals are in agreement with each other's purposes.

These actions of communication create human resources which are basic and deeply ingrained in this 'world of life'.

Action of communication is necessary as a part of social life and behaviour.

The resources are:

- *Identity:* a resource which helps an individual define who they are in contrast to the rest of the world.
- *Solidarity:* describes actions and interactions which are a person's practice of life. Through actions based on common norms, the person achieves connections with the community and the person is creating the resources of solidarity
- *Meaning:* made up of the cultural values and frames of understanding that motivate a person to act in the social world. These values are created by the social interaction between people. The knowledge of culture enables people to develop meaning as resource.

World of systems

- The market; controlling the financial life
- The government; controlling politics by power

In this 'world' there is no action of communication, which is coordinating the actions between people, because the purpose is not mutual understanding. Here we find strategic actions, which control the relation between people. That means that people are controlled by various promises of advantage or by threats of sanctions and punishment.

TABLE 10.1. Habermas's view of society. Source: Madsen (1997: 179).

Habermas sees these two versions of the world as two different aspects of social relations between people (Madsen 1997: 80). He looks at history as an expression of changes in these two worlds. In a primitive and simple community, these two worlds go hand in hand as a varied unity.

The processes and development of modern society have separated the world of life and the system. This separation has created some profound differences: the system tends to penetrate the world of life and pressures it so that the ordinary sense of communication and the community of communication are threatened. When the system dominates the world of life in this way, it leads to a breakdown of what is real and what is not real, of what is true and not true, and threatens the continuation of the world of life.

A short description of the community of Björkevatn

Björkevatn is in a rural area. Back in 1951, it was composed of a cluster of twelve villages with a total of 174 people, which was eventually reduced to ten villages with 39 people by 1991. Today the population of Björkevatn area is about 50 people. After the Second World War, there was a strong urbanization movement in Sweden. At the same time, a powerful and effective oppression of the language and culture of the Samic people occurred. Today, South Samic people don't even have a Swedish/South Samic dictionary anymore, so they have to resort to a Norwegian dictionary.

This project was born four years ago. Two women, Lena Östergren and Eva Helleberg, started the project in Björkevatnet. Lena wrote the play and was one of the actors. Eva directed, produced and performed in the show.

None of the actors in *Vattufall* spoke South Samic; they all spoke Swedish. However, many locals want to learn their old language. As a result, from 2005 all Samic theatre productions will be in South Samic. Everyone now has to begin to learn the local language if they want to perform in theatre productions organized by the Samic Theatre in Kiruna. This is a challenging goal.

The story of Vattufall/Waterfall and Björkevatnet

The story of this performance is about how the world of systems penetrated the world of life during the 1950s and 1960s in Björkevatnet. Locals made their living by farming, hunting and fishing. Their rights as Lapps had been strengthened over generations. In this period, the Swedish government decided to develop this indigenous area for hydro-electric power production.

The government first sent anthropologists to document the local ways of life. After the anthropologists had completed their research, engineers and workers were assigned to measure engineering requirements for the waterline (which is 13 metres higher than the tallest chimney). Then representatives were sent to convince the local population of the many financial benefits and improvements to their lives that they would experience from this hydro-electric project. The government's representatives visited every house, and counted every spoon, fork, knife and piece of furniture. Very carefully, all information was gathered and recorded.

The government invited the inhabitants to information meetings where the locals were promised a fantastic future filled with work and money, and the newest modern appliances. Then the face-to-face negotiations began. The government's representatives employed money as power; for many of the inhabitants, the change from a barter economy to a money economy was substantial, so they were easily persuaded. The locals used their pay-off money to buy the latest products available in both Sweden and Norway in the 1960s, including cars, typewriters and televisions – even though they had no idea of how to use many of these items. They bought television sets without realizing that there was no local electricity yet. The locals were promised free electricity for the rest of their lives – which they do now have. Unfortunately, the quantity of electricity they receive free is only enough to light a single lamp! Some people built new houses as close as they could to the lake; many people moved to the south of Sweden to work in factories. Others moved to the east coast. From the outside, it looked as if everyone was satisfied by this quick progress.

One of the consequences was fog. Another was that the local authorities appropriated the local hunting and fishing rights from the South Samic people. Some of them even lost their status as Samic people because they farmed rather than working with reindeer. The authorities claimed that they needed to give these rights to some North Samic people who had to move their reindeer herds to the south. A barrier was placed to close the old road; it was locked and impossible to pass. At the information meetings, everyone had been promised a key to the gate, but that was only one among many promises that were broken. After about 30 years, the local people began to talk openly with each other about what they really felt about this 'progress' and the negative impact it had had on their lives – particularly now many of them had returned to the area to retire.

From a great idea to a final performance

Vattufall is an attempt to tell their story, and all scenes of the script are based on the history I have just reconstructed. The playwright, Lena Östergren, conducted

detailed research. She attempted to study the official anthropological reports, but they were nowhere to be found. She read old local papers, held interviews and spoke at length with the local people. She took part in an academic course and received both response and guidance from other playwrights. Then the scenes she wrote were workshopped, revised and developed in close collaboration with a local cast of fifteen actors and musicians ranging in age from twelve to 72. Some of the adult and elderly participants remembered a lot of stories from the 1950s and 1960s.

The first performance was scheduled for July 2003, but during the spring one of the actors became ill and died. Two weeks after that, the playwright's father – an important contributor to the project – also died. Since this was such a small community, these events profoundly affected the group, so the production went into a temporary hiatus. It is difficult to replace personnel in a small local group like this. Eventually the grief passed, and replacements were found so that work on the production could resume.

The final script contains eleven scenes. It has a narrative dramaturgy, which ends up in an absurd finale where present time fuses with the past and the future. The performance has an authentic (realistic) design and is performed in a popular way.

Summary of the script

The story centres primarily on two families and their development during the change of basis of their existence. One family is more focused on this than the other. The first scene introduces us to daily life in this family. The mother, Stina, works at the local telegraph station, which is located in her kitchen, and her husband, Arvid, is responsible for the mail in the village. Their children are Karin, Kjell and Sofia. Greta, the children's grandmother and mother of Arvid, lives with the family. Greta helps Sofia to sew a doll, working with leather from reindeer. Karin and Kjell are playing cards at the kitchen table until the father comes and brings his outboard boat engine to the kitchen table for repairs.

Inferring the information from the telegraph calls to the station, Stina discovers there are foreigners along the lake who are knocking down sticks, and she demands that Arvid go and tell them that it is their land. When he returns with the mailbag, Stina asks, 'Let me know! What did they do?' Arvid replies, 'They told me they created a shoreline ... and that they had authority to do the work they were doing. They told that people will come from Vattufall ... to inform us later on.'

Stina and Greta are confused and repeat the same questions while Arvid continues, 'Yes, I did say this is our land. I told them I have the legal text at home ... and the law says trespassing is not permitted.'

Stina is interrupted by several calls and listens to what people talk about. A car arrives and immediately there is a knock on the door. It is Siklund, who will do all the face-to-face negotiations. This is his first visit where he makes notes of the valuables while he chats. Arvid asks him:

ARVID: What is on your mind? Speak up Mister?
SIKLUND: Well, I'm looking around for … to complete a task for … well, what does Mr Nilsson imagine?
ARVID: Sorry … about what?
SIKLUND: Your entire house and property. Yes, now when … Vattufal comes?
ARVID: Well … I do not …

They are interrupted by calls and by Ida, a single and independent woman from the village, who comes to pick up her mail. As Ida and Siklund shake hands, a mutual attraction begins, which he tries to use as best he can in the face-to-face negotiations with her later on. Ida is a smart woman who can handle both business and private affairs; Siklund will leave a party scene later on, quite humiliated by her state of mind.

During two meetings, the local authorities and the leading management of Vattufall inform the inhabitants about the beneficial consequences of the hydro-electric project. All homes will get free electricity for the rest of their occupants' lifetimes; there will be lots of jobs; they will receive enough money to settle down in other places and purchase new and modern items.

The people argue loudly against the project and the chief engineer says:

CHIEF ENGINEER: Hmm … well, well … in conclusion I will propose a few things … The question of whether and how great the scope of the regulation should be … will be made by a legal decision … and involving His Royal Highness himself … Sweden needs electricity … The trial will take some time … but should be complete by the end of this year. We are hoping to be operational before … 1960. Those of you with property in the lake have the right to get an ombudsperson paid by …
GRETA: What … but the King, will he pay attention to this …? The King is no electrician!!!

People leave the meeting, loudly arguing among themselves about the information.

The following scenes bring us to the next stage of development. Karin gets a job as a counter in the forest; Nasaren, a travelling merchant, visits Stina and Arvid. He knows that there will be compensation money and offers them credit. This is a part of the play where the consumer society is satirized. Locals want to buy things they need, but end up with useless objects, because of the lack of power converters for electrical equipment, or because they buy fashion items that don't fit. Nasaren tricks them and leaves as soon as possible.

A meeting in front of the locked barrier infuriates the locals, already upset by the broken promises about their traditional rights. Once more, Siklund has to leave the crowd.

The next and last parts merge into each other and end, as mentioned earlier, with the blues, and then with a *joik*.

Britta (the mother in the second family) and her family are going to move from the village. She comes to say goodbye to Arvid and Stina on the beach. Arvid tries to be nice and says:

ARVID: Well, my good neighbour, you are still around. I have heard you will move to Strann. How exciting for you to leave the farm and Björknes and go to a new place!

BRITTA: No, honestly, it doesn't feel good ... It's difficult for me to leave the cattle. We had planned to take one cow with us, Svala.

ARVID: Take Svala with ...!? How ...?

They talk about all the money they have and Britta says:

BRITTA: Well ... money ... here we have lived for a long time without it. The most important thing is to have food on the table.

ARVID: Yes, but there's no harm either. Recently Stina has been so strange.

Stina comes and says:

STINA: I do not understand ... to build a new house without a basement ... A house without a basement is like a house without a roof ...

Arvid tries to help:

ARVID: I think it will be pleasant to move into a new house, in the middle of the property.

Time passes. The fog comes down and Arvid ends with these words:

149

INSIGHTS IN APPLIED THEATRE

ARVID: But why didn't I … why did I not do as I thought! If I had known this … I regret indeed … I should have done as I thought. I regret so much … I signed that paper!

(Translated by Landvik 2004).

Present time takes over with the return of Britta and her grandchildren. She reminisces about how things were before the hydro-electric project changed everything. Her grandchildren complain about the walk; they don't see what she is describing. They try to catch some fish, but there is nothing left in the lake.

The blues begins.

My work as guidance director

I was asked to help in September 2003, right after the production had resumed. The first performance was scheduled for December. Problems with actors and the need to find replacements continued until another actor left a month before the opening. Things now looked very bleak indeed.

A party for all of the inhabitants in the larger community had been planned for weeks. Both Lena and Eva had looked forward to it, but now they lost the joy of going because everything looked hopeless. They then made up their minds to go to the party and not return until they had found a replacement. As if by magic, they ran into a local man who had just returned to the area after living for many years in Los Angeles, where he had worked as an extra in the movies. For me, it was fantastic to watch how quickly he began helping the others around him.

To get people involved in a project like this is easy, but to keep them involved is very challenging for a community theatre facilitator. As Eva said:

Every time we thought we had things under control, something happened. We were close to giving up, but the will and desire to tell this story were so strong, we simply couldn't. After each crisis always something positive took place – as if in the fairy tale.

When I came into the production to work alongside Eva, my task was mostly to listen to the actors' storytelling and direct them into the script and scenes. There was a double purpose to this approach. The local actors contributed to the play with their own memories (what was said by whom), while the playwright, Lena, decided what material would be included in the script. There were more than enough memories for several more scripts.

Storytelling was also a therapy of sorts for the local participants. Their fictionalized role in the play gave them enough protection to tell it in public. For example, 'the fog comes' scene opens with an old man, Arvid, sitting in his kitchen drinking his coffee looking out over the lake where the fog drifts in. He becomes frustrated as he has been many times before and calls the Vattufall/Electricity Board. But he hears only the mechanical voice of an operator offering him several choices and asking him to confirm his choice by pressing the 'star' button. He gets mad at the voice, but gets no replies. He hangs up and calls again. This time he tries to listen and eventually realizes his old phone does not even have a star. He takes a cell phone from his pocket and tries one more time. Of course, it's the same telephone answering voice again, so this time he decides to write a letter. He goes to his typewriter and begins to spell out: 'Till Vatufall', but he types it wrong and in frustration pulls the paper out of the typewriter. This is repeated several times.

Then it happens – the actor forgets that he is an actor. After several attempts, he finally succeeds in typing the opening of his letter correctly. This confuses him, because he no longer expected this to happen. So he says: 'Yes, so what do I write next?' He reads the opening one more time: 'Till Vattufall'

'... What to write? How?' He looks to me for some help. I tell him he doesn't need to write the letter because the script tells him to do something else. But he wants to write the letter: he is really furious about the fog and now that he has finally typed the opening correctly, he wants to finish the letter. I help him to complete the letter. Once satisfied, he puts the letter in his pocket. Then we start the scene from the top again. He had told me many times about all the people who had bought such typewriters despite having no clue how to use them. So why had they bought them in the first place? By doing this he was perhaps close to either his own experience or an experience he had heard of. Some time later, this particular actor left the project for various reasons.

In this way, during many of the rehearsals we went deeper and deeper into what this story was really about. In many ways, it had been a taboo to confess their sense of lost identity, to confess some of the core feelings they felt about the local tradition and culture. Working on this project, the local actors began discussing these issues openly. The discussions continued during breaks. One of the greatest challenges for me was to let the actors talk – my method was to let it happen in its own time. Then I would use what was obviously important, focus and direct or lead the actors into what we were doing, and try to incorporate their perspectives into their roles or the situations.

Another challenge was dealing with the diminishing memory capacity of the old actors. I had to build their self-confidence in the scenes. There are always challenges in theatre direction which are not necessarily connected to old age, but when the

actors are in the early stages of senility, things can become very difficult indeed. The more truthful an actor can be to himself in a role, the better the result will be.

The first performance

Finally the first performance came, and all went extremely well. The room where the performance took place only had seats for 40 persons, but about 55 were there from the village. Some had to sit on the stage behind the actors. During the performance, people commented out loud, 'Yes, it was just like this.' And they laughed. But the final scene ended with a blues that almost imperceptibly transformed into a *joik*. It was very moving for everyone. Sitting there, my thoughts went to Augusto Boal and his experiences in the rural districts.

The audience was invited to join the cast and crew after the show, with food and drinks served. Someone from the audience thanked us because this performance had everything he could have hoped for: 'Fun, serious drama, irony and sarcasm, love and poetry, power and humility. It was about life – our life and history.' He was so grateful.

When all the important speeches were finished, it became dark. Believe it or not, we'd had a power blackout! Candles were placed on the table and now the real storytelling could begin. As mentioned earlier, storytelling is the truest form of theatre, both among Nordic people in general and Samic people in particular.

As the story was told in the play, one of the characters had his outboard boat engine sitting on the kitchen table. A lot of our scenes took place around this kitchen table while the man tried to fix the motor. This activity became the inspiration for 40 minutes of spontaneous outboard engine stories told by people in our audience. They were told in such a hilarious way that people were howling with laughter. I could not comprehend all the references, but I understood enough to follow the gist. The energy was incredible.

The power in Bjørkevatn did not return until 11.25 a.m. the next day, which was a Saturday. It was the end of April. During the night, the ground had become white with 20–25 centimetres of snow, which was unusual this late in the year, even for this part of the world. There was still no power in Mårbacka at noon, and I asked Eva if they were going to cancel the next show, planned for that evening. 'Nobody can stop us,' she answered. 'And least of all the Vattenfall [the Electric Power Company]! A lot of people are making coffee at home; someone else has arrived with a power generator so that we can use our theatre lights; a third person went home to get a large container holding 1000 litres of water so that we can have functioning toilets.'

'See? Everything's under our control,' said Eva. 'They can do whatever they like to us and we don't care.' They were an amazing group of people.

So this is community-based theatre the way we practise it up north, and it shows how, as Habermas described it, the world of system penetrates the world of life.

Acknowledgement

This chapter was originally published as Article 5 in Volume 6 (2005).

REFERENCES

Graff, O. (2000), 'Joik: Joiken – den samiske folkemusikken', in *Ekko 1.Musikkorientering VK1*.Otta, Norway, Gyldendal Norsk Forlag ASA.

Graff, O. (2001), *Joik på nordkysten av Finnmark — undersøkelser over en utdødd sjøsamisk joiketradisjon*, Tromsø: Tromsø Museum, Universitetsmuseet Troms.

Landvik/Östergren (2004), *Vattufall*, Björkevatn/Kiruna: South Samic Theatre.

Madsen, B. (1993), *Sosialpedagogikk og samfunnsforandring*, København ad Notam: Gyldendal.

Van Erven, E. (2001), *Community Theatre: Global Perspectives*, London: Routledge.

11

Spectacular violence and the Kachahari Theatre of Sindhuli, Nepal

Alberto Guevara

This chapter is based on field research carried out among a Dalit theatre group working against caste discrimination in an atmosphere of fear and violence in Sindhuli, an eastern district of Nepal. It explores how and why Maoist and government troops *direct* states of violence and fear in a garrison town, and it pays attention to the ways in which the members of the theatre group negotiate witnessed and rumoured violence within this context.

I spent the summer of 2005 living among these activists and taking part in their theatre work, consisting of workshops, preparations, rehearsals and public presentations. One of my goals during this research was to gain a sense of how these theatre workers – who regard *theatre of the oppressed* as a tool for social change – practise their craft in this tense local and national context. What are the possibilities for and challenges of engaging in social activism in a context where critique of current inequalities is the cause espoused by Maoist rebels and therefore dangerous for the group?

As I came to realize, the ongoing work of the Dalit theatre group requires careful consideration and management of local authorities' perception of the group in town and a clear understanding of the national socio/political situation. As a study of the theatre group's embodied reactions to national narratives of violence, this work aims to contribute to understandings of the complex relationship between political violence, theatre activism and performance theory.

This exploration seeks to add to the study of performed violence from an interdisciplinary and cross-cultural perspective (e.g. Coronil and Skurski 1991; Feldman 2000; Parkin 1985; Scheper-Hughes and Bourgois 2004; Skidmore 2003; Taussig 2004; Taylor 1996, 2003). Understanding violence as encompassing all forms of 'controlling processes that assault basic human freedoms and individual and collective survival' (Scheper-Hughes and Bourgois 2004: 21), the focus here

is on symbolic violence as a 'theatricalized violence' in both national and local contexts. The study looks at violence as an evocative act that has cross-cultural resonance (Parkin 1985: 2), and that needs to be understood within its own particular cultural, social and historical context.

'Theatricality of violence' as an interdisciplinary and cross-cultural framework for analysing social relations revolves around the notion of 'rhetoricity' as a social, political and cultural intentionality in contested systems of power relations. From a 'dramaturgical standpoint' (Turner 1988), the *form* of presenting a situation (i.e. violence, control, force, power or social accommodation) by actors aiming to create a certain impression on audiences can be viewed as 'theatricality', and is shaped by environment, audience and actors (Goffman 1959). As in the conventions of the 'theatre', the purpose of 'theatricality' is to activate audiences' actions. The construction of social relations in this case involves roles, characters, props, supporting casts, scenes and audiences.

Echoing Taussig's (2004) view that cultures of fear and terror 'are based on and nourished by silence and myth ... by means of rumour and fantasy woven in a dense web of magic realism' (2004: 49), I propose that 'theatricalized violence' is a powerful tool for social control in the ongoing civil unrest in Nepal. As a tool and arena for domination and subjugation, the 'theatricality of violence' is both 'actual' and 'symbolic'. As a 'scopic regime', it is 'an ensemble of practices and discourses that establish truth claims' (Feldman 2000: 49), which normalizes social structures of control. I do not want to imply that a state of fear is not generated and perpetuated by actual physical violence in Nepal. Certainly, actual violence and fear suffuse people's everyday lives – thus the institutionalization of symbolic (i.e. theatricalized) violence staged by the protagonists of the war in Nepal with a population (audiences) in mind has become a powerful tool for maintaining and challenging power in the country. For example, casting others involved in the social and political conflict of Nepal as heroes, villains or neutral bystanders, depending who is enacting the social performance in Nepal during the conflict, can be seen as a deliberate effort to create a social environment facilitating the creation, imposition or replacement of normative systems in the population.

It is under the conditions of fear of violence, for example, that individuals and groups could enact social relations in public and private, as masks of intentions and feelings and as ritualized normative behaviours. 'Neutrality' or silence about what is going on around one in this context could become a password, a mask, a daily ritual – and a way to access a sense of 'normalcy' in one's social life. For the members of the Dalit theatre group, for instance, claiming 'neutrality' in public and even in private became a presentation of self, allowing their critical theatrical activist work against caste discrimination to continue. It is precisely in this normalizing framework imposed by the protagonists of terror and violence in

the country that the members of the theatrical group and others have found the tools to defy caste discrimination and systematized historical oppression, and to oppose social inequality.

During my stay in Sindhulimadi, the district headquarters of Sindhuli, I observed my informants' verbal and non-verbal reactions to national and local events. When it came to both their private theatrical and public everyday lives, I paid particular attention to the dominant and counter-hegemonic representations of Nepal's current political and social conflicts. I engaged in informal discussions with no particular priority of questioning, as open-ended dialogues allowed rich and diverse knowledge to emerge. I also conducted dozens of interviews with my main informants, Bir Bahadur and Deepak, their families and many other people in town. The written data I was able to assemble here represent my effort at a cross-cultural and intersubjective discussion. My hope is that this ethnographically negotiated article will serve as a catalyst for further research on this topic and on the region.

Contexts: The 'people's war' and the theatricality of violence and fear

I draw on performance theory (e.g. Beeman 1993; Fabian 1990, 1998; Reed and Reinelt 1996; Schechner 1993, 1998; Taylor 2003; Turner 1988) as a theoretical and methodological framework for this social/cultural inquiry. I draw on phenomenology (e.g. Desjarlais 1992, 2003; Feldman 2000; Jackson 1996) as an experimental vehicle that facilitates a close interaction between the internal (my own and my informants' subjective experiences) and external (external to the subject) conditions of knowledge. As a framework for analysis, I use the concept of the 'theatricality of violence' to navigate between two very important overlapping social spaces: the theatre of activism within a context of social conflict; and the theatricalization of the national conflict within the nation. Following is a brief exploration of the historical context of this national conflict.

As a multi-ethnic and caste-based society, Nepal is a nation where one of the fastest developing civil wars in the world took place from 1996 to 2005. The Maoists and the political parties signed a new peace agreement in the last months of 2006. This new deal sidelined the power of the monarchy to a great extent, and has given the Maoists a chance to participate in the 'democratic' process again. By 2008 the old regime gave way to a new republic and as of late 2008 the Maoists were occupying the most important positions of political power in the new republic. There is great optimism in the country about the prospects for long-term peace.

Ethnic and social groups such as the Dalits, the Magars, the Tharu and many others felt and still feel a sense of cultural and social prejudice, and are struggling to affirm their vision of a 'Nepali nation' (Thapa 2003). The establishment of a liberal market economy in the country in the 1990s did not change the marginalization felt by ethnic groups, Dalits and women (Roka 2005). Moreover, 'because of liberal democracy ethnic groups, Dalits and women, all of whom have long been oppressed, realized the extent to which they have been ignored in religious, social, political, economic and also psychological terms' (Roka 2005: 250). The traditional elites and ruling groups, the Brahmin-Kshetris, have become the target of those ethnic and social groups fighting for political and cultural emancipation. The 'people's war', an effort to put an end to the current political system that the Maoists perceive as oppressive, is seen by some (mostly intellectuals and academics) as the ultimate outcome of centuries of systematic inequality in the country (e.g. Hutt 2004; Thapa 2003; Thapa and Sijapati 2003). There are some intellectuals who disagree with the notion that the rebellion is the consequence of failed development, poverty and corruption (see Hachhethu, cited in Hutt 2004). The rebels have harnessed this 'longstanding resentment of many minority ethnic communities' to their cause (Hutt 2004: 18). They have organized a number of liberation fronts around these groups (the Tamang National Liberation Front and the Tharuwan National Liberation Front, among others). The Maoists have also taken the cause of groups such as the Dalits as they advocate the elimination of caste discrimination in the country. The 'people's war' launched in 1996 by the Communist Party of Nepal (Maoist) stretched to almost half of the territory of Nepal. What was initially a group of a few hundred poor peasants, former soldiers and unemployed youth grew to comprise an army of more than 25,000 fighters by 2006.

In February 2005, after almost a decade of bloodshed, King Gyanendra, in an attempt to put an end to the Maoist rebellion, declared a state of emergency and dissolved the government. This royal takeover brought the monarchy and the mainstream political parties into sharp conflict with each other. Political leaders were detained and some remained in detention seven months later. Mass detentions, the curtailing of freedom of speech, the security forces' involvement in the disappearance of alleged Maoist sympathizers and human rights activists, and the increasing military campaigns by the Maoists – sometimes against civilians, and not only in the countryside but also in the cities – were just some indicators of the country's delicate political situation.

When my wife and I arrived in Nepal in the summer of 2005, Kathmandu seemed at first unchanged from the previous year. In the main tourist zone of Thamel, shopkeepers found the flow of visitors low, but it had been that way for several years. As we joined my friends, local artists and expatriates, we started to

feel a sense of vulnerability and fear around us. The social and political violence streaming from the government's heightened war on 'terror' had taken its toll on my contacts. This situation – a ban on non-governmental radio stations, censorship of all media, the detention of political and student leaders, and the alleged torture and disappearance of some human rights and social activists – has created a state of apprehension in the population, which rendered my friends almost silent about the political and social situation. The previous year, some acquaintances and informants had openly expressed their dissatisfaction with the country's leadership. In contrast, this year the King's name was never uttered in my presence and the mention of the social and political situation was consistently vague. For example, one friend informed me that 'everything is not fine, but the conflict will be over soon'. He would not elaborate on how it was not fine and instead quickly changed the topic. Another friend, who manages a shop in Kathmandu, told me that the problem was in remote areas: 'If you stay in the capital there is no problem. Everything is fine here.' Many shopkeepers in Thamel were surprised to hear of our intended destination in the Eastern part of Nepal. This was a region, they told us in hushed tones, controlled by the 'second government' – a term I heard often throughout my stay in reference to the Maoists.

We were apprehensive about the safety of our contacts. We were mainly concerned about the consequences that their association with us – two Western scholars – could have for them under the present circumstances. After some days in Kathmandu, I established contact with Bir Bahadur and Deepak, the director and the secretary of the Dalit Kachahari Drama Group Sindhuli. While our theatre friends appreciated our ethical concerns, they encouraged us in our plans to go east. They assured me that the situation was calm and, perhaps most significantly, they emphasized that they had good relations with the local (government) authorities. The group had been waiting for us for a year since our last visit, and local authorities were aware of our imminent arrival. As the eastern area is not one frequented by tourists, and I apparently look Nepali – which they insisted could be dangerous for us – we were provided with an escort from another theatre group who accompanied us on the bus rides from Kathmandu to the town. Thanks to this guide and our Canadian passports, we were able to get through without incident the dozen or so military checkpoints that mark the journey on every route in and out of Kathmandu, and arrived safely in Sindhulimadi.

Although it is not far from Kathmandu (about 120 kilometres), it takes over twelve hours to access the district headquarters, Sindhulimadi, from the capital and annually the monsoon increases the town's isolation by destroying the dirt road leading to the town. Sindhuli is one of the many sectors affected by the recent waves of Maoist insurgency. Military checkpoints mark all entry points to the town. Some years ago, according to locals, the army and police tried to

dislodge Maoists from some of those few surrounding villages accessible by vehicle. Whether as a result of intimidation and/or strategy, army and police now do not venture beyond Sindhulimadi. Due to the presence of the insurgents in the area, the residents of Sindhulimadi and its surrounding villages observe a military curfew. From 8.00 p.m. to 4.00 a.m., people's movements are restricted to their own houses. No one can step outside. Violation of this restriction places one at risk of being shot by the police or military, who jointly monitor movement from vantage points throughout the valley.

Sindhulimadi (population about 5000) appeared to be relatively peaceful. With its throngs of goats, solitary cows and flocks of ducks wandering the streets at all times, and its many colourful shops exhibiting their merchandise, its inhabitants did not look particularly stressed or anxious. At the same time, there were hundreds of troops stationed in town, with a highly visible presence. They ride or walk through the streets in groups throughout the day; their guard posts surround the valley; an occasional helicopter flies overhead. In the morning, we would wake to the sound of hundreds of boots pounding the street marking the start of a series of daily spectacular exercises and patrols into the city. And yet, echoing our discussions with friends in Kathmandu, in Sindhuli there was no war; the war was in 'remote villages', our informants told us.

Such assertions by our contacts were given in spite of almost daily and sometimes dramatic protests from students, journalists and political parties in Kathmandu's streets and throughout the country, including Sindhulimadi. While I was in Nepal, there were daily rallies for press freedom, the liberation of political leaders in prison and the restitution of democracy. A motorcycle rally organized by Nepali Congress Party (*Kathmandu Post*, 31 July 2005), coconut offerings to monkeys in the Swoyanbhunath temple organized by journalists (*Kathmandu Post*, 22 June 2005) and a torch rally against student leaders' arrests (*Himalayan Times*, 30 July 2005) were some of the social and political dramas performed in Kathmandu. In a country experiencing violent, and sometimes deadly, political and social upheaval, the reactions of my friends seemed contradictory. I sensed fear and vulnerability all around me. However, there was total silence about the war and life continued as if nothing were happening.

Was I feeling something that was not being experienced by the people in town in general and by my informants in particular? As my sense of fear and vulnerability began to increase, I started wanting to know about the people's deep sense of (emotional response to) the situation. It became clear, as I experienced life among this community, that 'to an important extent all societies live by fictions ... as reality' (Taussig 2004: 49). Living by fictions and myth as reality helps carry on the status quo. According to Suárez-Orozco (2004: 384), referring to the 'regime of terror' perpetuated by the Argentinean government in the 1970s, 'some people came to

believe that there were minor abuses against only the ones who were involved in something'. Thus 'collective silence became part of the madness as if it intervened in the causality of events' (Suárez-Orozco 2004: 384–85). Fear shapes people's social interactions.

For Skidmore (2003: 9), referring to the political conflict in Burma,

> fear is the most common emotion constructed by the regime. At times its generation is an accidental, unplanned side effect of the regime's policies, but the majority of the time, the regime deliberately uses strategic and symbolic violence to engender fear and terror.

In Nepal, where the symbols of violence are all around, fear – as in the case described by Skidmore – is an instrument of control and domination. The performance of 'neutrality' as an effect of violence could be a necessity of which ubiquity may or may not be conscious.

This point becomes clearer if we consider that, besides brutal force, the main protagonists in the ongoing social and political struggle in Nepal – the government and the Maoists – use theatricality (in national and local contexts) as a rhetorical tool to advance their goals of political and military control. For example, the Royal Nepalese Army has been known to show military strength through the militarization of cities, towns and roads. Army personnel guard rotundas, plazas and important buildings throughout the nation; however, curiously, in the capital they rarely stop or question those they observe. The army's heavy presence in the country has become an everyday occurrence. The Maoists are also known to exhibit their force with highly 'dramatic' (as both 'actual' and 'symbolic' violent acts) bomb attacks on strategic targets in the capital and other places in the country. It is important to state that these attacks rarely kill anyone. These carefully staged social and political acts are obviously 'real' violence, the main point of which is to maintain power through assertion of military control and fear on the one hand, and the creation of a climate of unpredictable shock and fright on the other. By writing their own 'dramas' and representing them through their own rationalizations of their use of violence, and by casting the citizens in the country as heroes, villains or 'neutral' bystanders, both sides use this 'theatricality of violence and fear' in their attempts to reshape the current Nepali social and political situation.

Regardless of the 'reading' of this spectacularized violence, they can create an atmosphere of fear that allows the power brokers to maintain power. As Diane Taylor (1996) – referring like Suárez-Orozco to Argentina's dictatorial regime – exemplifies, through theatricality power brokers in a nation can maintain power by creating a climate of fear and violence, thus keeping people silent about atrocities

committed. The theatre of violence that envelops Nepal blurs the boundaries between rumour and actual events, 'fact' and propaganda, witnessed and suspected atrocities, real and alleged casualties, real and alleged arrests, real and alleged death. This 'theatricality of violence' and fear thus reshapes people's worlds and produces normative changes in society (Taylor 1996). Can the presentation of oneself as a 'neutral' or 'silent' citizen in the political situation be the key to staying out of danger?

Truth and illusion in private and public performances

The theatre group's struggle against caste discrimination should not be seen as taking sides in the political and military situation. As long as its theatre work is not framed as a critique of the regime or the Maoists, the group is allowed to operate – albeit with many restrictions and dangers. It became clearer to me after several weeks in his village that Bir Bahadur's declaration that the town was 'safe' was a result of his own very intentional positioning within the militarized zone of Sindhuli. Bir Bahadur's understanding – or at least his projection – was that Sindhulimadi was safe for those who observed the military curfew and for those who were not directly involved, or perceived as being involved, in the conflict. As long as the theatre group's work remained 'apolitical', in the sense of not belonging to a political party or the Maoist outfit, its members would be safe. Bir Bahadur assured me that the authorities and the 'second government' knew that the theatre group was neutral: 'Political parties are targeted by the rebels. Our theatre group is not a political party. We do not belong to any political party.'

One day, Bir Bahadur took my wife and me on a tour of his village, an arrangement of about ten houses some distance from one another and surrounded by a hill overlooking the town of Sindhulimadi. While he was (with a luxury of detail) introducing his neighbours to us, we heard a big bang. Later on, while having breakfast, we heard another big explosion. A bit concerned, I asked him about it. 'I think it is the army,' he said. 'They may be training with explosives.' Though visibly preoccupied, Bir Bahadur assured me that Sindhulimadi was 'safe'. Was this part of the silence or a theatricalized response to fear and the violence of the state? Was denying danger a way of establishing a sense of public neutrality that corresponded to the theatricalized violence in the nation? Bir Bahadur's attitude and persona seemed contradictory in light of the context where human rights activists and politicians seeking social reforms were being imprisoned as allies of the Maoists.

At times, the political situation restricted the place where and times at which the theatre group could show its plays. At one point, Bir Bahadur and Deepak organized

a week-long Kachahari workshop in which I took part. The idea was to train local and remote villagers in the use of theatre as a social tool. The group of new actors received a week-long workshop on the history of popular theatre, the uses of forum theatre, voice, movement and stage direction, and a seminar on the history of Theatre of the Oppressed. At the end of the workshop, the group had prepared three different theatre pieces to perform in town: one on gender inequality; one on environmental pollution; and the last dealing with child labour. While they were planning the public performance, they came up against a number of obstacles. At first, the group could not secure a permit to perform in public. As the disappointed participants milled around, Deepak detailed for my benefit the need to get permission:

> Our number one responsibility is to the actors. Then the performance. But first we need to make sure our participants are safe. Many participants are from villages. We always need permission, but if everyone here were from Sindhulimadi, there would be less risk. The authorities would know that it's just us, they know us, they know we do theatre, and they would recognize us. But many participants in the workshop are not regular participants in our group. They are new faces. Maybe the authorities don't recognize them and are suspicious. This can be a problem. It can also be a problem because if something happens during the performances, and the authorities didn't know we were performing, they may think we are responsible for a bomb, an attack, or a kidnapping.

Given our failure to secure permission, that day's presentation was cancelled. Under the political situation, any gathering of people needed to receive permission from a government official and the chief of police. The following day, Deepak was able to get a permit, but not before a number of conditions had been imposed by the officials on the public presentation.

In general, to ensure their work was acceptable to the government and the Maoists, Bir Bahadur and Deepak had to make enormous efforts to publicly maintain politically neutral personas whose main concern was to promote the Dalits' causes. In town, they are friendly with everyone and pay particular attention to those people who are Dalits like them. The presentation or projection of 'neutrality' manifested in public is the key to the group's survival. How did the public personas, obviously performed in public for everyone to see, correspond with their private realms? Was the social and political national conflict structuring or restructuring the daily lives of the members of the theatre group and their families within the home just as it was outside it?

My wife and I spent days and nights in the houses of Bir Bahadur and Deepak. In these relaxed and intimate situations, I could sense my informants' and their families' fear of violence and sense of vulnerability. One night, as a way of cultural

exchange, I cooked my host (Bir Bahadur), his wife and other members of his extended family *comida corriente*, a Nicaraguan dish consisting of rice, beans, a little meat and salad. After the meal was prepared, we retired to the second floor to eat as it was already past the 8.00 p.m. curfew. As we talked, watched some Nepali and Hindi films and commented on the similarities and differences between Nepali and Nicaraguan food, our conversation somehow switched to the political issues of the day. Venturing into such conversation was like entering a different room. As if invoking a terrible invisible force that punishes you when you do not do things right, the family members in the room physically changed. Their voices became soft. Bodies became tense. Some family members were visibly shaken and upset. One paid particular attention to shutting all the windows to ensure that nobody outside the room would hear the conversation, as misunderstanding could ensue. The words exchanged were not at all critical – they were just discussions of events, news items of the day reported in that day's newspaper. Bir Bahadur and his family were worried about being heard and misunderstood, as though any expression of concern or curiosity about the situation could be misconstrued as 'political' activity, as complicity with the 'wrong' side.

The protagonists of terror cast their audiences (the people) as villains, heroes and sometimes 'neutral bystanders'. The presentation of 'neutrality' in such a volatile system has become a necessary way of life. The members of the theatre group, such as Bir Bahadur and his family, considered it necessary to play the role of neutral bystanders even at home. Otherwise they feared appearing to side with the enemy of the state or the Maoists, and as a consequence becoming victims of the violence. They tried to play a very 'neutral' role as passive citizens with no views about the current situation. At the micro level, as in a small, private, intimate scene of a play, the theatricalization of violence and fear in Nepal can be experienced in situations such as occurred in Bir Bahadur's home. I believe that these are instances of social control where everyone in town could be considered the invisible eyes and ears of the regime or the Maoists: 'The truly crucial feature lies in creating an uncertain reality out of fiction, a nightmarish reality in which the unstable interplay of truth and illusion becomes a social force of horrendous and phantasmic dimensions' (Taussig 2004: 49).

Indeed, there are many instances in which violence has touched the members of the theatre group in Sindhuli indirectly – trying to help a Dalit victim of the security forces or the Maoist violence – or directly – a family member killed in the conflict. For example, during the third day of the theatre workshop, a Dalit woman aged about 35, who had travelled for several hours by foot to the district headquarters, came to look for Bir Bahadur and Deepak. Deepak immediately excused himself and went outside into the garden to see how he could help the woman. It turned out that her husband had been killed by the security forces a few months earlier,

accused of being a Maoist. According to the Dalit woman, her husband was not a Maoist; he was a poor farmer caught in the middle of the war. Now, because of ancient patriarchal laws (see Chhetri and Gurung 1999; Höfer 2004), the woman was left without any civil rights for herself and her family. She was looking for some help from the Dalit theatre organizers, who also manage a welfare society for Dalits in the district. Not surprisingly, this case of a Dalit farmer victimized by the security forces' violence was not an isolated incident. In the climate of war prevalent in the countryside, the Maoists also harm Dalits.

Remarkably, the members of the theatre group, although perhaps fearful of violence in their constructed 'neutrality', were not necessarily silent; they were prepared to speak against caste discrimination and the ills of social inequality in their plays. They managed to stage themselves individually and collectively as bystanders to both the Maoists' and Royal forces' violence. However, how they perform such 'neutrality' is interesting. The course of their struggle for caste equality, as a theatricalized response to the war through theatre activism, takes advantage of the overlapping social/political zone created by the presentation of the conflict in the nation by both the government and the Maoists.

Theatre, caste discrimination and intentionality

Some questions come to the fore when considering the role of the theatre group as both critical of caste discrimination and at the same time presenting itself as a neutral bystander in the civil war. Why is it that the theatre struggle against caste discrimination is not seen as a threat to the state? After all, the Maoists had made the Dalits' plight their cause. How effective could the group's work be if the issues of inequality they articulated in their theatrical work were of no importance to the state? On the basis of this research experience, I suggest that the answer to these questions lies in the way the group frames or performs a response to the socio-political situation, the spectacularized violence perpetrated by both Maoists and the government. By creating, performing, staging and living a theatricalized exist-ence, one that overlaps with the theatricalized socio-political state of the nation presented by both the government and Maoists, the group presents and maintains both its social struggle against caste discrimination and a position of 'neutrality'. Who group members are in terms of the social political discussions in the country is also important in the way the group frames itself *vis-à-vis* the history of caste discrimination in Nepal.

In Nepal, 'caste equality', or 'caste harmony', is government policy. Laws have been written that champion the fair treatment of Dalits. It is thus a govern-ment policy to – at least rhetorically – defend caste equality and speak against

caste discrimination. Within this context, it is the public discourse of the government that all disadvantaged groups in the country, including Dalits, will be protected. For the Maoists, as we noticed before, the cause of all the discriminated and oppressed peoples of Nepal – mainly the Dalits – is also presented as their cause. The Maoist rhetoric is almost indistinguishable from the rhetoric against caste discrimination presented by Dalits' leaders. Appearing to be against the fight against untouchability, or caste discrimination, would seem contradictory to their self-image. Thus, in principle, it would be against the official discourse of both (government and Maoists) to restrict the work of the theatre group.

The members of the Dalit Kachahari Drama Group are farmers, musicians, teachers, students and blacksmiths. The main theatrical tool they use to critique caste discrimination in their district is Kachahari (forum) theatre. A theatrical expression originating in Latin America, Kachahari (forum) theatre was introduced to Kathmandu less than a decade ago and has spread throughout the country. Implicitly and explicitly, the group's theatrical interventions question the social treatment of Dalits as second-class citizens. A solution to their problems of discrimination and lack of resources is sought through public education (about their rights as human beings and citizens) and through social action (critique of all understandings of caste relations). 'The reason why we do Kachahari drama is to raise Dalit issues,' Bir Bahadur told me:

> Slowly, slowly we have become excluded socially, economically and politically. We have become very marginalized. Higher castes treat us as untouchable and don't eat anything we have touched. They gave us a different name. They labelled us untouchables. They marked us with a black stain. To erase this black stain we do Kachahari. For many years our people have been living in a system of untouchability. In my village, upper caste people treat us as undesirables. They say that they don't believe in untouchability but they practise it. They treat us differently in their home. They dig a well and do not allow us to take the water. On the street they walk as far as possible from us. This mentality exists here in our district of Sindhuli. For those Dalits who are economically, politically and educationally discriminated against, we do Kachahari (forum) theatre in their villages.

One of the main strategies the Dalit theatre group has adopted in its quest for social equality, to take advantage of the overlapping social space between the rhetoric of the Maoists and the government towards caste discrimination and the theatricalization of violence, is the discussion of social issues that can be framed theatrically as Dalit concerns. For the members of the theatre group in Sindhuli, staging a specific type of discrimination such as gender inequality in a play is a good way to link such issues to the critique of caste discrimination. Furthermore, in such a

presentation, the critique of caste discrimination is distanced from a critique of any political party. The notion of neutrality thus plays out practically within the performance aesthetic itself. One play prepared during my stay, and later publicly presented, was about gender inequality in jobs, such as the construction of waterways in town, where women are paid much less than men. Due to the fact that the majority of women working in these hard jobs are Dalits, the main problematic discussed by the play was framed as a Dalit issue. Because of years of marginalization, Dalit issues thus correspond with issues of poverty, exploitation and discrimination that are widespread at the local and national levels. Under such circumstances, the theatre group can theatricalize its theatre work as neutral and in support of caste harmony. As such, the theatre group believes that Kachahari theatre has the power to be the tool with which it can reach out and change society. Bir Bahadur states:

> Through Kachahari theatre, we Dalits, who live at the margins, are trying to create a dialogue with all other groups in Nepal. We do Kachahari to facilitate our fight for Dalits' rights in a peaceful way. We do Kachahari to build and strengthen our community. To transform our internal divisions, we engage in Kachahari theatre.

For the theatre director and the rest of the troupe, Kachahari theatre has provided a powerful tool to express their hopes and visions of their future in their country. For them, their theatrical work has contributed to creating positive changes in local attitudes about their people (Dalits) in recent years. For example, according to Bir Bahadur, the whole notion of untouchability, the segregation of activities and areas for praying and eating, has slowly been changing in the town. New generations are now more willing to put aside centuries-old attitudes in favour of new ways of understanding inter-caste relations. A testament to this changing attitude, for the group, is the fact that people from other castes have joined their theatrical work. This does not mean that caste relations have changed significantly. Bir Bahadur and Deepak complain bitterly that people express one thing in public (i.e. that they don't agree with caste discrimination), but their behaviours show another. For example, Dalits are still banned from some hotels and restaurants in town.

The group is perhaps over-optimistic about the changes its theatrical work have brought to Dalits' struggle, but without a doubt its theatre work has opened up new avenues through which to approach life with a greater degree of self-reflectivity. Bir Bahadur, for instance, works against discriminatory practices in his everyday life. He is an excellent cook and helps with the cleaning – both traditionally women's tasks. He has also, against tradition (at least at the local level) and the will of his father and paternal family, married 'down' within the caste system. While he and his wife are both untouchable, she is of a lower sub-caste

than himself. Bir Bahadur's awareness of the importance of his own actions is a result of theatre: 'Before theatre, I never care about my activities and the impact of my actions on society. Nowadays I am always aware of the repercussions of my actions on the community.'

Bir Bahadur insists – and I had the opportunity to observe this – that his relationship with his wife is informed by his theatrical activities. 'One has to be aware of gender relations in and out of the performances, in performance and in the house,' he posits. For the members of the group, such as Bir Bahadur forum, theatre is the vehicle capable of facilitating social transformations that start by transforming the activists themselves.

Concluding notes

As a framework of analysis, the 'theatricality of violence' allows this inquiry to navigate between two very important overlapping spaces of analysis: the theatre of activism within a context of social conflict in Nepal; and the theatricalization of that conflict within the nation. As a social environment facilitating the creation and imposition of normative changes in the population, this analytical framework highlights very important conjunctural power relations in the country. It is exactly in this normalizing framework, imposed by the protagonists of the war in the country, that the members of this theatrical group and others have found the means to defy caste discrimination and systematized historical oppression, and to wrestle against social inequities.

A significant revelation in this research has been the ways in which the form and content of social and political materials can theatrically be transformed in order to persist even under politically and socially dangerous circumstances. Groups such as the Dalit Kachahari Drama Group have found a way to use the theatricalization of the civil war as a tool to advance their theatre activism. Responding to theatricalized violence stemming from the government and its political opponents alike, the theatre group has managed to maintain a public image of 'neutrality', giving it a space – albeit small – to continue its social work. The group's public critique of caste discrimination, framed within a rhetorical theatrical form of 'political neutrality', has shaped the group's participants not only in their theatre work but also in their daily lives. The boundaries between theatrical action and social action, between theatre and daily life, have become blurred – perhaps conveniently and reflexively – thus becoming similar to each other. This situation has been somewhat beneficial for the group. It has given its members a degree of reflexivity that is useful to them not only in the theatre but also in everyday situations. As Augusto Boal (1996: 47) points out, 'the most essential definition of

theatre is the capacity that all of us have, as human beings, to observe ourselves in action'. Thus, observing ourselves in action is the first step in creating knowledge about our position in a social structure whose main premise is social inequality. For the members of the group, theatre and everyday life have become indistinguishable arenas to play, to do, to act and ultimately to survive.

Acknowledgement

This chapter was originally published as Article 1 in Volume 10 (2009).

REFERENCES

Beeman, W. (1993), 'The anthropology of theatre and spectacle', *Annual Review of Anthropology*, 22, pp. 369–93.

Boal, A. (1978), *Theatre of the Oppressed*, London: Pluto Press.

Chhetri, R. B. and Gurung, O. P. (1999), *Anthropology and Sociology of Nepal: Cultures, Societies, Ecology and Development*, Kathmandu: Sason.

Coronil F. and Skurski, J. (1991), 'Dismembering and remembering the nation: The semantics of political violence in Venezuela', *Comparative Studies in Society and History*, 33:2, pp. 288–337.

Desjarlais, R. (1992), *Body and Emotion: The Aesthetics of Illness and Healing in the Nepal Himalayas*, Philadelphia, PA: University of Pennsylvania Press.

Desjarlais R. (2003), *Sensory Biographies: Lives and Deaths Among Nepal's Yolmo Buddhists*, Berkeley, CA: University of California Press.

Fabian, J. (1990), *Power and Performance: Ethnographic Explorations Through Proverbial Wisdom and Theater in Shaba, Zaire*, Madison, WI: University of Wisconsin Press.

Fabian, J. (1998), *Moments of Freedom: Anthropology and Popular Culture*, Charlottesville, VA: Virginia University Press.

Feldman, A. (2000), 'Violence and vision: The prosthetics and aesthetics of terror', in V. Das, A. Kleinman, M. Ramphele and P. Reynolds (eds), *Violence and Subjectivity*, Berkeley, CA: University of California Press, pp. 46–78.

Fisher, W. (2001), *Fluid Boundaries: Forming and Transforming Identity in Nepal*, New York: Columbia University Press.

Goffman, E. (1959), *The Presentation of Self in Everyday Life*, New York: Penguin.

Höfer, A. (2004), *The Caste Hierarchy and the State in Nepal: A Study of the Muliki Ain of 1854*, Lalitpur: Himal Books.

Hutt, M. (ed.) (2004), *Himalayan People's War: Nepal Maoist Rebellion*, Indianapolis, IN: Indiana University Press.

Jackson, M. (1996), *Things as They Are: New Directions in Phenomenological Anthropology*, Bloomington, IN: Indiana University Press.

Parkin, D. (1985), *The Anthropology of Evil*, Oxford: Basil Blackwell.

Reed, S. and Reinelt, J. (1996), *Crucibles of Crisis: Performing Social Change*, Ann Arbor, MI: University of Michigan Press.

Roka, H. (2005), 'Militarisation and democratic rule in Nepal', *Himal South Asian*, 16:11, pp. 56–61.

Schechner, R. (1993), *The Future of Ritual: Writing on Culture and Performance*, London: Routledge.

Schechner, R. (1998), 'What is performance studies anyway?', in P. Lane (ed.), *The Ends of Performance*, New York: New York University Press, pp. 357–62.

Scheper-Hughes, N. and Bourgois, P. (2004), *Violence in War and Peace: An Anthology*, London: Blackwell.

Skidmore M. (2003), 'Darker than midnight: Fear, vulnerability, and terror making in urban Burma (Myanmar)', *American Ethnologist*, 30:1, pp. 5–21.

Suárez-Orozco, M. M. (2004), 'The treatment of children in the "dirty war"', in N. Scheper-Hughes and P. Bourgois (eds), *Violence in War and Peace: An Anthology*, London: Blackwell, pp. 378–88.

Taussig, M. (2004), 'Culture of terror – space of death', in N. Scheper-Hughes and P. Bourgois (eds), *Violence in War and Peace: An Anthology*, London: Blackwell, pp. 39–53.

Taylor, D. (1996), 'Theater and terrorism: Griselda Gambaro's information for foreigners', in J. Reinelt (ed.), *Crucibles of Crisis: Performing Social Change*, Ann Arbor, MI: University of Michigan Press, n.p.

Taylor, D. (2003), *The Archive and the Repertoire: Performing Cultural Memory in the Americas*, Durham, NC: Duke University Press.

Thapa, D. (ed.) (2003), *Understanding the Maoist Movement of Nepal*, Kathmandu: Centre for Social Research and Development.

Thapa D. and Sijapati, B. (2003), *A Kingdom Under Siege: Nepal's Maoist Insurgency, 1996 to 2003*, Kathmandu: The Printhouse.

Turner, V. (1988), *The Anthropology of Performance*, New York: PAJ Publications.

PART 4

THE DESIRE FOR CHANGE: VOICE, POWER AND PARTNERSHIP

Introduction to Part 4

Penny Bundy

Shaking up the pre-existing social order

In each of the four chapters in this section, the applied theatre practice takes place against a background of pre-existing (and perhaps well-established) social order that has the potential to dominate what is able to take place in the drama work in each situation. All four writers show a desire, as Gallagher writes, to 'shake up the social order' of the contexts in which they work. For Gallagher in Chapter 12, it is a desire to work collaboratively with a classroom teacher, exploring the ways drama pedagogy might improve the engagement of several of the most alienated learners in a Canadian history classroom. In Chapter 13, Thompson tells the story of his shifting understandings about engagement and efficacy in applied theatre work in the prison system in Britain. In Chapter 14, Chinyowa writes about the difficult lives of young women and problems of teenage pregnancy in a township in South Africa, focusing on a theatre project that aimed to change the lives of those young people. In Chapter 15, Roozemond and Wenzel use the term, 'the public sphere of children', originally derived from the work of Negt and Kluge (1972), to refer to 'those moments in which children represent their own spaces,

times, forms of exchange and activities publicly'. They were concerned that the children's festival about which they wrote (the 2002 International Amateur Theatre Association World Festival of Children's Theatre) offered too little of this, being too much in the control and management of the adults, denying the children their public sphere. In all four chapters, the writers demonstrate their desire to understand and change the situations about which they write.

Voice and power

When these chapters were originally published, the expression 'giving voice' was not uncommon. You will notice its use in the chapters in this section, and also challenges to its use. It is not only insufficient, as Thompson points out; it is also, as the applied theatre field would now claim more broadly, inappropriate. Who are we to give this? If someone has the power to give voice, do they also have the power to take it away? Whose voice should, or would, we wish to silence? Whose to encourage? Why? Each chapter in this section tells a story that includes elements related to voice and power. As you read, you may find it interesting to consider how power is exercised in each of the situations discussed.

In the classroom described by Gallagher in Chapter 12, the voices of the confident and more able children had previously been noted to dominate. The drama work supported some of the children who might normally be less willing to engage and less vocal, offering them opportunities to respond differently. By being engaged in a dramatic situation in the classroom, the students had opportunities to express different thoughts and opinions and to see themselves and to be seen by others in a different and more positive light.

In the context of the children's festival, in Chapter 15 Roozemond and Wenzel note that the opinions that usually got the most airplay as public expression were often from the most powerful, dominant and wealthy – all adults. They describe a situation that was so heavily structured by the adult organisers that the children were severely constrained and contained in that context. They argue that if we wish children to have opportunities to genuinely express their interests and concerns in a public sphere, then those who organise such events need to find ways to genuinely incorporate the children's preferred ways of communicating. Having said that, they also note that even under very unfavourable conditions children find ways to communicate, sometimes non-verbally, that can challenge this. Perhaps it is time for the children to plan their own festival? After all, in recent years we have witnessed the ability of young people, led by the young environmental activist Greta Thunberg, to rally together to demand action on climate change.

Thompson raises what I would consider significant and unanswerable questions about voice, power, social context, responsibility and the role of theatre and theatre workers in a prison context. Quite often, previous discussions in this context have focused on processes of empowerment. Thompson reminds us in Chapter 13 that prison theatre also needs to be concerned with questions about how power is exercised.

Concerns about voice and power are really highlighted for me in Chapter 14 by Chinyowa. He writes about attempts to use community theatre in a patriarchal society to challenge the status quo. They didn't work. He writes from the position that community theatre practice has the potential to offer opportunities for participants' voices to be heard, and – one would assume – for their lives to be improved. However, as I read this it appears that the status quo was reinforced. I saw several possible reasons for events to have played out as they did. It will be interesting to see what other readers observe as they look back at this time and work. As a reflection, Chinyowa himself notes that if the ruling ideology of a patriarchal system is accepted by the majority as the norm, it is unlikely that a performance will change that!

Partnership and collaboration

As can be seen from the chapters in this section, most applied theatre workers operate in partnership or collaboration with other groups or agencies as well as with their participants. The nature of these collaborations – how they are formed and managed – influences the nature of the work that can take place in each context. The nature of collaboration and partnership in each of the situations discussed in this section of the book had an impact on the quality of the drama experience that was available to those who participated.

In Chapter 12 we see a carefully constructed partnership. This partnership was underpinned by a genuine collaborative approach between the classroom teacher and the author, who had entered as an experienced drama educator and researcher. Qualities of the partnership that contributed to the success of the work included a willingness to set aside what we think we know, to be open to experience the new ways of learning and teaching and new ways of seeing the children we teach. The structural frames of the drama also supported the participation and collaboration of the children with each other.

Working in a corrections context requires the applied theatre facilitators to build working relationships with staff who bring different expertise to the context and the workshop space. Each needs to listen to the other, to understand that other perspective. At the same time – and I have learned this from my own experience

as well – it is important to maintain the integrity of one's own field. As Thompson points out in Chapter 13, you still need to argue with your theatre voice.

Similar to the nature of the relationship developed between the classroom teacher and the drama educator/researcher as seen in Chapter 13, Thompson highlights the need for genuine collaboration. Those who collaborate in applied theatre contexts bring different viewpoints, knowledges, languages and expertise to the space. It is important to remain open to these different understandings and approaches. People must be willing to genuinely explore with those with whom they work. There needs to be an openness, an honesty, a willingness to not know, to be open to explore and experience anew. As he points out, the sustainability of applied theatre in prison contexts is more likely if non-theatre trained prison staff are engaged in the work.

The complexity or otherwise of the collaboration present in Chinyowa's project, discussed in Chapter 14, is a little more difficult to know fully. He notes that his project emerged in response to a request he received as a university researcher. He describes how a local community worker was concerned about problems of teenage pregnancy. In response to her request, he established a partnership with the woman and founded a youth theatre group. In terms of partnership and collaboration, though, one is left wondering who the various participants actually were and what each brought to the process. Exactly how did they collaborate? Who really made the decisions? Is it possible to have a collaborative partnership inside such an ingrained patriarchal system?

Various layers of partnership and collaboration were present in the research project surrounding the festival about which Roozemond and Wenzel write in Chapter 15. They collaborated with their tertiary students, who were research assistants, and they in turn collaborated with each other and the children who participated in the festival. The children collaborated with each other. The festival organizers collaborated with the authors who were researching the festival. However, what seemed to be lacking was a collaboration between the children and the adults who planned and managed the event. The chapter raises genuine questions about the structure and management of a children's festival designed to be for the children rather than with the children. Interestingly, they also show how the young people found ways to undermine the problems they encountered through their use of satire.

A few afterwords to take forward

As I reflect on these chapters individually and as a group, I am left considering how each leaves me feeling. If we expect applied theatre practice to change us,

then as a reader of the chapters I might also expect to be changed by engaging with them. How have they changed me? What significant ideas remain with me as I close their pages?

I am reminded that when we are in the thick of the work, we may not be able to see the assumptions we have brought with us. We need to remain aware. We need to sit back and reflect, perhaps to take time out, in order to reflect over time.

I am reminded that applied theatre practice involves partnership and collaboration, and that these need to be carefully structured and managed. To do so requires a willingness and ability to genuinely listen, to share our viewpoints, understandings and skills from the informed lens of our own position.

I am reminded that change may not happen and even if it does, it will probably happen just a little at a time.

I am struck by a comment made in Roozemond and Wenzel's Chapter 15 that continues to alarm me. Children are the most photographed and least heard people in the world. I don't think that has changed.

REFERENCE
Negt, O. and Kluge, A. (1972), *Äffentlichkeit und Erfahrung. Zur Organisationsanalyse von bärgerlicher und proletarischer äffentlichkeit*, Frankfurt: Suhrkamp.

12

Tabula rasa:
Starting afresh with classroom drama

Kathleen Gallagher

Classrooms are powerful places with well-established social orders. Whether the teacher sees a 'bell curve' of abilities when she looks out on her 30 students, or 30 unique individuals each bestowed with talents and gifts of their own, the classroom has entrenched a social (and learning) order all of its own. Within it, there will be 'over-achievers', 'under-achievers', 'middling students', troublemakers' and the kids – better than anyone – will know who's who and where they all stand. As Pinar et al. (1996: 380) remind us:

> Schools may have been designed as neutral places, but neutral places they have never been; always they have been places where some people's children are subordinate to other people's children.

That is why teachers who use drama in their classroom can often cite 'epiphanic moments' in which their understanding of their students and students' understanding of themselves and each other are radically altered. These moments that storytelling teachers share are key to our understanding of drama's special ability to shake up the social order of classrooms, redistribute power and redefine the rules of the game.

In drama, the wearing of new identities in fictional worlds is the modus operandi. Students are invited to engage in the building of these worlds through analogy or simulation (Johnson and O'Neill 1984), to role-play (Booth 1994), to devise scenes (Neelands 1990; O'Neill 1995) and to create alternate realities. What I have observed in my recent action research collaboration with a Grade 8 classroom teacher is that new roles/identities beyond the drama worlds – within the actual classroom – often become possible for those students marked most 'at risk' of failure. Further, these new roles or identities help to uncover ways of

being for students that encourage participation at their fullest potential. In short, drama has both intrinsic and extrinsic value for the most alienated learners in classroom settings.

My project with Judy Blaney, a Grade 8 teacher with twenty years' experience, represents a school-based action research collaboration. The concept of 'research partnerships' has been an influential one in recent educational reform discourses (Grundy 1998). This study of practice aims to document the actions of one teacher in her classroom and the challenges faced in the implementation of a new, mandated provincial social studies curriculum and assessment tools for Grade 8 students. Implicit in our method was a belief in the usefulness of action research in the implementation of pedagogical and curricular change. That is, it is research with an often immediate and ultimately practical application. As Maxine Greene (1996) reminds us, new voices, responsive to the talk of the reflective practitioner, are becoming audible in education research and novel modes of participant observation in actual classrooms are asking practitioners to think about their own thinking. In essence, this means that teachers can begin to explore beyond their own pedagogical boundaries.

The project also addresses specific issues related to student motivation and drama as a teaching methodology. In short, it not only investigates reality in order to change it but, as Kemmis and Wilkinson (1998) suggest, it has changed reality in order to investigate it. An intermediate teacher with twenty years of experience changed her approach to the teaching of a new social studies curriculum in order to critically reflect with a university teacher-educator on her own teaching style and the learning outcomes of her students.

Methodology

The research activity included field participant observation as well as interviews/ongoing discussions with the teacher implementing, reflecting upon and evaluating her new teaching methodology. Our action research became a way to create a culture of inquiry through her reflection on action with her students and her collaboration with a university researcher. As Kemmis and McTaggart (1988) describe elsewhere, this project also involved a systematic learning process in which one teacher acted deliberately to improve her educational context and emancipate herself from institutional constraints. The project therefore has dimensions of knowledge production and action that make meeting the demands of the new curriculum possible.

Our interview schedule centred on three basic phases. The pre-study interview invited the teacher to describe her teaching methodologies and her philosophy of

Intermediate teaching: How have you taught your history and geography curricula in the past? What kind of evaluation tools have you traditionally used? What has your students' interest been in the Canadian history curriculum? I wanted the teacher to paint a vivid picture of herself and her working environment: What do you like about your teaching environment? What do you find challenging? What has changed for you over your seventeen-year career? During these initial conversations, I attempted to understand the teacher's goals for the teaching of the history and geography curricula as well as her relationship with her profession and her students.

After my demonstration lesson in her classroom, we reflected on what she had observed about drama as a teaching strategy and what effects she believed it may have had on her students. Her fieldnotes and journal entries recorded the observations she made of her students as they worked through dramatic role-play with the 'guest teacher': What was it like watching your own students? Did anything happen that surprised you? What did you see that pleased you/disappointed you? In this discussion, I aimed to bring to light the teacher's assumptions about her students, the curriculum, and teaching in order that we might explore together how these assumptions can be challenged by drama methodologies.

Next, we met after the teacher had designed and implemented a history lesson using drama strategies. I observed her during this teaching and our interview following the lesson began to uncover the changes (both anticipated and unanticipated) that she experienced in her teacher role as well as the limitations of the methodology: How would you describe the rhythm of the lesson? What did you find difficult/interesting? How would you describe the nature of your students' engagement with the work? What would you do differently next time and why?

It was this ongoing reflection on practice, long-term observation, hours of videotaped drama work, students' writing-in-role, reflective writing, formal and informal feedback, and test results that provided us with triangulation of data and clear emergent categories of analysis in our research.

Teacher assumptions about learners

It is the second phase of our data collection that is the focus of this chapter. During this phase, I was invited into the classroom to lead a two and a half-hour drama with the Grade 8 class. In our pre-study discussions, Blaney had described her students to me, reflecting on the 'difficult ones' and describing previous efforts she had made to encourage their participation and success. As is the mark of many committed teachers, Blaney focused on the students she worried about, those who

found school hard. We began to hypothesize about the different ways that drama education invites participation and she revealed that she had noticed a new and unusual interest among some of her students during her 'dabbles in drama', as she called them. Before my session with them, she selected three specific students who she would track in order to begin to analyse the nature of participation in drama for some of her 'weakest' and most challenging students. One video camera was fixed on the classroom, while a second hand-held camera, operated by Blaney's team teacher, was focused on three students: Jenna, Katie and Nigel.

Jenna suffers from Tourette's Syndrome, for which she follows a regime of medications to prevent 'outbreaks'. In addition to her medical condition, Jenna is painfully shy. Hiding behind her mane of long brown hair, she never speaks voluntarily, and when addressed she responds only with great difficulty. She has undergone school board testing for a learning disability, but her parent stopped the process before she was formally 'identified'. Katie, by contrast, appears on the surface to have more confidence, although her often unpredictably aggressive attitude betrays her severe insecurities. She is what her teacher describes as a 'reluctant learner' and was discovered once this year to have gone home on her lunch break and consumed alcohol. Katie has been identified with a 'learning disability' and is considered by her teacher as her most 'at risk' student. Nigel is officially labelled 'learning disabled' and considered a 'behavioural' student. Statscan has flagged the under-performance of boys – who account for two-thirds of elementary students receiving special education – as a problem in Canadian elementary schools. Statscan reports in its recent *Education Quarterly Review* (Galt, 2000) that, according to teachers, males accounted for 65 per cent of all children receiving special education because of a learning disability, and for 83 per cent of all children receiving special education for an emotional or behavioural problem. In the classroom, Nigel is alone, always the last to be 'put in a group' for projects, and is known to suffer from depression. Diminutive in stature, this Grade 8 boy is considered socially awkward by his peers and has at times been the object of their unkind taunting.

Discovering history through drama

The new Ministry of Education Arts Curriculum Grades 1–8 seems to call for the integration of disciplines in its specific outcomes. For instance, the Dance/Drama Curriculum states:

Through exploring drama and dance, students will develop an understanding of themselves and others, and will learn about the lives of people in different times,

places, and cultures. They will develop practical, artistic skills in both disciplines, as well as critical-thinking skills and a variety of communication skills.

Role-playing is a key component of the drama and dance curriculum. Pretending to be someone else involves an act of the imagination that is of central importance in the development of the ability to understand others. As students 'live through' experiences of others, they learn to understand a variety of points of view and motives, and to empathize with others. They also learn to clarify their own point of view and develop their ability to think carefully.

In all grades, students will draw upon a variety of sources - such as literature, historical and current events, and topics and themes from other subject areas, particularly the other arts - in order to create presentations in which they communicate their interpretation of situations and the motives of various characters.

(Ontario Education Department 1999)

I was asked by their teacher to create a drama that would teach the students something about the Chinese migrant workers' experiences of building the Canadian Pacific Railway and the development of the Canadian west in the mid-nineteenth century. Using Paul Yee and Harvey Chan's (1996) children's book *Ghost Train*, I began with this story of a young girl named Choon-yi whose father left China to build the railroad in Canada. After reading the first few paragraphs of the story, I asked the students to draw a picture of what they figured Choon-yi's farm looked like in China. All set about drawing except Katie. When I passed her desk, she asked me – with a smile – whether I liked her picture, and revealed a blank page. She also shared this 'picture' with the videographer when he strolled around with the camera. Katie's insecurities, masked by an obvious defensiveness, were apparent in the very first activity.

Moving into a whole-group role-play, I assumed the role of William Cornelius Van Horne and the students became the Chinese workers being enticed to come and work in Canada. Reading the teacher's research journal sometime later, I saw that she had remarked on this initial invitation into role:

As the students stood silently, I initially feared that perhaps no one would respond to the invitation to 'ask Van Horne any questions they might have'. After perhaps a minute of silence, one student raised his hand and asked, 'Will we be allowed to return home after the railroad is finished?' At that point, I knew this would work. I was reminded of Gallagher's own comments in her chapter in Booth's (1998) book *Writing in Role*, when she says, 'When we are working with drama and writing-in-role, we are interested in engaging the whole of the student in inquiries relevant to her/him. Because of the great security of role, students and teacher can take greater risks. Because you are in safety, you can go into danger.'

(1998: 150)

180

TABULA RASA: STARTING AFRESH WITH CLASSROOM DRAMA

I thought how often, as teachers, we provide students with challenges that demand risk-taking on their part (write a story, move around the gym like an elephant, sing out loud as part of the choir) while we merely observe and encourage. In this situation, I observed that the students were able to take a risk and enter into role because the teacher was risking alongside of them (Reflective teacher journal, November 1999).

Then I asked the students to find a partner, with one playing a recruitment officer for Canada and the other playing a Chinese worker. The officer was to determine whether this person would be a suitable candidate for the job of building the railway. When they reported back, I noticed that Nigel was taking his role as officer very seriously and was one of the first to enthusiastically report that he would recommend his partner for the job. After this, I asked the class to get into groups and create a scene of the migrant workers in Canada. For this, each group received a different descriptive excerpt from their history text, detailing what life was like for the workers. For this activity, Nigel had to be placed in a group by the teacher, as he was left wandering once the groups had begun working. After some preparation time, the groups shared their work. Blaney's journal reveals her observations of her students' work:

> It occurred to me as I watched the scenes and listened to the students recite passages that they achieved a greater understanding of this event in history than if they had silently read the entire chapter and subsequently answered questions. They were there, actually swinging their heavy mallets, standing knee-deep in muskeg. They were actually walking carefully to ensure that the nitro-glycerine strapped to their backs did not explode.
>
> (Reflective teacher journal, November 1999)

Next, I read a letter aloud to the class, explaining that it had come to Choon-yi from her father. After I shared this letter, I invited the students to write a diary entry – as Choon-yi – after receiving the letter from her father. Nigel wrote one sentence and then spent the rest of the time tossing his pen in the air and catching it. Jenna and Katie, however, seemed consumed by their writing. Blaney remarked how the sheer quantity of writing was more then she'd seen either of these students produce before. Jenna writes:

> Dear Diary, I miss you so much, my father. He has been gone for two years now. He hasn't seen how Im growing up. He write me letters, but every time I read them I have to cry. I wish I could just see him. What ever I do, Im always thinking about him, but I got to stop thinking about him. Choon-yi.

When I later read Jenna's reflection on that day of drama, she revealed something important:

> I think she [Gallagher] maid it sound real when she was trying to convince us to come over. She lied about how good it was coming over, but that was what she was supposed to do, to make us come over. We started skits after that. I thought most of them were good. I dont really like drama because Im shy and I dont speak very clearly. I liked writing that letter because I felt what she was thinking a lot.

They shared their letters in a sound collage, as I moved about the room signalling students to read a chosen excerpt from Choon-yi's diary. Next, accompanying music and in groups of eight, students were asked to create a sequence, using movement and sound, from a dream Choon-yi might have. Katie's group's presentation had a few obvious glitches and she became visibly angry with her group members. She was terribly disappointed that her group didn't 'get it right'. We asked them to take another run at it, at the end of which Katie explained to the class the details of what they were doing so that everyone could follow the ideas they'd had. She was greatly invested in being understood. The teacher remarked that this investment in being understood was new behaviour for Katie. After we shared the 'dreams', we situated their chairs in the room to resemble a train. Each group created a frozen picture of the migrant workers moving across the country on the train and this image was to be 'painted' by Choon-yi. From the four groups, there emerged four different Choon-yi characters whom I interviewed about what they had 'painted'. Nigel took the role of Choon-yi within his group and his responses in role were so eloquent that others took note. Instead of giggling, his peers were obviously impressed. While the class sat on the 'train', I finished the drama by reading them the end of Yee and Chan's story.

Student assumptions about learning

Katie's final reflection about doing drama was especially revealing. As a student with poor self-esteem, she illustrated a profound understanding of her own abilities as a learner and about learning in general for those who are sometimes identified as 'learning disabled'. She writes:

> I thought this morning was fun, the best part was that we didn't get marked on this activity if we did me and Heather would probably have failed! I like doing stuff like that better than having to write notes and learn this kinda thing that way. I think that we have more understanding of the lesson when we do activities like that because when we write notes and stuff I don't know about everybody else but I know that I can't stay focused and I have a lower level of understanding the lesson. Then again when we do stuff like we did this morning, I understand better because I was having

TABULA RASA: STARTING AFRESH WITH CLASSROOM DRAMA

fun and it doesn't look like it but I actually concentrate and understand better. I think it gets too distracting when we are quietly writing a note because everyone jumps at every little noise! So it gets really distracting and boring and annoying! In other words, I like doing drama activities better and I think everyone else does too!

Ms Blaney had all her students reflect on 'learning history through drama' after our first morning together. The teacher and I had hypothesized about drama's special ability to draw 'reluctant learners' into the classroom activities. Nigel's reaction during the first history test he wrote after his experiences of drama was very telling. The following is an excerpt from Blaney's diary:

Test day – I assumed the role of Lord Durham as I handed out sheets. I told them that in Britain we were concerned about our colonies in British North America as they had always been better behaved and more reasonable than our rowdy cousins to the south. I understood that some of them had concerns about the future of the colonies. I asked them to write me a letter explaining to me what their concerns were and what recommendations they would like me to take back to Britain. Out of role, I explained that they had the option of adopting a rebel, moderate or conservative point of view.

I loved watching them write the test. Two students were concerned that they hadn't understood the instructions (Do we get to pretend we are farmers?) As I walked past Nigel, he said: 'This is fun. I feel like I really am a farmer and that I really am angry at the government!' It was silent for 15 minutes as he wrote.

There was a further education for us as we read the reflections of the academically strong students in the class. Some of these 'high achievers' had taken special note, without any solicitation, of the unusual participation of their peers who were normally quiet or unsuccessful in their work. One student explained in her assessment, 'I suppose that this [doing drama] was less tiring, and more fun than writing notes. I know that I learn just as good by reading, but this was still an interesting idea.'

I did like the casual atmosphere, and the freedom to express our feelings creatively. The only thing that could have been improved would be to include more facts and information into the technique.

I feel that if this could be met, it would be nearly perfect. Some of the less attentive students may be intrigued by the idea of learning through drama. In fact, they may not even realize that they're learning at all, but the information is more likely to 'stick in their minds'.

Many students in the class had taken note of surprising and new participation from their peers in the drama work and the subsequent breaking of old patterns and dynamics in the classroom.

(Reflective teacher journal, October 1999)

INSIGHTS IN APPLIED THEATRE

Turning over a new leaf

Ms Blaney has continued to use drama in her classroom, convinced by its ability to invite all of her students into the experience of learning, especially those who have long forgotten the excitement of being successful. She has reported that when the class was recently asked to establish their hotel room groups for their big history class trip to the country's capital city, Nigel was again left without a group. This time, before she could select a group for him, a few of the most popular boys in the class intervened, saying they'd like Nigel in their room. A small sign perhaps, but Nigel was good at drama and being good at drama had earned him new social status in the classroom.

In a lucid description, Swortzell (1996) recalls:

> Each time we leave a performance, we are reminded that theatre and dance are the most evanescent of art forms, and that what we have just seen can never be beheld again in the exact same way. Even if we should return the next night to repeat the aesthetic process, a second viewing cannot reproduce the reaction of the first because we have been changed, by both the production and by everything else that has happened to us in the interim.

In a classroom where drama has been exploited, there is often this experience of profound change for the participants. For the weaker students we tracked in Blaney's class, they had the surprising and necessary experience of success and in so doing became different learners and different people. Much educational research confirms that success begets success. What we could not have anticipated is the extent to which this success would change others' perceptions of their peers. For Jenna, she transcended the limitations of shyness through her writing in the drama. This reflective writing helped her to validate her own perspective in a kind of dialogue with herself and rehearse what she might say in advance, able then to participate in a way she had not imagined possible. For Katie, she felt able to take pride in her work, and to be angry when it did not go as planned. She had come a long way from her initial refusal to draw, masking her fear of failure with a contempt for success. For Nigel, drama enabled him to communicate, despite being an outsider to the dominant mode of expression in the classroom.

In our action research, we aimed to take up Gallas's (1994: 162) challenge presented to the research community, to

> look carefully at the stories teachers uncover and to consider the ways in which teacher knowledge articulates a more complete picture of the teaching community and learning process. In this way, when teachers' stories are weighted equally with

the body of knowledge coming from the research community, a larger and more powerful picture of how children learn, and the contexts which best foster that learning, can be obtained.

What we have learned in these early stages of our inquiry is that action research – with its focus on interpersonal relationships and context – can take in these relationships in classrooms to the extent that the data remain moving and changing phenomena. This research, grounded in the natural setting of a classroom and comprising students engaged in drama, allowed us to observe and critically analyse the negotiation and renegotiation of power and role that existed both within and beyond the drama worlds. The drama frame, in other words, afforded students in the classroom – weak and strong alike – the opportunity to reconfigure their default settings, to reframe their classroom relations inside and beyond the world of fiction. What began as one teacher researching her own practice soon became an investigation of the ways in which drama affords students often labelled as academically weaker the opportunity to reinvent themselves.

The greatest mark of Ms Blaney's success for herself was not that history became more interesting, but that Jenna, Katie and Nigel became learners in their own eyes and in the eyes of others. And as learners, these students had a glimpse again of their own potential, essentially connecting them to what Freire (1998) calls their 'unfinishedness'. He writes (1998: 54):

> I like being human because I know that my passing through the world is not predetermined, preestablished. That my destiny is not a given but something that needs to be constructed and for which I must assume responsibility. I like being human because I am involved with others in making history out of possibility, not simply resigned to fatalistic stagnation. Consequently, the future is something to be constructed through trial and error rather than an inexorable vice that determines all our actions.

Freire insists that this awareness of our 'unfinishedness' is essential to our human condition. For Ms Blaney's 'reluctant learners', doing drama renewed their curiosity, allowing them to shed preconceived ideas and rediscover their 'incompleteness'; doing drama afforded them that most critical educational experience of becoming – the very antithesis of their fixed and labelled identity.

Acknowledgement

This chapter was originally published as Article 4 in Volume 2 (2001).

REFERENCES

Booth, D. (1994), *Story Drama: Reading, Writing and Roleplaying Across the Curriculum*, Toronto: Pembroken.

Freire, P. (1998), *Pedagogy of Freedom: Ethics, Democracy, and Civic Courage*, Lanham, MD: Rowman and Littlefield.

Gallas, K. (1994), *The Languages of Learning: How Children Talk, Write, Dance, Draw, and Sing Their Understanding of the World*, New York: Teachers College Press.

Galt, V. (2000), 'Boys far outrank girls in behaviour, learning problems: Statscan', *Toronto Globe and Mail*, 8 March, p. A3.

Greene, M. (1996), 'Foreword', in P. Taylor (ed.), *Researching Drama and Arts Education: Paradigms and Possibilities*, London: Falmer Press, pp. xv–xvi.

Grundy, S. (1998), 'Research partnerships: Principles and possibilities', in B. Atweh, S. Kemmis and P. Weeks (eds), *Action Research in Practice: Partnerships for Social Justice in Education*, London: Routledge, pp. 37–46.

Johnson, L. and O'Neill, C. (eds) (1984), *Dorothy Heathcote: Collected Writings on Education and Drama*, Evanston, IL: Northwestern University Press.

Kemmis, S. and McTaggart, R. (eds) (1988), *The Action Research Planner*, Geelong: Deakin University Press.

Kemmis, D. and Wilkinson, M. (1998), 'Participatory action research and the study of practice', in B. Atweh, S. Kemmis and P. Weeks (eds), *Action Research in Practice: Partnerships for Social Justice in Education*, New York: Routledge, pp. 21–36.

Neelands, J. (1990), *Structuring Drama Work: A Handbook of Available Forms in Theatre and Drama*, Cambridge: Cambridge University Press.

O'Neill, C. (1995), *Drama Worlds*, Portsmouth, NH: Heinemann.

Ontario Education Department (1999), *Ontario Curriculum Grades 1–8: The Arts*, Toronto: Queen's Printer for Ontario.

Pinar, W., Reynolds, W., Slattery, P. and Taubman, P. (1996), *Understanding Curriculum: An Introduction to the Study of Historical and Contemporary Curriculum Discourses*, New York: Peter Lang, pp. 97–104.

Swortzell, L. (1996), 'History as drama/drama as history: The case for historical reconstruction as a research paradigm', in P. Taylor (ed.), *Researching Drama and Arts Education: Paradigms and Possibilities*, London: Falmer Press, pp. 97–104.

Yee, P. and Chan, H. (1996), *Ghost Train*, Toronto: Groundwood Books.

13

Making a break for it:
Discourse and theatre in prisons

James Thompson

Why is success in gaining work in theatre called a 'break'? Why isn't it called a 'mend', since so many unemployed theatre people seem broken by their experience of searching for work? My passage into prison represented a break – but not in the sense that it was a first opportunity; rather, it created a split with my theatrical past. Entering prison brought to a halt one world and quite abruptly started another. Prison does that. However, the crack driven through my theatrical certainties was a hairline compared with the dislocation often faced by thousands of prisoners and their families. For some, this dislocation can never mend, while for others it becomes a visible scar under their behaviour and for yet others still it heals, creating a smooth relationship between their life in prison and their life outside.

My second ever project in prison was to run with a group of student colleagues a series of workshops in a classroom in pre-riot Strangeways.[1] My first is another story. At the same time I was directing a group called APT Cabaret – which stood for 'Anti-Poll Tax' Cabaret.[2] We toured to anti-poll tax unions across the north-west of England with a healthy and worthy mix of sketch, song and earnest agit-prop. We were welcomed to many community and activist groups who were campaigning for non-payment. It was the last great national political movement that I have been part of so directly. It came to a confused and messy end not in the defeat of the poll tax but in the riots in Trafalgar Square in the spring of 1990. Whoever was to blame for these and however melodic the songs we wrote condemning the police may have been, a celebration was turned into a wake. The Trafalgar Square chaos created for me a personal dissonance between the music urging rebellion and a memory of fear, glass and blood. It was also an event that coincided (to the same weekend) with the explosion in Strangeways prison – politically, personally, theatrically, violently, many moments simultaneously became both broken and confused but also interrelated.

'I'm going to do some workshops in Strangeways,' says my tutor. 'Do you want to come?'

'But once we enter that space we collude with the oppressive practices within it,' I replied.

Of course we always report ourselves to be more eloquent than we are, and in our heads we wish we were more eloquent than we actually were. At this point I have a blank. I cannot remember the argument that proceeded from here. All I know is that it persuaded me in. However, I was right to be suspicious. Anti-poll tax work drew very clear lines in the sand. There were facts – we couldn't pay – and there were actions that arose directly from them – we wouldn't pay. Our theatre celebrated, sang and dreamt within these precise boundaries. Prison was, I thought, drawn along similarly measurable lines. There were facts … I can't remember what I thought they were now. And there were subsequent actions – you don't cross the gate. It was all blindingly, blissfully and unquestionably simple.

Of course, that week in prison kicked those sandy lines in my face. And I have been doing prison theatre with bleary eyes ever since. The work can now only be fumbling attempts to see some kind of shape … And dream of those wonderfully straight lines of my poll tax days.

So why has prison theatre been such a bully to my neat theatrical sensibilities? It immediately generated questions to some of the core ideas behind a socially engaged theatre that I thought I understood. For example, how do we create a celebration with people who have robbed others of joy? How do we seriously deal with issues when all the group wants to do is play? How do we work in fantasy when some of the group's fantasies have been performed in an abusive reality? How do we theatricalize prison's mundanity? How do you create a relevant theatre in a space in which the most radical action is escape?

We needed to move beyond the easy politics of 'giving voice'. In prison theatre work, we found ourselves sat between the desire to challenge the abusive rhetoric of certain voices and enabling others to find theirs for the first time. Prison is a context that severely restricts any ability of a prisoner to act for themselves – it deliberately thwarts a sense of subjectivity. However, simply positioning prison theatre as a bold attempt to rekindle the prisoner as social actor naively missed the complex relationship that previous 'actions' had with a prisoner's current situation. For a man who had abused, we had to situate the work in the limitations of one's ability and right to act as much as in our desire to empower. Prison theatre from these first moments had to be as much about questioning how power was exercised as it was about the process of empowerment.

So, after a week that shocked, inspired and confused, I desperately searched for new models. Seeing a six foot scouser (Liverpudlian) quietly crochet through a

bitter domestic scene, and an elderly Asian man play an assertive daughter to a Rastafarian father, as well as hearing a senior London prisoner who had been moved to Manchester as a punishment say that this was the best week he had had in seven years all made me more convinced of theatre's impact without an appropriate language to articulate it. The language of empowering oppressed communities and celebrating opposition fitted neatly at moments and was glaringly inappropriate at others. It was also a discourse that had to be firmly renegotiated in our bids to convince wary prison governors and prison officers of our 'good intentions'.

The convenient oppositional model was found in the world of probation. Competing with Home Secretary Michael Howard's vision that prison worked was a questioning movement that asked 'What works?' (McGuire 1995). This movement analysed offender interventions to discover those that reduced recidivism. It sought out models of positive and effective practice. The most highly regarded approach within this field was a form of cognitive behavioural group work that was based on a belief that individuals could change (see Harland 1996, McGuire 1995 and Rose 1998 for examples). Just the belief in change in the prison environment that so often regarded 'criminality' as a permanent personality defect provided us with inspiration. It was therefore into this field that we moved. The desire for answers – for clear lines in the sand – led us to make a discursive shift. We learnt the language and the practice of offending behaviour group work. This area, I believe, allowed us to draw some tentative lines around our work – it gave us a framework for analysis, discussion and advocacy.

So often when examining areas of applied theatre, we see the theatre work as central, and the meetings, promotions and demonstrations that surround it as secondary. All the planning and explaining are viewed as preliminaries to the most important moment that is the workshop or performance. This results in a concentration on the 'practice' and a sidelining of those aspects of the work that actually take up more time. There is a discursive whole in applied theatre that means we should not separate out and create hierarchies of certain moments. A meeting explaining prison theatre work to a group of probation officers should be seen as much part of the practice as a drama workshop with a group of prisoners. The development of a discourse around theatre and offending behaviour group work that was performed in meetings, in workshops, at criminal justice conferences and in prison officers' canteens was a total package. It was all practice. Of course, it adapted, shifted and was sensitive to different audiences – but in the early years of my experience in this work we constantly performed. And, contrary to popular belief, performance came first and its incorporation into a belief system or so-called behaviour came second. The new lines in the sand gave a number of years of comfort. They eased my bleary eyes. In this time the Theatre in Prisons and Probation or TIPP Centre, the organization of which I was

director, created programmes on offending behaviour, anger management, drugs, bullying and employment (Thompson 1999). Each interacted with the discursive practices of the related fields and sought to enhance them with the practice of participatory theatre. We happily learnt new languages, but importantly maintained a strong theatrical accent whenever engaged in the work. Theatre processes were promoted as enhancements, extensions and improvements to group work practice. We adopted a discourse but aimed to push its boundaries. For example, we would argue that participation engaged in ways that sedentary courses did not. Metaphor created different resonances, connections and memories that the literal could not. Role-plays created three-dimensional discursive acts that extended and perhaps complicated the explanations of behaviour that relied on speech alone.

The work became most interesting when we noticed that staff from within criminal justice institutions were picking up our language – when we could hear a new bastard discourse emerging. The TIPP Centre always insisted that their work could be done by non-theatre staff. To this end, probation and prison officers were trained to run a number of the programmes. This raises one of the most important questions for this work. Is the practice so corrupted by the criminal justice accent brought by these staff that it loses some kind of 'quality'? The fact that I have personally encouraged this staff training, and am currently involved with a project in the state of São Paulo, Brazil that trains prison staff across the system to implement drama-based programmes, demonstrates where I stand on this issue. For me, the questions of sustainability and embedded theatre practice are highlighted most acutely when we seek to push this type of practice forward.

I have been writing a lot in the past tense. In February 1999, I had another break and I left the TIPP Centre. I now have the privilege to look back at the work. One of the inspiring aspects of prison theatre was, as I explained at the beginning, how it disturbed neat frameworks – how it played havoc with neat lines of understanding. The learning and practising within the discourse of offending behaviour group work was a product of this state of confusion: it was a search for new shapes to make the work understandable.

However, in occupying a certain discursive arena, it often becomes hard to see beyond that arena. It is hard to see the boundaries of something you are in the middle of. Without seeing this edge, we can forget that lines around a field both shape it and also constrict it. The practice gets explained, created and performed from within a constructed field and starts to lose the possibilities offered by others. The bastard discourse becomes a new orthodoxy.

So how did these boundaries – the 'What works?' or the cognitive behavioural groupwork-inspired field – act to constrict? We were enamoured at first by the fact that this field challenged the official view that nothing worked and also that it held on to a belief in change. However, it is now the orthodoxy of UK government

probation practice. Page 15 of Her Majesty's Inspectorate of Probation Report called *Evidence Based Practice* (Chapman and Hough 1998) commends drama as an appropriate intervention tool. Should we cheer? I am not so sure.

Discursive frames can act to iron out confusions and doubts. My anti-poll tax clarity had been translated into a cognitive behavioural clarity about how human behaviour is formed, enacted and relearnt. It assumed that learnt behaviour is stored and reperformed at a later date; it accepted a role theory that says we are but exhibitors of social types; it hoped that if we rehearse something in one space it might be executed in another. It aspired to a form of human agency that could be aroused by theatre and transferred to the real world.

These lines must now be challenged because they are limiting. What started as a partial reading of the practice became a partial frame within which to develop that practice. The work was in danger of becoming a pale version of what it could be. I believe that now we must play bully to the new sand lines that we found it necessary to create. We need to re-find a critical voice to challenge the language and assumptions of the cognitive behavioural account. To continue, I need to rediscover my confusion. So here are four kicks or questions to start this process:

1. *We need to question role theory.* It is redundant and reductive and assumes that role is personally held when it is in fact socially constructed and situational. We adapt our performances from a range of resources not by choosing singular roles. We improvise and construct from a grammar of possible performances that are learnt, witnessed and inscribed. We do not regurgitate fixed roles. Theatre can't just create character.
2. *Perhaps we should abandon behaviourism.* We should be interested in action, not behaviour. Behaviour implies that humans create their world from the inside out. I believe the world is created within each different situation that arises. Action is understandable as adapting between people, not emanating from within. Theatre can't just change behaviour.
3. *Please no more cognitive gods.* There is no central Cartesian script or sorting and deciding. We perform adaptively within and between situations, people, times and contexts. There is no original cognitive process that is magically exposed by analysing our decision making. Theatre can't just create actors.
4. *No more rehearsal.* Demonstration of a skill in one place cannot be a guarantor that it will happen elsewhere. We do not simplistically store total interactions for later display. Perhaps the revolution will not be rehearsed. Theatre can't just prepare for the future.

In my work in prison theatre, the most radical moment was not the creation of a way to understand the work, but the actual break from certainties. Gaining

something in the world of theatre is called a break – not a mend. The break in my career is actually what created a more vibrant theatre practice. The first projects that I undertook in prison were in a state of bleary-eyed searching, and I now believe these were the most innovative and challenging. The more fixed and clear we found ourselves, the weaker our practice became. It is in the creases and roughness of doubt that creativity actually flourished. The ironing and smoothing was a process that erased and excluded as it strove to 'make sense'. If theatre was only a skills training method for probation clients to practise roles that they could then perform in later life, we lost the complexity of the theatre workshop and performance process as a dynamic, difficult, rich moment in itself. In creating a simplistic relationship between the group work room and the world outside, we restricted the variety of possible disruptions, confusions, memories or connections that theatre can make for a range of people.

Theatre could be the dissonance between worlds, but it could also be the means to a smooth transition. Theatre can be both opportunity and disruption. Success in theatre is called a 'break'. And we all need a break once in a while.

Acknowledgement

This chapter was originally published as Article 5, Volume 2 (2001). Much of this material was republished in Thompson's *Applied Theatre* in 2012.

NOTES

1. Strangeways is a major English prison in Manchester, where a three-week riot happened in 1990.
2. The poll tax was a notoriously divisive proposal by Prime Minister Margaret Thatcher that also caused riots and protests across the country; it did not become law.

REFERENCES

Chapman, T. and Hough, M. (1998), *Evidence Based Practice*, London: HMIP, HMSO.

Harland, A. T. (1996), *Choosing Correctional Options That Work*, London: Sage.

McGuire, J. (ed.) (1995), *What Works: Reducing Reoffending*, London: Wiley and Sons.

Rose, S. (1998), *Group Therapy with Troubled Youth: A Cognitive-Behavioural Interactive Approach*, London: Sage.

Thompson, J. (1999), *Drama Workshops for Anger Management and Offending Behaviour*, London: Jessica Kingsley.

14

Evaluating the efficacy of community theatre intervention in/as performance: A South African case study

Kennedy Chinyowa

The evaluation of community Theatre for Development in Africa has largely been premised on *product* rather than *process*. Even if such evaluation focuses on audience reception, consumption remains the major concern (Mda 1993). The primary goal of such theatre – to transform the lives of its target audience – has been overshadowed by an overriding tendency to treat it as a 'showy spectacle' (Breitinger 1992). Even if the workshop and/or performance process remains the central transformative mechanism, most critics are still preoccupied with viewing community theatre as if it is intended for consumers of a finished product. In this article, I examine community theatre practice *in, as* and *through* the medium of performance. I argue that if such theatre is to be regarded as a potent force for social intervention, then its efficacy should be found within the process of performance itself.

As community theatre strives to create alternative realities for its target audience, questions about its ultimate value remain contested. As Tobin Nellhaus and Susan Haedicke (2004: 14) point out, art is not neutral; its socially committed intentions do not shield the work from possible ambiguities. The immersion of community theatre practice in local relations of power, authority and engagement tends to obscure its positive intentions. What begins as a benefit to the community can be affected, for better or worse, by the politics of location, agency and culture, with far-reaching implications for the identity of participants. Hence the discourses that surround community theatre interventions must be interrogated to understand the ambiguous nature of identities emerging from such work.

Baz Kershaw (1994) asserts that community theatre has the potential to create an immediate and lasting impact on the evolution of wider cultural, social and political realities. Yet Helen Nicholson (2005) contends that such modes of applied

theatre can be viewed as both a gift and a poison. Apart from the ambiguous meanings that may be attached to the metaphor of a gift such as dependency, patronage and surveillance, Nicholson (2005) argues that the practice of making theatre in community settings creates spaces that enable participants' voices to be heard. Theatre practitioners and donor agents put themselves in the position of gift-givers. Their desire to identify with the lives of others (i.e. the target community) through the drama and theatre process constitutes the experience of the gift. But Nicholson (2005: 161–62) goes further to sound a warning on the paradox behind the gift:

> Because it can be seen simultaneously as both a present and a poison, it is sometimes worth remembering the unpalatable truth that a present, however well intentioned, may be thought to be poisonous by those who live in a different context, and whose version of a good life differs from our own.

James Thompson (2006) seems to concur with Nicholson when he describes applied theatre as existing in a state of bewilderment. The theatre practitioners and their participants remain in a transitory state of amazement and fascination mingled with doubt and uncertainty. As communities try to break away from familiar cultural practices or accustomed patterns of behaviour, they are likely to experience bewilderment, 'a great deal of hurt and damage, [but also] a powerful impetus to people's struggle to make sense of their lives' (2006: 24).

This chapter uses the illustrative paradigm of two performance interventions that were employed by Ikusasa Lakho Theatre, a young people's theatre group that I founded in one of the high-density suburbs of Pietermaritzburg in South Africa in 2006. The chapter begins by giving a brief background to the formation of the youth theatre group and the reasons for the group's choice of teenage pregnancy as a major concern. It then proceeds to evaluate the performance intervention strategies and the ambiguous nature of identities that emerged from these interventions.

Ikusasa Lakho Theatre

After I took up a postdoctoral research fellowship position in the Department of Drama and Performance Studies at the University of KwaZulu-Natal in August 2006, my host supervisor invited me to a meeting with Tholakele Mkhize, a young Zulu woman from Edendale high-density township in Pietermaritzburg, South Africa. The meeting marked the beginning of a community theatre project that,

to me, has been a challenge to the academy to engage with local communities in development education. At the meeting, it was agreed that Tholakele would come up with a draft proposal for exactly what she wanted and how the academy could help her community. In the introduction to her draft proposal, Tholakele wrote:

> The youth residing in the rural (sic) communities of Edendale are constantly exposed to crime, drugs, HIV/AIDS and povert (sic). The (sic) face a black (sic) future whereby they are unable to avoid the everyday pressures of their friends lading (sic) to them (and) engaging in illegal and immoral activities. (Mkhize, 2006: 1)

In spite of her shaky English, it was clear that Tholakele was calling upon the academy to intervene in the process of empowering the youth to do something about their own lives.

Eventually, I took up the challenge and focused my research on the youth in Edendale township. Through close consultations with my host supervisor and Tholakele, her original draft proposal was revisited in order to come up with a revised version. In the revised proposal, the mission statement for Ikusasa Lakho Theatre, the Zulu name for the newly formed community theatre group which means 'the future is yours', was:

> To empower the youth of Edendale township by engaging in community theatre practice and other activities that will enable them to realise their full potential for integrated development. (Chinyowa 2006: 1)

Ikusasa Lakho Theatre's vision was based on the desire to find alternative ways of bettering the lives of the disadvantaged people – particularly the youth – who had been placed on the margins of history by colonialism and apartheid. The name of the group, which came from the youth themselves, reflected the latent driving spirit that none but themselves should prepare for their future. Hence the aims and objectives of the group were geared towards enabling the youth to rise above the fetters of the past and make their own history. In her draft proposal, Tholakele had indicated that the youth in Edendale township were constantly engaged in illegal and immoral activities such as sexual promiscuity, crime and drugs. Hence the choice of context was largely informed by the potential desire of the local youth to make a difference to their lives and the community. The youth were tasked to collect stories from the community, which were eventually workshopped to create an improvised performance on teenage pregnancy entitled *Sbongile,* the name of the female eponymous character.

Teenage pregnancy

The debate about the pros and cons of teenage pregnancy as a social problem in South Africa remains inconclusive. It has been argued that, since fertility plays a central role in African women's identity, the negative consequences of teenage pregnancy can be mitigated by the birth of children. From their study on teenage pregnancy in KwaZulu-Natal, the province with the highest prevalence rate in South Africa, Preston-Whyte (1995) observes that, in general, mothers and grandmothers tend to condone pregnancy in order to encourage girls to 'prove' their fertility. The girls are told that pregnancy is far preferable than the prospect of infertility caused by taking contraceptive measures. Hence, falling pregnant becomes a way of striving for social acceptance. However, limited attention has been given to the adverse consequences of teenage pregnancy beyond matters of fertility and childbearing. Studies have revealed that more than 35 per cent of adolescent girls in South Africa become pregnant before the age of 20 (Cunningham and Boult 1996; Preston-Whyte 1995). In fact, the statistics are so alarming that it is inconceivable to ignore the possible ramifications. According to *IRIN News* (2007), apart from an average of one in three schoolgirls having a baby by the age of 20, there are hotspots in Gauteng and KwaZulu-Natal provinces where pregnancy rates are higher. For example, a 2006 survey showed as many as 71 per cent of girls at one school in Soweto township falling pregnant (*IRIN News* 2007). Clearly, the disadvantages of teenage pregnancy far outweigh the advantages. More often than not, adolescent pregnancies are a result of external pressure rather than personal choice, hence they are mostly unplanned and unwanted. The health hazards associated with adolescent pregnancy, coupled with the burdens of early parenthood, leave teenage girls at high risk. School dropouts, illegal abortions, social rejection, economic insecurity, child neglect, drug abuse and aborted relationships are only some of the multiple consequences of teenage pregnancy.

It was out of concern for what was happening to their peers in Edendale township and other parts of KwaZulu-Natal province that the members of Ikusasa Lakho Theatre decided to address the problem of teenage pregnancy. The performance of the play *Sbongile* became a frame of reference for the youth and the community to take action against teenage pregnancy. As performers, the group would act as mediators while the community participated as co-players in the action. The purpose of performing *Sbongile* was therefore to create a platform for action that could influence changes in values, attitudes and behaviour among the youth themselves.

The performance text as intervention

The performance text has been described as an ideological transaction and negotiation between the group of performers and their target audience (Kershaw 1994: 16). The language of the performance text – its signs or codes of signification – connects with the target audience's cultural frames of reference to forge a dialogue of world-views. In fact, Baz Kershaw (1994: 16) goes so far as to assert that:

> The totally passive audience is a figment of the imagination, a practical impossibility; as … the reactions of audiences influence the nature of a performance; … the [audience] is engaged fundamentally in the active construction of meaning as a performance event proceeds.

In other words, performance involves the transaction and negotiation of meaning between performers and audience as they interact either actively or vicariously. In the process, the performance will appeal to its audience to effect, at least in terms of memory and imagination, an alternative social reality.

Through direct observations of, personal engagement with and audience feedback on Ikusasa Lakho Theatre's performance of *Sbongile*, different levels of audience responses were experienced that demonstrated the efficacy of the performance text. From the group's performances, most of the young audiences tended to identify themselves with the eponymous character's double consciousness, responded rather strangely to the power of patriarchal ideology and displayed differing horizons of expectation in terms of levels of participation. These two forms of audience response will be analysed to reveal the ambiguous nature of identities that were emerging in the process of performance.

Double consciousness

When her father insists on barring her from home because of what he perceives to be deviant behaviour, Sbongile decides to go and live with a close friend. But as soon as she falls pregnant, she finds herself rejected by her world. Her friend, Zinhle, no longer wants to stay with her. Mandla, her 'sugar daddy', and Jabu, her boyfriend, want nothing to do with her. While she hungers to claim her rights as a woman, she cannot escape parental control, male chauvinism and social ostracism. In her soliloquy at the end of the scene, Sbongile decides to either terminate her life or return home to seek parental forgiveness. In the end, she opts for the latter and returns home to give birth to a baby girl.

Sbongile's double consciousness causes her to remain trapped between her desire for freedom and the reality of what she perceives to be sexual victimization. Discussions with audience members and their responses to the question 'What did you learn from this performance?' revealed an ambivalence similar to Sbongile's. Some tended to condemn Sbongile for not listening to her parents and falling prey to peer pressure, while others felt she did not have much choice over the circumstances.

Evidently, the performance text had struck a chord with the audience that allowed them to experience these paradoxical feelings. The text as performance 'played' with the fundamental beliefs of the audience to provoke a crisis of identity similar to that of the protagonist. In Helen Nicholson's (2005) view, various forms of applied theatre rely on the convergence of different narratives because participants bring a range of ideas and experiences to the drama. Through the process of identification, each participant 'triangulates' these disparate narratives to provoke an ethical ambiguity arising from the understanding of oneself in relation to others. Thus, paradox defines the potential efficacy of the performance when the possibilities it raises resonate with the realities affecting the audience.

Patriarchal ideology

Patriarchy operates as an ideology that compels women to internalize male domination. Sbongile's father expected his daughter to conform to cultural expectations regarding women as docile, submissive and obedient to men. But while Sbongile rejects such conformity, she goes on to 'imprison' herself by falling into the vicious love triangle consisting of herself, her boyfriend, Jabu, and her 'sugar daddy', Mandla. To an extent, the performance exposes patriarchy as a dominant ideology responsible for Sbongile's problems. Antonio Gramsci (1971) argues that ruling classes maintain their power and control over the social system because the majority accept the ruling group's hegemony as the norm. This was evident from most of the audience's responses to the performance. Male dominance lies at the centre of the cultural construction of gender in most African societies. Relations between men and women are still viewed in terms of a hierarchical tradition that privileges male authority over women. The power of patriarchy is thus enhanced by its tendency to extend Salvatore Cucchiari's (1981: 62) simple gender formula: woman equals 'passive nature' and man equals 'dominant culture'.

Rather than question the power of patriarchy over personal prerogative, one of the young respondents wrote:

> I thing (sic) the character who plays Sbongile must go back to her parents and apologise for what she did (extract from audience questionnaire).

Apparently, such responses reflect the young audience's acceptance of patriarchal values that seem to conflict with the postmodern conditions affecting them. As Fredric Jameson (1991) points out, postmodernism is closely related to the emergence of consumerist capitalism, the formal features of which express the logic of that particular socioeconomic system. In Sbongile's case, such consumerist values are portrayed by her preference for the world of materialism, pleasure and prestige offered by her 'sugar daddy', Mandla. James Thompson (2006) has observed that, even if applied theatre carries positive intentions – like suggesting a counter-culture that opposes the negative aspects of patriarchal ideology – the process itself produces a clash of expectations. As the audience engages with the action, the performance impacts in ways that are diverse, situation dependent and perhaps contrary to the issues at hand. The potential efficacy of such theatre may lie in it challenging the audience's complacence over the status quo and questioning the dominant ideology, or the issue itself may remain irrelevant to the audience.

Horizons of expectation

Each genre of performance raises expectations in the audience according to how it has been framed. The performance text had emerged from the stories that the group had collected from the community. As David Booth (1994) points out, the story is a basis for organizing human experience. What the story reveals is not simply that which is already known, but that which is there but not yet understood. The story thus provides the community with an aesthetic framework for learning about itself, reflecting on its needs and aspirations and interpreting the meaning of its own experiences. It is the multifaceted way in which the make-believe world of narratives affects the audience that gives rise to what Kershaw (1994: 24) calls 'horizons of expectation'.

Through the distancing effect of make-believe, the audience members willingly suspend their disbelief and allow themselves to accept the events of the performance as both real and not real. It is by entering into such a metaxic world – what Larry O'Farrell (1996: 129) calls 'the liminoid experience' that they are able to experiment with the norms, values and practices that govern their real lives. The outcome of such activity may not have an immediate consequence for them, yet it is such ambiguous experiences that constitute 'the first condition needed for performance efficacy' (Kershaw, 1994: 24). In response to the question, 'Do you think performances like this can work as a way of learning?', most of the respondents answered in the affirmative. Some went on to indicate that they had learnt about being responsible, the importance of forgiveness and the need for tolerance and acceptance. But the process of attaining a state of make-believe remains

ambiguous, and one wonders at the complexity of identities being constructed through such performance practice.

Forum theatre as intervention

Forum theatre is a function of Augusto Boal's (1979) Theatre of the Oppressed, the primary objective of which has been described as being:

> to encourage autonomous activity, to set a process in motion, to stimulate transformative activity, to change spectators into protagonists. And it is precisely for these reasons that the Theatre of the Oppressed should be the initiator of changes the culmination of which is not the aesthetic phenomenon but real life. (Boal, 1992: 245)

Forum theatre's main focus is on transforming the spectator into a protagonist, or the oppressed subject who undergoes a process of transformation that may eventually be extended to the larger society. To this end, forum theatre creates an 'anti-model' of oppression that lays the basis for a theatre-based dialogue in which the participating audience members, or 'spect-actors', intervene to try and change the outcome of the forum scene on behalf of the protagonist (McCarthy, 2004). The 'anti-model' needs the involvement of antagonists who embody and maintain the oppression through conflicts of interest targeted at the protagonist. The rehearsal of the 'anti-model' acts as an aesthetic space for actors and spect-actors as they engage in forum debate and experiment with alternatives to the oppression. The facilitator, or 'joker', manages the intervention by presenting the actors, engaging with the spect-actors and controlling the whole intervention process.

Apart from using the performance text as an intervention strategy by itself, Ikusasa Lakho Theatre also used the same text as an anti-model of oppression following Boal's forum theatre techniques. Although the forum interventions did not seem to yield as many efficacious results as the performance interventions, they acted as a necessary starting point for community dialogue. For instance, I played the role of joker at one of the community performances in the YMCA Hall near Georgetown library in Edendale township. As a theatre group, we had agreed to end the performance at the point where Sbongile returned home with her pregnancy after being rejected by her boyfriend, Jabu, her 'sugar daddy', Mandla, and close friend, Zinhle. While her mother, Mama Ndlovu, appeared sympathetic and willing to welcome her back, her father, Baba Ndlovu, remained adamant and threatened to beat her up with his knobkerry (a wooden weapon with a long handle and rounded 'head' at one end) if she did not go away. The characters froze at this moment and the forum intervention began.

I began by explaining the rules of forum theatre as a game in which the audience is free to intervene in order to change the outcome. After a long period of silence, an adolescent boy from the community volunteered to intervene. I invited him to come on to the stage and show the audience. His solution was to get both Sbongile and her mother on their knees begging for forgiveness. Although he played Baba Ndlovu's role to the audience's applause, the solution seemed to reinforce the patriarchy's domination over women.

Evidently, the spect-actor did not intervene on behalf of the oppressed protagonist, in this case Sbongile, but of the oppressor, Baba Ndlovu. It was as if the protagonist were confronted by an accumulation of oppressions. But, as Boal (1992) explains, the action of the anti-model may contain its own negation. Sbongile herself had accepted her wrongdoing and sought forgiveness from her parents. Her oppression was therefore compromised by her apparent moral shortcomings. The spect-actor was therefore simply expressing a dilemma by not breaking the oppression, but rather reinforcing the idea that gender oppression was not so easily defeated. At another level, Boal (1992) argues that only spect-actors who are victims of the same oppression as the character can replace, or act on behalf of, the oppressed protagonist to find new forms of liberation. Such spect-actors who are as oppressed as the protagonist will, at the same time, be training themselves to take action in their own lives. In this case, the young male spect-actor was not experiencing the same oppression as Sbongile. Thus, even though forum theatre decrees that the intervention should only be done on behalf of the oppressed, there may be incidents where its rules need to be reversed – for instance, by intervening on behalf of the oppressor. Boal (1992) himself admits that if the audience, at a particular moment and for a particular reason, decides to change the rules of the game, it can change them. However, as a social intervention strategy, the only forum theatre rules that cannot be altered are those where spect-actors can become the protagonists of the dramatic action and, by extension, they must prepare themselves to be the protagonists of their own lives.

At another performance that Ikusasa Lakho Theatre carried out in Amanzimtoti after being invited by Africa Cares for Life, a Christian-based non-governmental organization that deals with teenage pregnancy problems, the intervention posed by one spect-actor sounded more like 'evangelical theatre'. Perhaps it was because the organization's members who made up the majority of the audience were Christians. The theatre group stopped the performance on the same scene where Sbongile asked for forgiveness from her parents and the father remained adamant. A middle-aged white woman volunteered to intervene on behalf of the protagonist. She came on to the stage and put on Mama Ndlovu's apron and head-dress. As joker, I asked the actors to replay the scene with the spect-actor in role as 'Mama Ndlovu'. Baba Ndlovu came on to the stage raging with anger at the sight of

his daughter and scaringly wielding his knobkerrie. In spite of the violence and intimidation, the spect-actor simply asked him to calm down while shielding her daughter. The audience just burst into laughter. From the subsequent debate on the intervention, many audience members justified the spect-actor's action, suggesting that Baba Ndlovu would change his patriarchal attitude with time. The evangelical overtones of such a solution cannot be in doubt. However, Boal (1992) seems to privilege the power of debate over the 'magic' of the solution. In his own words:

> Debate, the conflict of ideas, dialectics, argument and counter-argument – all this stimulates, arouses, enriches and prepares the spectator for action in real life. Thus, when the model is not urgent, that is to say when it is not about having to act in reality immediately on leaving the show, finding a solution is not of prime importance. (Boal 1992: 231)

The question of gender hierarchy, of male dominance over women, cannot possibly be solved by imminent action. It is a long-standing question that calls for time-tested solutions. Perhaps the evangelical approach suited the specific context of performance and would fall into the category of Boal's (1992: 231) 'model of future action'. Although the model seemed to suit the majority who were present, serving as a stimulus for future action, its evangelical inclinations could remain problematic in practice.

From the forum sessions that were carried out by the theatre group, the audience appeared more concerned with questioning the role of Sbongile's father than any other characters. There were no attempts to question the more influential roles of Sbongile's friend, boyfriend and 'sugar daddy'. In fact, it was not an easy task to get the audience to participate in the forum sessions. This may be attributed to the audience's lack of familiarity with forum theatre as an intervention strategy and the apparent absence of a spirit of creativity and critical frame of mind. However, during the forum interventions the audience continued to call for a closure to the performance. They were not content with an open ending in the last scene. As one audience member from Amanzimtoti commented: 'How can we have men who still wield knobkerries at women in this day and age? It goes against the struggle for women's liberation.' In the end, the group had to improvise an ending in which Baba Ndlovu took up the advice of a close friend to forgive his daughter. The play closes with a sombre atmosphere in which Baba Ndlovu is holding Sbongile's newborn baby, Thando, in his arms. The closure ends with song and dance followed by post-performance discussions of teenage pregnancy.

Boal (1992) admits that forum theatre itself is still experimental. More research and exploration are still required if it is to attain its full potential to transform the spectator into a protagonist of the theatrical action, and ultimately to change

society rather than interpret it. More important is the need for catalysts of forum theatre interventions to help their target audience to make connections between the imaginary life of the aesthetic space and real life. Of all the different forms of applied theatre, forum theatre seems appropriately placed on the frontier between fiction and reality, between 'what if' and 'what is', between 'as if' and 'as is', or between the 'not real' and the 'real'. It is by crossing this often-blurred boundary that people's 'dreams' may be made to come true. Yet such a boundary appears to be not so easy to cross, considering the experimental nature of forum theatre itself. Its multiple shortcomings, such as the narrow divide between the oppressor and the oppressed, susceptibility to confusion by inexperienced jokers, a tendency towards individualized rather than collective interventions by spect-actors and a rather excessive freedom with the rules of the game, can negatively impact constructions of identity.

Conclusion

Teenage girls were the primary target audience for Ikusasa Lakho Theatre's performance and forum theatre interventions. From these interventions, the most outstanding problem remained that of silence. The girls were more conspicuous by their reluctance to actively participate in discussions on a matter that had direct relevance to their lives. Judging by their lukewarm involvement in discussions, it is difficult to assess the extent to which the interventions acted as an effective catalyst for change. On further interrogation, it was observed that the young girls were caught between the cultural ambiguities of a society in transition. The majority of the girls still felt protected by the social expectations of an indigenous Zulu womanhood in which they were socialized into obedient and respectful women. However, as a survival mechanism, this protective sensibility was being challenged by the reality of the contradictions in which the girls found themselves. They had become victims of unwanted pregnancy, patriarchal dominance and intractable diseases such as HIV/AIDS. The option was for them to begin to 'speak out' against the dominant ideological system using relatively safe means of cultural resistance such as community theatre to challenge, if not subvert, the prevailing status quo. It is in the voicing of silences that the young girls could be able to claim their right to make decisions about their sexuality.

Yet this seems not to have been the case with Ikusasa Lakho Theatre's interventions. Why? While community theatre remains in search of social change, it seems to be confronted by ambiguities in terms of the agency, power and representation of its participants. Perhaps it is in the gap between fiction and reality, in playing in-between the self and the other, that the construction of identity resides,

or maybe the matter of existence itself. As James Thompson (2006) concludes, if theatre were simply an opportunity to challenge people's antisocial attitudes and change behaviour, it would lose the possibility for the unexpected, surprising and radically disturbing.

Acknowledgement

This chapter was originally published as Article 5 in Volume 9 (2008).

REFERENCES

Boal, A. (1979), *Theatre of the Oppressed*, London: Pluto Press.

Boal, A. (1992), *Games for Actors and Non-actors*, London: Routledge.

Booth, D. (1994), *Story Drama: Reading, Writing and Role-playing Across the Curriculum*, Ontario: Pembroke.

Breitinger, E. (ed.) (1994), *Theatre and Performance in Africa*, Bayreuth: Bayreuth African Studies.

Chinyowa, K. C. (2006), Ikusasa Lakho Drama Group, unpublished project proposal II, Pietermaritzburg: University of KwaZulu-Natal.

Cucchiari, S. (1981), 'The gender revolution and the transition from bisexual horde to patri-local bands: The origins of gender hierarchy', in S. B. Ortner and H. Whitehead (eds), *Sexual Meanings: The Cultural Construction of Gender*, Cambridge: Cambridge University Press, pp. 31–79.

Cunningham, P. W. and Boult, B. E. (1996), 'Black teenage pregnancy in South Africa: Some considerations', *Adolescence*, 123:31, http://findarticlesw.com/p/articles/mi_m2248/is_n123_v31. Accessed 20 November 2020.

Gramsci, A. (1971), *Selections from the Prison Notebooks*, London: Lawrence and Wishart.

IRIN News (2007), 'Teenage pregnancy figures cause alarm', http://www.irinnews.org/Report.aspx?ReportId=70538. Accessed 20 November 2020.

Jameson, F. (1991), *Postmodernism: The Cultural Logic of Late Capitalism*, London: Verso.

Kershaw, B. (1994), *The Politics of Performance: Radical Theatre as Cultural Intervention*, London: Routledge.

McCarthy, J. (2004), *Enacting Participatory Development: Theatre-based Techniques*, London: Earthscan.

Mda, Z. (1993), *When People Play People: Development Communication Through Theatre*, Johannesburg: Witwatersrand University Press.

Mkhize, T. (2006), Ikusasa lakho Drama Group, unpublished project proposal I, Pietermaritzburg: Edendale Township.

Nellhaus, T. and Haedicke, S.C. (eds) (2004), *Performing Democracy: International Perspectives on Urban-based Performances* , Ann Arbor, MI: University of Michigan Press.

Nicholson, H. (2005), *Applied Drama: The Gift of Theatre*, Houndmills: Palgrave Macmillan.

O'Farrell, L. (1996), 'Creating our cultural diversity', in J. O'Toole and K. Donelan (eds), *Drama, Culture and Empowerment: The IDEA Dialogues*, Brisbane: IDEA Publications.

Preston-Whyte, E. (1995), 'Is DramAidE making a difference? Evaluations of the DramAidE programme', unpublished manuscript, KwaDlangezwa: University of Zululand.

Thompson, J. (2006), *Applied Theatre: Bewilderment and Beyond*, Oxford: Peter Lang.

15

'We like good disco!':
The public sphere of children and its implications for practice

Nora Roozemond and Karola Wenzel

Framework and questions

> We like good disco in festival, but we don't like early to go to workshop!
> — Festival participant

> I feel quite bad, the children are already put under a lot of pressure, I mean you can see it yourself. They are sitting in the workshop, very tired and shattered and then I have to bother them with my book? Today my impression was that the children should be protected against some adults so that they have a bit of time for themselves. I honestly don't feel like doing this at all!
> — A research student in the evening of her first day at the festival

For the seventh time since 1990, about 400 young people from over twenty nations met at the World Festival of Children's Theatre 2002 in Lingen, in order to show their theatre productions to each other and to play together in workshops. A varied programme was planned around the many performances. An adult symposium, Children's Theatre and Culture, which provided an exchange of views at the levels of professionals and directors, was also an important feature of the festival.

Two years previously, at the sixth World Festival in Japan, one of the main criticisms was the failure to address the participants of the festival – in other words, the children. Speeches, words of thanks, words of welcome, awards – the adult culture dominated in Japan. It was obvious that some changes needed to be made. Following enthusiastic debate, we decided to undertake some investigation concerning the *Kinderoffentlichkeit* – the 'public sphere of children' – at the festival,

and consequently to pose some questions and make recommendations that could be taken to promote this public sphere of children over and above dominating adults. The German term *Kinderoffentlichkeit* was first mentioned by Negt and Kluge (1972: 464). In the English translation of their book (1993: 283), the phrase is 'the public sphere of children'. The translation with which we first worked was 'children's public', but this was unfamiliar to English speakers. Colleagues from abroad recommended 'children's voices'. That term might fit for much of our practice, but it means something different and does not fit the connection between the theory we built on and the practice, so we decided to stick with the original translation, even though the phrase is lengthy.

The questions posed were:

- In what forms is the children's public sphere expressed among themselves?
- The festival creates its own public sphere – how much of this do the children create?
- To what extent do we allow the children to create their projects themselves and what affirmation do they receive from other children and from adults?
- To what extent do adults pre-ordain the structures?
- To what extent does the exchange of the theatre levels (in workshops and performances) contribute to the development of a public sphere of children?
- To what extent can adults recognize and interpret a public sphere of children?

All these points merged in the main question:

- To what extent (in spaces, times, forms) are children encouraged to make themselves public?

For the first time in the festival's history, there was not only a scientific exchange of expert colleagues in parallel symposia, but also a scientific investigation of the festival itself. A group of fifteen research students in the second semester of a Theatre Pedagogy course at the University of Applied Sciences Osnabrück/Lingen observed the festival from the perspective of these questions.

This chapter is an attempt to critically evaluate these findings and an attempt to establish some hypotheses as answers to the questions, in order to enable festivals and other participatory events in the future to move towards the realization of the involvement of children that takes their actual culture and public forms of communication seriously.

The public sphere of children

> One of the most effective ways of exposing the true nature of any public sphere is when it is interrupted, in a kind of alienation effect, by children.
>
> (Negt and Kluge 1972: 464)

Some time has passed since this statement – time in which the spaces of children and adults in the industrial nations have increasingly drifted apart. Public transport is one of the last places where, by the sudden regular boarding of groups of children or families, the 'concretized character of the individual public, its inflexibility and the fact becomes visible, that public always means the public of the adults' (Negt and Kluge 1972: 464).

A public sphere of children for the purposes of self-organization and self-regulation of children has always only existed as a passing phenomenon. The British school experiment Summerhill, the Play-group Movement or the Children's Republics of the Soviet Union were touched by the idea of crediting children with their own public. However, the connection to the general public claimed by Negt and Kluge was very loose here, too. The special status that has been accorded to these projects points to this fact.

Nowadays, this separation has intensified. The institutionalization of all areas of public life allows a 'public' only 'within' the respective establishment. It is obvious that, within institutions, the interests and views of the children must be accommodated. But who knows whether this alienates/changes the general public in the long run? In literature concerning the participation of children in public matters and decisions, exemplary projects are introduced from time to time (cf. especially Hart 1992). However, perhaps these have a certain frame (time and organizational) that is separated from the general broad public and so cannot develop as an alienating force.

In contrast to the abovementioned larger projects for the self-organization of children, there are certainly always smaller 'own publics' among children – self-regulated activities that become visible in public only very rarely. According to Lansdown (2001: 4–5), one reason for the gradual disappearance of children from the public sphere is, paradoxically, for their own protection:

> In many societies, children are increasingly perceived as at risk from dangers in their local environment – fear of their exposure to traffic, drugs, violence and sexual abuse has led to the imposition of far greater controls over the freedom and mobility of children.

As a consequence, children are often seen to be a nuisance when they appear in public.

Furthermore, the homogeneity of the adult general public has intensified since the 1970s. Just a few media make up the body of opinion makers. Whoever has the money buys the right press and so creates the opinions and the lobby. Public life is corrupt and people can be bought.

The fact that children do not have their own lobby has led to organizations such as children's delegates or children's parliaments protesting and claiming rights for children. So the first children's report of the Deutsches Kinderhilfswerk (2002) identified that children are exposed to stress and pressure to perform in the same way as adults because of the institutionalization of their learning and play areas, and that they do not have a 'public voice' of their own to influence this. The report claims a renewed greater participation of children by, among other methods, a government ombudsman – as in Norway – or a lowering of the age limit with respect to the right to vote. The use of the term 'participation' to describe an increased involvement of children in public decision-making processes has been asserted both in German and in English. Hart (1992), for instance, establishes a step-by-step model of participation that has been taken up in many other publications for the analysis of fieldwork.

In relevant publications, it is pointed out that children communicate in other forms and make themselves public in other ways than adults (Friedrich and Jerger-Bachmann 1995: 126). However, in the majority of the cases presented, adult forms of participation predominate – forms to which children (for instance, as delegates in parliamentary forums, appearances in media, project-related hearings or conferences) have to adapt themselves. In contrast to Negt and Kluge's (1972, 1993) idea of 'the public sphere of children', this kind of participation always adapts to the prevailing (adult) systems and structures, because for the time being prevailing social structures are not called into question; rather, such participation only incorporates the children – that is, it 'participates them' and partially even selects them. This exercise of system-confirming forms can be seen in many well-meant participation projects. It gives the impression that the adults tend to listen to such children who do not correspond to the scheme of things, leading to descriptions of children as 'engaged, funny, at ease with grown-ups, precocious'. Accordingly, such a process is very limited and the participation often tends to fulfil the token function of a 'mutual decision'.

The Summary Report of Children's Participation in Community Settings, the international symposium of Childwatch International (2000) and the MOST Program of UNESCO, held at the University of Oslo in 2000, includes some questions

that should be asked prior to every practical implementation of such projects if children's participation is not to be simply a token gesture:

- How are children already participating in their everyday lives and settings?
- How could these activities be made more visible?
- How can structures of governance be changed to accommodate children on their own terms?
- How can the culture of participation be aligned with children's own cultures?

One of the conclusions of the conference was that:

> Attention needs to be paid to creating environments in which children are invited to participate and feel comfortable participating; therefore adult attitudes and the role of adults as mentors are critical.

Only a few other publications consider the role of the adults in participation projects to be so critical. The questions that were asked in Oslo rose above the term 'participation' as it is usually shown in practice and theory. They picked up the concepts of a children's own culture and of a public sphere of children.

In the rest of this chapter, we therefore use the term 'the public sphere of children' to define those moments in which children publicly represent their own spaces, times, forms of exchange and activities. In representing themselves thus, they are deliberately playing to the adult public, alienating themselves from it and in fact both confronting and – according to our perspective – enriching it.

The method

In the broadest sense, one could describe what the drama students did under direction during the festival as 'practice research' (Moser 1995). This cautious formulation is necessary because of the developing research understanding of the students on the one hand, and because the field of observation had a dynamic that could not be estimated in advance on the other. To this might be added the intercultural dimension of the festival, with the findings needing to be analysed in terms of their cultural components. However, two students – independently of each other – noted in their summaries that the main differences between the children were not of a cultural but rather of an individual nature.

We could find hardly any comparable projects in the literature investigating a public sphere of children, and none at all relating to their participation. This was

not a field that had specifically been constructed for participation or research pro-jects, as is frequently the case (Hart 1992). It was obvious that hypotheses would need to be reached through a range of qualitative methods. A central means for arriving at hypotheses was the research diary for observation, which was placed at every research student's disposal.

The situations to be interpreted were to be examined from as many sides as possible in a comprehensive collection of material. The aim was to use the wealth of access to various interpretations and understandings of terms to prevent a facile (pre-)understanding and an easy judgement being made by the student researchers, and to help them remain critical with respect to their own interpretation. The par-ticipation of the observers during this process was crucial in order to understand the children from their own perspective, to respond accordingly and to simultan-eously observe the students, the children and the structures of the festival. All situ-ations that took place on stage within the scope of a performance were excluded. In order to limit the research context, the extent to which the formal perform-ances of the children represented a public sphere of children was not investigated.

The following concrete method instructions were provided to students:

- *Intensive observation.* One instruction was to find up to three partner children in the first three days of the festival and to observe their behaviour. The pur-pose of this was to identify the public behaviour of children that was different from that of an adult public.
- *Extensive observation.* The questions applied 24 hours a day. About 400 chil-dren participated in the festival, so there were always and everywhere possi-bilities for collecting observations.
- *Non-participating observation.* Students were to be silent observers – to collect information by writing, drawing, filming or taking photographs.
- *Participation observation.* Students' role here was to communicate, ask, tell, reply, play and also to hand out materials, to let the children draw, take photos and make films. But they also needed to remind themselves to be curious about questions but not to 'sound the children out' (to see whether a common lan-guage is possible); to acknowledge their own unusual ideas - for example, to let the children draw the way from the 'TPZ' (the local theatre education centre) to the festival area; as well as to observe communication at meal times, note communication through eye contact, bring two children from different coun-tries together, initiate non-verbal communication and bring various resources with them in order to start communication with or among other children.

Their instructions with respect to the research diary were to:

- document language as precisely as possible, using direct speech (better to have precise extracts than a woolly summary);
- describe observed moments as precisely as possible and be bold enough to attempt to interpret them through the students' own thoughts/pictures/communication patterns;
- encourage the students with the idea that the book exists to paint/draw/write something very interesting in.

In addition to the research diary, a photo or video camera was at the disposal of everyone, as well as being a self-selected identification object for the recognition of the partner children.

Furthermore, it was the task of the research students to participate and to assist the workshop leader in one of the four morning workshops in which children worked in mixed groups (at least two children per country) on different theatrical forms. The theme of the workshops was that of the Festival: *Let's Fly*. The titles ranged from 'Children and Rhythm' and 'Dance Theatre and Acrobatics' to 'Get Your Choochoo Wings', 'Let's Fly – The Flock of Feelings' and 'Icarus – Look Daddy, I'm Flying'. The workshop leaders came from Germany, Estonia, Finland, Croatia, Malta, the Netherlands, Austria, Russia, Serbia, the Czech Republic and Uganda. Here the students had various tasks: in addition to the responsibility for the room, materials and checking the attendance roll, they had to take the children to the festival area when the workshop had finished and sometimes helped with translations. In addition to this, there were daily follow-up meetings with the workshop leaders as well as two preparatory meetings. The students could reasonably couple this assistance with the research project because of their close contact with the children in the workshop. For some research students, however, this combination was a strain.

On two days, some of the research students took over an intermediary function in the symposium by introducing the perspective of the children. They presented selected moments from their data collection where they considered that a public sphere of children had begun to grow or even take over. The form of these presentations depended on the meetings that took place between research students and children. Children were not to be excluded, although a performance demonstration for adults was to be avoided for the sake of the children.

The preparation for the investigation took place in discussions in which the methods of observation were clarified, modified and agreed upon. The identification object, for example, proved controversial because some considered it to be bribery or too childish. Its usefulness was affirmed over the course of time as the students realized that recognition was easier if they wore the same clothes, the same haircut and so on. This became somewhat irrelevant because, in the structure

of the festival, only a few intensive observation strands and relationships with the partner children could be established.

During the three days following the festival, the results were analysed by the research group. The most important agreed findings were written down and the personal research diary was examined, supplemented and annotated as needed. This was followed by the instruction to each student to code their personal observations according to the research questions. Then they continued their work in small teams: two groups shared the research diaries, checked the allocations made, found further results and sorted them according to the questions; one group was responsible for the photo and film material; one group interviewed two children from Lingen who had participated in the festival; and one group wrote a reflection on the research work.

Initially, as the 'objects of the research', the children did not participate in the research process – that is, planning and publication. We are aware of this contradiction between the content of the research and its method. On the other hand, the research work done by the students had some validity in this respect because their data collection and presentation made the perspectives of the children public in all their aspects. The children were aware of the fact that what the students drew/wrote down/painted was all intended to go in a book or publication about the festival.

In future research, a more thorough participation of the children in the research and use of their own insights must be developed.

Findings

There is obviously a children's language that everybody understands.

The central finding of the students' final reports is that children – even under very unfavourable conditions – create their own ways of communication. In this context, not least because of the international character of the festival, these mainly comprise non-verbal sign language, which in contrast to comparable situations with adults works very naturally and without any effort. The children confirmed this in the interviews: 'And everything just with a smile!'

Only a few adults would have noticed the satirical nuance with which the Finnish group changed the festival song, which many children indicated they became very tired of: It became 'Let's Die!' instead of 'Let's Fly!' In addition to the sign language, musical and rhythmical forms also had great importance – as in the spontaneous dances that were observed to break out in a number of places, especially where many children mutually created their own atmosphere, which could be taken up by others (as in the disco and the bus ride together). The atmosphere

in the theatre was a powerful contextual stimulus – from the dynamic applause before and after the performance, often led and orchestrated by particular children, to the whizzing paper planes in the audience. All this enriched the detailed descriptions of the students, who perceived a public sphere of children in this 'different' atmosphere, and it was also described by the participating children themselves.

While the special applause dynamic was an area that was not foreseen or planned by the adults, there were other structures in which a public sphere of children was conveyed. In addition to the disco, these included the pavilions, which offered very different meeting possibilities, and the guest books, placed strategically. These books, as well as the 'Letters of Friendship', created a public forum for the festival children, where they could send messages to each other, as the children interviewed emphasized. With respect to the workshops, the opinions were very diverse. The possibility that the workshops contributed to the public sphere of children through non-verbal elements in the work was certainly raised, because through this the children could get to know each other intensively, and beyond the workshops they felt themselves belonging to a large group – suggested by the exchange of addresses among workshop participants.

From this point of view, the seventh World Festival of Children's Theatre offered spaces and forms in which children were encouraged to find and to live their own public culture. However, the time available did not correspond to these spaces and forms. The pavilions with the guest books, the tent with the 'Letters of Friendship' and the workshops were opportunities for which there was hardly any time in the schedule for the guest children to avail themselves if they wanted to see the performances of other children/acquaintances/new friends or to take part themselves. Sometimes it would appear that the workshops were planned as places where the children were kept, whereas they would otherwise would (possibly) have had unsupervised time for themselves, or to spend with their friends, with their guest families, visiting the pavilions or just finding their own activities in a public sphere of children. Only the disco was an exception to this, a breath of fresh air where no other parallel event was offered for the children. This event was described by all interviewed children and by the students as an outstanding event supporting children's culture.

All types of public speeches, to audiences of which at least half the members were always children, were an obstacle. Neither the formal (adult) or the exaggerated funny (children's) speech-making struck the right note, and it failed to excite the interest of the children. These comments apply equally to the opening speeches and speeches when children were presented with their awards: 'Melanie's cousin would say now that he did not bore us with his speech. When he practised, he never managed to let it not sound ironic (Sarah, thirteen, about her friend who was allowed to act as a presenter in the opening ceremony)'.

The youth presenters were perceived as adults who had been put in children's clothes rather than as children who had to give a message to a children's audience. The obtrusive and much too loud festival song accentuated the alienation.

Hopeful information emerged from the observations that children 'create their own public where they need it'. The crowded programme may explain the fatigue with which some of the children struggled each day. They had just taken the time to meet friends, to recompose the festival song, to write Letters of Friendship, to write in the guest books and a lot more. The seedling of the public sphere of children that was planted on this occasion barely managed to maintain its position in an adult's public. Nonetheless, we can conclude that children can escape from the adult forms: 'It cannot be the intention of the children, when they organize for themselves to be among-each-other and try self-regulation, to pay for this free space with a massive reality withdrawal and a withdrawal from the adult world (Negt 1972: 466)'.

At some places, the children might have made changes or alienated the general public atmospherically – for example, ordering the applause in the theatre or the festival song. An 'overload of the public sphere of children by adults' dominated, as the research students finally discovered – not least as the media were lying in wait everywhere. This confirms the finding that children are 'undoubtedly the most photographed and the least listened to members of society' (Hart 1992: 8).

Much of this can be explained as the demands of the organizational structures and the festival character, which is exciting (the children can sleep when they get home). However, it does suggest that children were not in the focus of the festival as partners who had to be taken seriously, but rather as a façade for an adult public, which pushed the children always into the focus of attention in order to be able to demonstrate their own kindheartedness – and perhaps also in order to refresh themselves in the children's purity of heart with the hope that the world might be good one day. This suspicion is given further weight by the detail not immediately noticeable: that all adults on the stage during the festival (as hosts/ game master/speaker) were allowed to fulfil their task uncostumed, while the children were always put into costumes – as players, of course, but also in the adjudications. Negt (1997: 64) formulates this even as a requirement:

> Not only children need adults. The adult status, the consciousness of being mature and superior, is seen in the extent to which within the event the children are allowed the pictures of childhood, and how the daily reality threatens this strenuously reached development step.

In this connection, Negt (1997: 62) talks about a 'social infantilization' of the children. Even if interpreted as a place for child-minding, the workshops did give the

children the possibility to decide on their own public time forms and their own behaviours. Of course, adults fear that they will lose control and this fact prevented some opportunities in which a public sphere of children could be demonstrated. This did not, however, apply to the spontaneous dance on the stage during the final event. In this, the scheduled room and time organization were questioned by the spontaneous activity of the children – which, as Negt (1997: 98) indicates, is a sign of a public sphere of children.

All in all, it can be said that the possibilities for children to follow their own public during the festival varied. These differences can be seen if one uses Roger Hart's (1992: 9) participation model as a standard. Parts of the opening ceremony could be classified in the category 'children as decoration', such as the younger dancers who could not see the performance because they had to wait for their own performance. Other parts fell in the category of 'token participation', such as the children presenters with the texts not written by themselves using gestures not developed by themselves. However, overall the project did fulfil some categories, which at least showed the first signs of a real participation – on a scale of participation up to cooperation. As the children were not permitted a decision in planning and implementation of parts of the festival programme, there were very few areas only in which they could perceive the festival as a place of their own public.

Finally, there remains the question of the extent to which adults either perceive a public sphere of children or can understand it. This problem has been explored already in the introductory statement, and it emerged strongly in the reflections of the students. The notes of the students were based on the premise that to desire a right to a voice on matters of substance, and in public, is a general human desire, so they reflected their feelings about and interpretations of the observed situations. Their notes frequently indicate their own opposition to too much structure, classification and objectification of the children, and also the constraints imposed by the observation procedures themselves. Their meetings with the children and their shared understanding of the situation became very intense when the students were freed from the pressure of making notes all the time. So, when one of the students handed out her research diary on the second day, the children wanted to take it home. When the student got the book back after some days, there were hardly any changes. Here, too, the time pressure on the children became visible.

Hypotheses

The research team came up with a number of hypotheses, at least about this festival context, based on the research project:

- Children want to be with each other.
- Children use many forms of communication for understanding each other and are not dependent on spoken language competency.
- The exchanges in workshops and working together can be beneficial to a public sphere of children.
- The public sphere of children is always accompanied by an escape from the adult world structured in advance by adults.
- Children create their own public sphere, particularly where adults offer a framework and the children have the chance to use such a framework.
- The public sphere of children was, in the context of this festival, in contrast to the programming and structure: 'adult structures' dominated and functionalized the courses, rituals and socializing.
- When they are asked questions perfunctorily, children give only such answers as they think the interviewer wants to hear.
- Where there are interim spaces and times besides the festival structure, children's publics can develop automatically. To safeguard, strengthen and allow such adventurous meetings is a challenge to the organizers of the festival. The challenge is to design and provide the necessary structural requirements for the festival while at the same time providing possibilities for children to create their own public sphere.

Outlook

This first research investigation into the festival has led to hypotheses that could be further analysed and embedded in concrete action. Therefore, it would be helpful to continue this research within the framework of the coming festivals and in coordination with the festival management under similar conditions. The basic condition would be that the hypotheses would be integrated into the preparation and planning of the festival. Some very concrete suggestions, which are mentioned within the framework of this chapter, should be thoroughly examined – for instance, with respect to a possible extension of the festival framework in which the children could follow and create their own public forms of expression. The participation possibilities would need to be trialled to see whether they fulfil the higher-level categories of Hart's scale. Some ideas worth examining along these lines have already been suggested by adults not directly involved in the research project:

- There are so many nationalities in Lingen, so why were there no speeches in more languages (Russian, Turkish, Italian, Dutch, Arabic, Chinese)?

- Why do adults award the prizes? There is a children's parliament in Lingen!

Epilogue

In one research diary, there was a stuck-in press clipping about the visit of the Prime Minister of Lower Saxony, Sigmar Gabriel, to the Cuban performance, with the headline: 'Gabriel: I haven't seen something great like this for a long time.' Underneath, a student writes: 'Of course, this was after the 1:0 against the USA. He arrived 20 minutes late because he first wanted to watch the football match in the circus tent. Then he could see the fantastic performance from Cuba.'

Acknowledgements

This chapter was originally published as Article 1 in Volume 5 (2004). The research project is based on the idea of Professor Bernd Ruping, who rediscovered the term 'the public sphere of children'. We also would like to thank Norbert Rademacher, the artistic director of the World Festival, who gave us access to all areas of the festival. We would like to acknowledge the support given by members of the Committee for Children and Youth in the International Amateur Theatre Association. They supported this work from the very beginning, and they made it a matter of their own concern. This project could only have been realized and published in this form through the excellent, committed and collaborative work of the research students: Vanessa Badners, Johanna Bethge, Inga de Boer, Maren Felix, Christina Geiler, Nadine Giese, Katrin Gold, Lennart Hohm, Meike Honemeyer, Melanie Meier, Jutta Nowak, Birte Remmerbach, Julius Rulik, Nicole Schillinger and Sylvia Schwab. The paper on which this chapter is based was first drafted in German in 2002. The English translation and revision were completed in 2004.

REFERENCES

Childwatch International (2000), *Children's Participation in Community Settings: A Research Symposium*, University of Oslo, 26–28 June, http://www.childwatch.uio.no/projects/participation/symposion.html. Accessed 28 November 2020.

Deutsches Kinderhilfswerk (2002), Kinderreport Deutschland: Daten, Fakten, Hintergründe Children's Report Germany: Data, Facts, Background, Munich: Kopäd Verlag.

Friedrich, J. and Jerger-Bachmann, I. (1995), *Kinder bestimmen mit: Kinderrechte und Kinderpolitik* München: Beck.

Hart, R. (1992), *Children's Participation: From Tokenism to Citizenship, UNICEF Innocenti Essays, No.4*, Florence: UNICEF/Innocenti (International Child Development) Centre.

Lansdown, G. (2001), *Promoting Children's Participation in Democratic Decision-Making*, Florence: UNICEF/Innocenti (International Child Development) Centre.

Moser, H. (1995), *Grundlagen der Praxisforschung*, Freiburg: Lambertus.

Negt, O. (1997), *Kindheit und Schule in einer Welt der UmbrÃ¼che*, Gättingen: Steidl.

Negt, O. and Kluge, A. (1972), *Ãffentlichkeit und Erfahrung, Zur Organisationsanalyse von bärgerlicher und proletarischer äffentlichkeit*, Frankfurt: Suhrkamp.

Negt, O. and Kluge, A. (1993), *Public Sphere and Experience: Toward an Analysis of the Bourgeois and Proletarian Public Sphere*, Minnesota: University of Minnesota Press.

PART 5

THEATRE OF INNOVATIONS

Introduction to Part 5

Peter O'Connor

The two articles in this section provide a peek into how applied theatre practice has shifted and continues to shift as a result of the multi-disciplinary contexts with which it engages, and how technological changes have also directly impacted on the aesthetic framing of applied theatre. The articles are particularly prescient in 2020 when the shape, purpose and function of applied theatre have all been deeply impacted by COVID-19 and the growing use of mediated online applied theatre practice.

Julia Gray's discussion of the role of applied theatre in health and wellbeing (Chapter 16) represents a growing interest in the possibilities of theatre in this context. There has been a proliferation of research into not just applied theatre but all forms of applied arts in health. Most significantly in this area, the World Health Organization presented its report on the arts, health and wellbeing in 2019 (Fancourt and Finn 2019), which synthesized over 7000 studies on the relationship between the arts and physical and mental health. The studies covered all aspects of the life span, from birth to old age to death, and the scale of this metastudy speaks powerfully about the effectiveness of the arts as both preventative and therapeutic intervention for individuals and communities. In New Zealand, significant investment in the arts as part of the response from the government to Covid-19 has been driven not simply by the need to aid the recovery of the arts as a vital part of the economy, but by a recognition that the recovery of the whole country will need

the arts to lead the spiritual, emotional and mental health recovery of individuals, families, communities and the nation. Recent research in applied theatre and health outcomes spans a range from work that is intimate one-on-one practice in hospitals (Sextou 2020) to large scale post-disaster projects that are centred on revealing community resilience (O'Connor 2016).

Gray highlights the way in which theatre applied in different contexts nearly always has to negotiate cross-disciplinary boundaries that are often epistemologically or ontologically opposed or contradictory. The prevalence of health research that uses cognitive behaviourist approaches, she suggests, makes the process of negotiation with the humanist, participant-based paradigm problematic, but certainly not unresolvable. My own experience in working in health settings for over twenty years is that there is a growing diversity of approaches and understandings of health that narrows the conceptual gap. This is particularly true in contexts where indigenous understandings of health and wellbeing provide a more holistic context to treatment and or prevention than conventional organisational structures.

Innovative practice in the sub-field of applied theatre and health can be seen in the way aesthetics, ethics and health outcomes are negotiated between artists and health workers. It might safely be argued that this is true of all applied theatre practice. These negotiations shape changes in theatre form and generate new pedagogic possibilities and opportunities for evaluation of the works' effectiveness, if this is appropriate.

Chapter 16 also reveals how applied theatre was bedevilled by claims of the 'approaches working' when it was difficult to ascertain what we understood as 'working', how we could know or measure the degree to which it was working, or the competing ideas of what working meant both in applied theatre and in the health contexts.

Gray also speaks of the capacity for applied theatre to generate, represent and present data. In the last dozen years, the possibilities for using applied theatre itself as research has been more expansively and thoroughly explored (Belliveau and Lea 2016; O'Connor and Anderson 2015; O'Toole and Ackroyd 2010). The intersection between arts-based methods, participatory action research and autoethnography is spawning both different theatre forms and ways of conceptualizing the very nature of research. The article on which Chapter 16 is based was the first to be published in this journal that explored the possibilities of ethnodrama, which now seems to be very much part and parcel of the tools used by applied theatre researchers around the world.

In many ways, Chapter 16 reminds us that ethnodrama and other participatory theatre research forms work on the cutting edge in theatre-making and directly challenge dominant research methods across multiple discipline areas. Brad

Haseman (2015) suggests that we are at a critical juncture in research where a performative research paradigm is a critical departure beyond both qualitative and quantitative methodologies.

John Carroll always seemed to be ahead of the game in his writing, leading the genesis of thinking on role, framing and distancing in his Ph.D. studies back in the 1980s. His and David Cameron's research on the relationship between process drama and online epistemic gaming was an extension of that work, drawing on the notion that sign is central to all theatre forms and that this is now available in the digital medium.

The technological advances that Carroll and Cameron discuss in Chapter 17 highlight the fast pace of change in the digital world. The article was written pre-Facebook, Instagram and Twitter, when the internet had to be largely procured at home via dial-up services. The speed of wi-fi connections for home use had still to be invented. The proliferation since of these media forms and the possibilities for engagement with embodied participatory theatre were unimaginable, yet in this article are to be found the kernel of the ideas that still inform much applied theatre work that engages with mediated performance. For example, the ground-breaking work of C and T in the United Kingdom owes much to the thinking found in John and David's research. C and T's development of their Prospero software, which makes drama education possible across continents with high-quality interactive online engagement, speaks to the prophetic nature of the article. The rolling role work on climate change led by Sue Davis at the University of Central Queensland, and the international collaborations that have resulted from this, also reveal the potential for understanding how gaming and online work can be part of the applied theatre arsenal.

Drama teachers across the globe had to reconfigure their teaching in 2020, as 1.2 billion children were required to learn from isolated in-home environments. The extraordinary challenge of the pandemic forced teachers to develop new pedagogical practices. Many have been determined to retain some element of embodied social practice in a world where bodies are isolated from each other. Teachers have had to struggle with the idea that although a virtual world might simulate the experience of classroom learning, it can never replicate the humanity of it.

I found myself during a lockdown in Auckland earlier this year working in what could be called Zoom-in-role. I was playing the role of a customer liaison manager working for a company that repaired torn dream cloths. I'd met with the little girl whose cloth was torn and the company I was working with needed details of the cloth to make the repairs. I had for years played the ineffectual messenger teacher-in-role (the role of a clumsy second-in-command) and this was a variant of that. My teacher-in-role work has always relied on silence. I often wait a long time for a response, testing in the stillness for resonance. I soon realized that wasn't

going to work in an online process. I found myself adapting how I worked, not laying trails as I usually do, being less nuanced and more direct as we looked at each other across the city in our isolated rooms. When we came out of lockdown, I met the class and the dream cloth repair company in person in their classroom. We sat and chatted about the difficulty of doing dream cloth recovery during a pandemic. I marvelled – in role as the customer liaison manager – how they had written reassuring notes to our client and attached them to the new cloth. I thanked them for the design they made for my van, which meant I could transport dream cloths across the borders of the city in lockdown to areas of the country we were not allowed to enter.

Out of role, we spoke about how the in-role work on Zoom had created a space where we felt connected – connected by a fiction to manage and cope with a disaster. We were using technological advances that are now commonplace to address the public health issues of isolation and to see ourselves as capable of helping others less fortunate than ourselves. Zoom-in-role isn't far away from the mediated teacher-in-role work about which Carroll and Cameron and others have written. Zoom, however, operates differently with multiple possibilities yet to be explored in how process drama can move into a mix of online and classroom practice.

As theatres closed around the world this year, community-based applied theatre processes also moved online. I have watched with fascination how applied theatre companies have adapted to both the health challenge and the technological opportunity. We wait on the research to understand the impact on the aesthetics of applied theatre in these contexts. We need to think now of the shifting meaning of embodied participatory theatre-making in an environment that would seem to make this impossible but where innovative theatre companies are making it happen.

REFERENCES

Belliveau, G. and Lea, G. (eds) (2016), *Research-based Theatre: An Artistic Methodology*, Bristol: Intellect.

Fancourt, D. and Finn, S. (2019), *What is the Evidence on the Role of the Arts in Improving Health and Well-being? A Scoping Review*, Health Evidence Network synthesis report 67. Copenhagen: World Health Organization, http://www.euro.who.int/en/publications/abstracts/what-is-the-evidence-on-the-role-of-the-arts-in-improving-health-and-well-being-a-scoping-review-2019. Accessed 2 December 2020.

Haseman, B. (2015), 'Life drama – applied theatre in Papua New Guinea', in P. O'Connor and M. Anderson (eds), *Applied Theatre Research: Radical Departures*, London: Bloomsbury Methuen.

Sextou, P. (2016), *Theatre for Children in Hospital: The Gift of Compassion*, Bristol: Intellect.

O'Connor P. (2016), 'Applied theatre and disaster capitalism', in J. Hughes and N. Nicholson (eds), *Critical Perspectives on Applied Theatre*, Cambridge: Cambridge University Press, pp. 172–89.

O'Connor, P. and Anderson, M. (2015), *Applied Theatre Research: Radical Departures*, London: Bloomsbury Methuen.

O'Toole, J. and Ackroyd, J. (2010), *Performing Research: Tensions, Triumphs and Trade-offs of Ethnodrama*, Stoke-on-Trent: Trentham Books.

16

Theatrical reflections of health: Physically impacting health-based research

Julia Gray

Connections between theatre and medicine on topics such as embodiment and psychological trauma might be long-standing from a theatrical point of view (for example, through classic plays such as *Camille* by Alexandre Dumas, *Fils* or a contemporary play such as *Half Life* by John Mighton); however, the formal connection between theatre creation and the dissemination of health research is relatively new, having emerged within the past several decades (Gray and Sinding 2002). One particular connection between the practice of theatre and health-science research is in the form of theatre to facilitate *knowledge translation*, which is the process of taking academic, health-based research on a particular topic and moving that knowledge to a specific audience, with the intention of reducing the gap between health-based 'evidence and practice' (Davis et al. 2003: 33).

This chapter explores how the translation of health research knowledge intersects with theatrical performance through the lens of a research-based theatre production called *After the Crash: A Play About Brain Injury*, of which I was the playwright and director (Gray et al. 2006). *After the Crash*, originally developed as part of a joint Toronto Rehabilitation Institute and University of Toronto research project, was created as a means to sensitize health-care providers working with traumatic brain injury survivors to their personal recovery experiences with the intention of improving professional practice. However, the play and its development process also raised methodological and conceptual questions about how performance practice merges with traditional scientific processes. The experience of creating *After the Crash* was an extremely positive one, with all members of the team – theatre artists and health researchers – open and receptive to each other's traditions.

That said, inevitable cross-disciplinary language barriers arose. Cross-disciplinary challenges have historically risen through arts-related health research

projects based on epistemological differences in approaches to working (Rossiter, Gray et al. 2008; Saldaña 2003), and the process for *After the Crash* was no exception. The theatre artists and health researchers involved in the project had the united goal of theatrically reflecting the source material as defined by the scientific research; however, the methodological approaches and the ultimate outcome in representing the source material were understood differently by artists and scientists.

In connecting the practice of theatre with health-based research through *After the Crash*, I became curious about how representing the human body through performance contributes to the dissemination of health research. There are two main ways in which I explore this relationship here: first, I discuss how embodied performance strays from traditional science-based dissemination methods; and second, I discuss the use of abstract movement in the context of a theatrical performance to reflect scientific health-based research. I use *After the Crash* as my discussion's frame, through which these ideas will be examined; however, first I need to place the play within academic and practical contexts, as well as provide a description of the production and development process.

After the Crash: A play based on health research

Using Rossiter, Gray et al.'s (2008: 136) terminology, *After the Crash* is defined as a 'theatrical research-based performance', in that it is a play that theatricalizes but also stays true to the essence of health-based research data. The development of *After the Crash* was greatly informed by original research findings; however, the final production did not adhere strictly to the original data. This genre of performance utilizes the 'aesthetic and creative power of theatre as an interpretive, analytic tool' (Rossiter, Kontos et al. 2008: 136), in comparison with ethnodrama, where the performance remains strictly tied to the primary research findings (Rossiter, Kontos et al. 2008: 134).

After the Crash follows two main characters, Elliott and Trish. Elliott is a young professional who is the victim of a car accident and who lives with subsequent brain injury. The play follows his recovery, exploring how his relationship with his wife changes, as well as looking at his physical and emotional journey. Halfway through the play, the plot shifts to follow Elliott's physical therapist, Trish, who also sustains a traumatic brain injury. Trish, a formerly physically active person, finds herself paralysed from the waist down, and the audience witnesses her emotional journey as she mourns the loss of her former life, including her physical abilities and her partner, who leaves her. Using text and traditional scene work, as well as theatrical devices such as clowning, abstract movement sequences and

mask work, the play addresses themes such as grieving the loss of your former self, seeing yourself in a new way, challenging assumed knowledge and moving forward in the face of undeniable odds, as well as the intricate relationship between brain injury survivors, their family members and health-care providers.

The creative development process of *After the Crash* was based on empirical scientific research about traumatic brain injury. The research team held focus groups with traumatic brain injury survivors, their family members and health-care providers. The transcripts from these focus groups provided the data used to develop the play. The transcripts were analysed by a data analyst using traditional, social science-based qualitative analysis methods, as well as undergoing a theatrical and narrative processing by me and the actors involved in the creative process. Theatre artists and health researchers worked together to develop the play; the artists worked intensely on a daily basis to develop theatrical material, which was presented to the researchers and community members for continued feedback to help focus the script. Within this project, as with many applied theatre projects, the work required a balance between the academic and educational needs of creating research-based theatre for the purposes of knowledge translation, and making strong dramatic and artistic choices, thereby making the art compelling, complex and engaging.

The creative process of developing *After the Crash* consisted of a multi-layered process of improvisation and brainstorming ideas based on the transcripts. As the playwright, I independently refocused the material generated from the improvisation and brainstorming sessions, exploring the themes from the transcripts through dramatic structure and character development. I then brought the newly refocused material back to the actors and continued to rework the text; this process also involved physical and abstract improvisations based on the qualitative thematic coding done by the dramaturg/data analyst. Three staged readings were conducted throughout this process to receive feedback: one reading with only researchers (consisted of sitting around a table and reading the script); one with invited audience of focus group participants and researchers (consisting of a partially staged reading – each scene was roughly staged and the actors had scripts in hand); and final dress rehearsal (full production, including movement sequences, transitions, etc.). In between each staged reading, feedback was gathered and integrated into the script and production. (For a more detailed account of the creative process, see Rossiter, Gray et al. 2008.)

Presenting presence: Connecting to health research through performance

During the development process, tension grew around the representation of some of the source material, specifically source material reflecting how brain injury

survivors can often use aggressive language and be sexually antagonistic. This incident involved several health researchers asking the theatre artists to modify content in the play that was felt to be too aggressive (specifically overt coarse language that was sexual in nature), and the situation was often addressed as the health researchers' objectives conflicting with the artistic interpretation of the material. These sexual and aggressive confrontations occur in the play within the context of a physical therapist's professional practice, with the intention of reflecting how this known behaviour might impact the clinical work of members of the target audience. However, questions surfaced around whether representing the sexually aggressive source material was appropriate for a professional health-care audience.

In health care, the importance of moving beyond traditional modes of research dissemination, such as the journal article, to more innovative methods continues to be recognized (Kontos and Naglie 2006). Indeed, Kontos and Naglie (2006: 301) write about the limits of the written text, indicating its flattening effect when processing data through traditional qualitative research methods. The authors champion the use of performance as a way to express the 'experiential immediacy of the body present in the original data-gathering setting' (2006: 302), which is essential to health-care practice and research, and is so often lost in traditional textual forms of research dissemination.

This translation process from the flattened, qualitatively processed written word to the embodied performance has some discrepancies. Actor, playwright and university professor Anna Deavere Smith (2000: 96) writes of how, in academia, researchers 'study' issues and how, in the theatre, 'we must embody the material'. In dealing with sensitive material, Smith (2000: 96) states that

> professors can glide right over the students' complicated feelings or their own complicated feelings about the subject with the excuse that they have to 'cover the material'. In the theatre we can't simply 'cover the material'; we 'become the material'.

Smith is speaking in general of 'the academy', but I am more narrowly applying her argument to the traditional health-based research field within academia.

Smith touches on a significant difference between the academy and the theatre: covering material versus becoming material. Through the process of the written word, the health researcher represents research findings through a cerebral understanding of that material, whereas in the theatre, in order for material to be represented, an embodied understanding must occur for the artists involved to fully relay that material to their audience. In relating this to *After the Crash*, a health researcher might be able to articulate verbally the impact of the sexually aggressive nature of a brain injury survivor on the professional practice of a

physical therapist more clearly than a theatre artist, but the artist's job is in fact to embody or reflect that complex reality, personally and wholly.

It is through the performer's presence – their body and voice – that the audience receives information. Amelia Jones (1998: 5) writes of artists embracing the use of the body, with all of 'its sexual, racial and other particularities', to 'unhinge the very deep structures and assumptions embedded in the formalist model of art evaluation'. While Jones is referring specifically to the use of the human body within formalist modern art, embodied presence is clearly linked to theatre as well. Jones (1998: 10) also writes of the 'engagement and exchange' that occurs when using the body directly in art. Indeed, renowned theatre director Jerzy Grotowski (1976) defines theatre as 'what takes place between spectator and actor' (1976: 183), indicating that theatre's communicative process can take place without costumes, sets, lighting, music and even text. Without relying on text, as the audience we are asked to reflect on the body before us, using only that body and all of its cultural, social, racial, emotional, mental, intellectual, physical and sexual aspects as reference, thereby reflecting on the material independently.

Simply put, the presence of the body itself carries great weight in communicating or challenging an idea. If, as Kontos and Naglie (2006) indicate, performance offers the opportunity for the immediacy of the body to be explored, the body alone offers the audience members a chance to reflect for themselves on ideas being presented, independent of the guidance or control of words. This approach of viewing bodies in space in the context of health research pushes against, as Kontos and Naglie state, the limits of the written text by asking the audience to interpret the material presented for themselves.

Through performances of *After the Crash*, I would suggest that the embodied reflection of material from the original focus groups was indeed startling. Physically reflecting data about traumatic brain injury through the expression of aggressive sexual language strayed from traditional forms of health-based research dissemination, often heavily confined to the control of the written word.

Being physically faced with an actor playing a character with a brain injury, who is getting very angry and shouting 'fuck off', leaves a very different impression from reading in an academic journal that a client with brain injury may act in an inappropriately aggressive way. In choosing to use the human body through theatrical performance to reflect academic research on health (in this case, traumatic brain injury), one is agreeing to move beyond the limits of the written text (Kontos and Naglie 2006: 301). This mode of communication – embodied theatrical expression of health-based research – has the potential to be highly effective, leaving a great impact on the audience, but it also has the potential to be disconcerting. The performers' presence, with all of 'its sexual, racial and other peculiarities' (Jones 1998: 5), asks us to question how we think about meaning

(1998: 14), and the audience responds to this penetrating presence – hopefully through self-reflection (Grotowski 1976: 186). The discomfort with this reality of embodied expression, if used effectively, can lead to such self-reflection, and ultimately to provocative learning, which one could argue is the goal of knowledge translation or bridging the difference between health-care research and practice.

Movement reflecting data: Representing science abstractly

During the developmental process of *After the Crash*, debate also emerged on the use of abstract movement sequences in the production. Some felt concerned that these sequences would obscure the initial research findings and qualitative themes in a production whose primary purpose was knowledge translation. Others felt that, in fact, the movement sequences spoke to an emotional truth represented in the research findings that text alone could not communicate. It is interesting to note that the partition in this debate did not clearly divide between theatre artist and health researcher camps, although the majority of members with concerns were researchers. Some artists also had concerns, in the same way that some of the researchers were enthusiastic about the abstract movement sequences. Out of this debate, questions about the role of aesthetic and abstract representation in theatre for the purposes of transferring health-based research knowledge came to light.

As an example of one of the movement sequences, the character Trish has just learned that not only has she sustained a brain injury, but her partner has left her, and she has injured her lumbar region and will never walk again. The audience witnesses a piece of choreography where Trish imagines that she can walk and dance – she steps out of her wheelchair and gracefully glides downstage, with the other actors moving with her. With great poise, she shifts her body and imagines being able to move around freely, as the other actors slowly shift away from her, leaving her in isolation. She reaches out with her arms, stumbles and eventually falls. The other actors fall and rise. She struggles to stand, turns to her wheelchair, slowly walks towards it and sits. She adjusts herself in her chair, placing her feet on the footrests.

Dance theorists push Jones's ideas about the performer's presence further by discussing how the presence of the dancing body on stage asks audience members to challenge their perceptions of mainstream social and aesthetic principles. Dance ruptures the perception of both time, as ordered through past, present and future, and space, as dance does not usually occupy a specific place. Dance disrupts our cerebral understanding and experience; it 'forces us to confront what our bodies alone can understand ... it is always in excess of our comprehension and this is its joy and its terror' (MacKendrick, 2004: 150).

In choosing to use abstract movement to communicate qualitative research themes about brain injury, such as grief, loss of self and anger, the team chose to push the boundaries of how the audience receives the information. The team was asking audience members to 'confront what [their] bodies alone can understand' (MacKendrick 2004: 150) before turning that experience into words. This experiential element, experiencing the material before articulating it – while central to the theatrical experience – also means that the empirical evaluation of such an intervention can potentially be difficult.

However, in using abstract movement as one mode of communication within *After the Crash*, we were not only using the performer's body to reflect this material; the *form* of performance was also being used to communicate ideas and challenge perceptions. Art, whether a decorative vase or a piece of theatre, is 'at root a meaning-making activity in which symbolic forms are deployed to take us on some kind of journey ... It may be a *retreat* from the everyday, or it may be a *detour*, offering us some vantage points from which to see the everyday in a new light or from a new angle' (Jackson 2005: 109). At the heart of the aesthetic process in theatre, as well as the action on the stage, is 'the realization created by the audience' (2005: 109). The best aesthetic practice is one that sustains 'the complex texture of the drama and the challenge to its audience's preconceptions, requiring active engagement and reflection both during and after the performance. The inclusion of characters and voices that genuinely resist neat categorization will be necessary if both learning and aesthetic experiences are to take place, if the audience is to be challenged rather than pacified' (2005: 112). Abstract representation of the more intangible concepts that emerged from the focus groups certainly deviates from traditional academic modes of research dissemination, which tend to be carefully assessed and controlled.

The risk in creating and presenting abstract representation in theatre, of course, is that the audience might not understand what you are trying to communicate; the level of abstraction is so great that the audience is left in the dark. However, clarity is a continual challenge in artistic creation, regardless of the form; there is always a risk of being *unclear*, thereby confusing your audience. Whether text-based or presented more abstractly through movement, the objective in creating theatre is to be clear – regardless of the mode of communication.

Enabling the audience to interpret the theatrical material being presented is, in great part, an immense strength of what the art form of theatre has to offer. Abstract or symbolic representation 'should not be misunderstood as appearing to undermine or compromise work that is social, progressive, transformative and educative' (Jackson 2005: 108). This abstraction or almost decorative representation offers a '*retreat* from the everyday', which allows an audience member to see the material in a new light (2005: 109). If done well and with clarity, the abstract representation can in fact complement traditional forms of research dissemination,

allowing the audience members *space* to reflect on the material personally and to integrate that material into their own experience.

This processing by the audience is at the crux of the theatrical experience. This communication, or 'what takes place between spectator and actor' (Grotowski 1976: 183), is in large part how theatre has the potential to be so powerful and leave a strong impression. Ultimately, 'the realization created by the audience' (Jackson 2005: 109) is where theatre holds its greatest power. The research-based theatre process, and ultimately the product, occurs with the intention of the audience learning or growing personally, spiritually, emotionally and intellectually. The audience is impacted by and interprets the theatrical experience only through complex representation of the source material, be that through text, symbolic images or abstract movement. Compared with traditional health-based research dissemination methods, where the written word manages the audience's reception of the material very closely, this theatrical space has the potential to be daunting.

In the final production, a balance ultimately was struck, where the team of artists and researchers felt that we were reflecting the source material accurately and authentically, in addition to comfortably portraying the material to an audience full of health-care professionals. Regarding the expression of sexual, coarse language, the artists eliminated excessive swearing but kept the embodied, heightened anger and frustration that accompanied the original offensive language. The movement sequences, however, stayed in the production in their entirety – after presenting the play to several audiences who responded positively on the whole, it was decided that each movement sequence contributed differently to the overall play. Deciding which movement sequence should be eliminated or changed seemed arbitrary when individual audience members responded to each sequence differently. The team was keen to further explore the impact of the movement sequences on audiences as a means to translate health-based research data.

Conclusion

Further discussion is needed as the areas of theatrical performance and health-based research continue to connect. First and foremost, questions around the notion of *truth* need to be explored further: What is truth? Who defines what truth is? What is authentic? Who defines authenticity? And how are these questions traditionally approached from scientific, empirical standpoints in comparison with theatrical and artistic perspectives? As an extension of these primary questions, how are these 'truths' traditionally represented through these different fields? What happens when these differing processes of searching for truth and representing that truth merge? More exploration also needs to occur about how the *form* of

theatre connects with the translation of health-based research knowledge. Specifically, how do dramatic choices, dramaturgical work, imagery, character choices, staging and design affect the way scientific research data are translated?

Further exploration of the notion of evaluation is also needed. The evaluation of the impact of scientific work is significant, especially in the area of health care, and the articulation of how and why research-based theatre interventions are or are not effective is vital in order for them to continue. However, as discussed earlier, given the importance of the experiential nature of witnessing a theatrical performance before turning that experience into words, the evaluation of such experiences is proving to be challenging (Colantonio et al. 2008).

In conclusion, I will highlight two main points about the connection between theatrical performance and the dissemination of health research. First, through a theatrical performance based on health research such as *After the Crash*, the audience is faced with an embodied, real-time reflection of the body. While this physical representation is partly what health researchers are looking for through performance and theatre, the reality of being directly engaged with the human body has the potential to be jarring. Second, as an extension of this concept, the presentation of the body – whether through abstract movement or through realistic representation – strays significantly from traditional scientific dissemination methods. The researchers and artists involved in the theatrical project are asking the audience to process the information they are encountering independently. This is part of theatre's strength: to allow the audience the space to integrate what they are witnessing into their own experience, thereby leaving a strong, lasting impression. Through research-based theatre, the performer's body allows the audience to experience the embodied, humanistic aspects of health-based research through witnessing, and it is what remains with the audience member after the performance and what leaves an impact. The power of the presence of the human body through theatrical performance has the potential to contribute to bridging the difference between health-care 'evidence and practice' (Davis et al. 2003: 33).

Acknowledgement

This chapter was originally published as Article 4 in Volume 10 (2009).

REFERENCES

Colantonio, A., Kontos, P., Gilbert, J., Rossiter, K., Gray, J. and Keightley, M. (2008), 'Research-based theater for knowledge transfer', *The Journal of Continuing Education in the Health Professions*, 28:3, pp. 180–85.

Davis, D., Evans, M., Jadad, A., Perrier, L., Rath, D., Ryan, D., Sibbald, G., Strauss, S., Rappolt, S., Wowk, M. and Zwarenstein, M. (2003), 'The case for knowledge translation: Shortening the journey from evidence to effect', *British Medical Journal*, 327, pp. 33–35.

Deavere Smith, A. (2000), *Talk to Me: Listening Between the Lines*, New York: Random House.

Gray, J., Rossiter, K., Colantonio, A., Kontos, P., Gilbert, J., Keightley, M., James, S., Machin Gale, S., Nacos, M. and Prince, M. (2006), *After the Crash: A Play About Brain Injury*, first performed at Department of Dentistry, University of Toronto, September 2006. Script remains with J. Gray.

Gray, R., Sinding, C., Ivonoffski, V., Fitch, M., Hampson, A. and Greenberg, M. (2000), 'The use of research-based theatre in a project related to metastatic breast cancer', *Health Expectations*, 3:2, pp. 137–44.

Grotowski, J. (1976), 'The theatre's new testament', In R. Schechner and M. Schuman (eds), *Ritual, Play and Performance: Readings in the Social Sciences/Theatre*, New York: Seabury Press, pp. 182–89.

Jackson, A. (2005), 'The dialogic and the aesthetic: Some reflections on theatre as a learning medium', *Journal of Aesthetic Education*, 39:4, pp. 104–18.

Jones, A. (1998), *Body Art: Performing the Subject*, Minneapolis, MN: University of Minnesota Press.

Kontos, P. and Naglie, G. (2006), 'Expressions of personhood in Alzheimer's: Moving from ethnographic text to performing ethnography', *Qualitative Research*, 6:3, pp. 301–17.

MacKendrick, K. (2004), 'Embodying transgression', in A. Lepecki (ed.), *Of the Presence of the Body*, Middletown, CT: Wesleyan University Press, pp. 140–56.

Rossiter, K., Gray, J., Kontos, P., Keightley, M., Colantonio, A. and Gilbert, J. (2008), 'From page to stage: Dramaturgy and the art of interdisciplinary translation', *Journal of Health Psychology*, 13:2, pp. 277–86.

Rossiter, K., Kontos, P., Colantonio, A., Gilbert, J., Gray, J. and Keightley, M. (2008), 'Staging data: Theatre as a tool for analysis and knowledge transfer in health research', *Social Science and Medicine*, 66, pp. 130–46.

Saldaña, J. (2003), 'Dramatizing the data: A primer', *Qualitative Inquiry*, 9:2, pp. 218–36.

17

Playing the game, role distance and digital performance

John Carroll and David Cameron

Process drama and digital role

Process drama is a form of improvised role-based drama with a history that goes back to the middle of the twentieth century. It draws on the earlier educational drama work of Haseman (1991), Heathcote (1991), O'Neill (1995), Bolton (1999), Bowell and Heap (2001) and many others. It is a form of improvised drama, situated in a specific context, that develops a performed dramatic narrative without a script or an external audience. It is lived at life-rate and operates from a discovery-at-this-moment basis rather than being memory-based (Bowell and Heap 2001: 7) The narrative, tensions and drama unfold in time and space through action, reaction and interaction without the use of a pre-written textual script.

This dramatic form has parallels with the developing digital 'interactive drama' within the field of gaming described by Ryan (1997), McGonigal (2003), Laurel (1991) and Mateas (2004). In this computer game-based dramatic form, the player assumes the role of a first-person character in a dramatic story, who becomes part of and influences the narrative action through interaction with virtual characters. Both process drama, with its role-based performance conventions, and digital game-based performance, with its filmic conventions, depend on the assumption of a form of role identification for success.

The concept of adopting a dramatic role and a separate identity has also been widely incorporated into everyday culture, from Goffman's (1974) use of frame analysis to Goleman's (1995) notion of emotional intelligence. It has been picked up by education, management training and business, as well as computer studies (Turkle 1995). It is also a central concept in the analysis of digital environments such as virtual reality spaces, online chat rooms and video games (Ryan 2001).

There appears to be some similarity between the conventions of the live role-based performance of process drama and the mediated performance within role-playing video games that could usefully be explored in terms of identity and learning outcomes. This focus on role-taking and ambiguous or multiple identities is a staple of cyberculture debates, postmodernist thought, popular visual culture and the current theoretical fascination with 'the body'. Ryan (2001: 306) notes the popularization of the view that we own not simply a physical body, but also virtual bodies – or body images – that 'clothe, expand, interpret, hide, or replace the physical body, and which we constantly create, project, animate, and present to others' through the developing digital culture.

Consider the following two statements by influential exponents from the fields of educational drama and video game-based learning respectively. First, Dorothy Heathcote 1991: 104):

> I am concerned in my teaching, with the difference in reality between the real world where we seem to 'really exist' and the 'as if' world where we can exist at will. I do live but I may also say, 'If it were like this, this is how I would live'. It is the nature of my teaching to create reflective elements within the existence of reality.

Second, James Paul Gee (2003: 48):

> They [video games] situate meaning in a multimodal space through embodied experience to solve problems that reflect on the intricacies of design of imagined worlds and the design of both real and imagined worlds and the design of both real and imagined social relationships and identities in the modern world.

As these practitioners point out, both process drama and video games deal with the shifts in identity formations that are possible within an imagined or virtual environment. This playing with identity is particularly evident in the way that the presentation of the self in the online environment is presented as mutable and capable of growth and an increase in status. In process drama, the exploration of the relationship between identity and power is a defining characteristic of the form (Carroll 1988). This experimentation with identity and power expressed within the parameters of a video game or a process drama session may challenge traditional notions of a central or essential identity – especially in the context of race, class and gender through the adoption of alternative dramatic roles.

The mutability or 'morphing' of a constantly reinvented identity provides a new metaphor for connecting the episodic nature of in-role performance and out-of-role reflection in both drama and video games.

These social constructivist notions emphasize the spatial and temporal locatedness of identity (Hall 2000). Rather than being fixed, identities are seen as 'necessary fictions' (Weeks 1995), or as 'points of temporary attachment to the subject positions which discursive practices construct for us' (Hall 2000).

Role and identity

The concept of enacted role and temporary identity, so thoroughly explored within the process drama field by Heathcote (1991), Boal (1995), Bolton (1999) and many others, could usefully be applied here to provide an analysis of the dramatic role possibilities of multiple identity play within the drama and the interactive games environments. The closeness of performance elements within both fields can be seen as an adaptation of dramatic role to the changing cultural forms being generated by gaming platforms, interactive networks and developing online digital media.

The field of identity formation encompassed by both drama and video games means they are uniquely positioned to grapple with this issue in a cultural climate of increasing openness and identity relativism. Process drama is able to provide a positive idea of the place of the individual in poststructuralist thought by providing drama conventions that negotiate constantly shifting identities. Within process drama, the participant can be seen as a subject-in-process, capable of agency, role differentiation and integration within a range of environments, both digital and dramatically enacted, that in some way replicate the multi-modal discourse of that long-standing semiotic signing system, the theatre.

As Heathcote says, 'The theatre is the art form that is totally based in sign' (1991: 169). In the past, a single mode (usually text or icon) of communication was the only form available in the digital world (Carroll 2002). However, digital technology has now made it possible for one person to be engaged in all aspects of multimodal immersion and production. In the past, this character immersion was usually the preserve of the trained actor or the participants in role-based process drama.

As a number of authors have argued (for example, Turkle 1995: 184), such role-based digital involvement may not be all fun and games – there may also be important identity work going on as there is within process drama role-taking. In the past, such role immersion was preceded by extensive training, in the case of actors, to clarify the distinctions between identity and role. In the case of untrained individuals, directors or skilled teacher/facilitators provided guidance in process drama. Within video games, the induction may be limited to the cinematic cutscenes and introductory narrative.

Turkle's argument suggests that, while some individuals may use cyberspace to express dysfunctional offline selves, most use the digital domain to exercise and experiment with what might be considered truer identities. Maybe it is here that the first collaborations of the digital world and drama classroom could occur.

However, other cybercultural critics have been less optimistic. Rather than any kind of radical performance, Nakamura (2000) suggests that this identity tourism involves the act of playing the fantasy 'other', reaffirming rather than challenging real-life (RL) stereotypes. This seems to be the case with the gender boundaries in *EverQuest, Diablo* and other online games.

Open texts: A case study of EverQuest

Whatever the pros and cons of this more radical 'stepping into another's shoes' (Heathcote 1969), the connection between the conventions of process drama and immersive digital role-playing is even stronger when considered in terms of semiotic production. Because both forms exhibit the multimodal 'open text' that Eco (1989) describes as characteristic of contemporary communication, they are both oriented towards the semiotic action of production. As Kress (2003) points out, the screen is now the dominant site of texts; it is the site that shapes the imagination of the current generation around communication.

As Eco (1989: 20) puts it, the author (or composer, artist, playwright, instructor, game designer) offers a work to be completed by the reader (or listener, viewer, performer, student, player), such that 'the common factor is a mutability which is always deployed within the specific limits of a given taste, or of predetermined formal tendencies'. In this manner, a work can be offered as a 'plastic artefact' that can be shaped and manipulated by its audience, but which still operates within the world intended by the author (Eco 1989). In particular, Eco defines a sub-category of open work – the 'work in movement' that Aarseth (1997: 51) suggests is the closest link to interactive media forms because it is built upon unplanned or incomplete structural elements, allowing a process of mutual construction to occur.

An environment where the conventions of the open text forms of both process drama and video games can be compared is Sony Online's *EverQuest* (http://eqlive.station.sony.com). This is a massively multiplayer online role-playing game (MMORPG). Thousands of players can be active at the same time, and they can share the same game world in real time. The world of *EverQuest* is a 3D graphical environment populated by players' avatars in the form of various races (humans, elves, gnomes) or even beasts. These characters take on roles such as ranger, druid, wizard or warrior. The combinations of races and roles produce game characters with different skills in a range of areas from combat to magic, and healing to

crafts. Players may simply explore the vast game world and deal with the events and characters that they encounter, or they can engage with various quests or missions that are part of the game design. Players can communicate via text-based chat tools built into the game interface, and they may form alliances to tackle a quest as a group by pooling specialist skills and abilities. Social interaction, either as ad hoc encounters or more formally structured as questing parties or guilds, is part of the game's appeal.

The texts of both process drama and video games demand constant interpretation and articulation. As Gee (2003: 11) points out, in role-playing games you can design your own character, and the same is true for process drama. Both forms exhibit the episodic form that alternates in-role behaviour with out-of-role activity. For example, within the video game *Diablo*, after completing a task in character role, the player as player returns to the armoury to buy upgraded weapons before returning to role performance with enhanced powers.

Within drama, there is the alternation of in-role enactment and out-of-role negotiation along with research, discussion and planning. Table 17.1 matches some of the obvious similarities that exist between these two forms.

When entering the dramatic frame in both process drama and video games, 'a willing suspension of disbelief' (Coleridge 1907) is established. In the case of drama, this occurs through the negotiated agreement of the participants and the formalizing of this agreement by the facilitator, often using narrative as a focus. Video games have a similar formal narrative expressed in cut-scenes and narrative

Process drama	Video games
Group narrative orientation	Video intro/cinematic cut-scenes
Teacher-in-role	Instructions from superior, helper, etc.
Discussion of role attributes	Selecting role attributes
In-role, attitudinal drama	In-role, playing
Out-of-role research	Handbook, cheats, history
Exercise focus	Speed challenges, custom games
Building role via costume, props	Inventory and attribute-building
In-role, character	In-role, experienced character
Discussion, debrief	Online chat, web user groups

TABLE 17.1. Comparison of process drama and video games.

overlay, which establish the dramatic world. Often instruction or guidance is provided by characters within the narrative and the dramatic frame of the game. This function operates as teacher-in-role in drama, and commonly as a superior (as in rank or status) or helper in video games. There are also out-of-role tasks that occur, which are nevertheless part of the activity, such as selecting role attributes or engaging in research. As well as these activities, there are different levels of playing involvement in both dramatic forms as well as out-of-frame discussion.

Role distance and role protection

Clearly, the concept of the dramatic frame is operating in video games such as *EverQuest*, where the player is engaging 'as if' the situation is real (Goffman 1974), but where a range of conventions vary levels of protection for the player. The player can 'toggle' between a close identification with their character and an observer/learner perspective that is more distant and willing to experiment at extreme levels in order to discover how to operate within the game environment. Often, as is the case with *EverQuest*, novice players suffer little or no penalty for failure in the early stages of a game.

This penalty-free behaviour reflects what psychologist Eric Erikson (1968) terms a 'psychosocial moratorium', which James Gee (2003: 62) succinctly sums up as 'a learning space in which the learner can take risks where real world consequences are lowered'. Within *EverQuest*, high-risk behaviour is sometimes rewarded in the early skill levels. For example, one of the authors learnt to take advantage of the 'respawning' that occurs when a character dies, so if he got lost or trapped in a difficult location, he would deliberately kill off his character (e.g. by drowning or attacking a much stronger foe).

His character would then be returned to a familiar location without major penalty – that is, without loss of treasure and equipment. Similarly, he learnt that attacking creatures of similar or higher skill level was a risky enterprise, but even if only occasionally successful in these battles, the player can accumulate experience points much more quickly as a reward for defeating a strong foe. While learning to play, 'death' is an inconvenient but acceptable penalty for pushing the boundaries of the game. In process drama, this concept has come to be known independently as 'role protection', where the personal distance from the consequences of actually being in the event have been elaborated and structured for different learning outcomes. This role protection or psychosocial moratorium can be seen in a metaphorical way as an interface that frames the dramatic and performative event. In earlier times, this 'frame' was seen as a picture frame or proscenium arch framing the action. More commonly today, it is the screen frame of the computer that performs such a function.

This frame acts as a border separating the images and events from those in real life. The participant enters this framed world with a mutable identity based on parameters of the performance role available to them. By focusing attention on the performative actions within the frame, it clearly delineates the difference between real life and the representation of reality we call role-based video games or process drama. This is the 'as if' device, which provides the dramatic role protection that allows the participants to enter the space of enactment.

This performance form is composed of two elements: first, there is the nature of the conventions operating on the screen or within the drama; second, there is a level of role protection or role distance present that allows the adoption of a new identity within the penalty-free area of the dramatic frame. Figure 17.1 shows these elements in a less metaphorical way.

The conventions operate as creative forms for both video games and process drama by developing non-naturalistic ways of presenting material and adapting roles within the performance frame. Within process drama, this covers a range of positions, including attitudinal role, signed role and character performance, as well as more abstract forms such as effigy, portrait, statue and narrative voice (Neelands 1990).

Within video games, the player has a similar range of positions from first-person shooter to central character, controller and interactive performer. These conventions are built into the performance frame and provide the structure for the fictional social world to exist.

There is also the protection of role distance that allows the psychosocial moratorium to operate for the participants within the performance frame. Within stand-alone video games, it is the penalty-free nature of the interaction that allows the character to constantly learn by mistakes. However, while providing high levels of role distance and role protection, stand-alone video games are still able to allow participants to experience the performance frame from alternate positions. For example, within the real-time strategy game *Starcraft*, the player can control any of three different species – Terran, Protos or Zerg – each with its own unique goals, technologies and abilities. Within massively multiplayer online games like EverQuest, the penalties associated with avatar death may be much closer to those of interactive process drama than non-networked or single-player games.

FIGURE 17.1. Elements of the performance frame.

FIGURE 17.2. The 'performance laptop', illustrating role distance and role protection.

In a more metaphorical way, the 'performance laptop' shown in Figure 17.2 illustrates these points. The laptop frame provides the space and performance conventions for a distanced performance, and operates for both drama and video games.

The player/performer always has the option to select from a range of distance and protection conventions. The most obvious position is immersion in the action of unstructured first-person participation. This full role, 'first-person shooter' (FPS) position, while providing high levels of involvement and activity, is one that provides minimal levels of protection for the participants. Within video games, FPS game forms are often based on reflex action and physical controller skills, and they depend on an ever-growing body count of increasingly ferocious adversaries for success. In other, more quest-based, video games such as Nintendo's *Zelda* series, the first-person view is more open and problem-based, and much closer to the drama concept of full role.

Within process drama, first-person full role and immersion in the event are usually the culmination rather than the starting point of any improvisational drama. First-person 'in-the-event' drama requires a background understanding of the context and high levels of group trust to operate in a situation with minimal role protection.

If this minimal role distance is overly confronting, then within both drama and video games, the participant/player can choose a greater role distance and stand back from the action by the assumption of an attitudinal role. This maximally distanced role requires only the agreement of the player to take on an attitude of a character in the drama for it to operate. An *EverQuest* player could choose to ignore the 'connected' aspects of the game, avoiding communication with other players and pursuing their own intra-game pursuits, such as mapping the game

world. They could imbue their character with a desire to observe the game world, rather than interact with it.

At a role distance closer to the action, the player can become a central character by 'signing' the role they have adopted through costume, name, career path or some other attribute. They can actively engage other human players, adopting a particular tone in their text-based 'conversations' in order to convey a deeper sense of their role. At the role distance level closest to being-in-the-event, the player can assume a full role and become part of the unfolding narrative action. The role distance chosen is always variable, and the player can 'toggle' between levels of involvement in a video game through changes of camera perspective. Sometimes this is for strategic reasons, to gain a larger picture of what is happening, but sometimes it is because the emotional closeness of the action becomes overwhelming.

As noted earlier, in terms of role protection, this first-person full role is the most emotionally exposed position. However, the player may choose to maintain a full role but stand back somewhat from the moment of unstructured participation by becoming a guide for the character, or an author of the narrative. In *EverQuest*, a player can choose to 'hire' other players to complete a difficult or dangerous task, rather than attempting it themselves. Similarly, a player can choose to develop their character as a service provider (for example, healer, tailor, fletcher, blacksmith, minstrel) to other players rather than participating in the game's pre-designed quests. These roles are often presented as non-player characters (software-controlled agents), but human players can take on these roles if they desire. Similarly, within process drama the teacher/facilitator may shift the role distance of the participants in a group enactment if the level of role protection does not provide enough artistic distance from the dramatic intensity of the event.

Both performance forms, unlike real life, mean that the participants are not trapped in the present moment of unstructured participation. The performance frame for both drama and video games allows the participants to structure the protection of role distance that is appropriate for their needs.

The performance frame, the conventions and the levels of protection are shown in a metaphorical way in Figure 17. 2. All the levels of protection and varieties of convention are available in any piece of work.

Of course, the ultimate protection for both drama and video games is to exit the performance frame altogether, and this episodic quality is part of the dramatic form – most games feature a pause function. However, the combination of role protection and role distance from the focus event provides the dramatic structure that protects the participants in their dramatic involvement with the narrative.

All varieties of role distance are performative – and distanced roles are often used in drama, although less so in video games. With drama, participants feel

more protected and work with more conviction if they are framed at some distance from the moment of real-time enactment. If too much is at stake, the role distance is often too close for an exploration of the situation and the performance frame becomes blurred while the belief in the convention and protection of the role is lost. Within video game genres, role distance varies. In first-person shooter forms, the visual rush of imminent destruction often drives the action. In other quest-based games, a more reflective position is available.

Player perspective, role distance and role protection

One way to explore how the dramatic conventions of role distance and role protection apply in video games such as *EverQuest* is to consider the screen views available to the player. Following a video game convention of equating player perspectives and role distance with 'camera views', the player can cycle through the options to choose to view the game from different angles, and also zoom in or out and pan left and right using keyboard commands. Table 17.2 outlines the camera views offered in *EverQuest*.

In practice, the authors found that playing the game comfortably and efficiently required a constant process of toggling between the first-person view, a view from over the shoulder of the avatar and a distant third-person view. The 'ideal' view depended on the task being performed. For example, the authors found a first-person view good for navigating through corridors in pursuit of another character, while switching to a third-person view was sometimes necessary in a melee fight to ensure the avatar wasn't being attacked from behind.

As noted earlier in Figure 17. 2, a first-person perspective in terms of both role protection and role distance is the most likely to equate with a sense of being within the action; it is 'as if' you are the character. First-person view is the most

Description	View	Camera position
First-person (default)	Straight ahead	Player cannot see character
Overhead (rotating)	From above	Rotates as character turns
Rear (rotating)	From rear	Rotates and stays behind the character
Overhead (fixed)	From above	Does not rotate as character turns
Read (fixed)	From rear	Does not rotate as character turns

TABLE 17.2. The camera views in *EverQuest*.

'real' perspective available in this game, and in others like it. Indeed, the 'first-person shooter' is recognized as a game genre in itself, modelled on neo-classics such as *Doom*, *Quake* and *Unreal*. It is the perspective that most places the player within the 'skin' of the character avatar. In this view, the world is seen through the character's eyes. The point of view afforded the player in video games is often discussed in terms of 'immersion' – the degree in which the player is drawn into the mediatized 'reality' of the game environment.

Other camera positions offered in *EverQuest*, as listed in Table 17.2, present options for varying degrees of role distance and protection, as outlined in Figure 17. 2. Whenever the player is in role, standing apart from the action and looking down on their avatar, this role distance brings highly affective subjective elements into the social relationship being negotiated (Kress 2003: 118). The player is always in control of the role distance they choose. It is their desire for engagement that dictates how close to the naturalistic frame of total involvement they will go. These conventions exist as a visual genre, which is similar in form to the illustrations that exist within a multimodal text as outlined by Kress (2003: 118). The distance and positioning of the viewer in any visual text, video game or drama are always critical to their role position. Like many games, *EverQuest* allows the player to quickly toggle or cycle through camera positions using keyboard commands. In this manner, role distance can be changed more quickly and more often than is usually the case with process drama.

FIGURE 17.3. Third-person (rear rotating) view in *Everquest*. Attacked from behind, the authors have adopted this perspective/role distance to identify their foe and plan a response.

Figure 17.3 illustrates the third-person view in *EverQuest*. Here the authors (in the guise of their character Elviss the Ranger) have been attacked from behind by a Restless Skeleton (a computer-controlled character). The authors have toggled from first-person to third-person perspective to quickly gain a sense of the melee. In terms of role distance, this is a mid-range engagement that is in the action, but not too close for comfort. Being able to assess the situation and plan a response in third-person view is less distressing than reacting to an attack from a seemingly invisible enemy in first-person view.

It is important to note that *EverQuest* intrinsically acknowledges that sometimes players want to shift to other role frames during the game. One of the communication modes afforded in the game is known as 'out of character' chatting. By typing in 'ooc' mode, a player speaks out of character to all nearby players. The game instructions describe this facility as being 'for speaking out of the context of the game and your character'. An odd but amusing example of this is shown in the transcript of text-based conversation below, in which the character of Bareback comments out of character about Elviss's name:

BAREBACK (OUT OF CHARACTER):	Love me tender, love me sweet.
ELVISS:	Do you like my hair?
BAREBACK:	Yes I do.
ELVISS:	I would like my shoes to be blue suede.
BAREBACK:	That would be cool.

This ability to toggle social interactions instantly and explicitly in and out of character clearly allows for shifts in role protection. This exchange equates to the role protection frame of critic, who can interpret and comment on the action. This level of spectatorship is highly protected and a long way from first-person involvement. Indeed, it is often the functional aspects of gameplay that afford the ability to alter levels of role protection. The player can choose to be in the action as a first-person participant or, as noted above, they can switch to a more protected role of critic by choosing to communicate out of character.

An even more protected position is that of the artist customizing their experience. In *EverQuest*, this is typified by the function of allocating accumulated skill points to selected areas to enhance a character's ability. In this mode, the character is not perceived as an avatar, but rather as a table of skills and abilities that can be favoured or ignored depending on how the player wishes to shape their experience. In video and computer games more generally, this high level of role protection is found in the practice of modifying the game code, or in creating new game levels or scenarios using software tools and programming skills.

Process drama, video games and learning

In learning terms, Eskelinen (2001) makes a critical distinction between the sort of learning exhibited by both process drama and video games, and that of engaging in traditional text-based learning. He makes the point that the dominant mode of learning in literature, mainstream theatre and film is interpretative, while in games and process drama it is configurative. He says:

> In art we might have to configure in order to able to interpret whereas in games we have to interpret in order to configure, and proceed from the beginning to the winning of some other situation.
>
> (2)

This type of learning is directly applicable to the ergodic learning pathwork that Aarseth (1997) describes. He is referring to a phenomenon whereby the player, or user, of a text is a closely integrated figure in the construction of a semiotic sequence. They construct the text by their input into the given elements. He argues that traditional texts require little input from the reader, apart from eye movements and page turning. He contrasts this with dramatic texts that require non-trivial effort to construct and traverse them, such as interactive fiction, process drama or video games. Aarseth uses the Greek words *ergon* (work) and *hodos* (path) to describe these as *ergodic* texts (1997: 1–2). Within process drama, the participants construct the narrative from the experiential moments of immersion within the negotiated group devised world. This is a very different experience from actors performing a written text or the theatrical experience of being members of an audience participating in the unfolding of a written text.

Similarly, within video games during the process of playing – for example, *EverQuest* – the participants are engaged in the construction of an individual and unique screen-based semiotic structure. This consists of a selective configuration of the game elements and their own player choices, which produces a unique improvised lived environment. The wide-ranging variable expression of meaning built into such a non-linear game text should not be confused with the semantic ambiguity of linear print-based texts, which allow for different reader interpretation of a pre-set format. The game world of *EverQuest* is constructed through an individual player's work and exists as a unique artefact, so is an ergodic text as Aarseth (1997) defines it.

Of particular interest is how closely learning concepts drawn from process drama, such as understanding role distance and role protection (Carroll 1986), apply to video games learning. For example, by initially ignoring a game's manual, most players appear to have a learning experience that closely mirrors the process of experiential learning that occurs in role-based process drama (Cameron and

Carroll 2004). In the role-playing video game *EverQuest*, a player's continued interaction with game elements and tasks is rewarded with points for experience. A new player practises martial skills by killing rats, skeletons and other creatures that conveniently exist in plague proportions on the introductory levels. By becoming successful at these tasks, the character is eventually promoted to a higher skill level. Each time a character is promoted, the player can distribute a small amount of experience points among a range of character skills and attributes. In this way, the player can shape the character's growing expertise in or knowledge of certain areas.

EverQuest's promotion system also allows for a penalty-free learning zone for the player. Until a character is promoted to a skill level of 10, they can die and be regenerated largely without loss. They will be returned to a safe location, and they will keep whatever items they were carrying at the time. However, once a character achieves level 10 experience, it becomes necessary for the player to locate their 'corpse' in order to recover those items. If the character has died in a particularly awkward location, recovery may not be possible. This can be a significant penalty in a game that relies heavily on the collecting of powerful weapons, useful tools, valuable objects and magical items. Maintaining this inventory can be an expensive pursuit, both in terms of accumulating the game wealth to purchase or pursue these items, and literally in terms of the subscription costs to play the game long enough to develop a character's worth.

Restricting the risks for characters below level 10 experience allows new or less able players to indulge in high-risk behaviour while at the same time being protected by their role distance from deep identification with the character so that their potential danger becomes a positive learning experience. The authors have noted a similar process at work when learning to play other video games, such as their introduction to *Resident Evil – Code: Veronica X* that frequently involved gruesome deaths for their avatar Claire, the character representation of the player, until their skills and strategies improved (Cameron and Carroll 2004).

Conclusion

There is already considerable discourse on the developing forms of digital 'interactive drama'. This chapter contributes to that discussion by suggesting a theoretical connection between the conventions of live role-based performance of process drama and the mediated performance of online role-playing video games. It is clear that a central element of both process drama and multiplayer online video games is their ability to allow participants/players to 'step into somebody else's shoes'. Both forms contain role distance and role protection conventions that allow a fluid 'toggling' between

close active engagement within the unstructured moments of the event and a more protected observation or reflection on the experience. In video games, this toggling can be as instant as a keyboard press to switch the on-screen viewing perspective.

The authors' experience of learning to play *EverQuest* demonstrates the increasing closeness of performance elements within both fields. Process drama's appeal in the educational setting is its ability to provide a protected means of experiencing and curriculum learning from an experiential position. The mutability of digital identities, as realized in online games, provides a similar penalty-free opportunity for exploring social relationships, identities and experiences 'as if' the player is somebody else. Switching in and out of (or between) characters, or toggling distance between first-person participation and third-person observation, provides mechanisms by which the participant/player can reflect on and adjust their involvement in the events they are a part of.

The challenge inherent in this digital gaming form is to explore how this connection might be further applied in fields such as education, where – at least within Western culture – young people's concepts of performance, role and individual identity have already been changed by an increasingly mediated world. The ability to manipulate or 'edit' identity is a concept already assimilated into the digital worldview of many young learners. As more video game-based resources for the classroom emerge, it becomes increasingly important to incorporate artistic notions of role distance and role protection in their development. This may also help to address the 'moral panic' reactions to the use of games in classroom learning.

A continuing discussion between educators and especially process drama specialists and game designers on how best to connect these new learning and identity conventions to artistic form and curriculum content would seem to be worth having.

Acknowledgement

This chapter was originally published as Article 11 in Volume 6 (2005). Much of this material was republished in Thompson's *Applied Theatre* in 2012.

REFERENCES

Aarseth, E. J. (1997), *Cybertext: Perspectives on Ergodic Literature*, Baltimore, MD: Johns Hopkins University Press.

Boal, A. (1995), *The Rainbow of Desire*, London: Routledge.

Bolton, G. (1999), *Acting in the Classroom: A Critical Analysis*, London: Heinemann.

Bowell, P. and Heap, B. (2002), *Planning Process Drama*, London: David Fulton.

Carroll, J. (1986), 'Framing drama: Some classroom strategies', *National Association for Drama in Education Journal*, 10:2, n.p.

Carroll, J. (1988), 'Terra incognita: Mapping drama talk', *National Association for Drama in Education Journal*, 12:2, n.p.

Carroll, J. (2002), 'Digital drama: A snapshot of evolving forms', *Drama & Learning: Melbourne Studies in Education*, 43:2, pp. 130–41.

Cameron, D. and Carroll, J. (2004), '"The story so far …": The researcher as a player in game analysis', *Media International Australia*, 110, pp. 62–72.

Coleridge, S. T. (1907), *Biographia Literaria*, London: Oxford University Press.

Eco, U. (1989), *The Open Work*, trans. A. Cancogni, Cambridge, MA: Harvard University Press.

Erikson, E. (1968), *Identity, Youth and Crisis*, New York: W. W. Norton.

Eskelinen, M. (2001), 'The gaming situation', *International Journal of Computer Games Research*, 1:1, n.p.

Gee, J. P. (2003), *What Video Games Have to Teach Us About Learning and Literacy*, New York: Palgrave.

Goffman, E. (1974), *Frame Analysis*, Norwich: Peregrine.

Goleman, D. (1995), *Emotional Intelligence*, London: Bloomsbury.

Hall, S. (2000), 'Who needs identity?', in P. du Gay, J. Evans and P. Redman (eds), *Identity: A Reader*, London: Sage.

Haseman, B. (1991), 'Improvisation, process drama and dramatic art', *The Journal of National Drama*, July, pp. 19–21.

Heathcote, D. (1969), 'Dramatic activity', *Drama, English in Education*, 3:2, https://onlinelibrary.wiley.com/doi/abs/10.1111/j.1754-8845.1969.tb01004.x. Accessed 1 December 2020.

Heathcote, D. (1991), *Collected Writings on Education and Drama*, Evanston, IL: Northwestern University Press.

Kress, G. (2003), *Literacy in the New Media Age*, London: Routledge.

Laurel, B. (1991), *Computers as Theatre*, Menlo Park, CA: Addison Wesley.

Mateas, M. (2004), 'A preliminary poetics for interactive drama and games', in N. Wardrip-Fruin and P. Harrigan (eds), *First Person: New Media and Story, Performance, and Game*, Cambridge, MA: MIT Press, pp. 19–33.

McGonigal, J. (2003), ' "This is not a game": Immersive aesthetics and collective play', in *Proceedings of the 5th International Digital Arts and Culture Conference*, Melbourne.

Nakamura, L. (2000), 'Race in/for cyberspace: identity tourism and racial passing on the internet', in D. Bell and B.M. Kennedy (eds), *The Cybercultures Reader*, London: Routledge, pp. 712–20.

Neelands, J. (1990), *Structuring Drama Work*, Cambridge: Cambridge University Press.

O'Neill, C. (1995), *Drama Worlds: A Framework for Process Drama*, Portsmouth: Heinemann.

Ryan, M.-L. (1997), 'Interactive drama: Narrativity in a highly interactive environment', *Modern Fiction Studies*, 43:3, pp. 677–707.

Ryan, M.-L. (2001), *Narrative as Virtual Reality*, Baltimore, MD: John Hopkins University Press.

Turkle, S. (1995), *Life on the Screen: Identity in the Age of the Internet*, New York: Simon & Schuster.

Weeks, J. (1995), *Invented Moralities: Sex Values in an Age of Uncertainty*, Cambridge: Polity Press.

PART 6

A NOD TO THE ANCESTORS

Introduction to Part 6

John O'Toole

The consensus naming of applied theatre, and the formation of a recognizable community, may be just about 30 years old. However, this last pair of articles reminds us that of course 'theatre and drama for instrumental purposes beyond entertainment, taking place outside formal theatres' (our hold-all definition of applied theatre in the Introduction) is as old as any other form of theatre, and has been around since at least the olden days in Takkaç and Dinç's case (Chapter 18) or indeed time immemorial in Eriksson's case (Chapter 19).

The articles also remind us of the long history of some deep and archetypal purposes for theatre that have not been touched on by any of the writers discussed so far. Applied theatre workers, including many of those in this book, such as Chan, Prentki and Schonmann, are front-of-mind aware of drama's possibilities for effecting social change, and of its ethical and moral dimensions. In different ways, both the articles in this section speak of a deeper and broader role for theatre, across vastly diverse cultures, as a kind of moral, ethical and social barometer and even arbiter – weighing up for its audiences the levels of good and evil in their society, of justice and injustice, of power use and abuse. Theatre provides touchstones, and it may take sides.

This ancient history is true at the simplest instrumental level, with countless examples of drama where entertainment was firmly subjugated to an immediate

practical purpose, with the drama workers sometimes using exactly the dramatic strategies and techniques that contemporary applied theatre workers and drama educators believe we have just invented. In fifteenth-century Vietnam, the doctoral examinations for wannabe mandarins included in-role writing and formal oral and poetic presentation in role (candidates had to discuss matters of state and formulate policy, assuming the personage of the Emperor himself) (Howland 2009: 102–7). In eighth-century Britain, the monk Ceolfrith taught his monastic students all about the Christian Bible by using 'teacher-in-role', letting them 'hot-seat' him as a biblical character, then getting them to do the same with each other (Bragg 2003). And just a few centuries later, this dramatic pedagogy exploded out of the churches and right across Europe for 300 years, in what we now call the Mystery or Miracle Plays, which had several vital instrumental purposes. The main one was for the citizens to perform those biblical stories themselves, in the vernacular and as stories from their present day. Thus, ordinary people could get to know the Bible for themselves, instead of it having to be explained and interpreted by the priests because it was in Latin – a monopoly on knowledge and power that was fiercely guarded.

Entertainment was indeed part of the package, because the plays were performed as festival fare on special holy days. This is a main theme for Eriksson in Chapter 19, along with his recognition that theatre shares deep and long historical roots with religion and mystery. Drama was the instrument that both Ceolfrith and the Miracle Players used, and in traditional cultures across the globe, theatre and religion go hand in hand. (We still lightly use the term 'the magic of theatre', usually quite unaware of its profoundly ambivalent meaning.) Theatre was a special occasion for the Miracle Players (as in some ways it still is in our society). However, that in itself points to something much more deeply important, which Eriksson identifies as the human need for carnival. Tim Prentki is another contemporary applied theatre scholar who has explored the link between theatre and carnival in detail in other *ATR* articles, though not in his contribution to this book. In one such article, Prentki (2016) points to another profound purpose for the theatre and social role for the actor, not unrelated to carnival, which is that of the fool. This is a theme taken up by Takkaç and Dinç in Chapter 18 because it is at the centre of their Karagöz theatre.

Naturally, these two articles have a different feel from the rest of the book, because both are the outcomes of scholarly research, not practice. Takkaç and Dinç have mainly used standard historical research to reveal a tradition of centuries that still exists – just – in a rather degraded form, in terms of its original intentions and purposes. Eriksson has used a novel approach, through the etymology of language (his own and English) to probe far back in time to find the

A NOD TO THE ANCESTORS

earlier deep significance of performance traditions that also still exist, in equally degraded and trivialized forms.

Chapter 18 describes and analyses what in Turkey was at one time a major form of popular theatre, the Karagöz puppet theatre. Part of its popularity was that it provided entertainment to working people, and it shares some characteristics (such as the 'wise fool' clown and the trickster) with many other traditional popular theatre forms, such as Commedia dell'arte and the Ashanti theatre of *Anansi the Spider*. They all use non-naturalistic or grotesque caricature of stock characters representing human foibles, virtues and vices (in this case, puppets), clearly mimicking their audiences' current concerns, desires and grievances.

Ironically, many contemporary applied theatre programs strive to be popular, because entertainment has to be the part of the bargain they make with their audiences and participants. Only when you've got and kept your audience's attention can the moral and social purposes operate. And that is really what Karagöz theatre was about – it was that moral, ethical and social barometer and arbiter. The plays at times seemed to exist to reinforce the moral and social status quo, but at other times to disrupt and undermine conventional power structures. The article's authors seem ambivalent themselves about which of those was the more significant or admirable function. Karagöz was the helpless, unlettered Everyman, put-upon but endlessly resilient and ingenious. Through his antics, children could be taught to behave, but also to empathize with the powerless; and subtly, local social ills, corruption and injustices could be exposed. The plays even took on criticizing the Sultan's rulings, and a favourite target was the malfeasances and hypocrisies of corrupt or venal religious leaders (though not religion itself, as the company was playing to faithful devotees of at least three major religions).

Stig Eriksson is known as a practitioner and educator of distinction and longevity, a leader in a diversity of educational and applied projects world-wide, and so this departure into historical scholarship within his own Norwegian context is an imaginative surprise, and no doubt a departure in content for his students. Chapter 19 is important here not only for cementing that time-honoured affiliation of religion and theatre, but for stressing the consanguinity of theatre and ritual. Ceremony and ritual and theatre have always lived together – rituals are public performances and they are how religion performs and maintains itself to its adherents. Today's most ubiquitous festival, Christmas, is rapidly secularising from its religious origins, and only vestiges of its meaning, its original story and its traditional ceremonies and rituals remain for most people. Cleverly, through his imaginative and meticulous delving into the etymology of Christmas, Eriksson reveals that underlying the still-recognized symbols and rituals that we enact at Christmas are even older mystical symbols, some of which predate the Nativity

itself. These include the very idea of Yuletide, which was formerly a time of sacrifice, the ubiquitous Christmas tree and, to non-Norwegians more surprisingly, the figure of Santa Claus himself. This Santa is not the popular media's avuncular red-and-white gift-giver bestowed on us by Coca-Cola. Nor is it St Nicholas, the dimly remembered third-century miracle worker from Asia Minor. Instead, it is Julenissen, a much more powerful, ambivalent figure of good and evil, forgiveness and retribution who still has currency in Scandinavia. Nowadays there is rather less fear and magic attached, of course.

In this chapter, Eriksson takes us right back to those broader purposes of theatre, which actually have little to do with entertainment and everything to do with using theatre to depict and manage a world that is unpredictable, filled with people struggling to make meaning, to create a just social structure, or just to survive … exactly our own primary purpose in what we now call applied theatre.

REFERENCES

Bragg, M. (2003), *The Adventure of English: The Biography of a Language*, London: ITV.

Howland, C. (2009), *Hanoi of a Thousand Years*, Hanoi: Thê´ Giói Publishers.

Prentki, T. (2016), 'Joking a part: The social performance of folly', *Applied Theatre Research*, 4:3, pp. 189–203.

18

Educational and critical dimensions in Turkish shadow theatre: The Karagöz Theatre of Anatolia

Mehmet Takkaç and A. Kerim Dinç

Turkish shadow theatre, also known as *Karagöz* (literally meaning 'dark eye') *plays*, is a form of theatre that is believed to have been brought to Anatolia from Egypt in the sixteenth century; it originally came from Southeast Asia. Although some claim that *Karagöz* is 'only' a puppet show, it was and is full-scale theatre, with curtain, scenery, plays and actors (shadow puppets). It served the need for theatre in the Ottoman state.

Each *Karagöz* play consists of four parts:

1. the prologue or introduction
2. dialogue
3. the main plot, and
4. epilogue.

The legend of the emergence of *Karagöz* in Anatolia is a sad one. The most widely believed story is that this theatrical form arose from the death of two construction workers, Karagöz and Hacivat. During the reign of Ottoman Sultan Orhan (fourteenth century), Karagöz was working as an ironmonger and Hacivat as a mason in the construction of a mosque in Bursa, the capital city of the state at that time. They continually distracted the other workers with their humorous and attractive dialogues, and so slowed down the construction of the mosque. Getting angry at this, the Sultan had them both put to death, which later caused him unending regret. To decrease the sultan's sorrow, and to cheer him up, Sheikh Kusteri, 'the so-called inventor and patron saint of Turkish shadow theatre' (And 1975: 34) set up a curtain and behind it recited the humorous dialogues of Karagöz and Hacivat

with yellow shoes in his hands. It is not known how much pleasure the Sultan got from this, but the public apparently loved it. As James Smith (2004: 187–88) notes:

> *Karagöz* became a popular art form in Turkey from the late sixteenth century on, coinciding with the rise in popularity of coffee shops. Islamic officials condemned both, but the poorer classes filled them. In Turkey, *Karagöz* shows were especially popular during Ramadan. Throughout the period of this observance, the most holy in Islam, there is no food or drink consumption during the day, and after sundown feasts are held. Typically, people would come to coffee houses for the feast and enjoy a *Karagöz* show at the same time, with a different show being performed every night of Ramadan.

The tradition of Turkish shadow theatre has been a melting pot of Turkish culture, world views, beliefs, religion, written and oral traditional heritage (including literature, folklore, social and economic structure), art and other types of drama and music. Thus the reflection of these concepts in shadow plays has met an important need in the field of art. *Karagöz* has always kept its characteristic features and stayed true to the nature of the original shadow theatre, with a threefold role of enjoyment, teaching and social criticism (And 1977: 80). This is, in fact, an inherent part of this particular theatre, as may be seen from what is said at the beginning of each play:

> Before the opening of the curtain, the nature of goodness is stressed; the viewers are informed of the importance of thinking properly, behaving properly, being reasonable, not being the slaves of temporary things but obeying the rules of absolute truth, working and earning honestly. They are also warned to see not only the surface of the reality but the inner part. The reality is not on the outer surface but within, it is in the core.
>
> (Çapanoglu 1977: 28–29)

Main characters

Each *Karagöz* play includes two main characters, Karagöz and Hacivat, and often other secondary characters. The character of Karagöz can be defined as a teacher, whose social function – though he is uneducated himself – is to make people think while making them laugh. This role started from the time of the Ottoman state, which had a long history of puppet theatre, and continues to the present. Those who played Karagöz have always assigned it this educational and critical role because they have accepted Sheikh Kusteri, who cared for these issues, as the founder and protector of this tradition (And 1977: 250).

As for Hacivat, he is on good terms with everyone around him, a go-between who concludes the bargain, solves disputes and establishes peace himself. He is thoughtful and moderate; he can take part in any company and has a flexible tongue and temperament. He listens to all individuals, gives advice and directs; he gains the confidence and love of everyone he encounters. As well as his wide acquaintanceship, he has knowledge of everything including music and literature – if not fully, at least partially. He reflects every sign of being a well-bred individual. He is a skilful coordinator of some gatherings. If a young man and a young girl come to him with the intention of marriage, he says flattering things to the girl's family about the man and to the man's family about the girl. He knows how to talk indirectly: instead of telling Karagöz 'Your wife is betraying you', he says, 'Strangers are picking the fruit in your garden' or 'Your nightingale is singing in someone else's garden' (And 1977: 300–1). These characteristics are attributable to the concept of 'learned behaviour' because the essence of mutual relationships in a society is based on a system that will facilitate shared life in a neighbourhood.

In addition to these main characters, others frequently seen are Celebi, Tiryaki and Beberuhi; tough guys like Kulhanbeyi and Efe; individuals from various cities of the state in Anatolia and Thrace; non-Turkish characters such as Arabs, Persians and Albanians; non-Muslim characters such as Jews, Armenians and Greeks; disabled characters such as Deaf, Mad, Hunchback and Stammerer; amusing characters such as Kavuklu, Pisekar, Little *Karagöz* and Little Hacivat; supernatural beings such as Witch and Djinn; and Zennes (women).

The educational and critical dimension

The question of how Karagöz, an uneducated person, can enlighten the public properly is one that has been raised many times with regard to the educational role of shadow plays. The answer to this question might be provided when one takes into consideration the nature of *Karagöz* plays and the ultimate moral aim of each play. Many of the plays contain scenes related to educational issues pertaining to the lives of citizens during the time of the Ottoman state. For instance, in *Ters Evlenme* (The False Bride), Karagöz tries to keep a drunken man away from alcohol, and in *Kanli Nigar* (The Bloody Nigar) he spends all his energy in an effort to direct women to the true path (Alptekin 1998). In *Kirginlar* (The Offended Ones), Karagöz kills Hacivat's three brothers and does not want to be seen by Hacivat's son. This traditional mind-stimulating aspect of Turkish shadow theatre was witnessed and recorded by European travellers in the Ottoman state (for accounts of European travellers on Turkish shadow theatre, see And 1975).

Any *Karagöz* scene is a place of learning, and its philosophy – embellished with a peculiar mystical meaning – is unique. In the scenes presented to a sultan, despite the fact that the sultan is praised as first among men, he is reminded of the fact that he too is among those created by God. The beauty of the universe, the power of God, the meaning of life and existence, and related notions are reflected behind the curtain with a slogan: 'What you see is a curtain, but what you should see is the reality reflected behind it' (And 1977: 274). Sheikh Kusteri created a curtain representing the outer shape of the world. When the candle is lit, the hearts of mature individuals are intended and expected to grasp the inner, not the outer, self of the characters behind the curtain. Those in search of pleasure get what they want, and those who are there to see reality see it.

Karagöz himself provides a critical backdrop: he comes from the lower class, he is uneducated and unemployed. He has to accept all jobs offered to him regardless of his personal suitability for the job. In *Yazici* (The Public Scribe), Karagöz becomes a public scribe in a haunted shop, where he writes nonsensical letters for his clients.

Karagöz plays are designed to enlighten the audience about the issues involved in their lives. Each detail of the plays created by the 'imaginative minds of their creators' (Sakaoglu, 2003: 69) is designed to serve this purpose. This includes even the choice of words in the dialogues between Karagöz and Hacivat. Hacivat uses extensive vocabulary to show off his knowledge, and Karagöz misunderstands most of the words uttered by Hacivat. Hacivat even tests Karagöz by questioning him and proving in public that he does not have enough knowledge for a man of his age. This is done purposely to represent Karagöz as a layperson who is pure, who can grasp the comic side of events with great skill, who is intelligent but not trained, and who is far from being a scholar but not far from refinement (Banarli 1977: 61).

One example of Karagöz's choice of words is an inspiring dialogue intended to serve an important critical function concerning education. In a performance in the presence of a sultan, Mahmut, Karagöz focuses on education through some symbols he includes in his conversation regarding the overall conditions of the primary schools of the age. Karagöz is a student, and Hacivat tries to teach him how to read and write. However hard Hacivat tries, Karagöz cannot manage what is required. However, with some tricky words he manages to get three golden coins from the sultan. This dialogue includes the teaching of the vowel point indicating the sound of 'e' using a phonetic symbol. When Hacivat says *üstün* — an Arabic word to indicate that sound, Karagöz says *altin*, a Turkish word which seems to be the opposite of the word *üstün* in Turkish, but which also means 'gold'. When the sultan says that he is not going to give him any more golden coins, the puppet player says that his sole aim is to attract attention to the conditions of schools.

Although humour is a natural aspect of the dialogue in this theatre, the sultan takes this seriously and he decrees that the conditions of schools should be considered carefully, and children should not be sent to work before they learn how to read and write (Bey 1977: 23). The occurrence of such a change also indicates that 'some minor things can be instantly arranged or inserted into the main story during the performance, depending on the circumstances and the taste of the audience' (Yerebakan 2002: 12).

The nature of the spectators is a fundamental aspect of the choice of subjects and vocabulary for dialogues and exchanging ideas in Turkish shadow theatre. If the performance is for children, Karagöz is careful not to use obscene words; if it is for adult males, there is no such a limitation; if there is a disabled person among the audience, he avoids using words that might make that person remember their condition; again, if some members of the ruling class are present, words are chosen appropriately.

Social commentary

Karagöz represents the understanding of morality and common sense of ordinary people. Spectators tolerate his mistakes. He expresses his thoughts directly, without thinking of possible undesired consequences. He is poor, which is a humbling aspect of his behaviour and a facet of his educational deprivation. His poverty and fear of losing his life force him to help brigands, but his sense of right and wrong will surely cause him to report those brigands disturbing him to the forces of law. He is fearless, brave; he is in opposition even to tough guys. Unlike Hacivat, he does not turn a blind eye to the happenings in his neighbourhood. He assigns himself the role and duty of protecting the honour of his locality. He is not a liar, and he is strictly against double standards. As a realist, he does not favour a life in a dream world or a life based on artificiality or dishonesty. Even if he loses opportunities due to the fact that he hates showing a face that is not his, such as paying extravagant compliments or being too intimate in return for something, he still keeps his integrity and becomes an exemplary individual. This trait brings him rewards at the end of the performance. His praiseworthy bravery saves his life and, despite all the hardships he faces, he is able to keep himself honourable, which plainly indicates that he is a spokesman for the public, allowing people to define themselves and also criticizing the upper classes and public servants.

In the process of reflecting a critical point from a moral perspective, such considerations as a character's physical appearance, way of speaking, behaviours and other people's thoughts about that character are worth considering. Turkish shadow theatre contains many examples. Since the last capital city and centre of

culture of the Ottoman Empire was Istanbul, characters from other cities and states tended to be reflected unfavourably. However, this critical discourse on individuals in Turkish shadow theatre was not directed at any particular religion, race, social status, residents of a geographical district or sex as a whole. Muslims, Christians and Jews, men and women, and individuals from various cities of the state were individually open to criticism without any discrimination or prejudice against the whole. Karagöz is especially careful when he handles the concept of religion. He never criticizes religion – in fact, religion is a sacred institution for him. However, Karagöz is ruthless in his criticism of the vices of men of religion. Those who use religion for their own objectives are a special target for Karagöz. It is the same with race. Turks, Jews, Armenians, Arabs and Persians are among those members of races criticized for their individual behaviour in one way or another, yet Karagöz is careful not to include the whole race, only some members who are brought to the stage to convey a message. It is always certain that those who deserve to be criticized are unsympathetically reflected behind the curtain.

Morality and gender

Turkish shadow theatre has served as a mirror to show people their lives. Some men are presented as individuals without anything useful to contribute to the society in which they live. Even worse are the men who are disobedient to the country's laws. The choice of names for male characters reflects certain personal aspects. Of these, Tiryaki (Karagöz also calls him 'Sleeping Gentleman' or 'Opium Father') uses opium; Beberuhi earns his living with the money he gets from women; and Matiz has killed before and often threatens to kill Karagöz. Such characters are presented to the audience to show the meaning and significance of their own behaviour.

Women are also treated critically in Turkish shadow theatre. Karagöz's wife and Hacivat's daughter are disapproved of because of their desire to spend more money than their family earns. Another fault found with women is presented through the inclusion of prostitutes, portrayed as women renting a house in the vicinity and receiving men into their house. Some women are also shown to be fond of women, not men. They do not hesitate to express their sexual preference publicly, although the society in which they live rejects this and they are said to lower the moral values of the society. Some women seek to live in luxury at any cost. Some of them give birth on the day they get married. They recite love poems and serve alcoholic drinks to the men with whom they make love.

The moral perspective of *Karagöz* plays requires that the society as a whole should be shown the good and the bad in order for the educational function of

the theatre to serve its purpose. That is why *Karagöz* shadow theatre reflects all sorts of women, so that the spectators can reach a logical conclusion about what is decent and what is not. The fact that Karagöz uses even his wife for this proves that he is not prejudiced against women because they are women; his sole aim is to teach while making people laugh. This indicates that, while the tradition of shadow theatre may originally have come from the Nile valley, the character of Karagöz seems much more homegrown and characteristic of Turkey (Gorvett 2004: 62–63).

The content of Turkish shadow theatre is sometimes claimed to be obscene, and spectators are said to enjoy this. Even when performances were held in a sultan's presence, they retained their coarseness as a way of presenting critical ideas concerning the conditions of the society. Sultans mostly had sympathy for issues portrayed by shadow theatre, however much it criticized them and reflected unpleasant social issues. The main reason for the tolerance of sultans was their belief that actors (shadow puppets) of shadow theatre were not real people (And 1977: 86).

Effects of Karagöz plays

Some researchers suggest that Karagöz in fact did not include issues concerning the state and religion into his critical issues behind the curtain in the Ottoman State, implying that Karagöz had a kind of inviolability in state and religious circles. But other sources demonstrate that he directed his critical ideas to those occupying important positions in the state for their attitudes, behaviours and applications. Even the Sultan was not an exception in this regard. In a dialogue between Karagöz and a young man, when the young man says that he is looking for a job and asks for advice, Karagöz replies that he should join the navy but should be an admiral. He adds that the young man does not have any ability, which is enough to occupy a position as an admiral. Similarly, the janissaries (a group of soldiers in the Ottoman state) are said to have lost their traditional courage and prominence. *Karagöz* also informs the sultan of the bribery of governors. Taking all these into consideration, it should be noted that, despite the system which had an absolute control within the country, *Karagöz* had absolute freedom. This feature of *Karagöz* was both impressive and functional. The highest man below the sultan is brought to the curtain, blamed for his deeds and sent to a cell because he cannot defend himself properly. Somewhere else in the state, if somebody repeats even a line of what Karagöz pronounces, he is sure to be punished, but nothing happens to the actors, who represent persons from every layer of the society and every profession including pashas, scholars, bankers and tradesmen. Some European researchers have noted that the criticism of the state affairs reminded them

of an uncensored newspaper which was more aggressive than those in England, France and America. Being an oral and not a written newspaper, it was more functional than its counterparts in the West (And 1977: 345–48).

Karagöz has always been a satirist: 'Karagöz plays are not intended for children: they are the voice of the public, they handle political issues when needed, and they must' (Akdemir 2003). The rulers of the Ottoman state had to take him into consideration in their public responsibilities and duties. They had to remember the fact that Karagöz would reflect, in a critical way, the actions and decisions not liked and approved by the public (And 1969: 311). They had to keep in mind the point that Karagöz was 'a political weapon with which to criticize local political and social abuse' (And 1975: 83). Yet it is also a fact that from time to time some authorities felt obliged to hold a meeting to come to a decision about this function of the theatre. They even banned the exhibition of some concerns in order to protect their traditional respectable positions (Kudret 1968: 38). Yet it would be a misconception to claim that the court and Islamic leaders were against shadow performances; they consistently encouraged the public to see Karagöz plays because these plays gave the lower classes a sense of power and a feeling that they also had a say in the affairs of state.

Here, it may be claimed that this extent of freedom for not only Karagöz but for anyone else is not substantive, since nobody else has the same rights. However, it can be noted that Karagöz was not considered by rulers to be a living being. Nevertheless, there were times when they tried to keep Karagöz under official control. For instance, in the nineteenth century, the satirical and coarse style of Karagöz received some negative reaction from the state. Efforts were made to prevent plays from including issues of education: because of the peculiar nature of teacher–student relationships, and because of the fact that interfering in this relationship is regarded as improper, religious authorities felt that they had the right to determine what issues were not to be included in the dialogue behind the curtain (And 1969: 22). However, the coarseness of the plays was intended to be an escape from a rigidly closed society and public inability to act. The plays had the duties of distinguishing the good from the bad and warning the public against evil, injustice and tyranny.

Karagöz plays point towards the problems of daily life in the country, like the lack of means in people's lives and the ill-management of those in administrative positions. In this reflection of the conditions with a focus on the needs and expectations of the public, traditional urban settlements and their realities are shown behind the curtain, including some aspects of Ottoman culture. Karagöz questions both traditional values and social problems originating from them. He frequently draws attention to sex, violence and bribery. He also reflects instances of lesbianism, hermaphrodites and multiple marriages. Throughout this process,

sexuality – like violence – is presented in a way that was outside the norms of typical Islamic society (Smith 2004: 188). Sokullu draws attention to this issue, revealing the point that Turkish shadow plays could be described as a mirror reflecting the society at large:

Poverty, unemployment and illiteracy, among the basic problems of daily life, may be said to constitute the main theme of each play. In *Karagöz* plays, following the opening, the introduction section generally is about these problems resembling the acknowledgment section of a film. Although it is not the main theme of the dialogue, poverty takes place as an implication and a complaint. For this reason, in the development of the subject matter it emerges as the core problem (Sokullu 1979: 92).

Karagöz is the symbol of poverty and illiteracy, and in almost all shadow plays he is unemployed. This must have been deliberate, to give a sign of the critical idea that unemployment as a result of the ignorance of the state is a grave problem that ultimately leads to dire consequences. Not having been trained in a craft, Karagöz cannot earn his living in an urban settlement like most citizens of the state: 'Karagöz reflects the lives of ordinary people. While describing the daily life and traditions in the forefront, he makes the spectators feel the deep problems of the society as a whole' (Sokullu 1969: 268). This generalization involves the issues of education on the one hand and criticism of the rulers on the other, since they do not perform their public duty properly. The contrast between the well-to-do citizens of the country and the poor ones is reflected behind the curtain as a clear sign of inequality resulting from administrative fault. Karagöz is forced to work in professions he does not like because of his lack of training, just like numerous settlers in the capital city coming from different parts of Anatolia and Thrace. Almost all the characters belonging to different races passing in a parade behind the curtain are poor.

Unemployment – a natural consequence of poverty and illiteracy, closely associated with despotism and the lack of a proper establishment – is reflected as reducing the quality of life in the country. In *Karagöz* plays, there are signs of injustice behind the colourful life of the neighbourhood brought to the stage.

While honest members of the young generation are very few, there are many intimidators who try to change the system to serve their purposes. This is intended to put the blame on those responsible for the organization of a proper order in the society (Kudret 1968: 17). It also reflects the general anxiety, and Karagöz criticizes both the emergence of such oppressors and their actions. Even Karagöz becomes an intimidator: he tries to get rid of or beat those he does not like, or is beaten by them if they are stronger than him. Karagöz doesn't always get rid of the problems he meets, but he is always rebellious and creative in the face of them. In this atmosphere of intimidation, moral values seem to have lost their significance. In

Mandira (Dairy Farm), when his wife leaves the house taking the goods, Karagöz marries the first woman he meets. This woman accepts men into the house. Ironically, Karagöz asks for money from those men, which is 'a clear indication of a critical view of the social life' (Sokullu 1979: 97–100) – how poverty can lead a just man to behave in an unjust way.

Karagöz today

Karagöz theatre's glory days have passed. The decrease of the popularity of shadow theatre in Turkey started with the introduction of Western theatre in the first half of the nineteenth century. The educated class wanted to establish an understanding of Western culture, law, individuality and society, and playwrights and critics of the period were eager to support this undertaking. There was also a strong claim that shadow theatre caused moral degeneration. Some famous dramatists of the period, like Namik Kemal, wanted the state to totally ban shadow puppet theatre. There was some validity in their attacks.

Shadow theatre in the period was not in the hands of those who utilized it as a cultural means, but in the hands of those who used it to earn their living by exploiting the obscenity and immorality reflected by *Karagöz* plays. Since there was no effort to keep this traditional heritage in proper hands, there was a preference for destroying it.

The decrease in puppet theatre in Turkey continued through the twentieth century. The changes in every sphere of the society also impacted on theatre. The dominant trend was Western-style theatre, and *Karagöz* was neglected. Another factor impacting on the loss of interest in shadow theatre in the Republican period was the introduction of television and cinema. With the coming of television in particular, this theatre form further lost prominence. As shadow performers retired, there were no trained apprentices to replace them. Although there have been individual efforts to make *Karagöz* theatre a focus of interest, there is no popular move to restore it. The Ministry of Culture and Tourism supports the activities of this traditional theatrical form, and some shadow puppet plays are performed both within Turkey and abroad, but this is not enough to re-educate and familiarize the entire public about the importance of this long-rooted tradition. It is interesting that today *Karagöz* is a theatre performed mostly at children's festivals. The original content and goals are preserved, although the coarse language is no longer used.

Conclusion

The aim of satire in Turkish shadow theatre is to warn the spectators about vices and to force them to take measures against those involved in vicious acts. Stressing the irregularity resulting from ill-management in the country through the 'political content' (Ayça 1974) of some plays, Karagöz notes that the results may be expected. By including in his narration undesirable behaviours resulting from social conditions, he aims to teach moral lessons. He is especially meticulous in his effort to help people to evaluate logically and acceptably the concerns related to their lives. As he reveals the vices in the society and the nature of those involved in such actions, his comic and satirical dialogues urge the need for proper training for individuals belonging to all segments of the society. This need includes examples like 'preventing Karagöz by wardens from cutting trees' (Mutlu 2002: 9) in *KanliKavak* (The Bloody Poplar) – which is surprising, coming from an age when protection of nature was not on the agenda of the nations of the world.

In conclusion, Turkish shadow theatre documented stories that could still captivate the imagination of the audience. From the beginning of the sixteenth century, it was a main component in the court celebrations of the Ottoman Empire, and it became a popular performing art form in Turkey in a short time. Its function was to hold a mirror up to a society in which the public deeply felt the need for betterment and justice. It only wanted to be a mediator, not a destroyer. Karagöz especially stresses this point, apologizing to the audience at the end of each performance for any inconvenience caused during the presentation.

Acknowledgement

This chapter was originally published as Article 1 in Volume 6 (2005).

REFERENCES

Akdemir, G. (2003), Interview, *Cumhuriyet*, 3 August.

Alptekin, F. (1998), An interview with Tacettin Diker, *Cumhuriyet*, 17 January.

And, M. (1969), *Geleneksel Türk Tiyatrosu: Kukla-Karagöz-Ortaoyunu*, Ankara: Bilgi Yayinevi.

And, M. (1975), *Turkish Shadow Theatre*, Ankara: Dost.

And, M. (1977), *Dünyada ve Bizde Gölge Oyunu*, Ankara: Is Bankasi Kültür Yayinlari.

Ayça, E. (1974), Interview, *Milliyet Sanat Dergisi*, 103 (October).

Banarli, N. S. (1977), 'Karagöz', in Ü. Oral (ed.), *Karagözname*, Istanbul: Türkiye Is Bankasi Kültür Yayinlari.

Bey, A. R. (1977), 'Padisah Önünde Bir Karagöz Oyunu', in Ü. Oral (ed.), *Karagözname*, Istanbul: Türkiye Is Bankasi Kültür Yayinlari.

Çapanoglu, M. S. (1977), 'Istanbul'da Eski Ramazanlarda Karagöz', in Ü. Oral (ed.), *Karagözname*, Istanbul: Türkiye Is Bankasi Kültür Yayinlari.

Gorvett, J. (2004), 'The shadow puppetry of *Karagöz*', *Middle East*, 348, pp. 62–63.

Kudret, C. (1968), *Karagöz*, Ankara: Bilgi Yayinevi.

Mutlu, Mustafa (2002), *Karagöz sanati ve sanatçilari*, Ankara: Kültür Bakanligi Yayinlari.

Sakaoglu, S. (2003), *Türk Gölge Oyunu: Karagöz*, Ankara: Akçag.

Smith, J. (2004), 'Projections and subversion of conformance', *Asian Theatre Journal*, 21:2, pp. 187–93.

Sokullu, S. (1979), *Türk Tiyatrosunda Komedyanin Evrimi*, Ankara: Kültür Bakanligi Yayinlari.

Yerebakan, I. (2002), 'A reappraisal of Turkish traditional theater of Ortaoyunu in relation to contemporary anti-realistic performances of the West', *Acta Orientalia*, 63, n.p.

19

Christmas traditions and performance rituals:
A look at Christmas celebrations in a Nordic context

Stig A. Eriksson

This chapter grew out of a project with our drama students at Bergen University College, Norway, in December 2002. I wanted to introduce the students to the pre-Christian roots of Yule, and to give them an historical introduction to extant dramatic/ritual Christmas customs in our country. During the research process, I became intrigued about the etymology of words and names associated with Christmas and the 'figures' and 'spirits' belonging to the Christmas season. It gave me an angle for making our students conscious of the way the church has appropriated ancient religious beliefs and rituals, and it provided a means to inspire them to take another look at our cultural past. It also helped to make more visible probable remnants of ancient dramas embedded in many of our Christmas celebratory rituals, and the transformations of such dramas and rituals that occurred during Christianisation and up to our (more or less) post-Christian time. Our students gave a surprise performance in the staffroom just before the Christmas break, showing the two sides of the Saint Lucia traditions described at the end of the article: a Saint Lucia procession in one group confronted by a pagan-inspired Lussi in another. It is the intention of this chapter that its content may inspire others to develop a performance project for their own Christmas.

A number of theories exist regarding the origins of theatre. Among these are theories based on the idea of theatre developing from religious cult or religious ritual, theories presenting the origin of theatre in mimetic rituals of totemic hunting clans, theories seeing the origin of theatre in shamanism, theories purporting that the origin of theatre is to be found in play and theories that the origin of theatre comes from human beings' enjoyment of mimetic acts – that there is a general

human theatrical faculty (primeval theatre), which can be found in all cultures. The reader should keep this context in mind, as the chapter does not purport to develop a thesis on the intrinsic interrelationship of ritual and drama as such.

The word *Jól* was in pre-Christian times the name of a feast celebrated by sacrifice on mid-winter night, 12 January. According to the Norwegian historian Olav Bø (1993: 11), the Anglo-Saxon *géol* and the English 'yule' are the same word. From these words, the names of the 'Christmas-months' were derived: November/December and December/January: the old Norse word *ýlir* marked the time from 14 November to 13 December, the Anglo-Saxon word *giuli* was used for both December and January, and the Gothic word *jiuleis* denoted December. It seems logical that these names point towards a common Germanic origin of a pagan mid-winter feast, which in Norway is still called *jul*. This is an age-old time for ritual, procession, festivity and merriment: Merry Christmas!

Falk and Torp (1994: 339) point out that in old Germanic the primary form for *jul* is *je(g)hwla* (from Indo-Germanic *jeqeo-*). This is a form that has a probable connection with the Latin *jocus* (jest), which shares its root with *joculatores*, the travelling jesters/actors in the Middle Ages. So, it is very tempting to listen to Falk and Torp's suggestion that the ancient *jól*-feast was a form of saturnalia, like the winter solstice festival (see below). The fact that the French word *joli*, the English 'jolly' and the Italian *giulivo* come from the same Germanic roots underlines the aspect of something merry and playful, and jest, joke and ridicule have belonged through the ages to the basic fare of the theatre.

Dramatic and religious seasons

The most important seasons in pagan life – and for pre-Christian drama – were the winter solstice and the celebration of the new life season in the early spring. Ritual dramas like the burning of King Winter or the sword-dances and round-dances of springtime belong, according to the Austrian Theatre historian Heinz Kindermann (1966: 398), to the primeval theatre of humanity. And such traditions – often expressed with masks, ritual dances, processions and grotesquerie – belong in their turn to the origins of carnival and farce, as we shall see. Thus, it is hardly accidental that the major Christian seasons – and their accompanying drama cycles – became the Passion Plays at Easter and the nativity plays at yuletide.

Even if the exact meaning of the ancient word *jól* is not known, an interesting association with its origin exists through the Norse god Odin (Wotan). An entry in Falk and Torp (1994: 339) indicates that Odin in old Norse is referred to as Jólnir (Lord of the Yule) when he is leading the wild band of ghost riders – Jóleskreia/Oskoreia/(Aasgaardsreia) – raging across sky and land at Yuletide. There could

CHRISTMAS TRADITIONS AND PERFORMANCE RITUALS

be a connection here with a Teuton Feast of the Dead at the winter solstice, and with yule as the time for communicating with the dead. But there could also be a connection to the Norse god of midwinter, Ullr, or his stepfather, Thor. The latter is best known as the god of thunder, but he is also a fertility god. The pagan Vikings worshipped Thor and his goats. According to the myth, his goats were slaughtered every evening and rose again the next morning. It could be that the little drama performed by masked participants in old 'yule-buck' processions (see below) in which the leader carrying a goat head and dressed in a goatskin would 'die' and then return to life, is a carryover from pre-Christian dramatic rites. It could be an act of sacrifice to the gods as propitiation for a good year and a ritual act symbolizing the death of winter and resurrection to a new and life-giving year. A connection may also exist to the Norse god Frey. There is an old expression of *'drikke jul'* (to drink to Yule), which was also associated with *'Frøys leik'* (playing for Frey – verse 6 of Torbjørn Hornklove's *Haraldskvede*, quoted in Bø 1993: 9). Frey is the goddess of fertility, vegetation and a good harvest. There is a theory that the Vikings played some sort of ceremonial games or dances to honour Frey, but evidence is very scarce (Kjølner 1980:30).

However, theatre history research indicates that some form of ritually rooted popular drama may very well have existed in the North during the Viking period. The Norwegian researcher Kristin Lyhman (1985) suggests the existence of early theatrical expression based on rune finds, and the Swedish researcher Terry Gunnel (1995: 32) points out that such a tradition would have provided a general context for early dramatic performance of the dialogic poems of the Edda.

In old Norse tradition, much importance was put on the brewing and serving of beer at this time of the year. The Norse solstice feast should, according to tradition, be a celebration of a good year; one should have *jól* beer, and drink to the honour of the gods. It was also a time for inviting neighbours and relatives for a feast with good drink and food – the best products of the previous season – in many ways a custom showing signs of what has later become known as Thanksgiving, but which was in old Viking times known as *haustblot* (autumn sacrifice). According to the Norwegian Gulating legislation of the tenth and eleventh centuries, the beer should be ready by the Holy Mass of 1 November, which is also the time for the celebration of St Martin. In Norway and other European countries, dramatic traditions were associated with Mortensaften (Martinmas Eve), 11 November. This celebration seems to have taken up several customs from a pre-Christian autumn feast. In many countries, it marked the official start of carnival or Shrovetide – named after shriving, or absolution through confession, that was the central ritual of the period. The Norwegian comedy writer Ludvig Holberg (1684–1754) describes from his young days in Bergen processions in the town on Mortensaften, where young people marched in a procession led by a boy carrying

a goose on a stick, and sang a song about Mortens *gås*, after the roast goose served on this day (Holberg 1920: 68).

Although there is no solid evidence of a carnival tradition in old-time Bergen, the Norwegian dramatist and theatre historian Wiers-Jenssen (1921) does suggest that carnival plays (*fastelavn-spill*) happened in Bergen. He points to the close connections between Bergen and Germany through the Hanseatic League, and states that, as early as 1625, farces in the German manner were performed in the city – much like in Nürnberg where the Fasching Spiele, the origins of farce, were made for the fun of it and with topics from daily life. 'Artisans make them, travel from house to house, from inn to inn, and perform them' (Wiers-Jenssen 1921: 16, 50).

As briefly mentioned earlier, interesting roots for the carnival/Shrovetide farces may be found in the performing rituals of the ancient Greek and Roman comic processions and dramatics. According to Kindermann (1966: 297–402), convincing evidence exists of a common ground between ancient comic performance and pre-Christian drama in Germany and Scandinavia. He argues persuasively that popular comic theatre traditions in Europe most likely originated first from the ancient Mimus – the early mimetic traditions that grew out of fertility rites and spring celebrations – and only secondly from the comic scenes of the Christian religious theatre of the late middle ages, the latter also stemming from the same ancient performance roots. If his theory holds good, it constitutes a good example of pre-Christian tradition influencing, but also being taken up by, Christian tradition. So, in the Christian drama of the Middle Ages, the church transformed and incorporated pre-Christian dramatic elements (such as procession and chorus song) and/or allowed comic scenes and farce to function either as a safety valve or as a moral corrective, such as the Feast of Fools and Carnival.

Through Christianity, the Norse solstice festival became a celebration of the birth of Christ, as it did in all European countries. In Norway, Håkon the Good ruled that the old Midtvintersblot (mid-winter sacrifice) be moved from 12 January to 25 December (Falk and Torp 1994: 339). Hellig-tre-kongers-dag ('Three Kings Holy Day', or Epiphany) became the first Christian festival. Epiphany in our church calendar is placed at the first Sunday after New Year, but originally it was an early nativity celebration of 25 December, the same day the Romans celebrated the birth of the Sun-God. In the Julian calendar, this was the day of the turning of the sun. Two other Roman festivals at this time of the year were incorporated in the Christian Christmas celebrations: the Saturnalia (in mid-December) and New Year's Day, the start of the official year. During the Saturnalia, all class differences were suspended, and all people set out to enjoy life. At the New Year's festival, gifts were given, plans were made, promises issued and omens taken – many traits that we recognise from the same season even today. The Roman Saturnalia feast also contained role reversal and revelry, a ritual practice that was

continued in the Middle Ages as the Feast of Fools. A King of Fools was set to rule over a 'kingdom' turned upside down, with the master as slave and the slave as the master (Nygaard 1992: 126).

From the star to Santa Claus and Julenisse

In Bergen, a remnant of a lost liturgical Christmas play existed up to the end of the nineteenth century. It was called *Stjernespillet* (The Play of the Star). Most likely, this was a play about the Three Magi, performed at Epiphany. In its earliest fashion, it probably had many characteristics of the original play, but from the time when records began to exist – 1609, according to Wiers-Jenssen – it had become more of a procession with dramatic elements than a play. Initially it was the schoolboys – students from the cathedral school – who were in charge of *Stjernespillet*. They had both dramatic and musical training in their education (cf. the school drama tradition of the Humanists). Later they were forced to share the responsibilities of performing the play with artisan guilds. We know that at its peak of popularity, as many as five troupes performed it in different parts of Bergen. But after the demise of the craft unions, the tradition faded. Star troupes of varying artistic qualities filed through the streets at Christmas time, but by the end of the nineteenth century they were forbidden under the warrant of being a street disturbance.

The most important ingredients of the star-processions were the star (heading the processions carried on a tall stick), the song (serious and edifying) and the collection of gifts at each and every house where the procession stopped. The collection was usually performed by Joseph, a fool-like figure hopping and skipping, holding out his cap for the gifts, while the kings were singing:

> Ok no e den livsalige tid forbi, (and now the blessed moment is over)
> for no kommer Josef med hætto si. (for here comes Joseph with his cap)
> (Wiers-Janssen, in Losnedal 1980: 24)

Here there is an interesting dramatic contrast between the holy song at the beginning and the popular song at the end. It was probably created mainly as entertainment, or for the purposes of the dramatic structure. However, in the context of the research for this article, although I have no other evidence for it, it also seems to be associated with ancient and medieval religious performance traditions, exhibiting elements such as procession, impersonation, song and dance, the combination of positive and negative powers and contrasting the sacred with the profane.

The Norwegian theatre historian Kari Gaarder Losnedal (1980: 21–24) points out many interesting parallels between the old star processions and the present-day *julebukk* tradition. (To my knowledge, no English parallel exists for this latter phenomenon; the closest may be the tradition of carol singers at Christmas Eve in some English-speaking countries.) In the *julebukk* tradition, which here in Bergen takes place on New Year's Eve, children (both boys and girls) wander from house to house, sing Christmas carols and collect gifts (mostly sweets, Christmas titbits and fruits) as a reward for the performance. They are costumed and masked. Here too, the often-absurd contrast between the (serious) content of the carol and the (profane) costuming can be observed. What is now missing is the star, and the link to the origin of Epiphany has become increasingly blurred. In recent years, the commercialisation of Christmas and the Americanisation of its traditional expressions have taken place to such an extent that carols are now occasionally replaced by pop songs and children wear party or Halloween masks. We are experiencing a watering down of tradition, partly because of globalization and commercialization, and partly because of a loss of significance of the tradition itself. As Losnedal (1980) argues, 'By the very fact that the "main character" has been dropped, the procession has changed its character.' This is a common when traditions change or disappear.

As already mentioned, there also exists a pre-Christian origin of the *Julebukk*. The origin of the Yule-buck (or the yule-goat) could be the billygoat that was slaughtered at Yule in hope of a good and prosperous year. Later it became the name for a person who went around at Yul-tide, costumed in a pelt and usually wearing a goat mask. Originally a rural tradition, this was commonly a fearsome mask worn by young men (not children). The mask had horns and shag, and it could be worn on a stick or directly on a person's head. By tradition, the goat was supposed to entertain by violent and comical jumps and kicks. A goat song usually accompanied the visit, and before the goat left the house, beer or a nip were served. Different local variations of the yule-buck tradition have been reported by historians throughout the country. Bø (1993) is an authoritative source. One theory indicates that the tradition also contained an element of social control. The visitors in their roles as yule-bucks could check that the revelries took place according to custom, and if they were not served well, the punishment could be that the house or the farm would not be visited the next year.

There are disagreements between researchers about whether the *Julebukk* belongs to ancient pagan fertility traditions (cf. the function of the goat in the cult of Dionysos), or if it is more likely a remnant of church processions from the Middle Ages, in which the one who impersonated the devil was wearing a mask with horns. Bø (1993: 127) finds the latter theory more probable. In a similar fashion to Bø, Losnedal (1980: 21) suggests that Julebukken has come from the

CHRISTMAS TRADITIONS AND PERFORMANCE RITUALS

figure dressed in a sheep skin and in chains who accompanied Saint Nicholas on his wanderings in December in search of good children. (According to legend, Nicholas was bishop of Myra in Turkey about 300 BCE.) The pair symbolized the victory of the good over evil. Later in history the two separated, with St Nicholas becoming Julenissen or Father Christmas and Julebukken going his own way.

Julenissen stems from about 1800. It is probably a misinterpretation of pictures of a white-bearded St Nicolaus. His name was Anglicised and became Santa Claus. However, in the Nordic countries, another adaptation has probably come about as a mix of the Norse Gardvord (*husnisse, tomtegubbe*) in popular superstition and the catholic St Nicholas. Our supernatural *nisse* creature is similar to the brownie, leprechaun or pixie. In people's imagination, he is portrayed as a small man, wearing grey clothes, a red pointed cap and a long beard. Just like the *Julebukk*, he is a being who does not bring Christmas gifts, but is himself a demander of food and treats. In old rural Norway, much attention was paid to him. He is a creature with great strength and could help with the farm work. As a reward, he received good food and drink, particularly on Christmas Eve. If not treated well, he could turn malicious and cause harm to the farm, the crops and the people. He belongs to the supernatural beings that in our folklore are called *Vette* – spirits who live near humans, and with whom the humans need to be on friendly terms. The same applies to *Lussi*.

Lucia and Lussi

Even since old times the *jól* season was a time for the awaiting of good food and drink and gifts, family gatherings and jolly companionship with good neighbours, it was also a season of uneasiness and fear of the dark forces. There was the *Lussi*, and the scariest night of all: Lussinatta (the *Lussi* Night). As Bø (1993: 20) points out, little help is to be found in the modern concept of Santa Lucia to explain *Lussi*.

Popular tradition is rooted in another custom and belief than the Christian Lucia alternative. The belief in *Lussi* was strongly connected to the carrying out of work tasks. Again and again, the lore prescribes that such and such work must be finished, or else the *Lussi* will come to punish. The *Lussi* is conceived of as a woman, usually with evil traits, like a feminine demon. Such a spirit is found in mid- and southern Europe as well, and given the name of darkness, like Lucia die dunkel (the dark Lucia). Her contrast is Lucia die helle (the fair Lucia), a Christian takeover which is associated with Saint Lucia.

The old date for the *Lussi* Night is 13 December, regarded as the longest night of the year and associated with the solstice. That was carried over into the new era. Between *Lussi* Night and *Jól*, all kinds of trolls were out and about. It was

particularly dangerous to be out during *Lussi* Night. Children who had done mischief had to take special care, because *Lussi* could come down through the chimney and take them. Bø (1993) explains that the lore also tells about a whole *Lussi* group travelling past: the Lussiferda. They were named as in a verse: Lisle-Ståli and Store-Ståli, Ståli Knapen and Tromli Harebakka, Sisill and Surill, Hektetryni and Botill. They could take people away, just like the *Oskoreia* or *Jólaskreia* could. This is another company of spirits (*vetter*), riding horses, which towards Yuletide journey through air and over land and water, leaving eeriness and discomfort. Although not mentioned in any of my sources, it is very tempting to look at Father Christmas's journey with his reindeer as a commercial relic inspired by such popular superstition.

Another name for this phenomenon is *Aasgaardsreia*, from Old Norse *reið* (ride, riding train). The myth of *Aasgaardsreia* corresponds to the German folk-belief in *wütende Heer* (raging host), originally from Wuotan's (Odin's, Jôlnir's) *Heer* (Falk and Torp 1994: 6). I find the referencing of Odin's name as Jôlnir of particular interest here. This was the name used for Odin in old Norse at Yuletide, referring to him as the commander of Jólaskreia. An interesting supplement to this is an observation made by the Norwegian theatre researcher Jon Nygaard (1992). Outlining the links of the fool figure and pagan religious rituals, in which the fool was a fertility demon, Nygaard refers to the fool character Harlequin and the possible origin of this name from *Her(e)la cynz* ('the lord of the dead host'). This name can also stem from the Germanic *Herleke* (from Harilo – commander of the host). This, in turn, refers to the great commander: *Wode, Wodan, Wuotan or Odin*. Several stories relate to him as leader of the Wild Hunt: *Aasgaarsreia*, the feared train of the dead. But during time it lost its importance and became associated with a train of boisterous comic demons flying through the air, accompanied by song and jingling bells. 'It means that the original pagan ritual had lost its meaning, and the jingling bells became part of the fool's costume' (Nygaard 1992: 126).

The Saint Lucia tradition, then, is another example of Christianisation of pagan beliefs and customs. This Swedish tradition, which seems to have spread throughout the Western world, is probably an old-culture loan from Germany and explains the use of lights (Lucia from *lux*, light). Lucia, adorned with the lights, resembles the Christ Child (*Christkindchen*), who in certain parts of Germany wanders about in the community and entertains the children. This child is usually a costumed girl carrying a crown of lights. The name 'Saint Lucia' that is given to this light procession tradition comes, according to Bø (1993: 23), from the Italian saint who suffered a martyr's death under the Roman Emperor Diocletian in Syracuse, Sicily around 300 AD, and whose memory was already celebrated by about 400

AD. In one of the stories associated with her legend, she was working to help Christians hiding in the catacombs. In order to bring with her as much food and drink as possible, she needed to have her hands free. She solved this problem by making a wreath to wear on her head, to which she attached lights; this enabled her to see in the darkness of the catacombs.

There are traces of the legends of Saint Lucia even in the Nordic countries in the Middle Ages, and her day of remembrance is also 13 December (just like the *Lussi*). However, yet another name is relevant here: Lucifer. His name has the same etymological background (*lux* is Latin for 'light'). Once he was an angel of light, then he was dethroned and became the Prince of Darkness. And to go full circle here, *Lussi* was also conceived of as Adam's first wife, she who was the ancestor of all fairies, goblins, little people – a Lilith-figure …

Many of our traditions associated with the Christmas season are in fact remnants of a much older, pre-Christian tradition associated with *Jól*. In most European countries, the Christianisation of the pagan feast established itself quite early, manifested in the new names for it – Christmas means Mass of the Saviour, *Weinachten* means holy night, and Noël means birth celebration. In the Nordic countries, however, the ancient name was kept. Even in Finnish, the word *Joulu* is still being used for Christmas, a loan-word from old Norse stemming from a period before Viking times. It seems logical to assume that the solstice festival had a particularly strong position in the North, where the seasons are so distinct. Many of our yule traditions are dramatic and ceremonial, both in form and content. That may be another reason why they are still alive and keep changing through history.

Acknowledgement

This chapter was originally published as Article 3 in Volume 1 (2003).

REFERENCES

Bø, O. (1993), *Vår norske jul*, Oslo: Samlaget.

Falk, H. and Torp, A. (1994), *Etymologisk Ordbog over det norske og det danske sprog [1903–1906]*, Oslo: Bjørn Ringstrøms Antikvariat.

Holberg, L. (1920 [1737]), *Bergens Beskrivelse*, Bergen: F. D. Beyer.

Kindermann, H. (1966), *Theatergeschichte Europas – 1. Band*, Salzburg: Otto Müller Verlag.

Kjølner, T (1980), 'Dramatiske element i julefesten', *Drama – Nordisk dramapedagogisk tidsskrift*, 4, n.p.

Losnedal, K. (1980), 'Våre dagers julebukker – en reminisens av en teatral begivenhet?', *Drama – Nordisk dramapedagogisk tidsskrift*, 4, n.p.

Lyhman, K. (1985), 'Båten, Nordens eldste scene?', *Spillerom*, 3, n.p.

Nygaard, J. (1992), *Teatrets historie i Europa. bind 1*, Oslo: Spillerom.

Wiers-Jenssen, H. (1921), *Billeder fra Bergens Ældste Teaterhistorie*, Bergen: A. S. F. Beyer.

Editors' biographies

John O'Toole, Penny Bundy and Peter O'Connor have been the editors of *Applied Theatre Researcher* and *Applied Theatre Research* from 2003 to the present. John was the editor from 2003 to 2005, then Penny and John co-edited from 2006 to 2017, when Penny stepped down and was replaced by Peter. In 2019, John stepped down.

John, Penny and Peter have spent most of their lives working in applied theatre and drama education projects, sometimes together; they have worked with and taught applied theatre workers and students in more than 25 countries.

John O'Toole

John has worked in drama education for over 50 years, and has taught students of all ages at all levels. Some examples of his applied theatre work follow. From 1970 to 1975, he co-directed a theatre-in-education company in the United Kingdom and in 1977 wrote the first book on the subject, *Theatre in Education*. In 1982 and 1992, he worked with township protest theatre groups and schools in South Africa. From 1983 to the mid-1990s, he co-designed and provided human relations training for the Queensland Police Service, with colleagues and students. From 1996 to 2003, he co-directed *Cooling Conflict*, an international project on conflict transformation in Sweden, Australia and Malaysia to give school students the tools to manage conflict and bullying through drama and peer teaching. In this period, he also wrote for and co-directed with Peter two applied theatre projects in New Zealand. From 2007 to 2011, with a Melbourne theatre company, he directed leadership training courses for senior university managers. From 2009 to 2012, he was the lead writer for the Australian Curriculum: Arts. He is currently working with a Singapore theatre company to establish *Cooling Conflict* in local schools.

Penny Bundy

As a primary teacher education student in the mid-1970s, Penny was a member of the first Drama Queensland executive committee (known as QADIE in those days). She was a founding member of KITE Theatre, an early childhood theatre-in-education company based in Queensland, Australia, where she worked as a teacher/actor before leaving to pursue a freelance career as a writer and director. She joined the teaching staff at Griffith University in 1986. Her Ph.D. thesis was co-winner of the 2003 American Alliance for Theatre and Education Distinguished Dissertation Award. Attending the 1998 IDEA Congress in Kenya had a profound impact on the way she viewed her theatre practice. The need to work on projects that might have a positive social impact and address concerns in society became compelling to her. Her interest is in sustained interaction in complex situations. She has been a Chief Investigator in a number of Australian Research Council-funded applied theatre projects, working as a drama facilitator and researcher with adult survivors of institutional abuse, and more recently with children and young people with refugee backgrounds, including young asylum seekers.

Peter O'Connor

Peter trained as a drama teacher in the United Kingdom in the early 1980s and has taught drama at all levels of education from early childhood to doctoral students. He has held several national education roles in New Zealand, including as the national manager for the Race Relations Office running a theatre in education project on racism with the older women's theatre company and theatre projects with the Holocaust Centre at the Auckland Museum. At the Mental Health Foundation, he created an arts-based approach to countering stigma associated with mental illness in psychiatric hospitals that became the basis of his Ph.D. He was the National Facilitator for the New Zealand Ministry of Education, overseeing the introduction of a compulsory arts curriculum. In 1999, Peter set up his own theatre company, Applied Theatre Limited, which has produced applied theatre projects across New Zealand, the Pacific and more widely. Everyday Theatre, established in 2004, has worked with nearly 100,000 children exploring issues surrounding family violence and child abuse. Peter's most recent applied theatre work includes working in disaster zones and creating theatre with the homeless in Auckland and on Skid Row in Los Angeles.

Contributors' biographies – original and updated

Judith Ackroyd

Then (2000)

Judith Ackroyd taught drama in secondary schools before moving into drama advisory work, where she supported teachers in the primary as well as secondary phase. She is currently a senior lecturer in drama at University College Northampton, in the United Kingdom. She has published widely in the field of drama in education, her most recent book being the edited collection *Literacy Alive: Drama Projects for Literacy Learning*.

Then (2007)

Dr Judith Ackroyd (currently associate dean (research) at the University of Northampton, United Kingdom) will become dean, Regent's College, London in January 2008. She worked in initial teacher training before teaching in a division of performance studies. She has published a wide range of books for teachers at both primary and secondary phases and two more recent texts, *Role Reconsidered* and *Research Methodologies for Drama Education* (both Trentham Books). Current research interests include drama and health and performed research.

Now

Emeritus Professor Judith Ackroyd enjoyed teaching in schools before higher education, where she worked in teacher education and performance studies at home and overseas. A wide range of publications include *Role Reconsidered* and involved happy collaborations, such as primary lesson books with Jo Boulton and her last edited text (*Performing Research*) with John O'Toole.

Andrea Baldwin

Then

Andrea Baldwin is a clinical and organizational psychologist, an applied theatre practitioner and a researcher. She holds a Ph.D. in psychology, a master of arts in drama and a graduate certificate in health management. Her major professional and research interests lie in the fields of community cultural development and promotion of health and wellbeing, particularly across cultures and among young people. Dr Baldwin has a strong interest in issues of meaningful and appropriate evaluation of arts-based projects. She is currently a senior research fellow in the Creative Industries Faculty, Queensland University of Technology and project manager for the Life Drama project.

Now

Andrea Baldwin is a psychologist, applied arts practitioner, writer and researcher. She holds doctorates in psychology and creative writing and a masters in drama. Andrea currently manages the Birdie's Tree initiative for Queensland Health, using storybooks to help young children and their families cope with natural disasters and disruptive events.

David Cameron

Then

David Cameron lectures in new media and journalism in the School of Communication at Charles Sturt University, Bathurst. He teaches in the areas of broadcast journalism and digital media production, and he coordinates postgraduate journalism studies. His Ph.D. research is examining new forms of authorship emerging from digital media, role-playing and games. Previous research projects include the creation of a web-based journalism training simulation using software-driven characters.

Now

David Cameron is a senior lecturer in communication at Charles Sturt University, Australia. He currently teaches subjects in media production and journalism. David's professional career and research and publication record span fields such

as journalism, radio production, applied drama, digital games, museum studies, mobile media and social media.

John Carroll

Then

Dr John Carroll is an associate professor in communication research in the School of Communication at Charles Sturt University, Bathurst, Australia. His research area is mediated performance, drama and role, focusing on the relationship between production and performance. He is an active member of Drama Australia and is a past director of publications. John Carroll has worked in a wide range of educational settings in Australia, Europe, England and the United States, examining the connection between process drama and identity. Other research interests include dramatic role and online/television performance as well as interactive video games.

Now

John Carroll was professor of communication research at Charles Sturt University until 2011. He died in 2011.

Chan Yuk-lan (Phoebe)

Then

Chan Yuk-lan (Phoebe) is lecturer/programme coordinator at the Hong Kong Art School, where she convenes a master of drama education programme co-organized with Griffith University, Australia. She has an MA in drama in education from the University of Central England and she is currently undertaking Ph.D. study with Griffith University. She has worked extensively with theatre companies, schools, community groups and NGOs in stage performance, applied theatre and theatre in education, teacher education in the use of drama as pedagogy and research, as well as editing, translating and authoring publications. She is the co-editor of *Planting Trees of Drama with Global Vision in Local Knowledge: IDEA 2007 Dialogues.*

Now

Chan Yuk-Lan Phoebe is founder of Chan's Applied Theatre Lab. She convened the first masters programme in drama education and applied theatre in Hong Kong (Hong Kong Art School and Griffith University) from 2003 to 2015, and was head of performing arts research at the Hong Kong Academy for Performing Arts. She is also a founding member of the Hong Kong Drama/Theatre and Education Forum (TEFO).

Kennedy Chinyowa

Then

Kennedy Chinyowa is a postdoctoral research fellow in the Department of Drama and Film Studies at Tshwane University of Technology. He is also a visiting lecturer and researcher for the Drama for Life (DFL) program at the University of the Witwatersrand. He has taught at the University of Zimbabwe, Griffith University (Australia) and University of KwaZulu-Natal (South Africa). Kennedy obtained his Ph.D. degree from Griffith University. He has won numerous research awards and has published widely.

Now

Kennedy Chinyowa was professor and director of the Centre for Creative Industries, in the Department of Drama and Film Studies at Tshwane University of Technology, Pretoria, and formerly head of dramatic arts, University of Witwatersrand, South Africa. He has published and presented widely in books, refereed and accredited journals. He died in June 2021.

Kerim Dinç

Then

Kerim Dinç is currently working in the Turkish Department, Kazim Karabekir Faculty of Education, Ataturk University, Turkey. He has a Ph.D. in Turkish drama and he has published articles and presented papers in Turkish drama; he also taught Turkish in Moldova for a year.

Now

Abdulkerim Dinç is an assistant professor in the Department of Turkish Literature, Faculty of Education, Ataturk University, Turkey. His major is Turkish drama. He is interested in the history of Turkish drama and social dimension in modern Turkish drama.

Stig Eriksson

Then

Stig A. Eriksson is an associate professor in drama education at Bergen University College, Norway. Eriksson has written a number of articles related to drama pedagogy in Norwegian and international journals. He has also conducted many workshops in national and international conferences on drama and theatre in education. Eriksson served on the international working group for the forming of the International Drama/Theatre and Education Association (IDEA) and was elected into the first IDEA Executive Committee (1992–95). He became project coordinator for IDEA's 4th World Congress in Bergen (July 2001) and is the editor of the CD-ROM *The Congress Handbook* (2002).

Now

Currently, Stig A. Eriksson is professor emeritus at Western University of Applied Science (HVL), Bergen campus. His research areas include applied drama and theatre, process drama, Brecht's learning play and the history of theatre and drama education. For an update of his publications, see http://www.drama.no.

Kathleen Gallagher

Then

Kathleen Gallagher is an assistant professor in the Department of Curriculum, Teaching and Learning at the Ontario Institute for Studies in Education of the University of Toronto. In 1999, her doctoral research was awarded the American Alliance of Theatre and Education's distinguished dissertation award. In 2000, her dissertation also received the Barbara McIntyre distinguished research award. Dr Gallagher's new book is entitled *Drama Education in the Lives of Girls: Imagining*

Possibilities (University of Toronto Press, 2000). Her research in drama continues to focus on questions of inclusion and democratic practice as well as the pedagogical possibilities of learning through the arts.

Now

Dr Kathleen Gallagher is a fellow of the Royal Society of Canada and a distinguished professor in the Department of Curriculum, Teaching and Learning and the Centre for Drama, Theatre and Performance Studies at the University of Toronto. She studies theatre as a powerful medium for expression by young people of their experiences and understandings.

Julia Gray

Then

Julia Gray is a Canadian theatre director, playwright and researcher. Her most recent health and theatre collaborations include projects at Mt Sinai Hospital and University Health Network (both in Toronto), University of Toronto, York University's School of Nursing (Toronto), Toronto Rehabilitation Institute and The Cameron Bay Child Development Centre in Kenora, Ontario, Canada. Julia recently completed her master's degree in theatre studies at York University and is the Artistic Director of Possible Arts, a company committed to the connection between health and arts.

Now

Julia Gray is a playwright, theatre director, and performance and cultural studies scholar; her work spans the arts, humanities, social and health sciences to elucidate and overturn cultural assumptions of ageing and disability. Currently, she is a visiting scholar at Sensorium, a creative research centre at York University in Toronto, Canada.

Andrea Grindrod

Then

Andrea Grindrod has a background in community health nursing and education. Her work over the past seven years at Ranges Community Health Service

has been in the area of health promotion and mental health. For the past three years, Andrea has been coordinator of the Community Health & Drama Project (CHAD).

Now

Andrea Grindrod is a research fellow and the projects manager at La Trobe University's Public Health Palliative Care Unit. She has over twenty years' experience in public health, health-promotion policy and practice, and the development of sectors and communities to address a range of health and social issues, including the end of life.

Alberto Guevara

Then

Professor Alberto Guevara pursues a lifelong interest in the intersections of performance and politics. Under the Nicaraguan Sandinista government, he participated in a cultural brigade and received training at the National Theatre School. His scholarly work focuses on contestations of social and national politics through performance and the theatricality of violence. He has collaborated with a number of international intercultural theatre organizations, and has co-curated and contributed multimedia works to two exhibitions dealing with the aftermath of the Nicaraguan revolution. Recent major projects include a documentary film and article, 'Pesticide, performance, protest: The theatricality of flesh in Nicaragua' (*InTensions*, 1, 2008, available at http://www.yorku.ca/intent/issue1).

Now

Originally from Nicaragua, Alberto Guevara is currently associate professor of theatre and performance studies in the Department of Theatre at York University, Canada. Professor Guevara is the author of *Performance, Theatre and Society in Contemporary Nicaragua: Spectacles of Gender, Sexuality and Marginality* (Cambria Press, 2014).

Tordis Landvik

Then

Tordis Landvik is an assistant professor at Nesna University College, Norway. Her master's dissertation (1998) was titled 'Theatre and Identity: Three Performances Based on Local History and their Role in Identity Formation'. Before joining academia, Tordis directed and taught in northern Norway (1978–97), first at Nordland Teater and then at Vefsn Folkehøgskole. Her special interests are youth theatre, locally created small community theatre and the impact of these forms on their audience. She is currently researching community theatre and drama as a method for teaching mathematics.

Now

Tordis Landvik is an associate professor, Faculty of Fine Arts at the University of Agder, Norway, where she has been since 2013. Her current research work is still in the field of community-based theatre, such as *Kvinner over en lav sko/Women Over a Low Shoe*, involving local issues combined with characters (2014).

Tim Prentki

Then

Tim Prentki is a professor of theatre for development at the University of Winchester, United Kingdom, where he runs the MA in theatre and media for development. He is a member of the editorial board of *Research in Drama Education* and has recently co-edited an issue on impact assessment. He is co-author of *Popular Theatre in Political Culture* and is currently co-editing the *Routledge Companion to Applied Theatre*.

Now

Tim Prentki is professor emeritus of theatre for development at the University of Winchester, United Kingdom. He is the author of *The Fool in European Theatre* and *Applied Theatre: Development*. He is the co-editor of *The Applied Theatre Reader*, *The Companion to Applied Performance* and *Performance & Civic Engagement*.

Bjørn Rasmussen

Then

Professor Bjørn Rasmussen works in the Department of Arts and Media Studies at the Norwegian University of Science and Technology. He teaches drama education and has been engaged in the international development of drama research for many years. He has written books and articles, and works with drama theory based on post-structuralist ideas of cultural production. He was a visiting fellow at Griffith University in Brisbane in 1999–2000.

Now

Professor Bjørn Rasmussen still works in the Department of Arts and Media Studies at the Norwegian University of Science and Technology. He teaches drama education and applied theatre, mainly at a postgraduate level. Currently, he collaborates with Witwatersrand University, Drama for Life, on a research project called Theatre and Democracy, focused on building democracy in post-war and post-democratic contexts.

Nora Roozemond

Then

Nora Roozemond worked for 20 years until 1979 in schools and colleges with young people from kindergarten to university, and also as a freelance extracurricular drama teacher in organizations for the arts, and amateur and community theatre. For the next twenty years, she was drama education inspector for the Ministry of Culture. During these years, she was responsible for the quality of drama education in the extra-curricular field and amateur theatre in the Netherlands. Since 1996, she has been an active member of the Committee for Children and Youth of IATA/AITA. From 2000, she has been a board member or chair of various institutions in the Netherlands, including a youth theatre school (Gouda), an amateur theatre group (Studio Noordholland), a professional community-theatre company (Stut), a professional youth theatre company (Speeltheater Holland) and a commercial organization to provide corporate and conference theatre (Aenit).

Now

Nora Roozemond retired from these activities in 2009, and also from her work as a member of AITA/IATA. In her retirement, she remains active as a private teacher of Dutch language for disabled youngsters and for migrant adults. She plans to continue this work for as long as possible.

Shifra Schonmann

Then

Shifra Schonmann is a senior lecturer in the Faculty of Education at the University of Haifa, where she conducts the theatre teachers' training program and is head of the Laboratory for Research in Theatre/Drama Education. The continuing focus of her research is aesthetic theatre/drama education, curriculum planning and teacher education. She has published numerous articles on these issues, as well as a book, *Theatre of the Classroom* (in Hebrew). Another book, *Behind Closed Doors* (SUNY Press) was co-written with Ben Peretz. Shifra is currently engaged in extensive research into children's theatre, and also acts as the academic counsellor for the National Theatre Committee for Youth and Children in Israel.

Now

Shifra Schonmann is full professor (emerita), chair of education, society and theatre for young people at the University of Haifa, Israel. Her numerous publications include *Theatre as a Medium for Children and Young People: Images and Observations* and, as editor, *Wisdom of the Many: International Yearbook for Research in Arts Education*.

Christine Sinclair

Then

Dr Christine Sinclair is a lecturer in writing at Swinburne University. Until recently, she was a research fellow and lecturer in drama education at the University of Melbourne. She is also a freelance community artist, working as a writer and director in many community settings.

Now

Christine Sinclair was head of drama in the University of Melbourne Graduate School of Education from 2011 to 2019. She died in 2020.

Mehmet Takkaç

Then

Mehmet Takkaç is an associate professor in the English Department, Kazim Karabekir Faculty of Education, Ataturk University, Turkey. He holds a Ph.D. in language teaching and his main interests lie in drama, especially political theatre. He has published books on television and drama, and articles on drama.

Now

Mehmet Takkaç is a professor at the Department of English, Kazim Karabekir Faculty of Education, Ataturk University, Turkey. He holds a Ph.D. in British literature and his main interests are drama, especially political theatre. He has published books on television and drama, and articles on drama.

James Thompson

Then

James Thompson is a Leverhulme Special Research Fellow at Manchester University Drama Department. He was founder and director of the Theatre in Prisons and Probation Centre and has worked on applied theatre projects in the United Kingdom, United States, Brazil, Burkina Faso and Sri Lanka.

Now

James Thompson is a professor of applied theatre at the University of Manchester. He was the founding director of In Place of War (http://www.inplaceofwar.net) and has written widely on socially engaged arts. His most recent books are *Performance Affects* (2009), *Humanitarian Performance* (2014) and (as co-editor) *Performing Care* (2020). He is working on a book on care aesthetics.

Els van Poppel

Then

Els van Poppel is a theatre director and lecturer in Nicaragua, Central America. Originally from Holland, where she studied theatre science at the University of Utrecht, Holland, combined with practical theatre work at the Theatre Academy, she went to Nicaragua in 1982 to support the revolution and is still living there. She has participated in various directing projects in Holland as well as Nicaragua. After many years' work in theatre, presenting workshops, directing plays, organizing festivals and interchanges, and supervising students, in 2000 she formed MOVITEP with four Nicaraguan arts professionals. Apart from this, she co-organizes an annual International Theatre Festival in Nicaragua, now in its thirteenth year.

Now

After over 30 years in Nicaragua, Els van Poppel returned to the Netherlands, where she is currently director of TEATRADE, a Latino migrants theatre group that participates in festivals and presentations nationwide. Every year she goes back to Nicaragua to give workshops, and to reanimate theatre groups and MOVITEP in these changing times.

Karola Wenzel

Then

Karola Wenzel studied as a primary teacher, and additionally in theatre and music, with tutors including Walter Ybema of Odin-Teateret, Yoshi Oida and Keith Johnstone. Her special study was on philosophy with children. From 1995 she worked in Hanover as a freelance drama teacher, actress and director. In 1999 she was nominated for a German children's theatre prize for the philosophical performance *Hinter den Augen* with children's theatre group Bananas. Since 1999, she has been a lecturer in theatre pedagogy and communication at the University of Applied Sciences Osnabrück/Lingen, responsible for children's theatre, improvisation and music in theatre.

Now

Since 2004, Karola Wenzel has been running Hindsæter Hotel in Norway, together with her husband.

Milton Keynes UK
Ingram Content Group UK Ltd.
UKHW031312250923
429345UK00033B/260